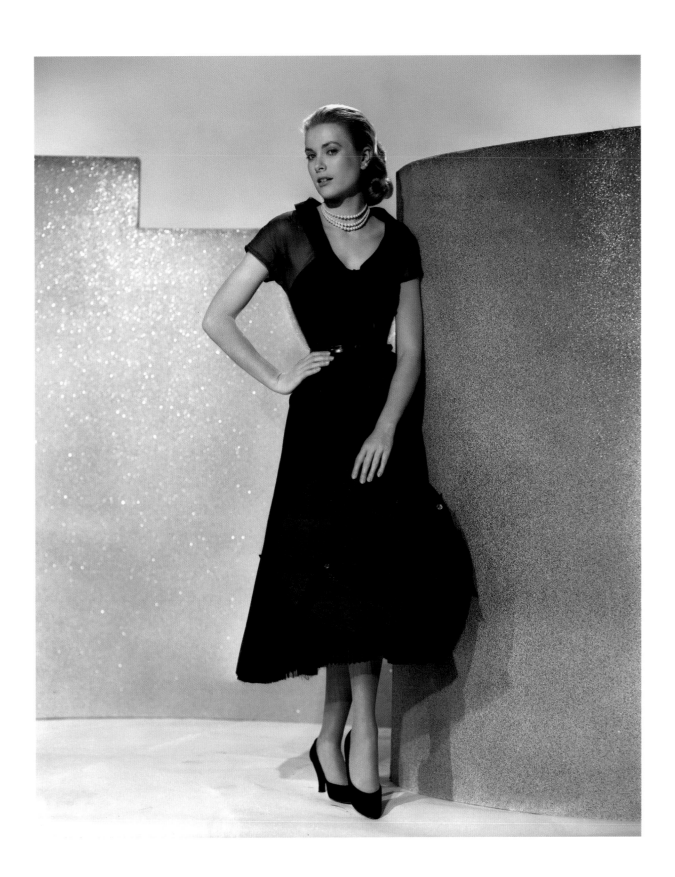

# GRACE

# KELLY
## HOLLYWOOD DREAM GIRL

BY JAY JORGENSEN AND MANOAH BOWMAN

DESIGNED BY STEPHEN SCHMIDT

DEY ST.
An Imprint of WILLIAM MORROW

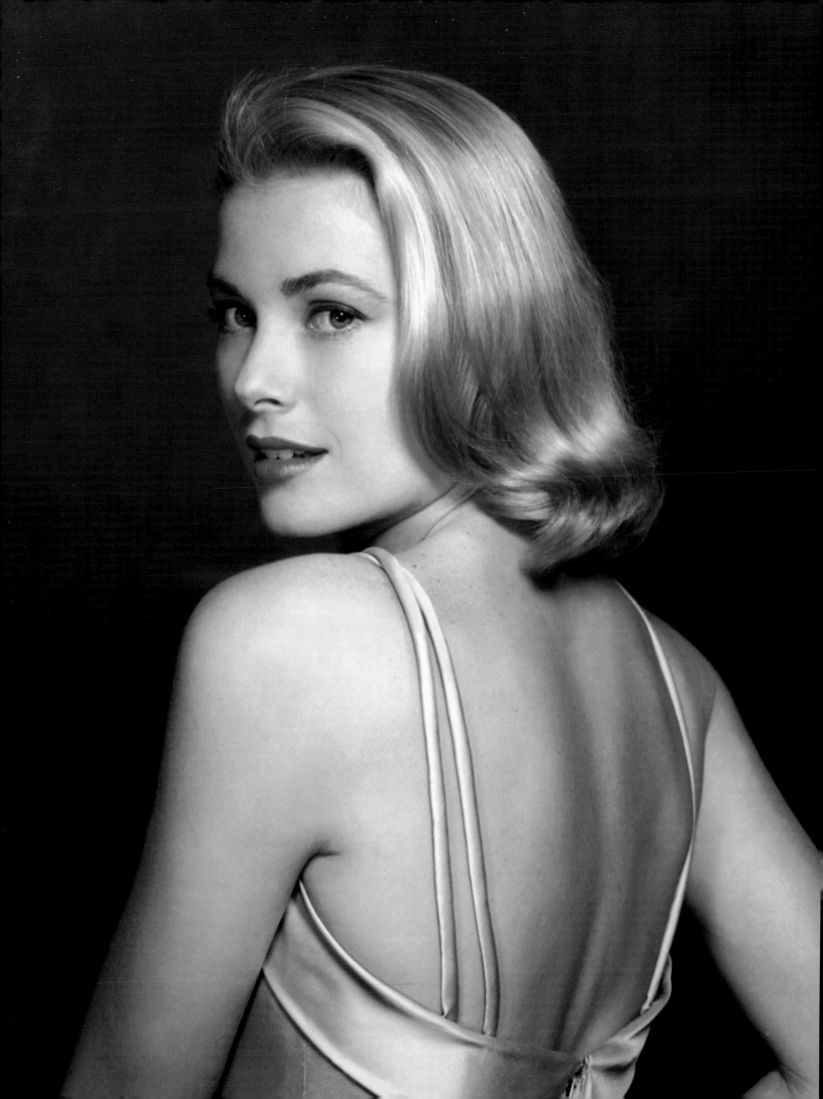

For Merica

# CONTENTS

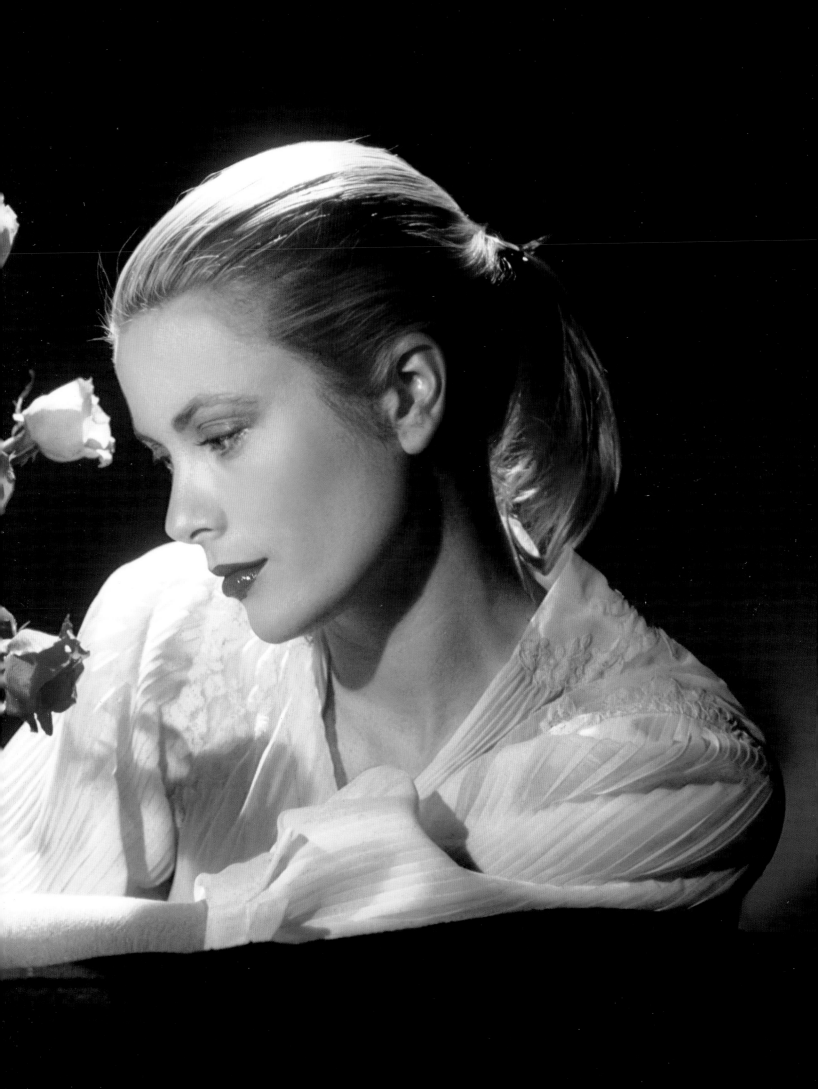

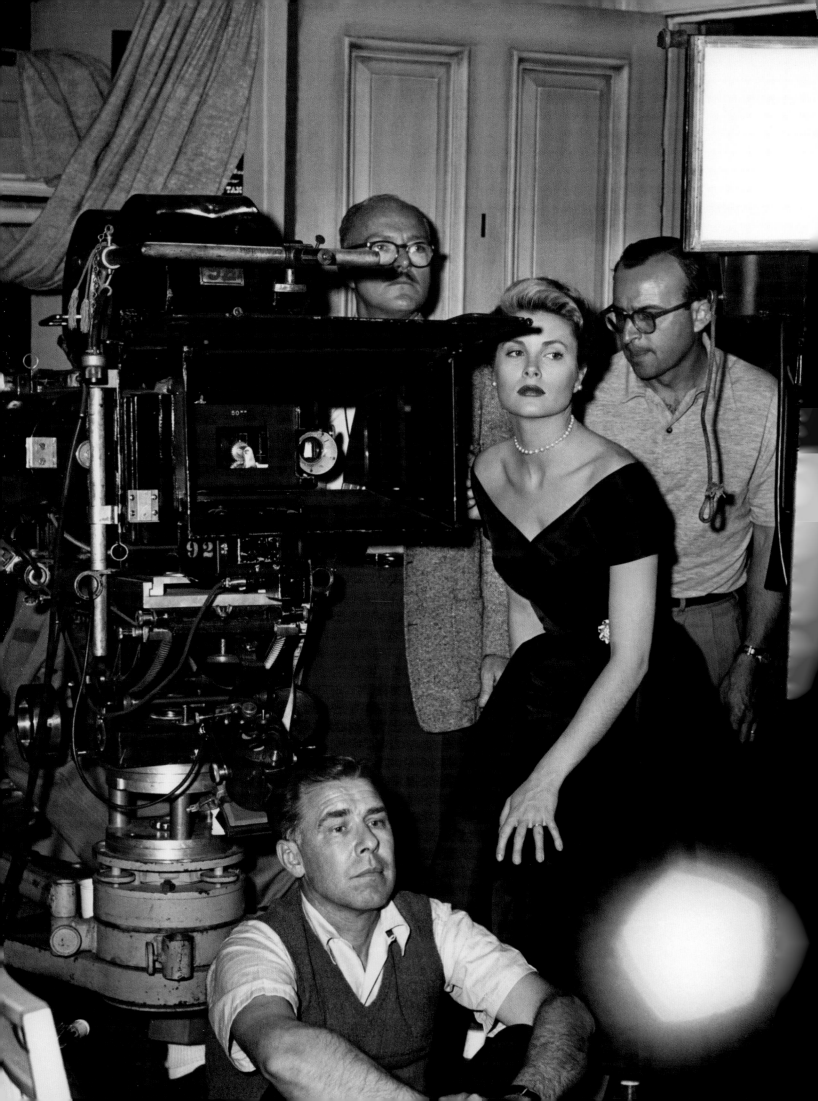

# GRACE KELLY

## CREATING A MOVIE STAR

Grace Kelly's beauty is legendary. But any assumption that she was handed fame and success because of her looks would be a false one. In fact, Grace refused to use her beauty or sex appeal to get roles. She not only dressed plainly, even dowdily, at auditions, she hid her face behind horn-rimmed glasses and pinned her blond hair into a bun when not on camera. Especially in her early days, the off-screen Grace was far from the iconic princess Danny Peary defined as "criminally beautiful."

In the pages of this book, an alternative story of Grace Kelly's life emerges in photographs, quotes, and memorabilia from what was arguably the most exciting and empowered period of her life: her Hollywood years. Indeed, this may be the first book ever to present the story of Grace's life as viewed through the lens of her film career. Here, her creative life takes center stage. Her passion for acting, her creative process, and the evolution of her screen persona are examined in detail. Grace Kelly—though she was born into privilege and blessed with enviable physical assets—did not appear fully formed on Hollywood's doorstep and ascend to stardom overnight. She was made into the star that we know today.

A quiet, nearsighted child in a family of beautiful, robust overachievers, Grace was never considered exceptionally good-looking by her relatives. From her earliest days, she was forced to look inward and seek other ways to distinguish herself. She could never be the dazzling beauty of the Kelly family—that honor went to her older sister, Peggy. But Grace could be the most thoughtful, or the most creative, or the funniest, or the most dramatic, or the most tenacious. She aspired to attain inner qualities that would sustain her throughout

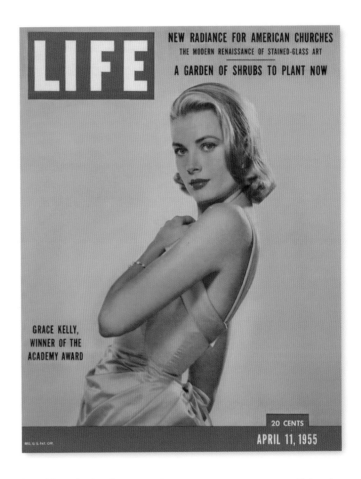

her life. Flashy, fleeting glamour was never something to cling to.

When she began auditioning for theater roles in New York, Grace could have wowed producers with her ice-blue eyes, chiseled bone structure, and lithe figure. Instead, she wrapped herself in cardigans, woolen skirts or slacks, and flat, sensible shoes. Her characteristic bun or ponytail gave the impression of a young schoolteacher or serious college student. Why did she deliberately dress herself down? Because she had grown up emphasizing her internal qualities over the external. It was as simple as that. For Grace, displaying talent, sensitivity, and dedication to her craft was more important than displaying her legs.

OPPOSITE Grace Kelly on the set of *The Country Girl.* ABOVE Grace appeared on the cover of *Life* after winning her Oscar.

She lost countless roles because she was considered too quiet, too reserved, or too plain-looking. Her black-and-white headshots were stark and unremarkable. A cameraman who observed Grace's first screen test was quoted as saying, "On film, she just didn't come across. She generated absolutely nothing—no sex, no vitality, just a kind of subdued prettiness."

But she persevered, and began to get small parts on TV and in films. In her early movie appearances and Hollywood photo sessions, the industry was still not sure what to do with her. She had a high forehead and a square jaw, and had to be photographed from the proper angles or she looked too severe. It wasn't until Alfred Hitchcock and Paramount Studios got a hold of her in *Rear Window* that Grace the glamour girl was created.

The Paramount team, including costume designer Edith Head, makeup artist Wally Westmore, and still photographer Bud Fraker, were largely responsible for transforming the natural beauty behind the glasses into a stunning woman on camera. The most flattering hairstyles, cosmetics, and clothing were established for Grace. A perfect balance between glamour and simplicity had to be struck; she must be made up, but not too heavily or

she looked artificial. "You can't use trick lighting or hokey poses with the girl," Fraker said in 1955. "The secret of her personality is naturalness."

That same naturalness was also the secret to her Oscar-winning performance as Georgie Elgin in *The Country Girl*. By the time she got the role of the downtrodden Georgie in 1954, Grace had established herself as a symbol of glamour and sex, albeit reluctantly. Off camera, she still wore her glasses and casual slacks. On the screen, she radiated sheer splendor. That sparkling exterior is just what Hollywood mistook for the real Grace Kelly, and so the town was baffled when she discarded the makeup and evening gowns to play a plain-Jane hausfrau in an old dress and flats in *The Country Girl*. The irony was that Georgie Elgin's look was closer to the real Grace than the public knew. To earn her Best Actress Academy Award, Grace had to strip away her newly acquired high-gloss façade and return to where she had started in the first place: a clean-scrubbed girl in a cardigan sweater that everyone accused of looking dowdy. It wasn't so much a case of de-glamorizing herself as it was of being herself.

Once she had taken Hollywood by storm, suddenly Grace's simple elegance became all the rage. A 1955 article

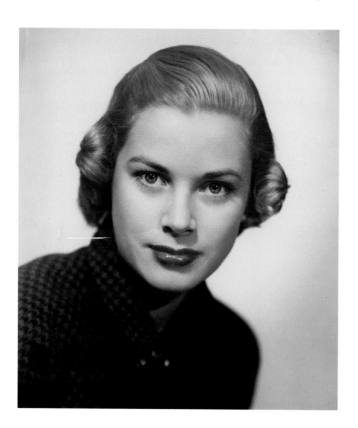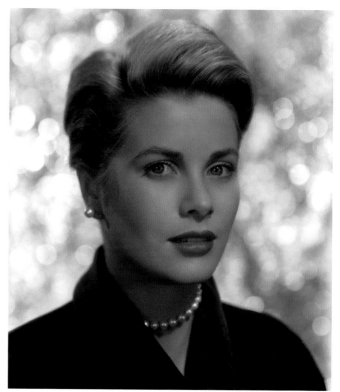

**ABOVE** Grace Kelly's theatrical headshot from the late 1940s (left) and as Georgie Elgin in the film *The Country Girl*.

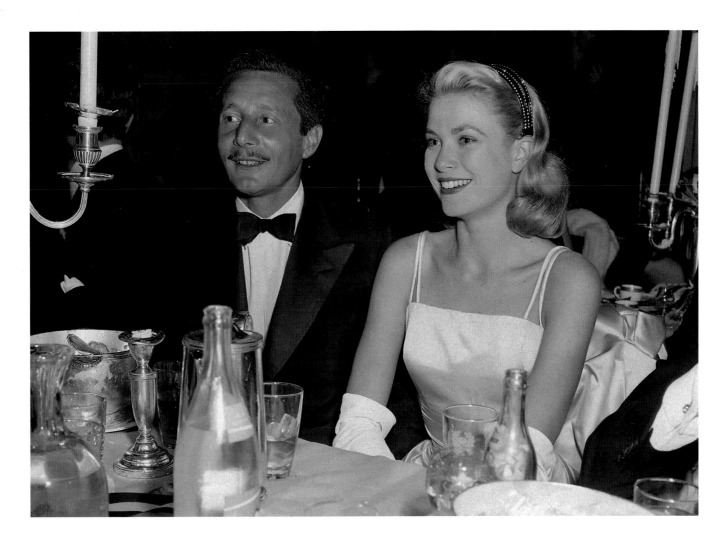

in *Modern Screen* credited Grace for revolutionizing style. "Alone, singlehanded, and quite unintentionally, a bright new screen star is changing the tastes of Hollywood," wrote reporter Marva Peterson. "Fashion experts find themselves promoting styles that de-emphasize the bosom and the tight skirt. . . . The swing toward genteel charm really started with Deborah Kerr and Audrey Hepburn. It was Grace's phenomenal success, however, combined with her genuine refinement, that really wrought the mild revolution." Grace had always dressed tastefully and conservatively, and had no intention of setting trends. "I'm merely being myself" was her only explanation for the phenomenon.

Her on-screen image, however, was carefully molded by her own judgment, by industry experts, by Hitchcock, and by the guiding hand of influences like Oleg Cassini, who encouraged Grace to heighten and refine her natural style until it befitted royalty. "You don't have to dress like a schoolteacher or please the headmaster at

Bryn Mawr," Cassini told her. "Your beauty should be set off like a great diamond, in very simple settings." Grace's name would eventually become synonymous with her style: the fresh ivory face, the lips delicately painted crimson, the short, sleek golden mane, the tailored dress, the single strand of pearls, and the signature little white gloves. For Grace, however, substance would always take precedence over style.

With hundreds of revealing images, this book offers a rare glimpse behind the scenes at both sides of Grace: the young woman yearning to express herself creatively and to be taken seriously, and the image she had to create in order to make her dreams come true. One purpose of this book is to illuminate all the hard work required to make Grace Kelly one of the biggest and most enduring superstars of cinema. After all, Grace was one of the few celebrities who not only attained the status of living legend in her own lifetime, but who remains an icon for the ages. Even icons have to start somewhere.

**ABOVE** Grace attends the April in Paris Ball with fashion designer Oleg Cassini in January 1955. Cassini helped shape Grace's signature style off-screen.

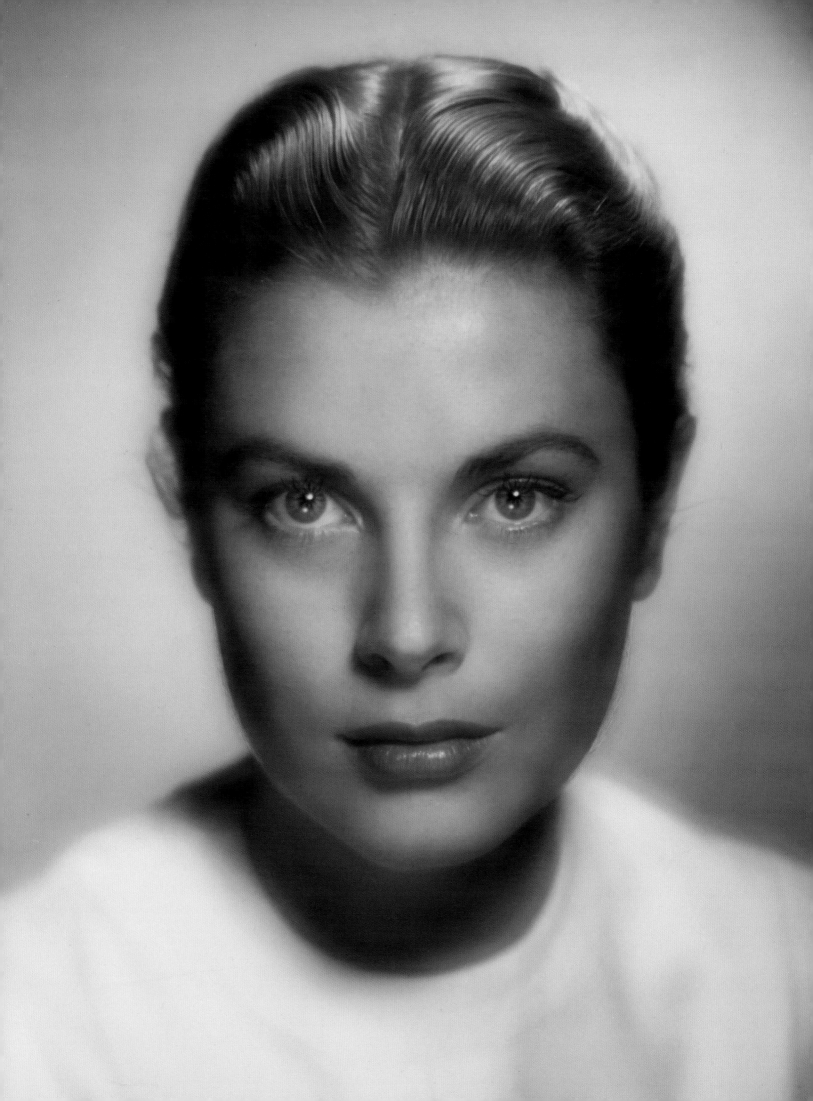

# THE EARLY YEARS

## 1929–1951

*"What other actors and actresses yearned for and tried to fake, beg, borrow, or buy, Grace Kelly was born with."*

—Film critic Charles Champlin

Entering Hollywood as a struggling actress in 1950 and leaving to become a princess in 1956, Grace Kelly sizzled in eleven motion pictures, looking equally sumptuous in glorious Technicolor or shadowy black and white—her charisma and talent adaptable to westerns, mysteries, musicals, dramas, or romances. Many memorable stars glittered across movie screens in the 1950s, but nobody added more charm to more film genres in a shorter amount of time than Grace Kelly.

Looking back today, it is almost impossible to imagine 1950s Hollywood without Grace Kelly. Yet the void that she filled can only be defined in retrospect. In the early fifties, Grace was the actress Hollywood didn't realize it needed.

Ruling this era was a class of actors who had risen to fame in the 1930s, and who were still big box-office stars twenty years later—Clark Gable, Gary Cooper, James Stewart, and Bing Crosby among them. By the early fifties, the screen personas of these aging men needed invigorating. Their bankability depended upon their being seen as objects of desire, but in a dignified manner befitting their maturity.

Before Grace Kelly appeared, an actress like Ingrid Bergman would have been the logical choice to pair with these cinema legends. But in the late 1940s, Bergman fled to Italy and began an affair with Roberto Rossellini, tainting her Hollywood image. Katharine Hepburn had the wit and the elegance, but her brittle style lacked sex

appeal. Besides, Hepburn was in her early forties and Bergman in her late thirties, and Hollywood has always been notoriously less forgiving of its female stars' ages than its males'.

Deborah Kerr's British eloquence and Audrey Hepburn's gamine sophistication may have appealed to feminine audiences, but neither one quite clicked with the brash post–World War II American culture—successful, independent, sexual, and moral all at the same time. A new face was required, a woman who could simultaneously exude both lust and class.

"Grace had a very particular quality," observed her friend Rita Gam. "It was the 'fire under the ice' and I guess the ice was always the temptation for the fellows, and boy, they were tempted by Grace. I mean, they just fell like tenpins." Grace had an irresistible quality, and there was simply no other actress with her *niveau social* who was American. In contrast to a sexy American bad girl like Ava Gardner, Grace could be either saint or sinner—or *both* saint *and* sinner. She could safely smolder behind the mask of morality that American society demanded.

"She had one great weapon," onetime fiancé Oleg

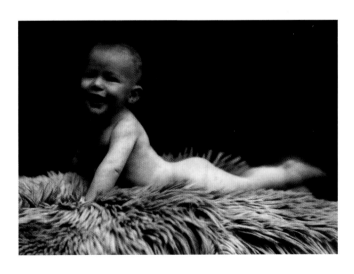

**OPPOSITE** Grace's headshot by Marcus Blechman helped to launch her career in films.  **ABOVE** Baby Grace in 1930.

DECEMBER 4, 1920                                    PAGE 47

# The Farm Journal

*Over 1,050,000 This Month*

**"PEACHES" AT CHRISTMAS TIME**

To over 1,050,000 of Our Folks, "Peaches" carries the holiday message of The Farm Journal's editors. It is not just a pretty cover, this photograph, but a Christmas greeting of one friend to another—outward and visible expression of a personality that, for forty-three years, has been helping all agricultural America to happier living and fatter pocketbooks.

Cassini said. "She had that sort of delicate, subtle sex appeal, and the coolness of her, and the reticence of her attitude, camouflaged a very, very sexual personality."

It was Grace's potent combination of warmth and coolness that tapped into the zeitgeist of the 1950s. The idealized postwar American woman was classy, sexual, yet slightly maternal. In *Rear Window*, Grace embodies this ideal: a poised, beautiful lady, who mothers Jimmy Stewart, feeding him a delicious dinner and catering to his whims. Then she turns around and slips into a provocative nightgown, casually informing him that she plans to spend the night. She even offers to subjugate her own career to his, but in the end she remains firmly her own woman.

Once Hollywood caught on to her unique gifts, Grace Kelly became irreplaceable—literally. Her early retirement left a void in the movies that has never been filled by an actress with Grace's caliber of acting, beauty, and pedigree combined.

"Have a goal and make it." This was the credo that Irish immigrant Mary Costello lived by. When she married Irish laborer John Henry Kelly in Vermont in 1867, Mary raised their ten children—including John B., George, and Walter—to achieve their goals. The large Catholic family

settled in Philadelphia and thrived until tragedy struck. In 1917, daughter Grace, a rising young comedic actress, died young from myositis, an inflammatory muscle condition. Though the Kellys were devastated, the misfortune made them even more determined to persevere.

The ambitious John B. Kelly's goal was to row his way to the top; he became one of the best oarsmen on Philadelphia's Schuylkill River as a teenager. Once he finished school, he started his own construction and brickmaking business, Kelly for Brickwork. With financial backing from brothers George and Walter—both making names for themselves in show business—Kelly for Brickwork soon became the largest brick firm on the East Coast. John B. quickly amassed a fortune, though he never attained the "Main Line" status of the old-money Philadelphia families, because he had worked as a laborer.

Determined to prove his worth, John trained hard and qualified for the 1920 Olympics, held in Belgium. Kelly won a gold medal for sculling, became an American hero, and was elected to the City Council of Philadelphia. His wealth, athleticism, and good looks made Kelly one of the city's favorite sons.

In 1924, Kelly married Margaret Majer, a beautiful blond model and champion swimmer of German lineage. Margaret had met John B. Kelly at a swim meet in 1913 but postponed marrying him until she had achieved her own personal and professional goals. She graduated from Temple University with a degree in physical education and became the first female to head the women's physical

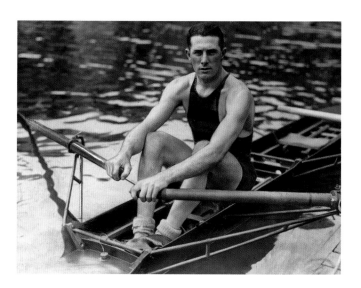

**TOP** Margaret Kelly was an athlete and cover model.   **ABOVE** John B. Kelly Sr. was a triple Olympic gold medalist.

education department at the Woman's Medical College of Pennsylvania.

On June 13, 1925, Margaret "Peggy" Kelly was the first child born to John B. and Margaret. A year later, the Kellys moved into a seventeen-room brick mansion at 3901 Henry Avenue in the East Falls section of Philadelphia. On May 24, 1927, a baby boy arrived. John B. Kelly Jr., also known as "Kell," would be the couple's only son.

On November 12, 1929, just two weeks after the historic Wall Street crash, Grace Patricia Kelly was born. Grace was named after her late aunt, at the urging of Mary Kelly. Dire economic conditions of the Great Depression did not mar the happy event. John B. Kelly Sr. was unaffected by the stock market panic, and his fortune remained intact. On June 25, 1933, Elizabeth "Lizanne" was born and completed the Kelly family.

By the time the youngest girl came along, Grace had grown accustomed to being the center of attention. "I resented Lizanne terribly," Grace admitted. "I gave Grace the most trouble," Lizanne recalled. "For three years, she was the baby of the family. Then I came along and elbowed her out of the way. I used to beat her up—yes, I really did! And let her say she wanted something, and I'd grab it first. When we grew older, I was the brat sister who made her life miserable, especially if she was with her boyfriends."

Peggy, the apple of her parents' eyes, enjoyed attention from everyone, including Grace. "I was always telling her what to do, and she always did it," Peggy later remembered. Grace simply said, "I worshipped Peggy."

In 1934, Grace was enrolled at the Academy of Assumption Ravenhill, in the parish of St. Bridget's Church, where the Catholic family attended Mass on Sundays. Academics and good citizenship were emphasized over physical education at Ravenhill. "The children had worship in the chapel," remembered Sister Francis Joseph, one of Grace's instructors. "They were taught to be respectful and reverent and to pray. And that certainly must have had an ingrained effect upon her soul."

The Kelly children were driven by their parents to excel, particularly in sports. But Grace was thin and fragile, frequently suffering from colds and sinus infections. By nature, she was more introspective than her brothers and sisters, preferring to play with dolls and invent stories rather than to compete on the athletic field. However, she idolized her athletic hero father, and winning his approval was her ultimate desire.

**ABOVE** The show-business Kellys—Grace's uncles vaudevillian Walter Kelly (left) and playwright George Kelly (right).

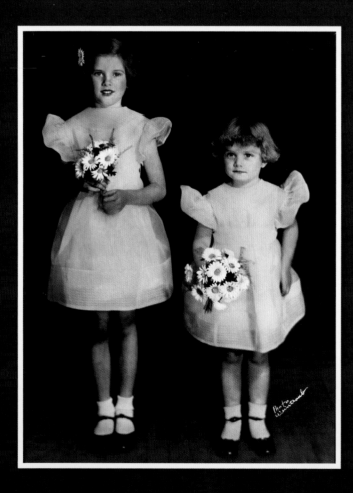

TOP LEFT Grace and baby Lizanne in 1933. ABOVE (from left to right) John B. Kelly Sr., Margaret, Peggy, John Jr., Grace, and Lizanne at the Jersey shore, circa 1935. LEFT Grace and her sister Lizanne, dressed for a fashion show in May 1936. OPPOSITE TOP LEFT An undated photo of (left to right) John B. Jr., Peggy, Lizanne, Margaret, and Grace. OPPOSITE TOP RIGHT (left to right) Lizanne, Margaret, Grace, and Peggy Kelly in 1938. OPPOSITE BOTTOM LEFT Grace greets her father, John B. Kelly Sr., upon his return from a trip to California in December 1937. OPPOSITE BOTTOM RIGHT Grace in 1941.

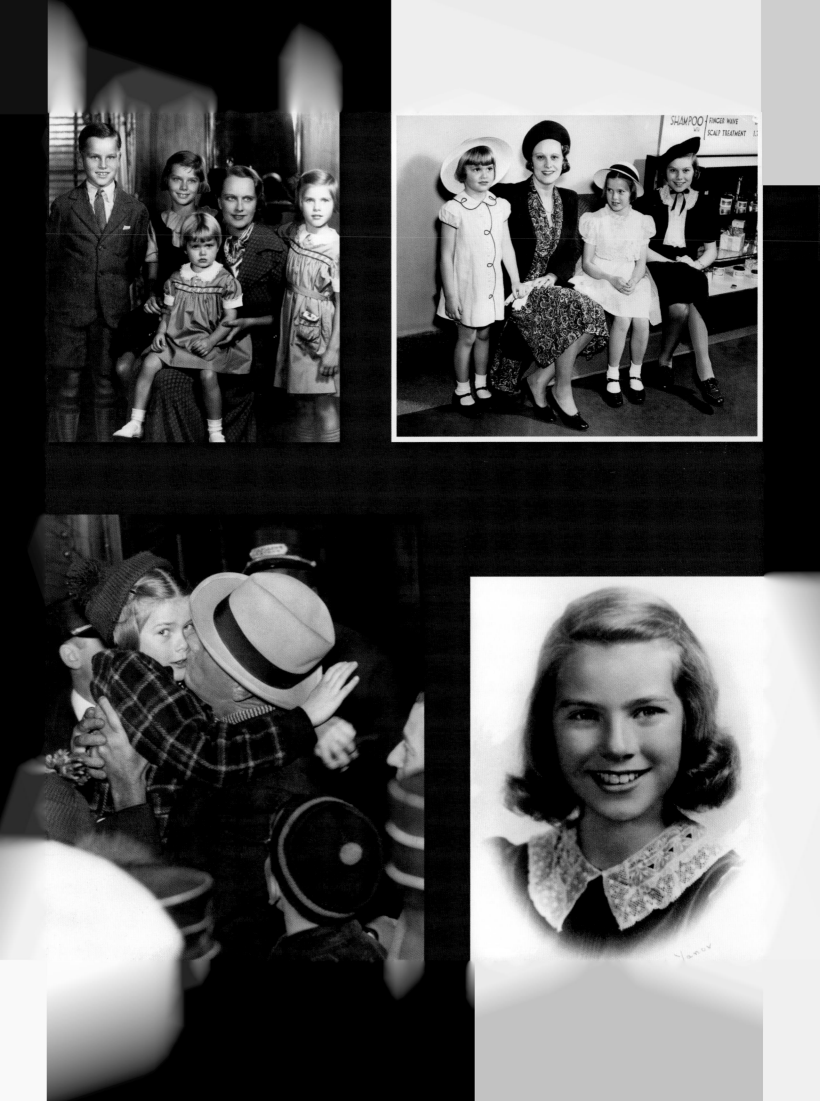

"Her father believed absolutely that Peggy, the older sister, was going to make the big star of the family and succeed," Grace's friend Rupert Allan said. "He never paid any attention to Grace, who was in the middle of the family of these four children. She was quiet, observant of the others . . . I don't think he understood her at all. But she adored him." Grace's friend Judith Balaban Quine has speculated, "One wonders, when you don't get from a parent what it is perhaps you need, if that isn't what creates a great deal of the drive in you to go out and become the fullest part of yourself."

Lizanne remembered Grace as a child in need of loving attention. She later reflected, "Grace, when she was very young, was very shy and a mama's baby. . . . She was very sweet and soft and loved to be held and cuddled and kissed and loved. I, on the other hand, and I think my brother and older sister, were more 'Don't get around me. We want to do our own thing.'"

Consumed with his business, golf games, and politics, John B. Kelly was rarely at home. Margaret Kelly was the disciplinarian of the family, and her children received strict, old-fashioned punishments. "Today, Ma Kelly would be arrested for child abuse because she did not spare the rod," Lizanne said. "And she certainly did not spoil the child. She demanded obedience."

All of the Kelly children showed an interest in amateur theatrics. "When they were all home, they always had a show of some sort going on," John B. Kelly Sr. remembered. "They could mimic anyone's voice and they'd also get the gestures and character down pat." The good-looking Kelly kids also modeled at society fashion benefits. But Grace was never comfortable mingling with the luminaries from politics and films who dropped by the Kelly household. When her schoolgirl crush, movie star Douglas Fairbanks Jr., visited, Grace simply felt awkward and self-conscious.

The family spent summer weekends taking dips in the ocean and the pool at their second home in Ocean City, New Jersey. Both Peggy and Lizanne became competitive swimmers, but Grace saw something more sinister in the family's competitive spirit. "We were always competing," she remembered. "Competing for everything—competing for love." Grace knew she would never beat her siblings in athletic endeavors, so she set her sights on the stage.

In 1942, Grace made her theatrical debut in *Don't Feed the Animals* produced by the Old Academy Players, an amateur theatrical group in East Falls. The applause from the audience hit Grace like a wave of love. She had found her home. Her namesake, Aunt Grace, had been an actress, and her uncle Walter Kelly had

**TOP** Lizanne, John Sr., and Grace at the family's summer home in Ocean City, New Jersey. **ABOVE** Grace in Ocean City, New Jersey.

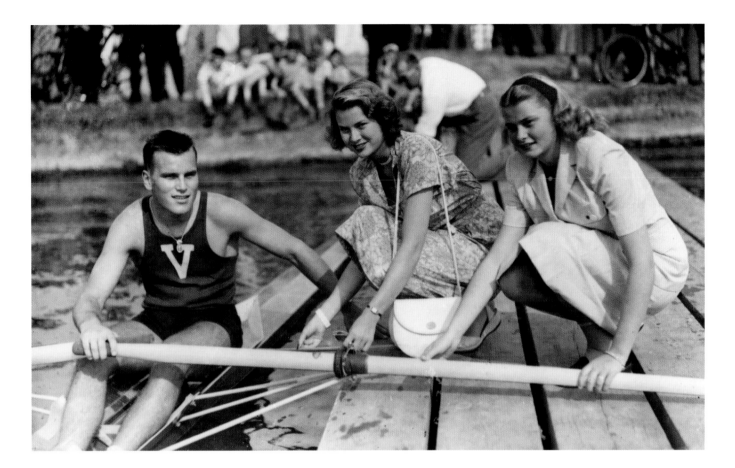

toured vaudeville and appeared in films in the 1930s. The theater was truly in her blood.

It was another uncle, actor-turned-playwright George Kelly, who had the biggest influence on Grace's creative soul. Among his plays were *The Torch-Bearers* and *Craig's Wife*, both indictments of humanity's narcissism and its consequences. He was awarded the Pulitzer Prize for Drama in 1926. His great successes were confined to the 1920s, however, and by the time Grace came of age, his prime had passed.

"Her Uncle George Kelly was a great example to her," said Rita Gam. "He was sensitive and kind and talented, and I think of all the men she ever knew, rather than going for the athletic macho type, her idea of a man was her Uncle George."

In 1944, Grace's father decided that she should attend the private Stevens School, as it placed more emphasis on sports. In her years at Ravenhill, Grace had come to appreciate the discipline offered by the church. And while Grace wanted very much to conform, the duality in her nature had started to emerge: her quiet manner camouflaged a distinctly rebellious streak. Grace

organized smoking parties for her friends, and when she didn't like what was served for lunch, she could send the entree sailing out an open window.

When Grace arrived at Stevens School, she wore glasses, and was slightly overweight. Though tall for her age and quite poised, she was insecure about her small bust and had a thin, nasal voice from years of sinus problems. "We had no idea she was as beautiful as she was," said Alice Godfrey Waters, a friend. "Grace always had a bandana on, had the glasses, the sweater. Nothing glamorous. And then when she went to New York, we started to see her on television, and we'd see her in magazines. It was 'My heavens! That's *our* Grace?'"

By fifteen, a strikingly beautiful young woman had begun to emerge, and acting in school plays increased Grace's confidence. At Stevens, she appeared as Kate in *The Taming of the Shrew* and in the title role of *Peter Pan*. At sixteen, the boys started to take notice. "She always had a lot of boyfriends," her friend Jane Hughes recalled. "I didn't feel she was wild. She was just attractive and she was kind of a star. . . . I don't think she ever missed any of the dances or was without a date on the weekends."

**ABOVE** Grace (center) and Lizanne (right) with John Jr. at Henley Royal Regatta in 1947.

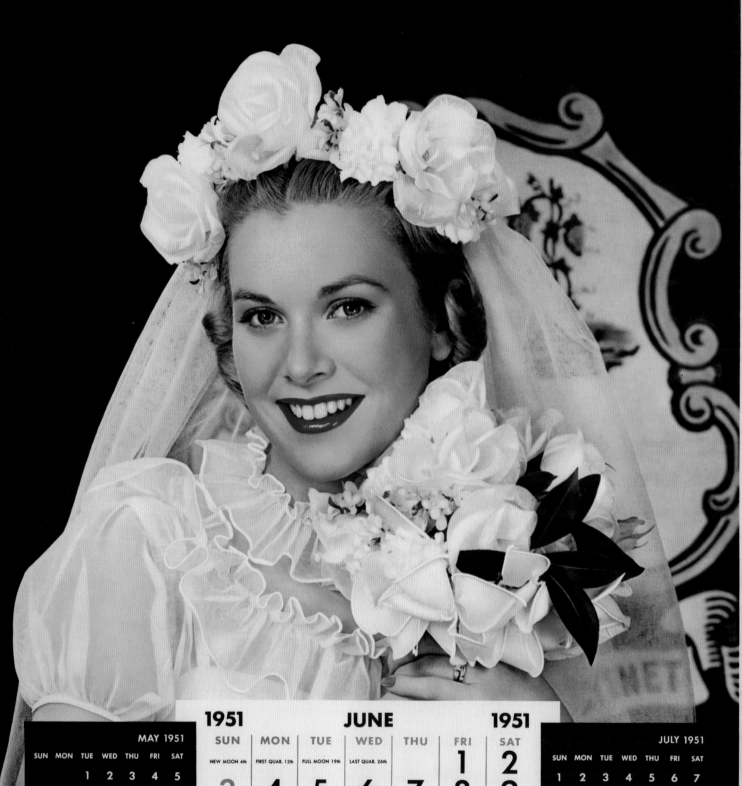

**1951**     **JUNE**     **1951**

| SUN | MON | TUE | WED | THU | FRI | SAT |
|---|---|---|---|---|---|---|
| NEW MOON 4th | FIRST QUAR. 12th | FULL MOON 19th | LAST QUAR. 26th | | 1 | 2 |
| 3 | 4 | 5 | 6 | 7 | 8 | 9 |
| 10 | 11 | 12 | 13 | 14 | 15 | 16 |
| 17 | 18 | 19 | 20 | 21 | 22 | 23 |
| 24 | 25 | 26 | 27 | 28 | 29 | 30 |

MAY 1951

| SUN | MON | TUE | WED | THU | FRI | SAT |
|---|---|---|---|---|---|---|
| | | 1 | 2 | 3 | 4 | 5 |
| 6 | 7 | 8 | 9 | 10 | 11 | 12 |
| 13 | 14 | 15 | 16 | 17 | 18 | 19 |
| 20 | 21 | 22 | 23 | 24 | 25 | 26 |
| 27 | 28 | 29 | 30 | 31 | | |

JULY 1951

| SUN | MON | TUE | WED | THU | FRI | SAT |
|---|---|---|---|---|---|---|
| 1 | 2 | 3 | 4 | 5 | 6 | 7 |
| 8 | 9 | 10 | 11 | 12 | 13 | 14 |
| 15 | 16 | 17 | 18 | 19 | 20 | 21 |
| 22 | 23 | 24 | 25 | 26 | 27 | 28 |
| 29 | 30 | 31 | | | | |

LITHO. IN U.S.A.       COPYRIGHT 1950 BY THE TIMKEN ROLLER BEARING COMPANY

**MILES OF SMILES ON TIMKEN BEARINGS**

Grace began dating a young man named Harper Davis, who attended her brother's school, Penn Charter. Grace broke it off when her father decided that the relationship was getting too serious. Later, Davis developed multiple sclerosis. "Grace would visit him at home, then in the hospital, and it really changed her," her brother, John, remembered. "It really dampened her spirits. Harper died from it. He was just a kid, just nineteen. I never recall seeing Grace sadder in my life."

Grace was known as "Kel" at Stevens, and her yearbook description paints a rough sketch of the Grace Kelly the world would soon know: "Kel is one of the beauties of our class. Full of fun and always ready for a good laugh, she has no trouble making friends. A born mimic, Kel is well known for her acting ability, which reached its peak in her portrayal of *Peter Pan* in our spring play."

After graduation in June 1947, Grace planned to study dance at Bennington College, but she failed the entrance exam—math was her weak subject. She next set her sights on the American Academy of Dramatic Arts in New York. The school was not accepting new students at the time, but when administrator Emil Diestel discovered Grace's relation to George Kelly, he made a special allowance. Grace wrote on her application, "I hope to be so accomplished a dramatic actress, that someday my Uncle George will write a play for me and direct it." Grace's audition was rated as "intelligent" and "sensitive," and it was only her voice that concerned Diestel. But that could be overcome. Grace was accepted.

The Kellys could hardly imagine Grace surviving New York City on her own. "My mother and father especially [were] surprised because she was a shy and a retiring girl," Lizanne said. Her father remembered, "We neither encouraged nor discouraged Grace. We felt she was entitled to have her fling at it. We hoped that she would get it out of her system early and grow up to marry some nice boy."

But Margaret Kelly was concerned. "The stage really is too hard a life for a young girl," she said. "There are too many lonely nights when you're out on the road, too many rough characters for a girl to deal with. But if Grace wanted it, we wouldn't stop her." Her parents had one

stipulation: Grace must live at the all-female Barbizon Hotel, former home to the likes of Joan Crawford, Gene Tierney, and Lauren Bacall. Afternoon tea was served daily, and there were two lounges where the young ladies could play backgammon or listen to records, and entertain gentleman callers. No men were allowed past 10 p.m., and never past the ground floor.

In October 1947, Grace began her studies at the American Academy of Dramatic Arts, located in Carnegie Hall. The academy taught the traditional theatrical approach to acting, not the new "Method," later brought to prominence by Marlon Brando. Grace flourished as she learned breathing, elocution, fencing, and poise. Instructor Edward Goodman helped the actress lower her voice and smooth out her Philadelphia accent. By the time he finished with Grace, her pronunciation was more England than East Falls.

New York was everything Grace had hoped it would be—an exciting, inspiring escape from the restrictions of the Kelly household, and a place where her creativity could find expression. She dated the handsome actor John "Johnny" Miles, who was also from Philadelphia,

OPPOSITE Grace modeled as a bride for the 1951 Timken Bearings calendar. ABOVE Grace, as a young actress and model, in an undated photo.

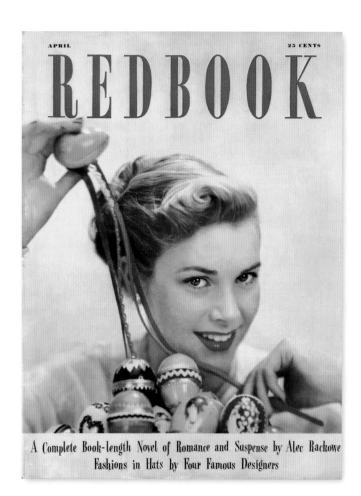

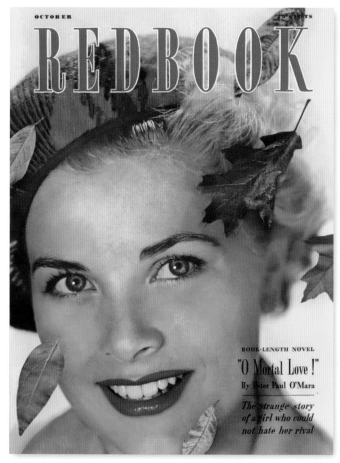

and they talked of an engagement. Grace also began seeing her academy classmate Herbie Miller, later known professionally as Mark Miller.

When Grace accompanied Miller on a photo shoot one weekend, the photographer asked if he could take some pictures of Grace. Those photographs led to Grace appearing on the covers of *Redbook*, *Cosmopolitan*, *True Romance*, and *True Story* within a span of a few years. Her fresh, natural beauty was made for the camera, and she was soon represented by the Society of Models, Inc., modeling agency, and then by John Robert Powers Agency.

Modeling was lucrative, the perfect way for Grace to repay her father for his investment in her education and living expenses. "Grace knew that her father didn't think very much of an acting career," said Judith Balaban Quine. Grace was determined to prove that she could do this on her own, "so that she could justify her own existence by her own earning power."

Grace modeled for various advertisements and fashion newsreels, often earning $400 a week. She

became known as "good old dependable Grace." Most photographers were used to models showing up late, red-eyed after a night on the town. Grace was the opposite—punctual and businesslike. She was also an independent young woman, years ahead of the women's liberation movement. "When I went away to school and started working, I felt very free and liberated already," Grace said. "I was earning my own living before I was nineteen."

In 1948, during her second year at the academy, Grace began a romance with Don Richardson, one of her instructors. The couple kept their affair a secret, both from the school and from Grace's parents. Richardson wanted to help Grace achieve her dreams but saw little future for her in the theater. Because she was photogenic but lacked the ability to project her voice, Richardson sensed that any success Grace might have would be in front of a camera. He arranged a meeting with his friend Toni Ward at the William Morris Agency, who was not particularly impressed by Grace. So Richardson tried again with another contact, Edie Van Cleve at MCA.

**ABOVE LEFT** Grace appeared on the cover of *Redbook* magazine in April 1949 (left) and October 1949 (right).
**OPPOSITE** Grace models for a portrait to be used as an artist reference for a painting by Joe DiMaggio in 1948.

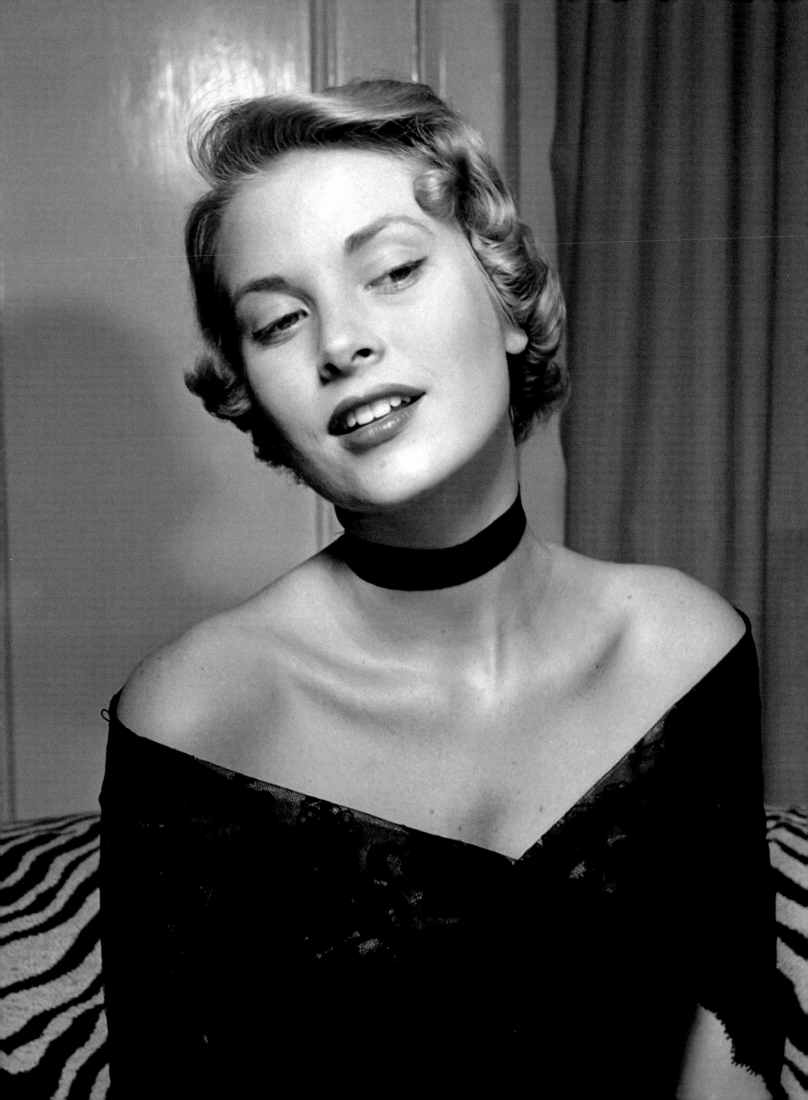

The PLAYBILL for The Cort Theatre

Raymond MASSEY    Mady CHRISTIANS

IN

THE FATHER

Dec. 1949

This time lightning struck. Van Cleve agreed to represent Grace.

Fittingly, Grace's academy graduation performance was in Philip Barry's *The Philadelphia Story*. The part of Philadelphia socialite Tracy Lord seemed almost tailor-made for Grace. A talent scout for MGM, the world's most prestigious movie studio, was watching. He wrote, "There isn't any doubt of this girl's photogenic quality. She has distinction, poise, charm—in sum, everything other than professional theatre experience. . . . I feel that we should [test her], because if we don't someone else will and I feel they will have a future star on their hands."

But her youth and inexperience made it difficult for Grace to convince anyone she was a future star. "After I finished my studies, I went looking for a job," Grace recalled of those early days. "Whenever they asked me what I'd done, I had to explain that I had just graduated from the American Academy of Dramatic Arts, and you know, the name was so long that sometimes I didn't think I'd be able to get it out. Then the receptionist would be terribly condescending and tell me to come back when I had a little experience."

The actress had another problem—she was five feet seven, considered quite tall at the time. "I was too tall to act the part of the innocent little girl, which my face and blue eyes suggested to the directors," Grace recalled. "How many times I heard those words, 'Thank you, Miss Kelly, we'll write to you.' I knew very well that nobody would ever write to me because of my height."

Grace also had issues to resolve in her personal life. Margaret Kelly grew suspicious and asked her daughter directly if there was a man in her life. Grace confessed that she was seeing Don Richardson. She brought him to Philadelphia and introduced him to the Kellys, but the meeting did not go well. The Jewish Richardson found John B. Kelly Sr.'s boisterous humor somewhat anti-Semitic. When Richardson expressed his opinion that Grace was going to be an important movie star, some family members burst into laughter.

When Grace and Richardson went out the next day to visit Grace's uncle George, the Kellys rifled through Richardson's suitcase and found a letter detailing his upcoming divorce. Grace and Richardson returned to the house to find Grace's mother adamant. She ordered the still-married man to leave and never return.

Grace was humiliated and hurt, but absolutely impassive. Variations of this same scenario would repeat themselves over and over again in her life, but Grace always found it difficult to express her darkest emotions.

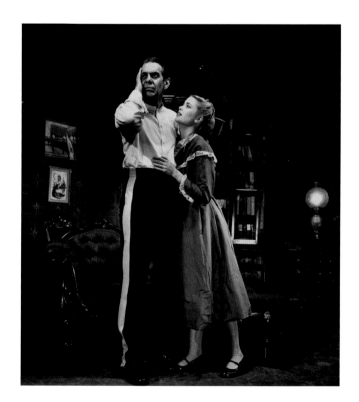

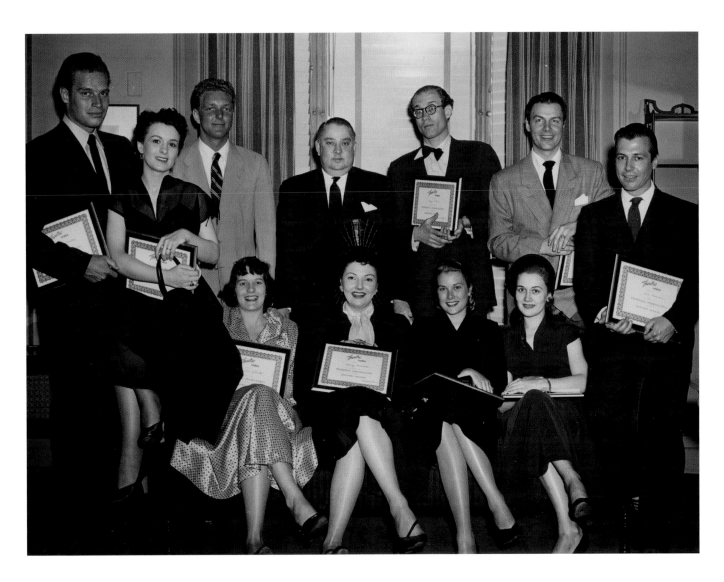

OPPOSITE TOP Playbill for *The Father*, Grace's Broadway debut, which ran for 69 performances, November 1949 through January 1950. OPPOSITE BOTTOM Grace with Raymond Massey in *The Father*. Massey cast Grace based on her work at the American Academy of Dramatic Arts. Though Massey knew Grace's father, John Sr., Massey did not realize Grace was his daughter until opening night. ABOVE Grace, seated third from right, accepts a 1950 Theatre World Award for her performance in *The Father*. Other recipients included: Nancy Andrews (*Touch and Go*), Phil Arthur (*With a Silk Thread*), Barbara Brady (*The Velvet Glove*), Lydia Clarke (*Detective Story*), Priscilla Gillette (*Regina*), Don Hanmer (*The Man*), Marcia Henderson (*Peter Pan*), Charlton Heston (*Design for a Stained Glass Window*), Rick Jason (*Now I Lay Me Down to Sleep*), Charles Nolte (*Design for a Stained Glass Window*), and Roger Price (*Tickets, Please!*). RIGHT Grace's professional stage debut in her uncle George's play *The Torch Bearers* at the Bucks County Playhouse in July 1949.

"Lots of times you get beyond the point of anger," she once said. "You don't react to what's being done. And, after all, what's the use of getting angry? . . . I'd rather give up. I don't like fighting, all the loud voices and the angry words. Some people don't mind it, I know. They just shout and say awful things, and then it's all over and they forget it. I can't. When it's finished, I feel as though a steamroller has gone over me, and I remember it for a long time."

The adventure was over; Grace was forbidden to return to New York. She made one last visit to collect her belongings from the Barbizon Hotel, and promptly moved back to Philadelphia. The turn of fate proved fortunate for Grace, as stage parts were much easier to land outside of the competitive Big Apple.

In the summer of 1949, Grace joined the company of the Bucks County Playhouse in New Hope, Pennsylvania. Her first role was in *The Torch-Bearers*, by her uncle George. When it opened on July 25, 1949, the play marked Grace Kelly's professional stage debut. That same summer, Grace won a small role in the drama *The Heiress*.

Later that year, formidable stage and screen actor

Raymond Massey gave Grace a chance to return to New York by casting her in the Broadway production of *The Father*, which Massey both starred in and directed. "She got the part because she showed the most promise," Massey recalled. "All through the rehearsal period we were all impressed with her earnestness, her professionalism and her good manners. She was . . . a rare kind of young person who had a hunger to learn and to improve herself."

This time, her father arranged for Grace to live in apartment 9A of Manhattan House, one of his building projects on the Upper East Side. The Kelly family drove up from Philadelphia for the opening night of *The Father*, on November 16, 1949. The reviews were generally poor, but Grace was praised more than Massey. Eminent drama critic George Jean Nathan wrote that Grace "relieves the stage from the air of a minor hinterland stock company on one of its off-days."

When *The Father* closed after sixty-nine performances, Grace struggled to regain her footing in the New York theater. Romantically, she began secretly seeing Don Richardson again. John B. Kelly Sr. found out and offered Richardson a Jaguar to end the relationship.

**OPPOSITE** Grace performs on television in "Ann Rutledge." **ABOVE LEFT** Grace in "50 Beautiful Girls" for the dramatic anthology series *Suspense*.
**ABOVE RIGHT** Grace Kelly and Ralph Meeker perform "The French Lesson" from *Good News* on Ed Sullivan's *Toast of the Town*.

29

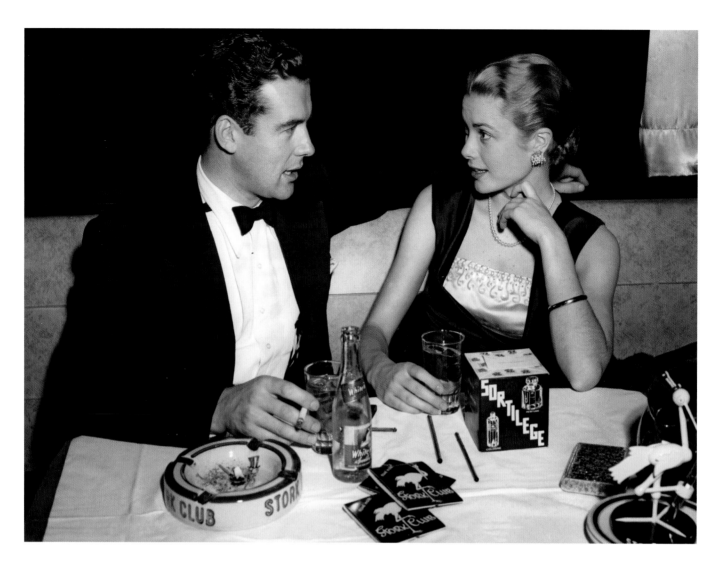

He declined the offer, but it was only a matter of time before the relationship ended. Ultimately, Grace would succumb to her parents' wishes.

For two years, Grace tried unsuccessfully to win another role on Broadway. "She always had this inner image of being an 'old-fashioned actress' with the kind of glamour that you have on Broadway," said Rita Gam. "Unfortunately, she never did realize that every part she went up for on Broadway, with the exception of *The Father*, she lost."

Grace's performance in *The Father* made an impression on director Delbert Mann, who cast her as Bethel Merriday, the title role in a production based on the Sinclair Lewis book. On January 8, 1950, Grace made her television debut in "Bethel Merriday" on *The Philco-Goodyear Television Playhouse*. "She was so stunningly beautiful, and just so electrifying, you just couldn't take your eyes off of her," Mann recalled. "I don't think I've

ever seen a human being as ethereal, as beautiful as Grace was."

More TV opportunities quickly followed in "The Rockingham Tea Set" (1950) and "Ann Rutledge" (1950), a historical drama about the paramour of Abraham Lincoln. Grace Kelly and television found each other at the perfect time. Just the year before, CBS began broadcasting on a sixteen-hour-daily basis and the fledgling entertainment medium needed new faces. Television attracted a few established film stars—like Red Skelton and Ozzie and Harriet Nelson—but most studio-contracted actors avoided TV, as the studios viewed the medium as competition. In the early days, television relied on a stable of young New York actors to fill its roles, including James Dean, Steve McQueen, and Eva Marie Saint.

"Her speech was not yet, as an actress, blended with her posture—with that stately figure that she projected,"

**ABOVE** Grace dines with Richard Greene at the Stork Club in New York City in 1951. **OPPOSITE** A portrait of Grace from *Fourteen Hours*.

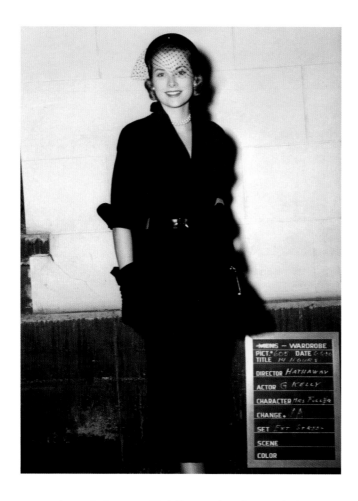

remembered director Ted Post, who directed Grace in *Danger* for CBS in 1950. "Her mother came up, and I think her brother came up to watch a rehearsal. When the rehearsal was over, I heard her mother say, 'Darling, your speech is affected a little bit, can you kind of make it more natural?' and she said, 'Mother, I'm working on it.'"

As she gained more television experience in a variety of programs—ranging from *Believe It or Not* (1950), an anthology show based on Ripley's stories, to *Actors Studio*, on which Grace appeared three times in 1950 (including playing Princess Alexandra in "The Swan")—directors were finally able to see what made Grace different.

"Beyond the beauty, which was palpable, Grace had class and style," said Delbert Mann. "She was a lady. You felt that underneath that facade, there was passion—which she expressed in her acting. But she did it in such a womanly and ladylike manner that she was enchanting." Ted Post agreed, saying, "There are a lot of people that have just quality [but] have no electricity. She combined them."

Soon Grace had performed in more than sixty live television dramas, all the while auditioning for theatrical jobs. In March 1950, Grace was considered for the ingénue role in *The Wisteria Trees* with Helen Hayes but lost the part. However, Hollywood offered a consolation—her first movie. Edie Van Cleve secured a small role for Grace in the noirish Fox drama *Fourteen Hours* (1951). The film was based on Joel Sayre's 1949 article "That Was New York, The Man on the Ledge" for *The New Yorker* detailing the 1938 suicide of John William Warde.

Richard Basehart stars in the film as Robert Cosick, a mentally ill young man who has perched himself on the fifteenth-floor ledge of a hotel, keeping an entire city gripped in suspense while he threatens to jump. Paul Douglas is Charlie Dunnigan, a traffic cop who tries to negotiate with Cosick. The above-average supporting cast includes Barbara Bel Geddes, Debra Paget, Agnes Moorehead, and Jeffrey Hunter in his first film appearance. Grace was cast as Mrs. Fuller, a woman contemplating a divorce in her attorney's office—which happens to be directly across the street from Cosick's ledge.

*Fourteen Hours* was directed by Henry Hathaway, known for such stylish films noir as *13 Rue Madeleine* (1946), *The Dark Corner* (1946), and *Call Northside 777* (1948). The original ending had Robert falling to his death, as had actually occurred with John William Warde. But tragically, on the day of the film's preview, the daughter of Twentieth Century Fox president Spyros Skouras committed suicide by leaping to her death. Skouras tried to halt the release of the film indefinitely but finally agreed to an alternate ending where Richard survives his fall from the ledge.

Fox offered Grace a standard seven-year contract, the common practice for studios when they discovered new talent. In the studio era, contracted players were at the mercy of the studios. All career roles, projects, publicity, and image were decided by the powers that be. Grace would lose control of everything for which she had worked. Even worse, if there was something her parents found unsavory, she would not have the power to say no. Grace turned Twentieth Century Fox down flat. Consequently, Grace was scarcely mentioned in any promotion for the film because Twentieth Century Fox

**ABOVE** Grace's wardrobe test for *Fourteen Hours*.

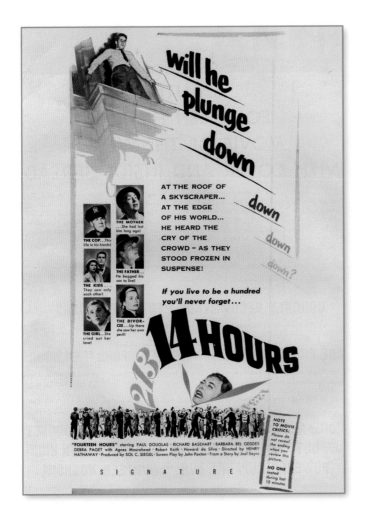

had no stake in building up her reputation. In her film debut, Grace Kelly was hardly noticed.

Though her body movements are slightly stilted, and her voice becomes a bit shrill during her emotional scene, Grace gives an admirable performance, and one that hints of great potential waiting to unfold. However, Basehart's exceptional characterization drew the bulk of the film's critical attention. *Fourteen Hours* was nominated for an Academy Award for Best Art Direction, and Basehart won the 1951 Award for Best Actor, National Board of Review of Motion Pictures.

It was back to television for Grace; she portrayed Helen Pettigrew in "Berkeley Square" (1951) for *Prudential Family Playhouse*, followed by another historical costume role as Mrs. Kennard in "A Kiss for Mr. Lincoln" (1951), part of the *Nash Airflyte Theatre* anthology series.

Meanwhile, the twenty-one-year-old enjoyed being young and pursuing her dreams. According to her roommate at Manhattan House, Sally Parrish, Grace often hosted informal parties with other actress friends

from the academy and the Barbizon Hotel. One of the games they would play was called "Giggle Belly." They would lie on the floor with their head on another person's stomach. Then they would tell stories funny enough to make heads bob as bellies bounced with laughter. "Grace adored jokes," said Judith Balaban Quine. "She liked clean jokes, dirty jokes, practical jokes, puns, and even sick jokes. Anything so long as it was really funny."

In May, Grace appeared in *Ring Round the Moon* at the Ann Arbor Drama Festival in Ann Arbor, Michigan. She played the ingénue Isabelle, starring alongside actors Donald Buka and William Allyn, both of whom would become Grace's lifelong friends. Discussing their dreams for their careers, Grace told Allyn, "I'm going to be the most famous movie star who ever lived." But, Allyn recalled, "it wasn't said out of super ego. It was said out of a natural statement of fact. There was a great need to compete and achieve in the best sense of the word."

In the summer of 1951, Grace traveled to Denver, Colorado, to appear at the Elitch Theatre. There, she met a handsome actor named Gene Lyons. Both were from Pennsylvania, though from opposite sides of the state—Lyons hailed from Pittsburgh. Almost instantly, Grace fell in love with him. Grace was scheduled to do a series of plays at Elitch that summer, but on August 10, she received a telegram from her agent Edie Van Cleve to report to Stanley Kramer's office in Los Angeles. Hollywood wanted her for another film.

**TOP** Grace was featured in the advertising art for *Fourteen Hours*. **ABOVE** With James Warren in *Fourteen Hours*.

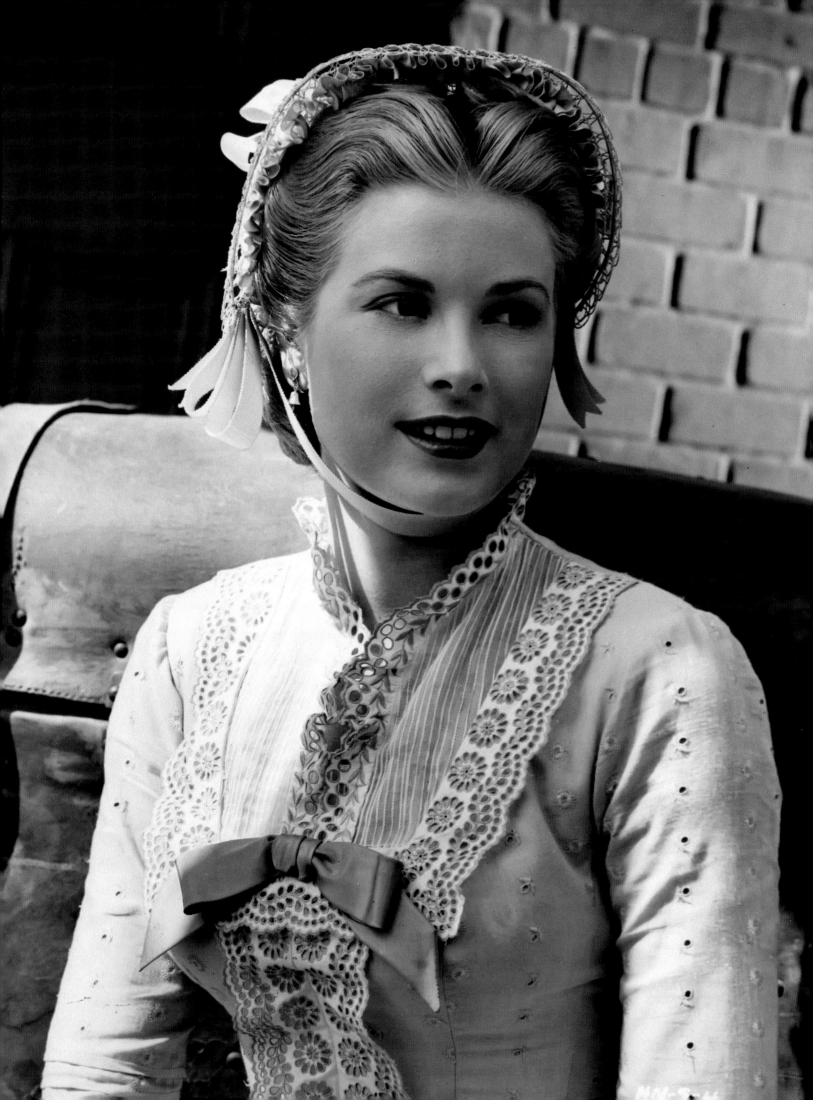

# HIGH NOON

## 1952

"The role was not demanding," director Fred Zinnemann recalled of the character of Amy Kane in *High Noon*. "We simply needed an attractive, virginal-looking, and inhibited young actress, the typical western heroine." Enter Grace Kelly, who, at twenty-two, exhibited the kind of fresh, blossoming beauty and quiet reserve that young western heroines are made of.

*High Noon* originated in 1947 as a four-page outline by screenwriter Carl Foreman. When Foreman became aware of a similar Old West story published in *Collier's* magazine in 1947, John M. Cunningham's "The Tin Star," he optioned the material just to be on the safe side. Foreman then developed an original screenplay with producer Stanley Kramer, with whom he had recently worked on *The Men* (1950).

The story's hero is Marshal Will Kane, the retiring sheriff of the town of Hadleyville. On the day of his wedding to his Quaker bride, Amy, Kane receives word that Frank Miller, a criminal whom the sheriff has helped to put away, has been released from prison on a technicality. Kane must round up a posse to fight Miller and his gang but finds resistance among the townspeople.

Stanley Kramer wanted a hot young talent to play the lead. He contacted Jay Kanter, a young agent at MCA who had been instrumental in casting Marlon Brando in *The Men*; he hoped to land Charlton Heston as Will Kane. But Heston's career was catching fire at the time, and he was unavailable.

Several other actors reportedly turned down the part before Gary Cooper finally stepped into the sheriff's boots. Cooper was getting on in years and had endured two box-office disappointments prior to making *High Noon*. Kramer was not convinced that an aging Cooper would appeal to audiences as a character who was

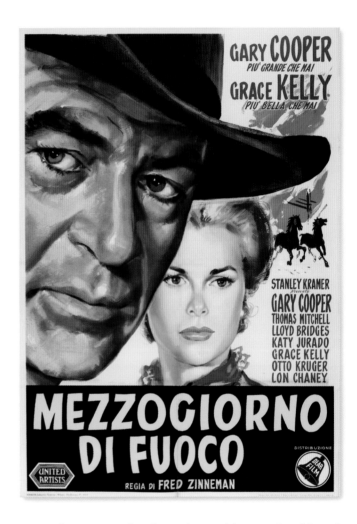

originally supposed to be in his midthirties. But "Coop" was a western legend, and Kramer, Foreman, and Fred Zinnemann were thrilled to have him in the film.

Kanter realized the role of Amy was ideal for a young actress just starting out. There wasn't enough money in the budget to hire an established star. Amy had little screen time, but the character would be memorable. Edie Van Cleve at MCA's New York office had been telling Kanter about Grace Kelly, and he had seen her in some television roles. Kanter took a small headshot of Grace (taken by Marcus Blechman in New York) to show

to Kramer and Zinnemann. "They had never seen her do anything," Kanter later said. "But to some degree they took into account that if our office was representing her, she had great potential as a young actress."

The producer and director must have had great faith in MCA—they cast Grace solely based on Kanter's recommendation and the small black-and-white photograph they saw. But Zinnemann still wanted to interview the actress. At that time, Grace was appearing in a stage comedy at the Elitch Theatre in Denver, Colorado. It was there that she received a telegram from Edie Van Cleve requesting a meeting for *High Noon*.

"I didn't look in a crystal ball," Jay Kanter later said. "But I really had a feeling that this young lady was really

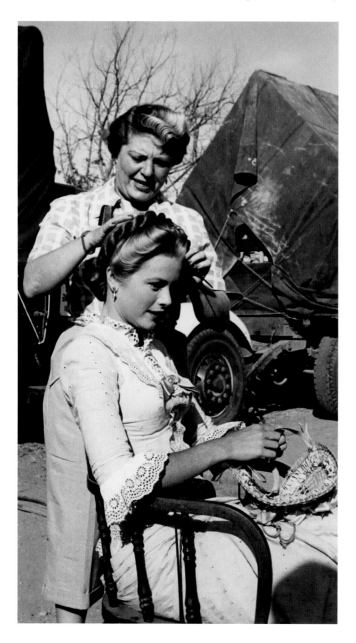

going to go right to the top. She seemed to have a charisma about herself and she seemed to have a lot of confidence in herself. She knew what she wanted and she really didn't seem to doubt herself."

Kanter picked Grace up at the airport when she flew to Los Angeles in late August 1951, and escorted her to the studio to meet the producers and director. At their meeting, Zinnemann found Grace to be "beautiful in a prim sort of way and indeed seeming rather inhibited and tense." Both Kramer and Zinnemann were intrigued that Grace chose to wear white gloves to a Hollywood interview, "a thing unheard of in our low-class surroundings," as Zinnemann put it. The white gloves were a fashion staple for all the Kelly women. "My mother insisted every time we went into town, you wore hat and gloves," recalled Lizanne LeVine. "Not only my mother. We were brought up in a convent, and the nuns insisted that you wore white gloves on special occasions." To Zinnemann and Kramer, Grace's gloves fit well with the character of Amy Kane.

Grace's shy manner also seemed appropriate for Amy. "She answered most of my questions with a 'Yes' or 'No' and, as I am not good at small talk, our conversation soon came to a halt," Zinnemann said of their first encounter. "It was with a sense of relief that I sent her on to Foreman's office." Zinnemann and Kramer picked up on Grace's insecurity, but neither saw that quality as a drawback to her fulfilling the role of the young Quaker woman. Zinnemann's only reservation was about the thirty-year age difference between Kelly and Cooper. "But the die was cast," he said. Grace officially had the role and was rushed into makeup tests and wardrobe fittings that same week.

*High Noon* played out differently from most westerns of the time. There was no noble hero riding into the sunset or beautiful, sweeping shots of open prairie skies. Zinnemann and cinematographer Floyd Crosby crafted an unusual aesthetic: they wanted the film to capture the look of Mathew Brady's Civil War photographs—a washed-out sky with a documentary or "newsreel" feel. Most of *High Noon* was shot at the Columbia Ranch in Burbank, and the smog of the San Fernando Valley contributed to the desired effect.

**ABOVE** Grace's hairpiece is attached. **OPPOSITE** The confrontation between Will Kane (Cooper) and Amy (Kelly).

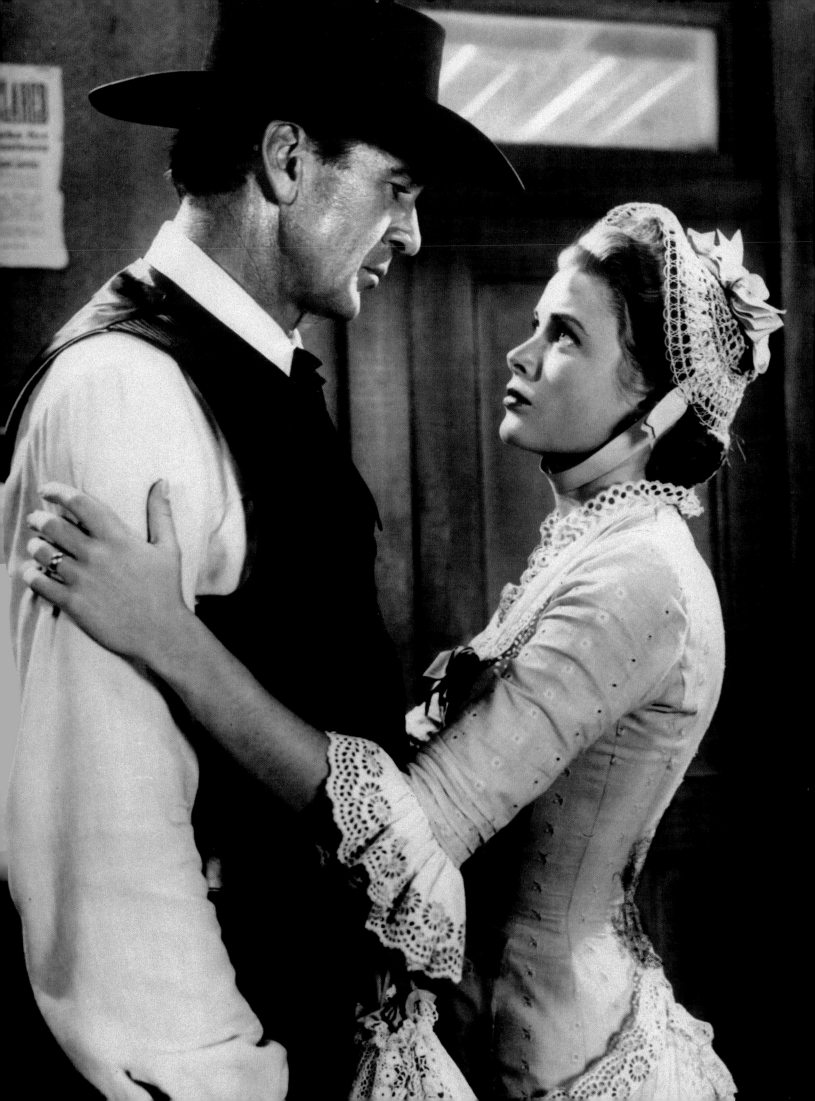

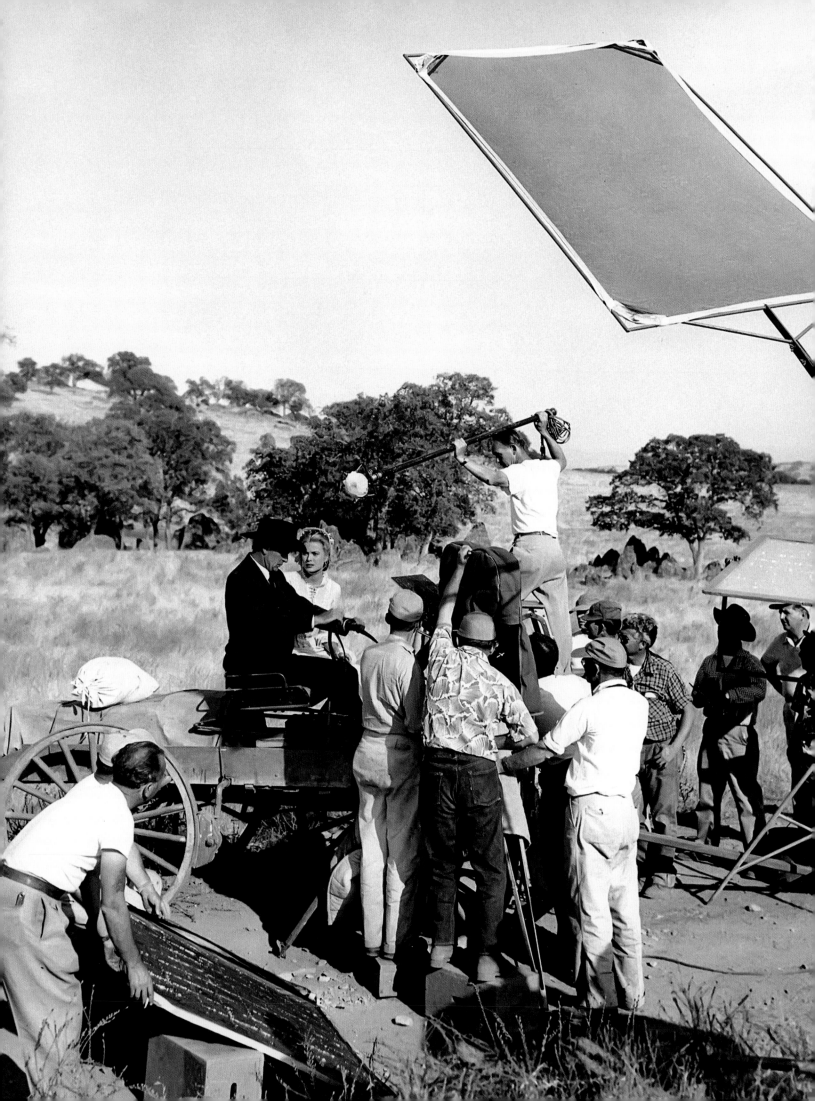

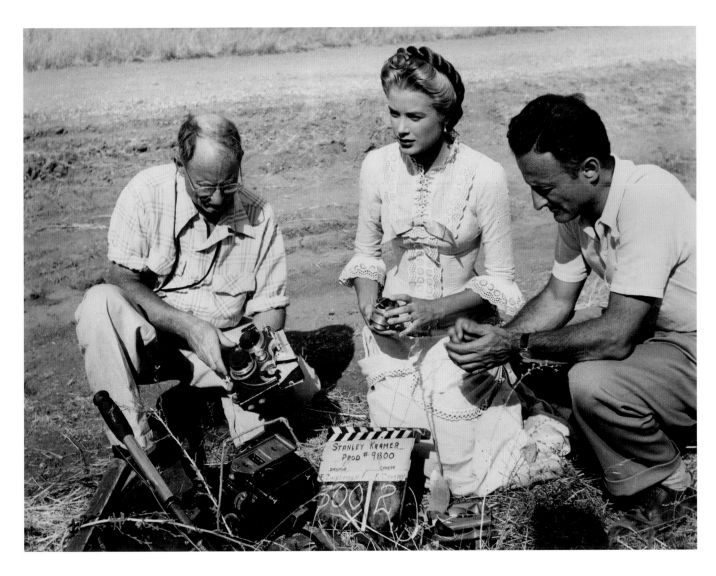

Kramer believed the story was about "a town that died because no one there had the guts to defend it." Carl Foreman saw his story of the abandoned sheriff as an allegory for his own persecution in the McCarthy era; the House Un-American Activities Committee accused the writer of Communist ties while he developed the script. Zinnemann described it as "the story of a man who must make a decision based on his conscience. In the end, he must meet his chosen fate all by himself, his town's doors and windows firmly locked against him."

It did not take the director long to realize that his lead actor was perfectly cast. "Working with this most gentle and charming man turned out to be one of the happiest experiences of my life," Zinnemann remembered of Cooper. "Not once did he make an attempt to look younger than his years. Gaunt, somewhat stooped and walking a bit stiffly, he was exactly the right shape for

the character." His costar agreed. "It was a whole new experience for me," Grace recalled. "Working with Gary Cooper was fascinating. He was a very gentle, shy kind of person and underestimated himself."

During filming in the autumn of 1951, Grace rented an apartment at the Chateau Marmont in the Sunset Boulevard foothills. Both Lizanne and Peggy came to stay with her, to act as chaperones and help calm their sister's anxiety about her first major film role. Lizanne drove Grace to the set in the mornings, and evenings were spent rehearsing lines. On Sundays, their uncle George would take the girls for a drive.

Remarkably, the production was finished in twenty-eight days for the modest figure of $750,000. After refusing to name names for the House Un-American Activities Committee, Carl Foreman was forced to resign as Associate Producer halfway through shooting. He then

**OPPOSITE** Filming in Jamestown, California. **ABOVE** Grace, flanked by cinematographer Floyd Crosby (left) and director Fred Zinnemann (right).

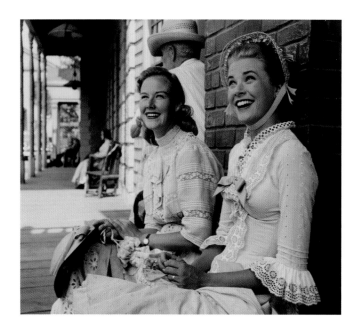

relocated to England and spent the next several years there, one of many victims of the Hollywood blacklist.

When *High Noon* was edited, Harry Cohn, the head of Columbia Pictures, obtained a working print and screened it without the musical track. According to Zinnemann, Cohn called it one of the "worst dogs" he had ever seen, and passed on a chance to distribute the film. Once the picture was released by United Artists in July 1952, initial box office receipts seemed to prove Cohn right. Theaters were picketed by Americans who considered the film subversive because of Cooper's gesture of contempt when he throws down the tin star, a symbol of federal authority. Accusations of Communism swirling around the film's exiled screenwriter only added fuel to the fire.

But *High Noon* weathered the storm, not only finding an appreciative audience but earning millions at the box office and becoming an enduring cinema classic. Dimitri Tiomkin won two Academy Awards, for Best Music Original Song (with Ned Washington) and Best Scoring; Elmo Williams and Harry W. Gerstad won for Best Editing; and Gary Cooper earned his second Oscar for Best Actor.

Ultimately, Grace was unhappy with her performance in the film. "You look into his [Gary Cooper's] face and you see everything he is thinking. I looked into my own face and saw nothing. I knew what I was thinking, but it didn't show," she reflected. Zinnemann regretted

not giving Grace more direction, but the compressed shooting schedule allowed for little rehearsal.

Kramer felt that Grace's gifts were not used to their best advantage in the film, but still believed she held her own on the screen. "I went overboard because she had that ladylike quality, that kind of dignity which was in contrast to the western scene, which worked so well, vis-à-vis Cooper," Kramer said. "There was a girl in the film named Katy Jurado, who played a Mexican gal in the town. Katy Jurado was dynamic and overpowering, and yet Kelly wasn't swallowed . . . because the ladylike thing came through."

Actress Katy Jurado agreed with Kramer that Grace possessed a strong presence in person. "I could see a girl with a lot of dignity and a lot of character," Jurado said. "Because she wants to be a somebody in movies, and she worked very hard in that picture. She looked weak—very tiny—but she was a very strong person. I really think she was one of the strongest movie stars I worked with. She knew what she wanted and she did it."

Critics praised the film but had little to say about Grace. The *Los Angeles Times* called her "pensively sincere" in their review, and ran a separate article predicting big fame for the newcomer. "She's one of the Philadelphia Kellys," reporter Louis Berg wrote. "She's sure to be a star."

Grace would later say of her performance, "I was new then. I knew at the time I was bad. I realized movies were different from the stage and I had much to learn. I went back to New York and television to try to learn it." Grace departed Hollywood as swiftly as she had swept in, and began studying with Sanford Meisner on the East Coast. Meisner pioneered a technique that trains actors to rely on their instincts; the goal, as he saw it, was to "live truthfully under imaginary circumstances."

Grace flourished under Meisner's training and "began to work harder on concentrating on her objective," according to Delbert Mann. "That would eventually be the cure for the way she attacked her characters to make them come alive, to make her eyeballs shine with meaning." The famous "fire under the ice" that would later come to be associated with Grace Kelly was still hidden beneath the surface, waiting to erupt.

**ABOVE** Grace and her stand-in Dorothy Towne. **OPPOSITE** The climactic final scene.

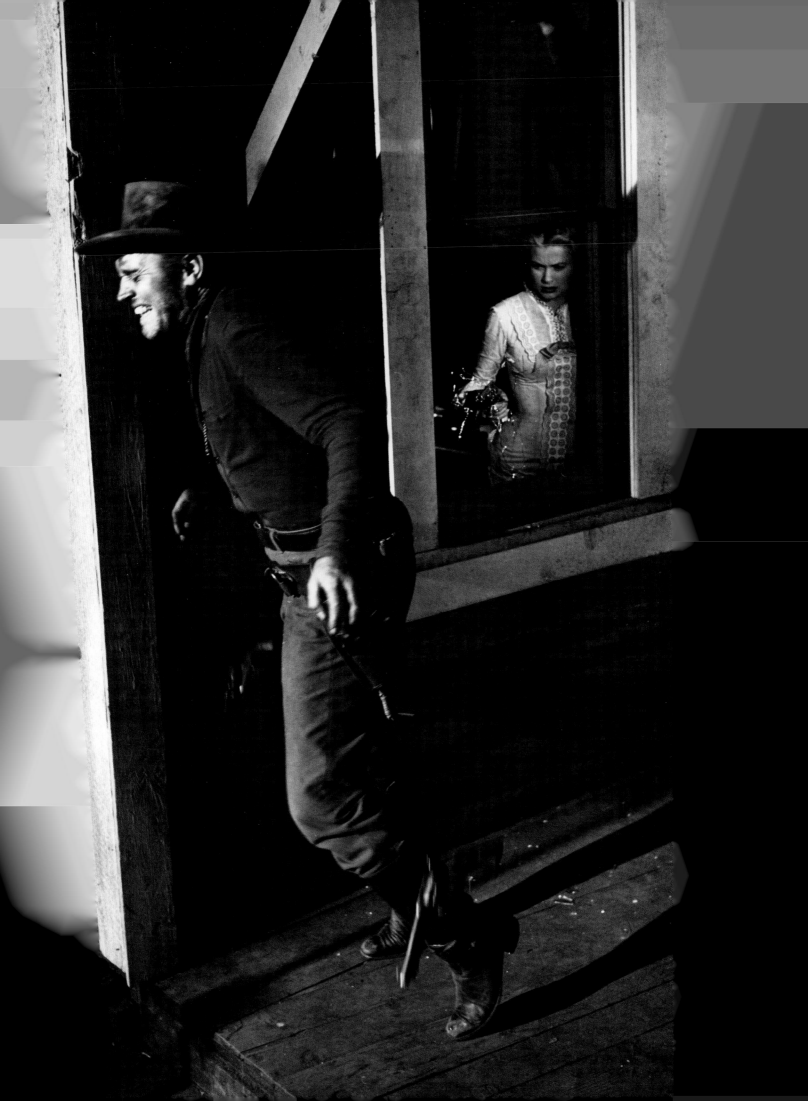

"Working with Gary Cooper was fascinating. He was a very gentle, shy kind of person and underestimated himself."

GRACE KELLY

**ABOVE** Between takes, the cast watches the opening of the 1951 World Series on television.

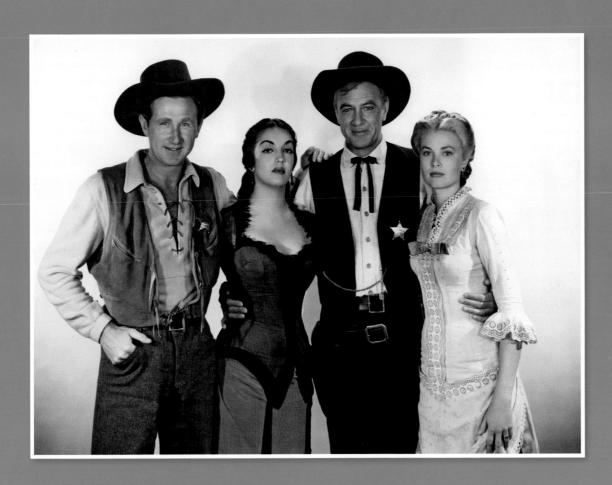

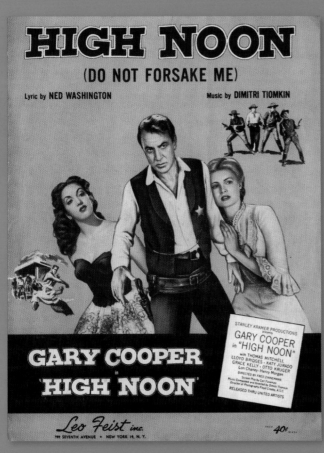

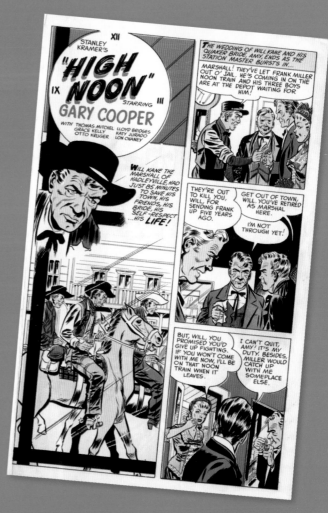

TOP (left to right) Lloyd Bridges, Katy Jurado, Gary Cooper, and Grace.
BOTTOM LEFT The best-selling sheet music for the film's title song.
BOTTOM RIGHT A promotional comic distributed by theaters.

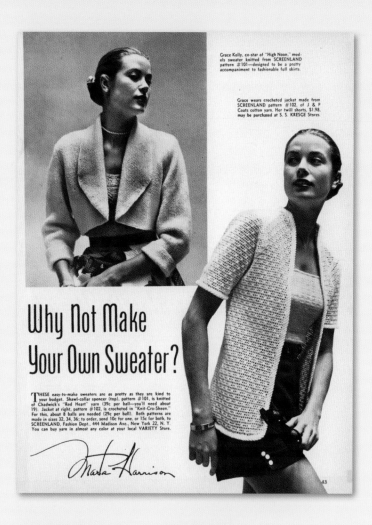

## Why Not Make Your Own Sweater?

**THIS PAGE** Grace's modeling helped to publicize *High Noon*. **OPPOSITE** A photo used to promote Grace's appearance in the film.

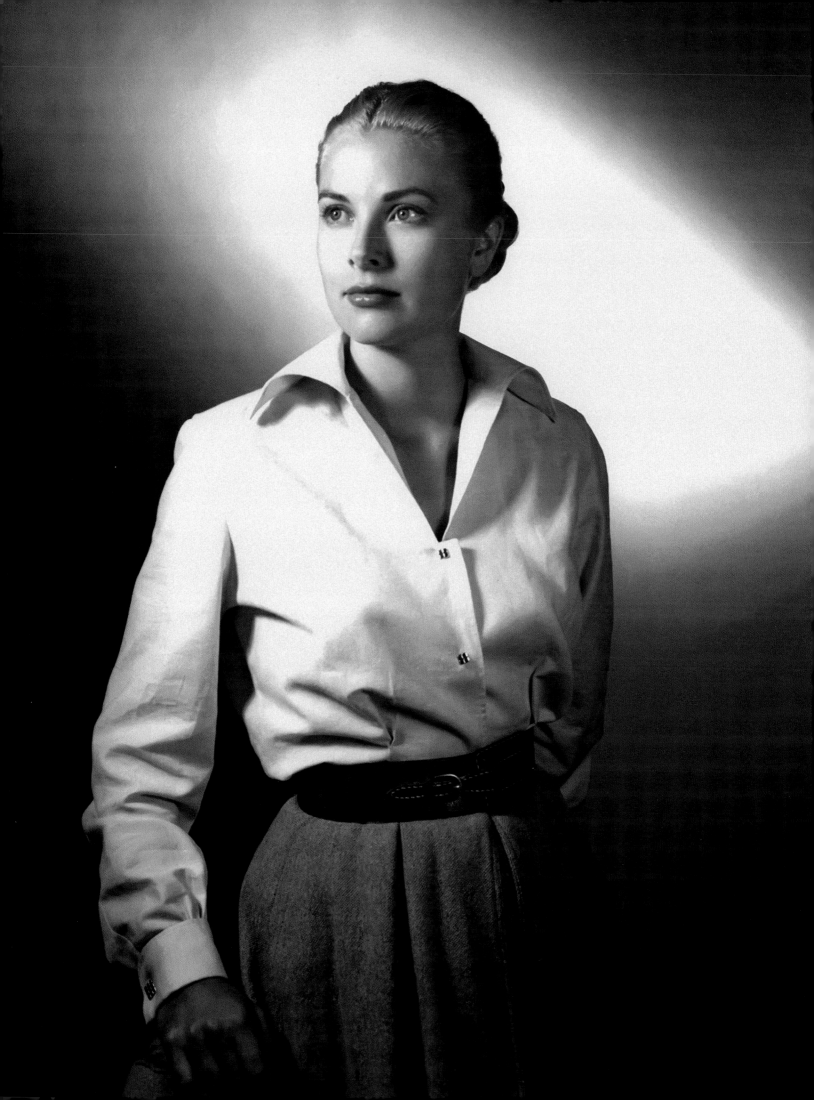

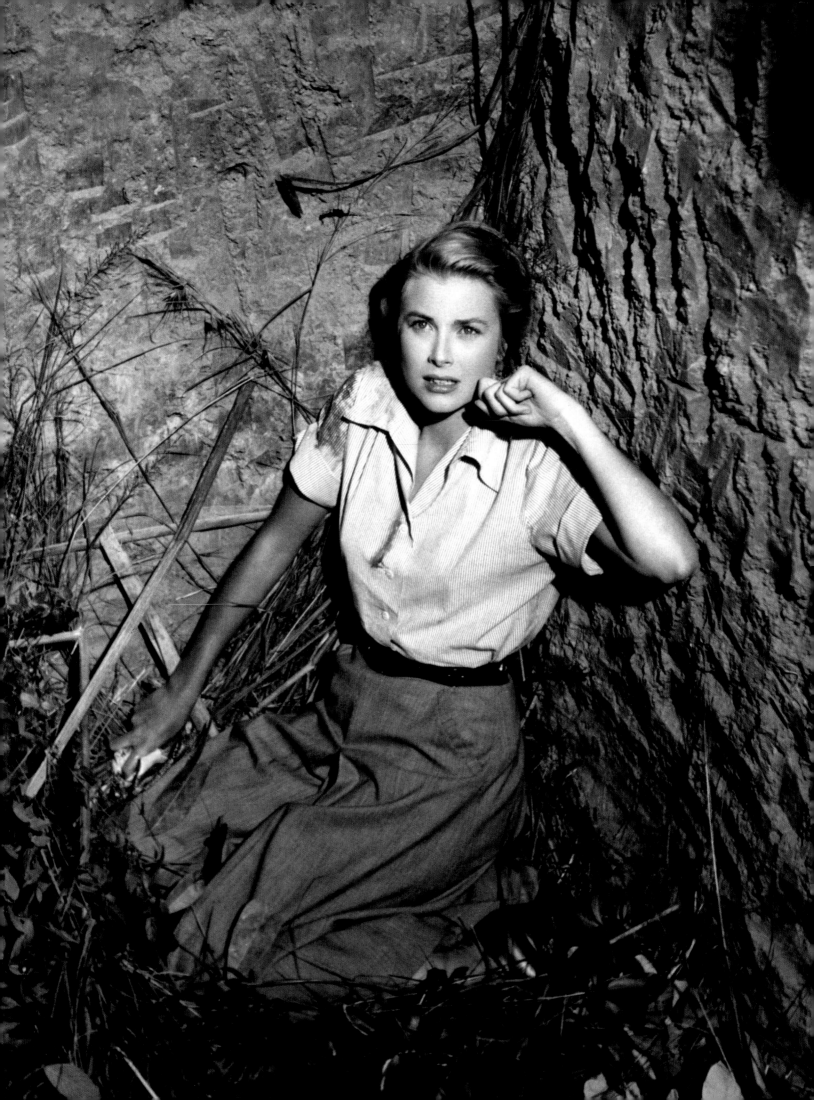

# MOGAMBO

## 1953

Though she had been playing lead roles in TV before filming *High Noon*, when Grace returned to New York, she could "hardly get bit parts," as she recalled. "I discovered that, in television, they forget quickly." It was a setback that forced the budding star to reevaluate her career. "I had to face up to the possibility that I might not be a great actress. I had to come to a decision in my own mind. Would I be happy if all I could ever be was a character actress, playing subordinate roles? I thought about it a lot, and my final answer was yes, I could be happy if that was how it had to be."

But that was not how it would be. In March 1952, Grace screen tested for director Gregory Ratoff, who was casting his new film *Taxi* (1953). Grace rushed to the meeting in the old clothes she wore to acting class. "I looked so terrible," Grace recalled, "but when Mr. Ratoff saw me, he said, 'Perfect.' That was a switch. My whole life people had been telling me I was imperfect. 'What I like about this girl is that she is not pretty,' Mr. Ratoff said. My agent insisted, 'But Mr. Ratoff, she is pretty.' Mr. Ratoff would not be talked out of it. 'No, no, no, she is not,' he said."

The role in *Taxi* required an Irish accent, something Grace had never attempted before. "I put together what I thought might pass for a brogue," she recalled, "and flunked the screen test." Still, Ratoff wanted Grace for *Taxi*, but he was overruled by the producer. But the fateful screen test would change the direction of her career later that year.

Grace's "plain" looks were often noted during this period, when she dressed casually and hoped her acting skills would speak louder than glamour. In January, she had portrayed Dulcinea in a *CBS Television Workshop* production of "Don Quixote" (1952), opposite Boris

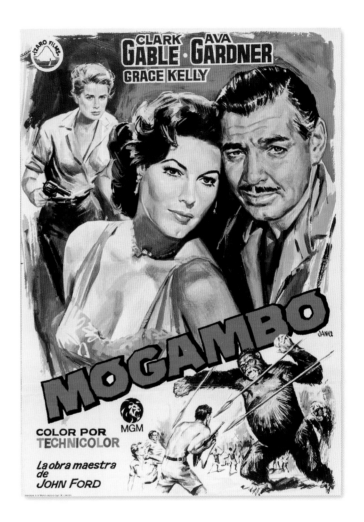

Karloff. Sidney Lumet directed the broadcast, and his wife, actress Rita Gam, visited the set. "They had told me this girl from Philadelphia, this terrific actress, was going to be on it," Gam remembered. "Somebody introduced me to a very nice but very plain looking girl with her hair tied back, and flats on, and a cotton dress. . . . And I thought 'That's a schoolteacher, that isn't an actress.' And it was. It was Grace."

After "Don Quixote," Grace and sometimes-boyfriend Gene Lyons appeared together in a television production of "Rich Boy" (1952), based on an F. Scott

**OPPOSITE** Linda Nordley (Kelly) is terrorized by a panther.  **ABOVE** *Mogambo* film poster.

Fitzgerald story. But the romance with Lyons was not to last. Grace found him attractive and charming, but his heavy drinking proved an obstacle she could not overcome.

On October 23, 1952, Grace made one of her first public appearances as a film star when *High Noon* was screened at the Lee Theater in Fort Lee, New Jersey. Meanwhile, back in Hollywood, producer Sam Zimbalist was selling MGM head Dore Schary on the idea of remaking the Clark Gable–Jean Harlow film *Red Dust* (1932). Though Zimbalist had already brought veteran director John Ford on board, Schary initially turned the project down. But Zimbalist convinced him this remake would be different. Instead of a rubber plantation in Indochina, the setting would be the wilds of Africa. It would once again star Gable, who was older but still vigorous.

Ford wanted Maureen O'Hara for the Harlow role, but Schary believed Ava Gardner would furnish more sex appeal. But who to cast as the Englishwoman, originally played by Mary Astor? Deborah Kerr and Greer Garson were "too mannered," according to Schary, so Zimbalist and Ford sifted through reels of screen tests from other studios.

When they called Schary to the projection room to see the test Grace had made for *Taxi*, Schary found her to be a "pretty girl who had a rather ordinary Irish accent and who looked drab and uninteresting." But Ford saw a spark in Grace and reminded Schary that Grace had played Gary Cooper's wife in *High Noon*. Schary was still unimpressed, believing Grace's performance had been overshadowed by Katy Jurado's. Ford told Schary, "But this dame has breeding, quality, class. I want to make a test of her—in color—I'll bet she'll knock us on our ass."

On September 3, 1952, Grace headed to Hollywood for the test. Ford was right. In color, Grace Kelly lit up the screen as she had never done in black and white. Schary was so impressed that he insisted she sign a long-term contract. It was the showdown Grace had dreaded. "She didn't want to come out to Hollywood and be one of the crowd," Jay Kanter said. But Grace was lured by the exceptional project, the talent involved, and the trip to Africa. Grace's lawyer demanded two contractual stipulations before she signed: every other year, Grace

could take off to do a Broadway play, and she could live in New York. The studio agreed, and Grace became one of the MGM crowd, with a seven-year contract for $750 a week.

In *Mogambo*, Gable plays big-game hunter Victor Marswell. Ava Gardner is Eloise "Honey Bear" Kelly, an international playgirl. Grace portrays Linda Nordley, whose husband, Donald (played by Donald Sinden), hires Marswell to guide them as they film gorillas on safari. Linda tries to suppress her growing attraction to Marswell, but a tumultuous love triangle soon erupts.

The dangers of the African location required the cast and crew to endure a series of shots for smallpox, yellow fever, typhoid, and other ailments. They flew to Nairobi, Kenya, and met up with a caravan to transport them to Uganda, the primary location. The base camp boasted a city of tents about 300 strong, including tents for dining, wardrobe, recreation, medicine, and even one that could be used as a jail, should the need arise. Due to the recent Mau Mau uprising, a thirty-man police force guarded the location, and incredibly, each member of the cast was issued a gun for protection.

Grace was swept away by the natural beauty of Africa. The sensitive actress responded to her exotic surroundings by falling in love with Clark Gable, a screen legend old enough to be her father. Both were single at the time, and neither made any attempt to conceal their on-set romance. The genuine sparks between Grace and Gable added a much-needed dose of authenticity to the glossy Technicolor melodrama.

Shooting in Africa posed a challenge. The intense heat, uneven lighting conditions, and live animals caused delays and problems—and John Ford was known to take his frustrations out on his actors. Ava Gardner, never one to mince words, described Ford as "one of the crustiest sons of bitches ever to direct a film." Alcohol was used liberally by much of the cast—partly because the African water was not drinkable. Frank Sinatra accompanied his then-wife Gardner on location, and joined in the drinking as well.

Grace "was never much of a drinker," Gardner remembered, "though she tried hard. Her little nose would get pink, she'd get sick, and we'd have to rescue

**BIOGRAPHICAL**                                    **INFORMATION**

NAME ___Grace Kelly___
BIRTHPLACE ___Philadelphia, Pa.___BIRTHDAY ___Nov. 12___

HEIGHT ___5' 6½"___ WEIGHT ___115 lbs.___COLOR HAIR ___Blonde___ COLOR EYES ___Blue___

FATHER ___John B. Kelly___ OCCUPATION ___Building Contractor___ RESIDENCE ___Philadelphia, Pa.___

MOTHER ___Margaret Major Kelly___ OCCUPATION ___Housewife___ RESIDENCE ___Philadelphia, Pa.___

EDUCATED ___Raven Hill Academy and Stevens School in Philadelphia.  American___
___Academy of Dramatic Arts for two years.___

MARRIED TO ___Single.___
_____
_____

CHILDREN (Names & Date of Birth) _____

CITIES LIVED IN ___Philadelphia, New York, Hollywood.___
_____
_____

STAGE AND RADIO EXPERIENCE ___Amateur theatricals; "Don't Feed the Animals",___
___"Cry Havoc", "Wall Flower".  On Broadway in "The Father" starring Raymond___
___Massey.  Appeared in "To Be Continued".  Summer Stock.  Frequently appeared___
___on television in dramatic plays.___

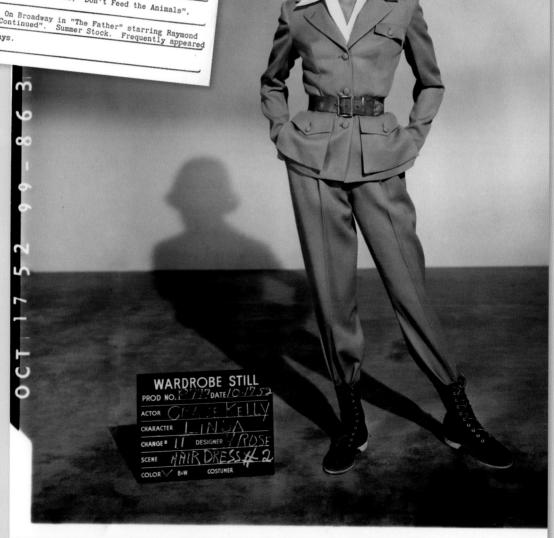

**TOP** Grace Kelly's MGM studio biography.   **ABOVE** A wardrobe test for one of Helen Rose's costumes.

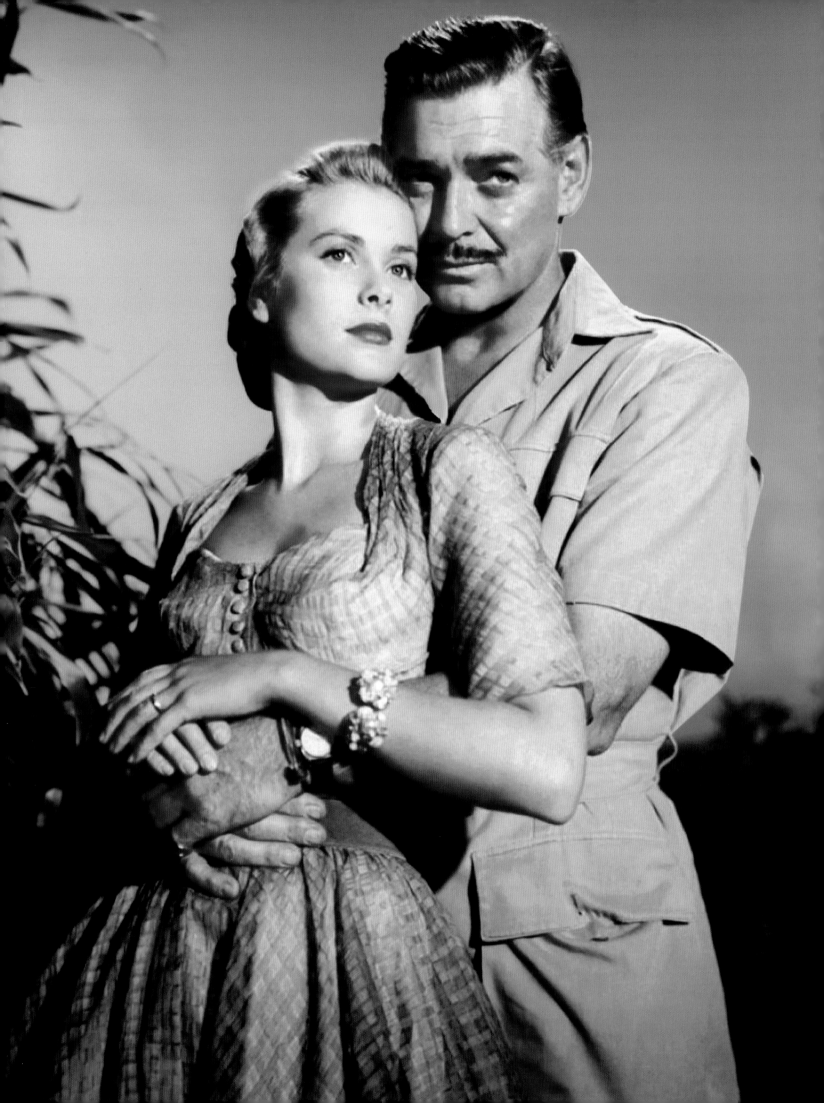

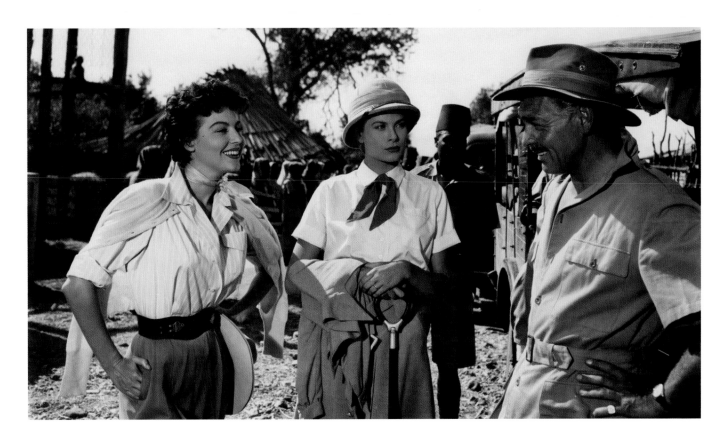

her. Or she'd get easily hurt . . . and run off into the darkness."

Grace believed the relationship with Gable would continue when filming ended, but it was not to be. When the cast returned to London, Gable denied all rumors of a romance to reporters, leaving Grace feeling hurt and betrayed. Gable did accompany Grace to the airport when she flew back to the United States for the wedding of her agent Jay Kanter to Judith Balaban (later Judith Balaban Quine). "I was unable to stop crying the morning I flew home for your wedding," Grace told Balaban Quine. A few months later, Gable escorted Grace to the Academy Awards.

"Many years later, when it was too late to tell Grace," said Balaban Quine, "a friend of Gable's told me that 'the King' had been seriously in love with Grace. He had, I was told, determined that they should part only as friends because he sadly believed their age difference would bring them unhappiness and distance in too few years."

After *Mogambo* wrapped, Dore Schary had a difficult time casting Grace in further roles at MGM. The producers wanted female stars with a proven track record, and there was no shortage of those at Metro, including Ava Gardner, Lana Turner, Elizabeth Taylor,

and Deborah Kerr. It was not until the box office proved *Mogambo* a hit that producers began to take interest in Grace. By that time, Alfred Hitchcock had discovered her talents.

Though her attempts at an English accent are not altogether convincing, and Ava Gardner was given most of the good lines, Grace received acclaim for her *Mogambo* performance. She won a Golden Globe Award for Best Supporting Actress, and *Look* magazine even proclaimed Grace the "Best Actress of 1953." Gardner was rewarded with an Oscar nomination for Best Actress and Grace received a nomination for Best Supporting Actress, though neither of them won.

Enormous success was just around the corner for Grace, and it would spark a debate over who had really made Grace Kelly's career. Stanley Kramer believed he "discovered" her by casting her in *High Noon;* Dore Schary disagreed, as Kramer made no plans to use her again. Schary thought Alfred Hitchcock could lay some claim—but Hitchcock had seen the same *Taxi* test that John Ford saw, and had still not cast Grace immediately. Schary ultimately credited John Ford with seeing Grace's screen potential: "He spotted something all the others had missed."

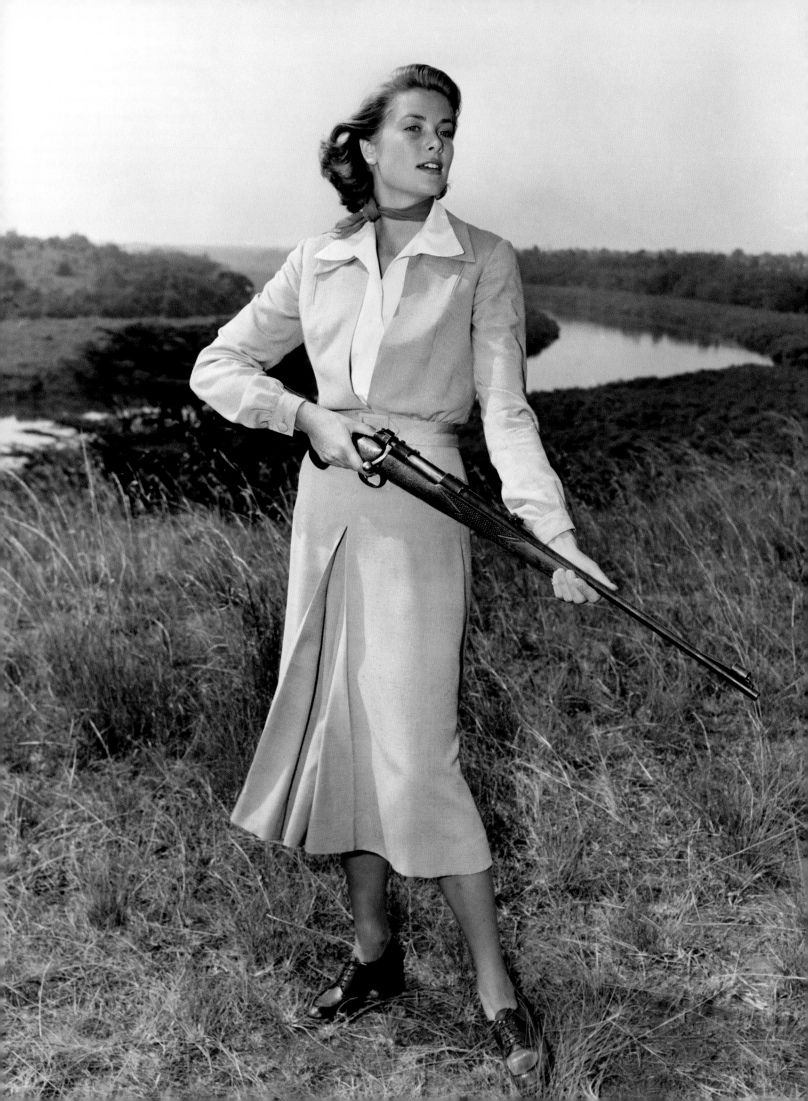

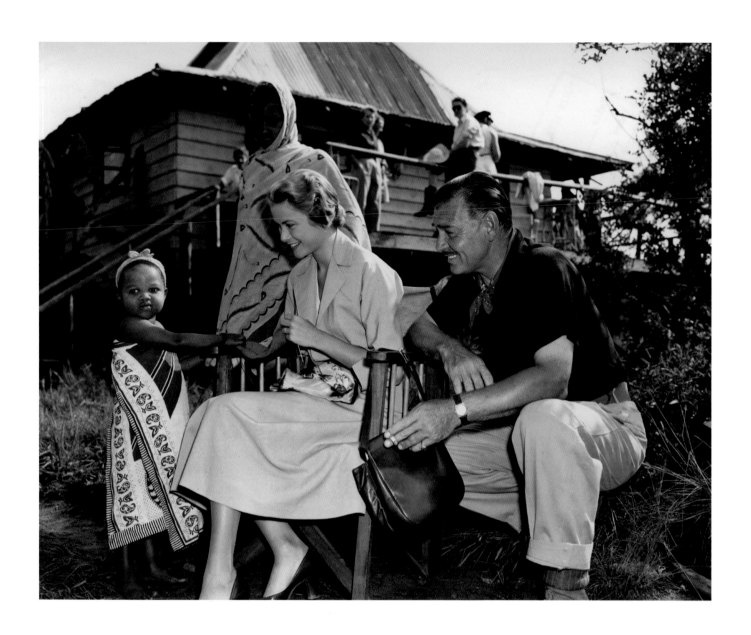

"For a time, she [Grace] got nothing but young Englishwoman parts. You should have seen the take-offs the other children did. If ever she had tended to be conceited, they brought her down to earth fast. I'm afraid they did rather let her have it."

MARGARET KELLY

OPPOSITE Grace on location in Africa.  ABOVE Grace and Clark Gable (right) meet a local child.

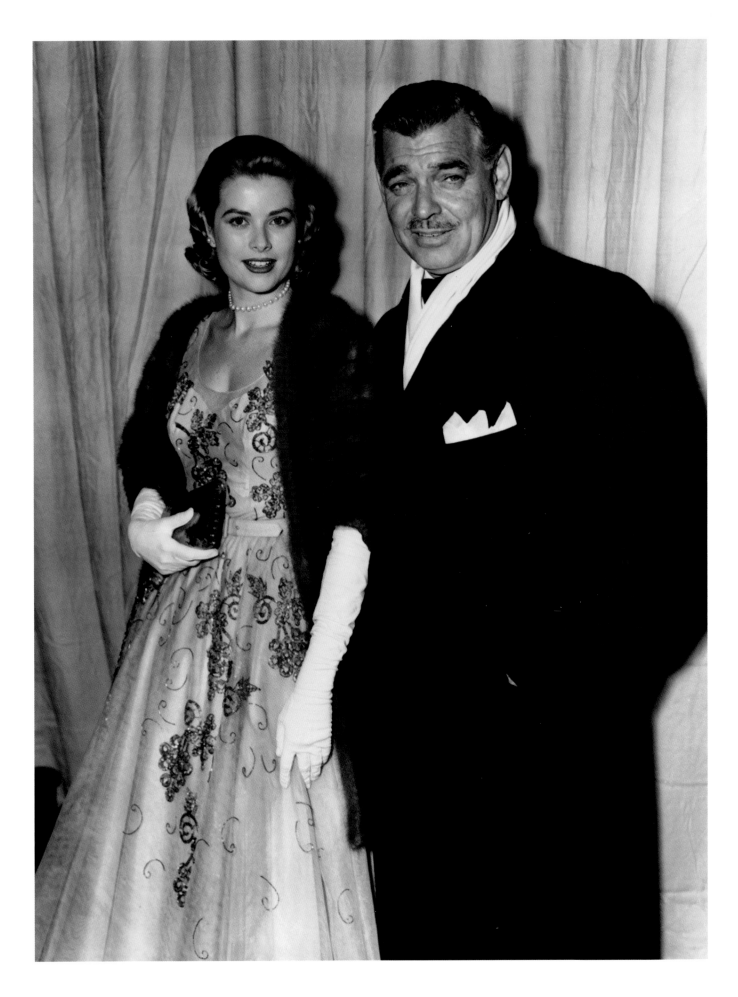

**ABOVE** Clark Gable accompanies Grace to the 26th Annual Academy Awards. **OPPOSITE** An MGM publicity portrait.

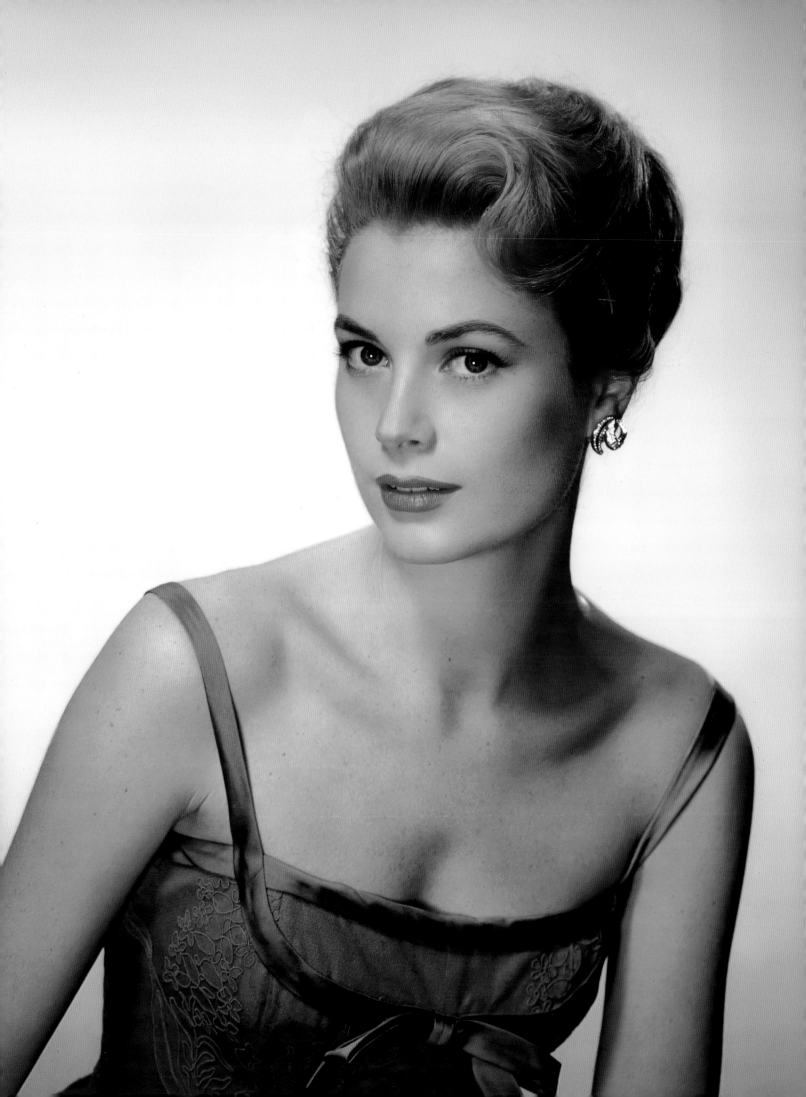

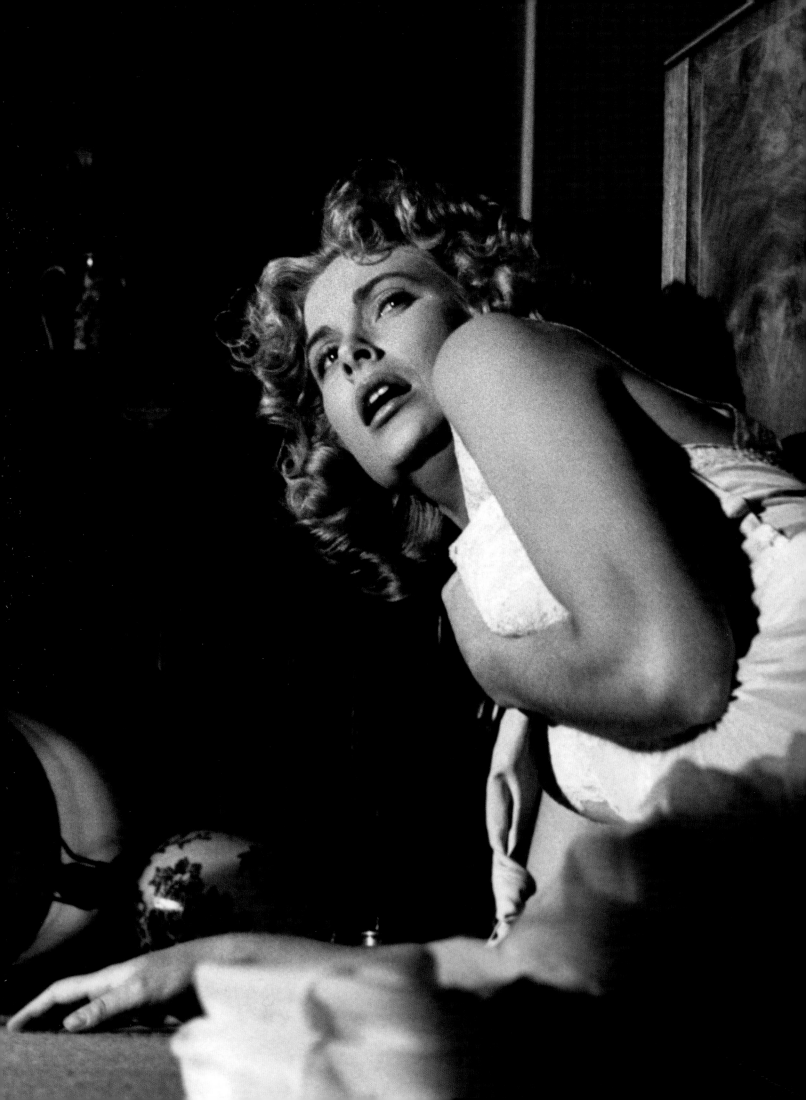

# Dial M for Murder

## 1954

Under contract to make one last film at Warner Bros. before heading to Paramount, master of suspense Alfred Hitchcock set his sights on the hit stage play *Dial M for Murder*. Warners purchased the rights for Hitch, with one stipulation: the film must be made in 3-D, the new process studios were using to lure the public away from their television sets and into theaters. Hitchcock was less than thrilled with the "gimmick."

The director encountered another challenge in pre-production: his budget did not allow for a top-tier female star. Leading ladies were vital ingredients to Hitchcock films; his recent successful collaborations had been with Ingrid Bergman in *Spellbound* (1945), *Notorious* (1946), and *Under Capricorn* (1949). Since those films, neither Marlene Dietrich in *Stage Fright* (1950), Ruth Roman in *Strangers on a Train* (1951), nor Anne Baxter in *I Confess* (1953) had generated the kind of magic Hitchcock had with Bergman. And he could not afford the likes of Bergman this time.

In a sudden inspiration that would change the course of two careers, Hitchcock remembered a screen test that he had seen the year before—a young actress playing an Irish immigrant. In fact, Hitch had met Grace Kelly after seeing her *Taxi* test, but did not recall the meeting. Grace remembered it; she had frozen up completely. "I could not think of anything to say to him," she said. "In a horrible way, it seemed funny to have my brain turn to stone."

When Hitchcock attended a preview of *Mogambo*, Grace returned to his mind. She was photogenic, she could act, and she looked smashing in color. Furthermore, MGM was willing to loan her for $14,000. It was a deal Hitch could not refuse, and he cast his new leading lady on little more than gut instinct. Reportedly, the director

sensed qualities in Grace that reminded him of Ingrid Bergman.

Hitchcock had wanted Cary Grant for the role of the husband but could not accommodate Grant's salary request and demand for a percentage of the profits. The director settled on Ray Milland, a handsome Welsh actor twenty-two years Grace's senior, but with some clout and a Best Actor Academy Award (for *The Lost Weekend*, 1945) under his belt.

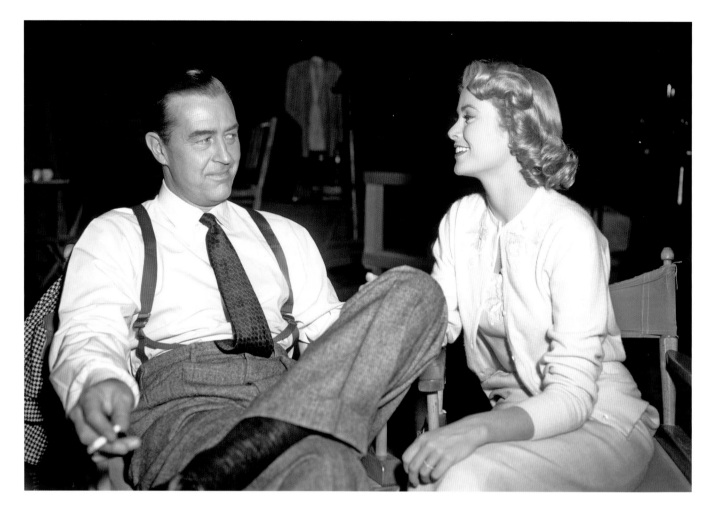

In June 1953, Grace was appearing in *The Moon Is Blue* at Philadelphia's Playhouse in the Park. Her sister Lizanne was also working on the production (it was there that she met her future husband, Donald LeVine). Grace was thrilled when Jay Kanter phoned with the news that the deal had been struck for *Dial M for Murder*. A leading role in a prestigious Alfred Hitchcock film might finally be the breakout role that would make her a star.

After her Philadelphia stage run, Grace returned briefly to New York to star in "The Way of the Eagle" (1953) for *The Philco-Goodyear Television Playhouse*. Grace, still wounded from her experience with Gable, initially kept her distance from her dashing French costar Jean-Pierre Aumont. "Miss Kelly arrived, very pretty, very blonde, a tall girl with blue eyes that could turn to steel at a moment's notice," Aumont wrote in his autobiography. After several days of Grace coolly referring to him as "Mister Aumont," one day Aumont pointed to a sign on the wall of their rehearsal space that read "Ladies, be kind with your gentlemen. After all, men are human

beings too." Grace laughed, and her reserve melted.

Following the sudden death of his beloved wife, the glamorous actress Maria Montez, in 1951, Aumont was also wounded and searching for companionship. Grace and Aumont dated throughout the summer of 1953, even posing for a photo spread at Palisades Amusement Park in New Jersey for *Movie Life* magazine.

On August 8, 1953, Grace was back in Hollywood— this time at the Warner Bros. studio in Burbank—to start production on *Dial M for Murder*. In the film, Grace portrays Margot Wendice, the wealthy wife of former tennis professional Tony Wendice (Ray Milland). When he discovers that Margot had a brief affair with writer Robert Halliday (Robert Cummings), Tony hatches a plot to murder his wife for her money.

Hitchcock thought shooting on one single set would be easy, but was unprepared for the enormous 3-D camera. It was, quite literally, the size of a room. Often the director wanted to try a shot but was warned it would be impossible with the bulky camera. Hitchcock relieved his

**ABOVE** Ray Milland and Grace. **OPPOSITE** Margot (Kelly) tells Mark Halliday (Robert Cummings) that she is being blackmailed.

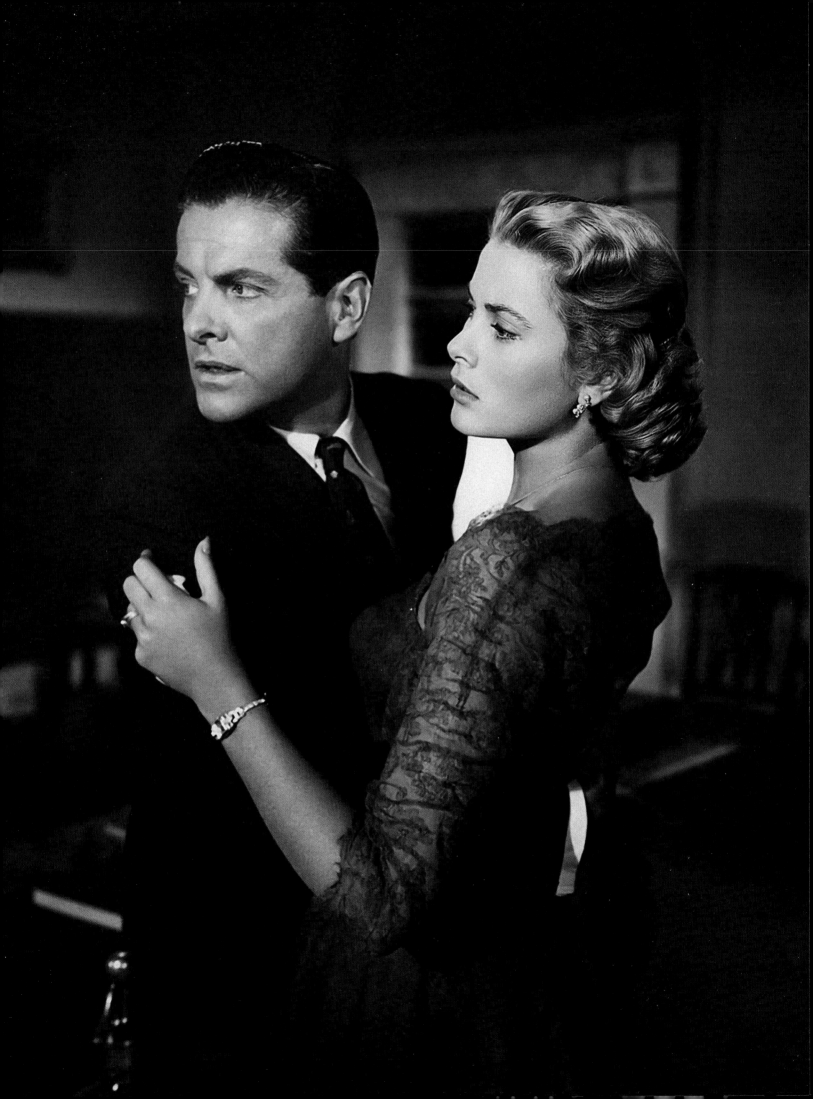

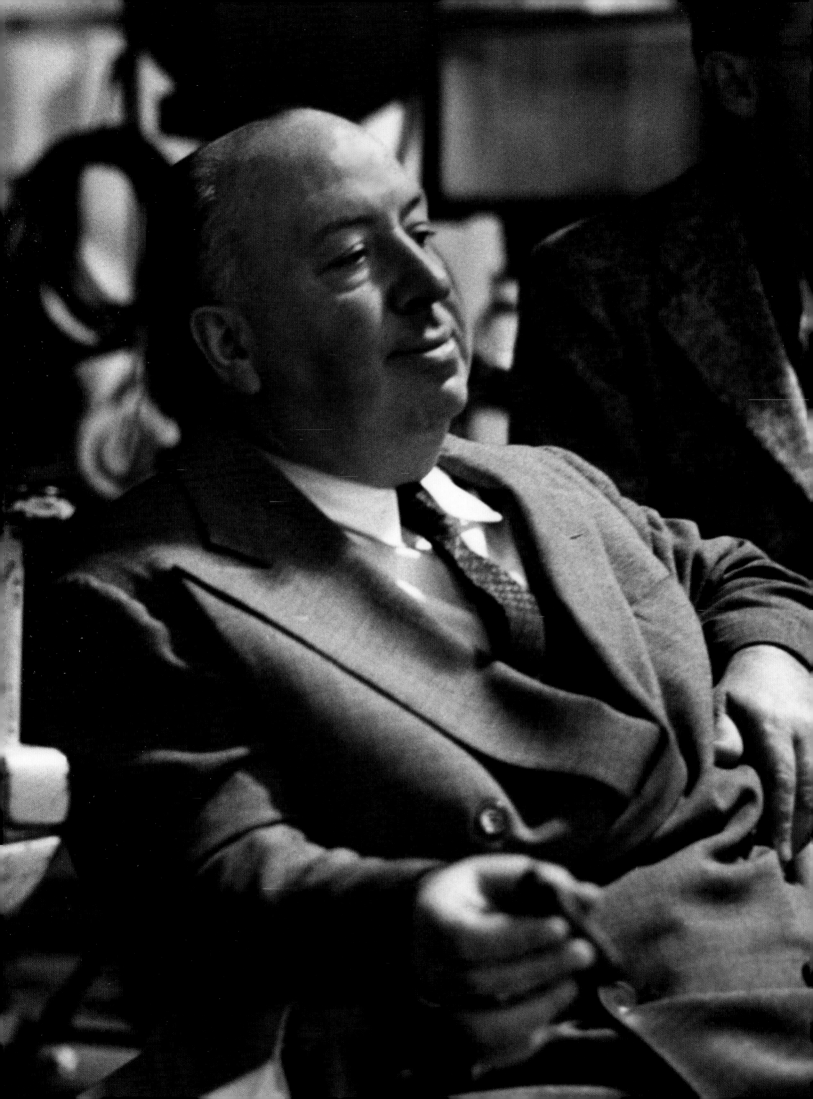

on-set frustrations by regaling Grace with exciting ideas for his next project, which would be called *Rear Window* (1954).

Margot is a multilayered character—a victim, but not exactly an innocent one. To the 1950s audience, Margot at face value is an adulterous wife. She has deceived her husband but has been convinced by him to give their marriage a second try. The audience understands that this renewed attempt at fidelity stems from guilt and not a change of heart; she still loves another man. It took bravery for Hitchcock to show a real woman, an imperfect one with a dirty secret. But his genius lies in casting Grace Kelly to portray her. Grace makes Margot sympathetic—even within a repressed and judgmental society—as her delicate qualities shine through. Margot's sense of nightmarish betrayal is generally shared by the audience. Her own indiscretions and lack of integrity are forgiven in the shadows of the larceny and murderous actions of her husband. But would they have been so readily accepted in an actress lacking in Grace's finesse and angelic looks? The public would have had a harder time forgiving the lapses of an Ava Gardner, or even a plainer actress like Jane Wyman. They might think she should have known better.

The role and the director both suited Grace perfectly. "The combination of Alfred Hitchcock and Grace Kelly was, indeed, a strange one," biographer Gwen Robyns wrote. "Of all the directors who could have worked with her at that time, he seemed the most improbable. Elia Kazan might have appealed to her intelligence and brought out another dimension in her. . . . George Cukor was the obvious choice, with his ability to get inside the feminine mind. . . . But it was Alfred Hitchcock, the rank outsider, who took the long chance that paid off. He wanted the kind of inner brilliance that could ignite a screen; and she, in turn, needed firm handling, the hallmark of Hitchcock's direction." No one could have predicted it, but their union was a marriage made in heaven.

"He controlled her perfectly," writer Alexander Walker said of Hitchcock and Grace. "He told her exactly what kind of reactions he needed. And he was very interested indeed in the smoldering amorousness that the ladylike exterior concealed. I think Alfred Hitchcock saw in Grace Kelly a lady who he could humiliate. . . . When he got his hands on women, he did so through his camera. He put them through it. He made the ladies suffer. And then he redeemed her at the end and she finished up still a lady and intact."

Hitchcock had Warners stylist Gertrude Wheeler create a new hairstyle for Grace with a part down the center—a style Grace would never wear again. Hitchcock used a color-coding system for Margot's clothes, which he sometimes did with his characters. At the beginning of the film, she would wear a bright wardrobe, including a red dress marking her as a scarlet woman. As she becomes more victimized, first by a man attempting to murder her and then by her husband, Hitchcock instructed that her clothes were to go "brick, then to gray, then to black."

For the brutal attack scene, Hitchcock had costume designer Moss Mabry construct a heavy velvet robe for Margot. Grace disagreed with Hitchcock's choice, telling him that a woman at home alone would never put on a robe to answer the phone. "Well, what would *you* do?" the director asked. Grace told him she wouldn't put anything over her nightgown. Hitchcock gave in, agreeing that his leading lady was right. Grace worked for days on the pivotal scene, often to the point of exhaustion, trying to give the master exactly what he wanted. From then on, Hitchcock trusted that Grace understood her character and what he needed from her.

Along with Hitchcock's trust came an appreciation of Grace's sense of humor. He once told some off-color stories to Ray Milland in front of her. "Does that shock you, Miss Kelly?" he asked. "No," she replied. "I went to a girls' convent school, Mr. Hitchcock. I heard all those stories when I was thirteen."

As the sole female in the cast of *Dial M for Murder*, Grace attracted the attention of members of the male crew, including costar Anthony Dawson and writer Frederick Knott. Ray Milland was separated from his wife at the time, and he promptly fell head over heels for Grace. Though Lizanne had once again been sent to Los Angeles to keep things respectable at the Chateau Marmont, she put her chaperone duties on hold for Milland. Milland courted Grace openly, and the couple

was seen often having dinner together. What Grace didn't know was that Mrs. Milland was fighting to get her husband back and was prepared to use her connections to Hollywood gossip columnists to get her way.

After a tidbit in *Confidential* magazine portrayed Grace as a homewrecker, the Kellys got involved. Grace knew her parents would never approve of Milland as a suitable husband if he had to divorce his wife to marry her. The actress wanted very much to live her own life, yet could not quite escape her deep-seated desire for parental approval. "She was full of paradoxes," Judith Balaban Quine said of Grace. "I think it's why she was so totally fascinating—all the time, even to people who knew her extremely well." John B. Kelly ordered Grace to stop seeing Milland and to return to New York when *Dial M for Murder* wrapped. Grace was devastated when, in the end, Milland returned to his wife.

*Dial M for Murder* finished production on September 24, 1953, fifteen days behind schedule. The final budget was $1.3 million, and the film made $5 million worldwide in its initial release. Though Grace was nominated for a BAFTA for Best Actress in a Leading Role and a Bambi Award for Best International Actress, critics were not exactly effusive in their praise. Philip K. Scheuer of the *Los Angeles Times* and Bosley Crowther of the *New York Times* agreed that Grace was lovely to look at and performed her role adequately and competently, but nothing more. Hitch had unleashed Grace Kelly on the public, but the public was not yet sold on the new star.

Hitchcock himself may not yet have been totally convinced of Grace's acting ability, but he was convinced she possessed a certain quality he sought in his heroines. In a 1962 *Hollywood Reporter* article, Hitchcock wrote about what kind of woman fascinated him: "I like women who are also ladies, who hold enough of themselves in reserve to keep a man intrigued. On the screen, for example, if an actress wants to convey a sexy quality, she ought to maintain a slightly mysterious air. . . . Remember Grace Kelly in *High Noon*? She was rather mousy. But in *Dial M for Murder*, she blossomed out for me splendidly, because the touch of elegance had always been there."

**TOP** Grace behind the scenes. **ABOVE** Tony Wendice (Ray Milland) has become a model husband for Margot (Kelly). **OPPOSITE** A portrait sitting to promote *Dial M for Murder.*

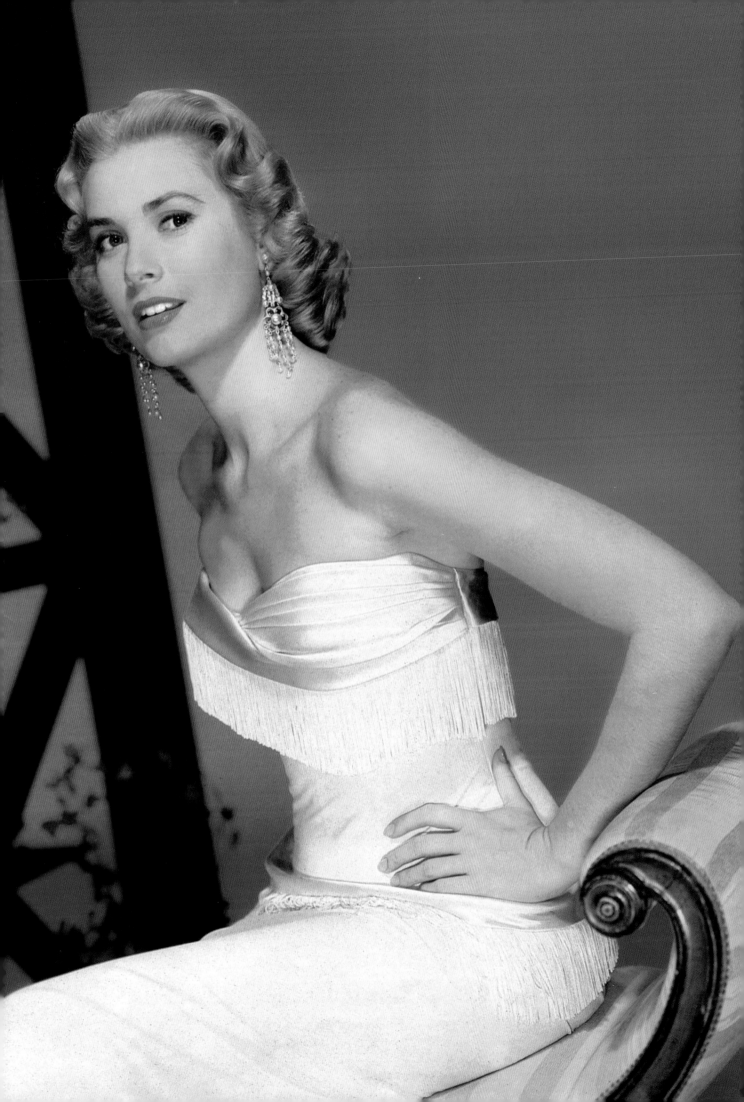

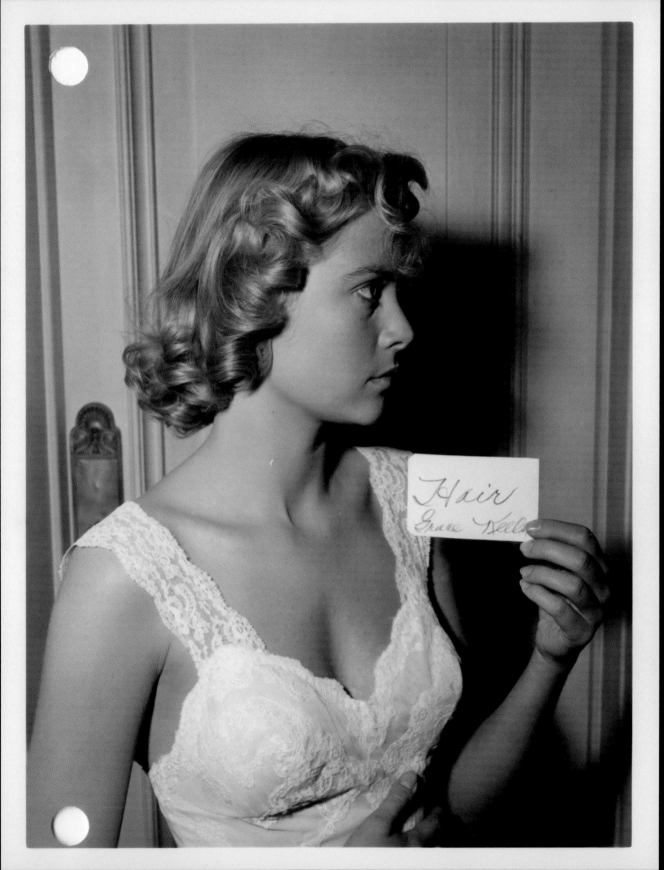

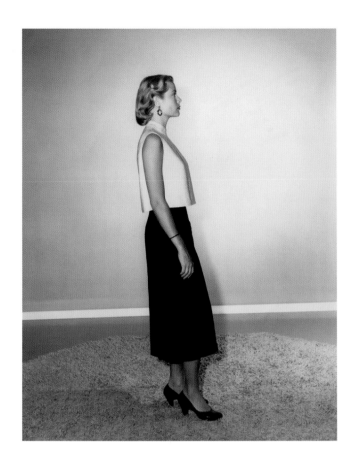

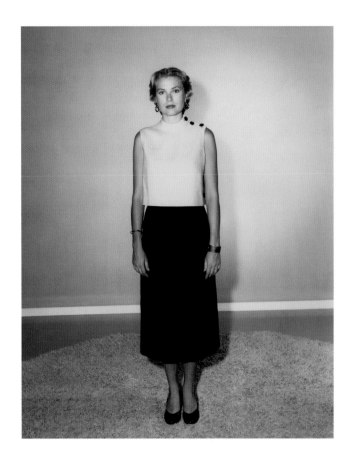

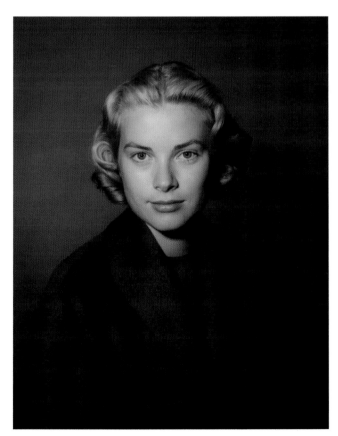

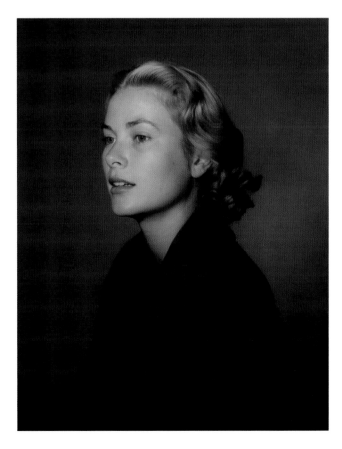

**TOP LEFT AND RIGHT** Wardrobe tests for an unused design by Moss Mabry. **BOTTOM LEFT AND RIGHT** Hair tests for Margot's return to the apartment. **OVERLEAF** Alfred Hitchcock directs Grace.

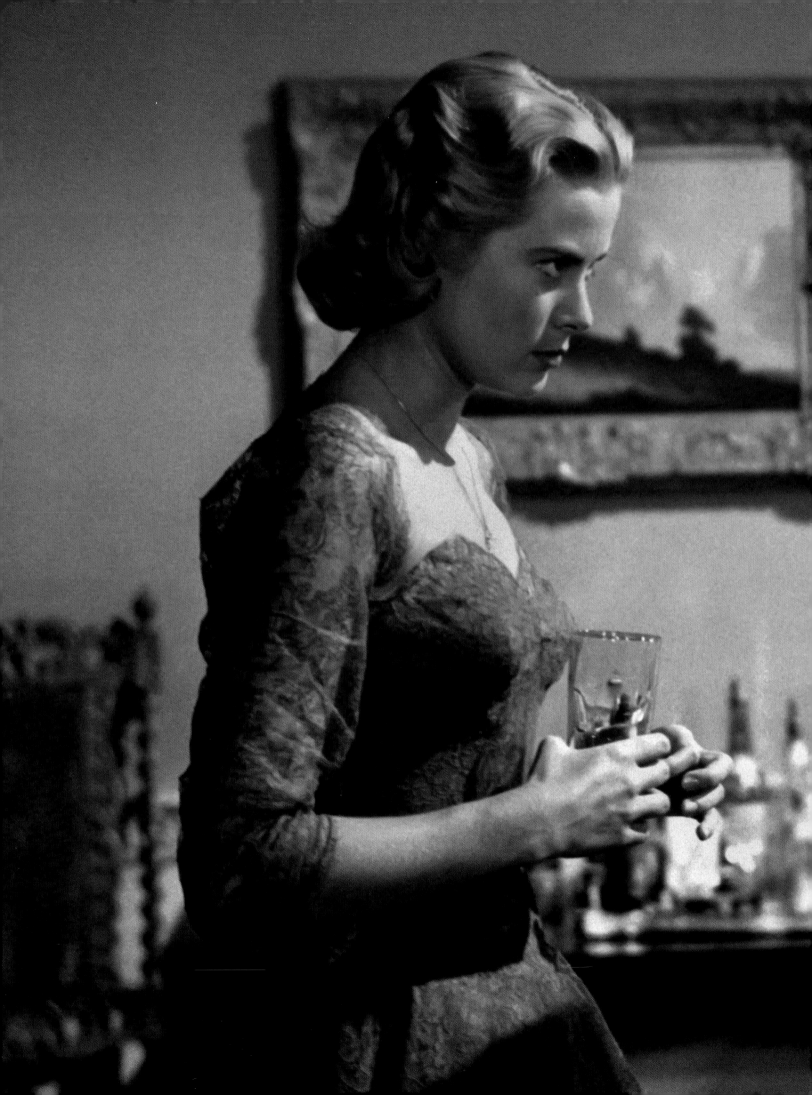

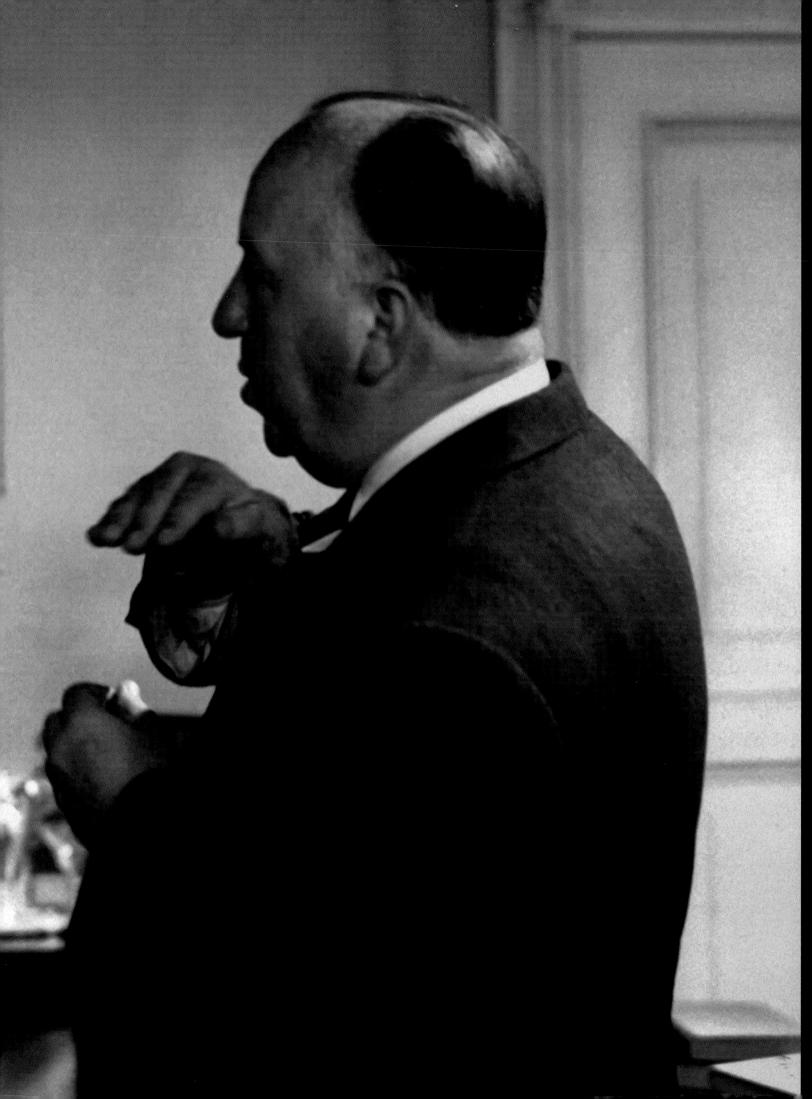

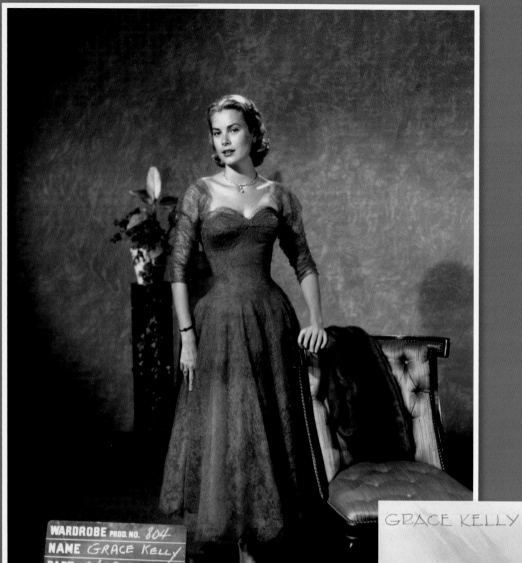

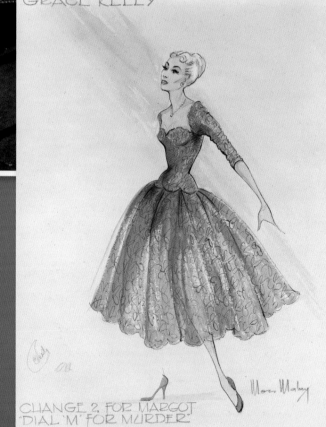

GRACE KELLY

CHANGE 2. FOR MARGOT
'DIAL 'M' FOR MURDER'

**TOP AND OPPOSITE** Wardrobe tests.   **ABOVE** Moss Mabry's sketch for Margot's shocking-red dress.

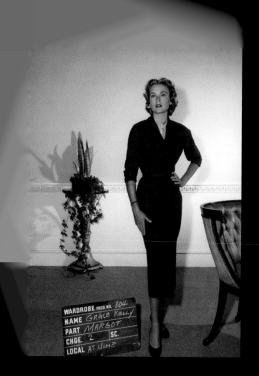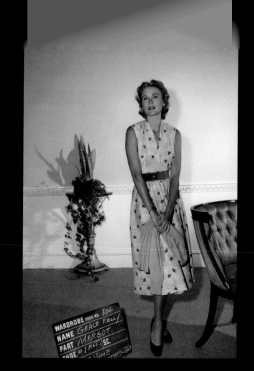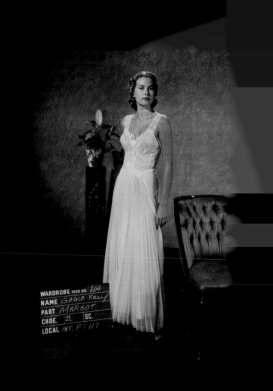
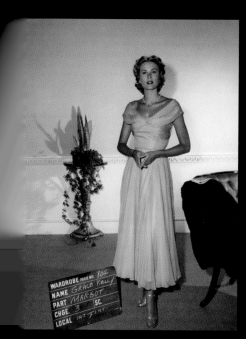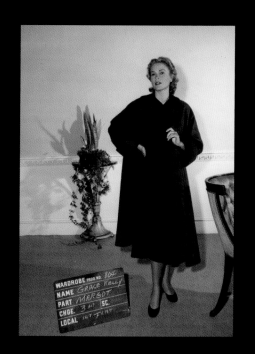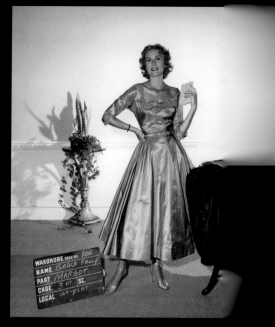
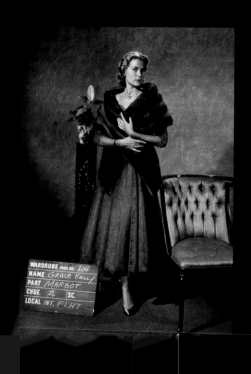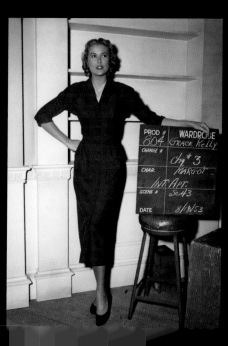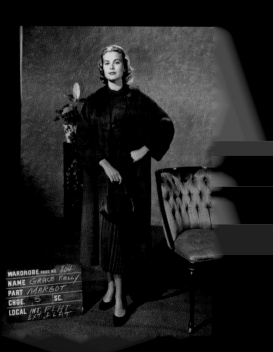

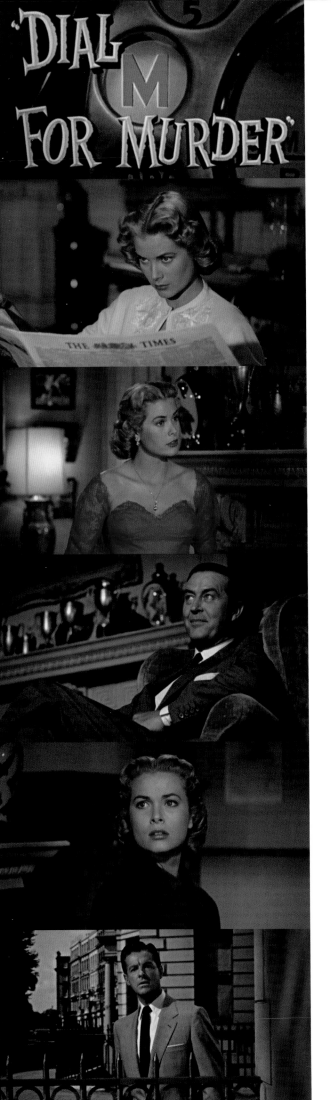

"When he [Hitchcock] got his hands on women, he did so through his camera. He put them through it. He made the ladies suffer. And then he redeemed her at the end and she finished up still a lady and intact."

ALEXANDER WALKER

**OPPOSITE** Grace was being molded into Hitchcock's perfect muse—a woman who held enough of herself in reserve to be intriguing.

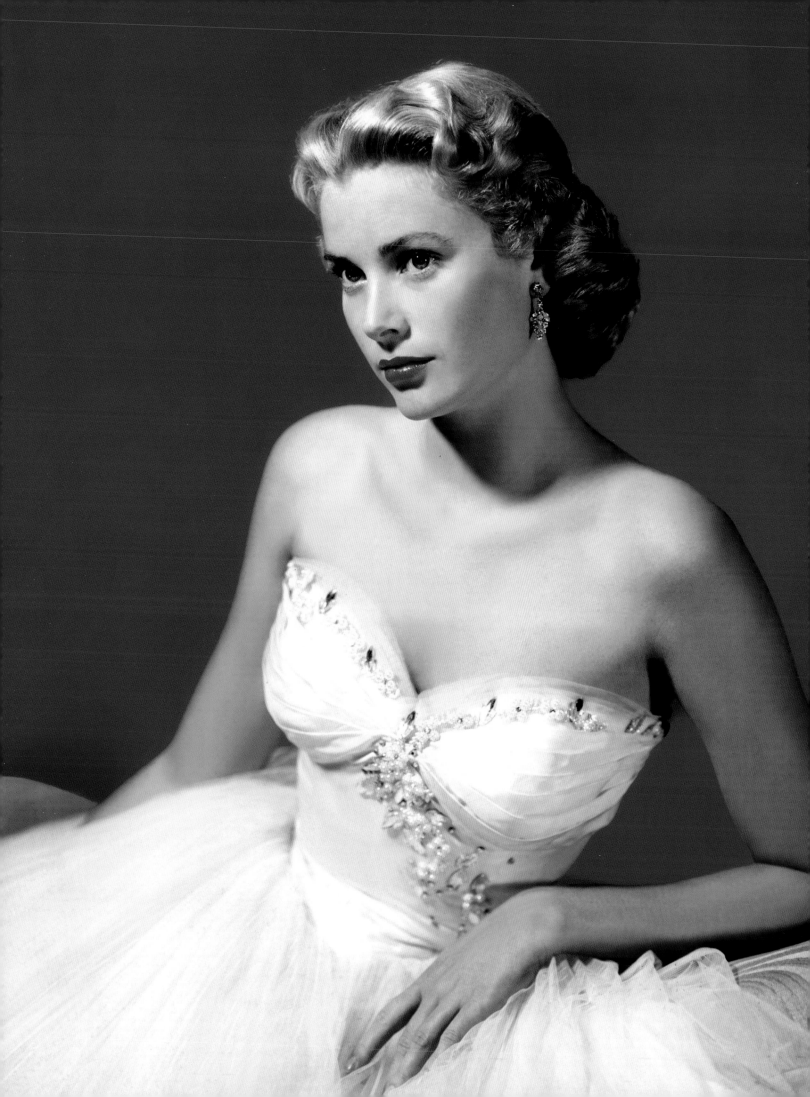

TOP Grace with playwright and screenwriter Frederick Knott. ABOVE LEFT Alfred Hitchcock demonstrating how three-dimensional film technology worked. ABOVE RIGHT Grace demonstrates for Robert Cummings, and the camera, what she will have to endure during the murder sequence.

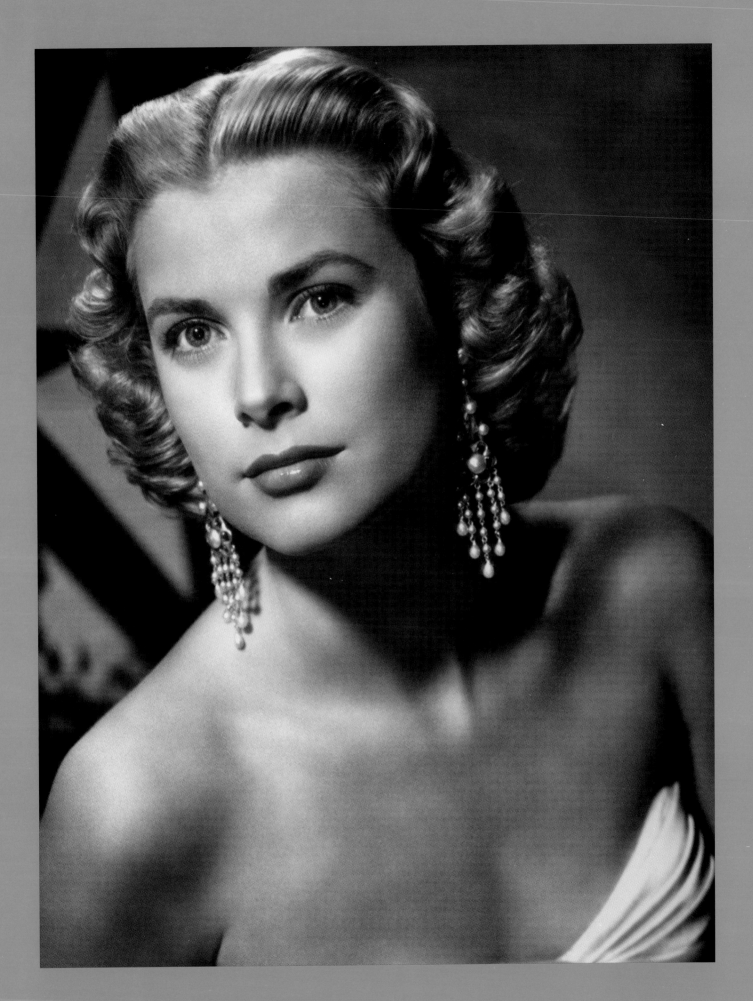

**ABOVE** Grace wears earrings by Joseff for a publicity portrait.

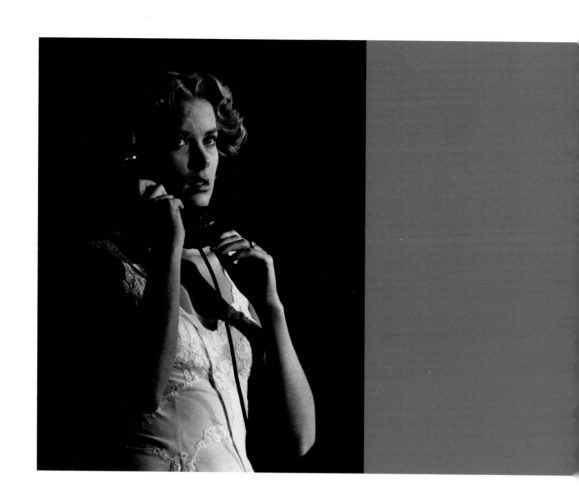

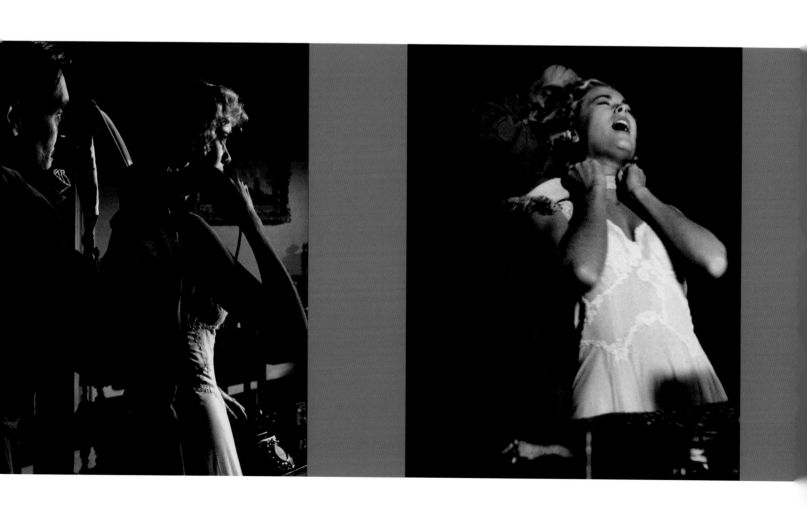

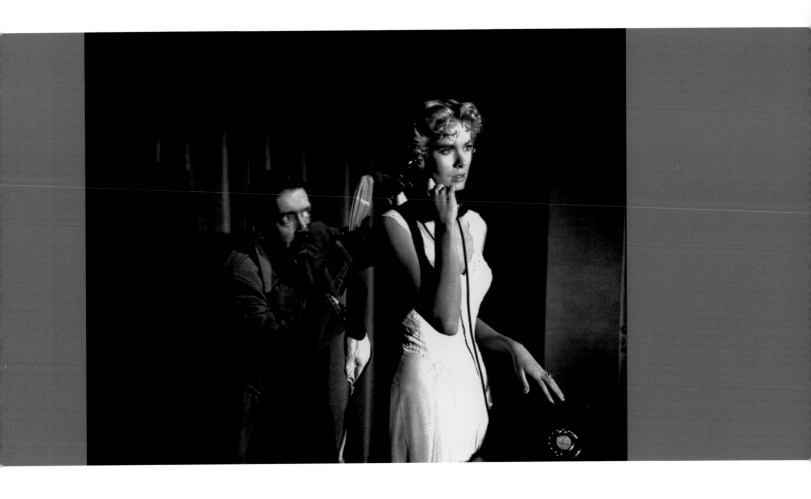

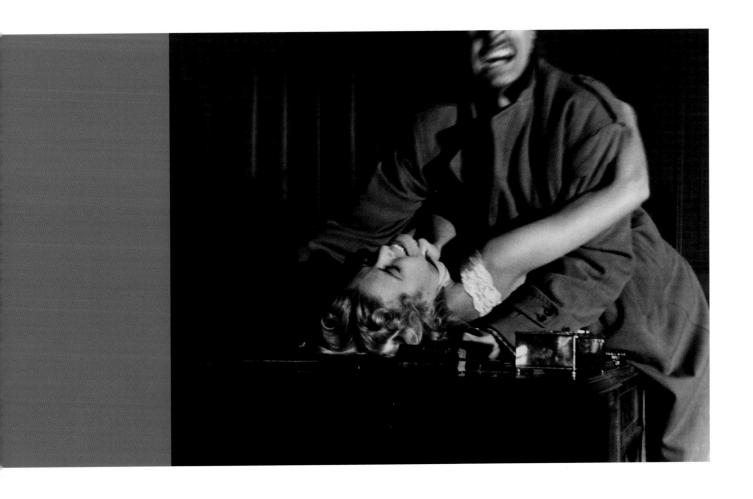

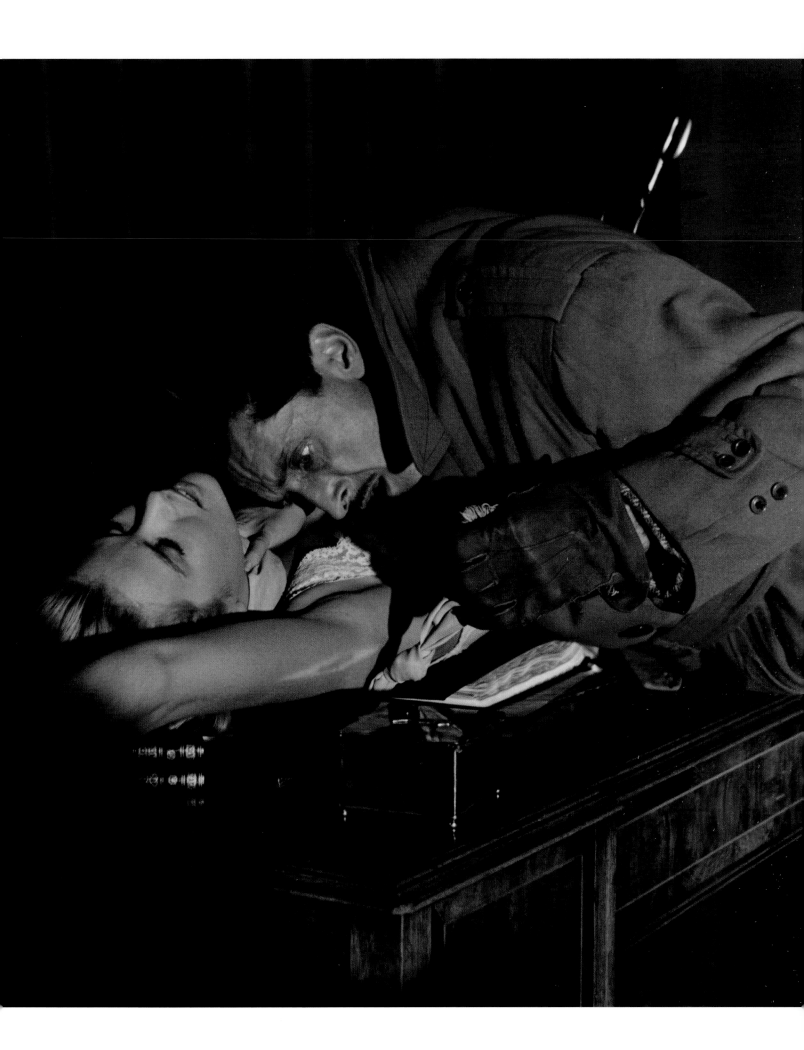

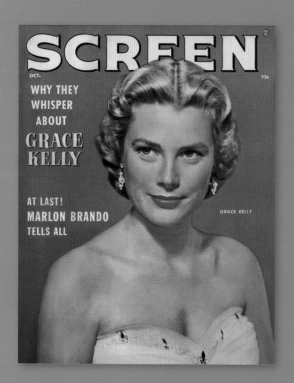

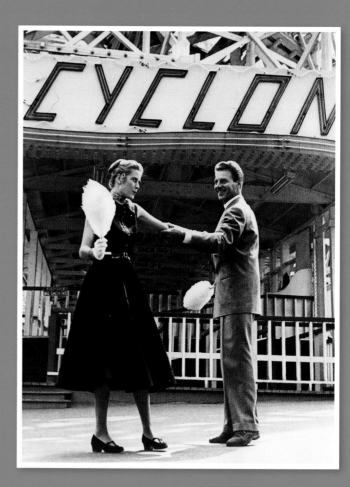

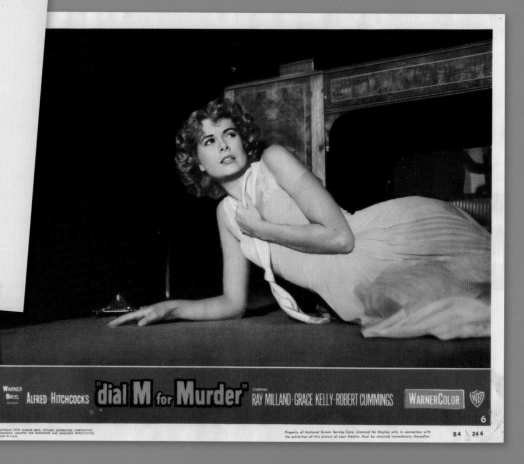

PRECEDING PAGES The grueling murder scene. TOP LEFT *Screen* magazine, October 1954. TOP RIGHT Grace and Jean-Pierre Aumont, photographed at Palisades Park in New Jersey during their courtship. BOTTOM LEFT Program for *The Moon Is Blue*, the play in which Grace was appearing when she was cast in *Dial M for Murder*. ABOVE A lobby card used to promote the film in theaters. FOLLOWING PAGES The Warner Bros. campaign manual shows how Hitchcock promoted his new female star—including marriage advice from Grace. An alternate American poster for the film.

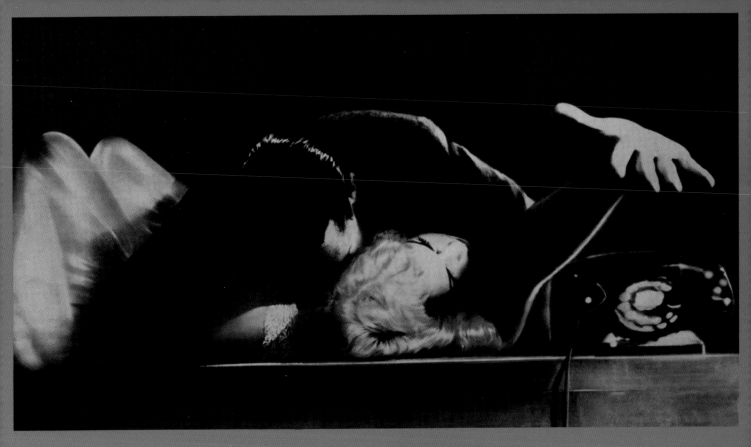

ALFRED
HITCHCOCK'S

"dial
M
for
Murder"

WARNERCOLOR

A
WARNER
BROS.
CAMPAIGN

# The Billing

## Warner Bros.

*Pictures Presents*

### Alfred Hitchcock's

## "DIAL M FOR MURDER"

The International Stage Success

Color by
WarnerColor

Starring

# RAY MILLAND
# GRACE KELLY
# ROBERT CUMMINGS

with

### JOHN WILLIAMS

Written by Frederick Knott

Music Composed and Conducted by
Dimitri Tiomkin

A Warner Bros. Picture

*(marginal percentages: 50%, 5%, 50%, 100%, 20%, 15%, 30%, 75%, 75%, 75%, 25%, 20%, 5%, 3%, 5%)*

RAY MILLAND     GRACE KELLY
Still 804-621 Mat 804-2A

# The Cast

| | |
|---|---|
| Tony | RAY MILLAND |
| Margot | GRACE KELLY |
| Mark | ROBERT CUMMINGS |
| Inspector Hubbard | JOHN WILLIAMS |
| Capt. Lesgate | ANTHONY DAWSON |
| The Storyteller | LEO BRITT |
| Pearson | PATRICK ALLEN |
| Williams | GEORGE LEIGH |
| 1st Detective | GEORGE ALDERSON |
| Police Sergeant | ROBIN HUGHES |

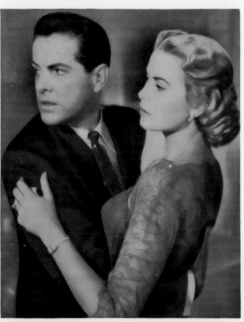

ANTHONY DAWSON     GRACE KELLY
Still 804-15 Mat 804-2B

# The Story (Not for publication)

Society playboy Tony Wendice (RAY MILLAND), fearing divorce and disinheritance from his wealthy wife Margot (GRACE KELLY) because of her affection for American writer Mark Halliday (ROBERT CUMMINGS), plots her death. Contacting Captain Lesgate (ANTHONY DAWSON), an old school chum now operating in illegal activities, Tony outlines his plan for murder, then blackmails Lesgate into carrying it out. Next night, Tony leaves Margot at home alone, hides her key under the stair carpet outside the door to be used by Lesgate in entering. The assassin takes his stand behind curtains near the telephone, awaiting Tony's phone signal which lures Margot into position for the attack. However, the murder attempt backfires as Margot, in self defense, stabs Lesgate with a pair of scissors. Unruffled Tony, taking full advantage of the strange twist of events, gives subtle testimony, leading Scotland Yard to believe Margot guilty of deliberate murder. Confident of Margot's innocence, Mark works diligently to clear the woman he loves. Aiding Inspector Hubbard (JOHN WILLIAMS), the writer and the detective finally trick Tony into admitting his part in the crime. Exonerated, Margot and Mark begin a new life together.

# The Production

Directed by Alfred Hitchcock. Screen Play by Frederick Knott as adapted from his play. Photography by Robert Burks, A.S.C. Art Director Edward Carrere. Film Editor Rudi Fehr, A.C.E. Sound by Oliver S. Garretson. Music Composed and Conducted by Dimitri Tiomkin. Wardrobe by Moss Mabry. Set Decorator George James Hopkins. Makeup Artist Gordon Bau. Assistant Director Mel Dellar.

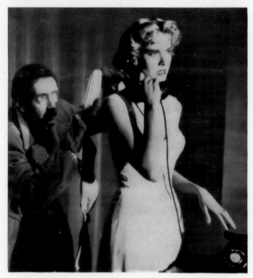

ROBERT CUMMINGS     GRACE KELLY
Still 804-6 Mat 804-2E

# Alfred Hitchcock's 'Dial M for Murder,' Warner Bros. Suspense Thriller, Due

*(Lead Story)*

"Dial M For Murder," the widely heralded, new Alfred Hitchcock picture, starring Ray Milland, Grace Kelly and Robert Cummings, opens at the Theatre. Filmed by Warner Bros. from the international stage success which ran a year and a half on Broadway, "Dial M For Murder" will be presented in 3-D and WarnerColor.

Suspense and mystery are the elements which are reportedly mixed with dangerous romance in the story of a three-cornered love affair which leads to murder. Ray Milland is Tony Wendice, married to lovely Grace Kelly, new Hollywood star. The role, as portrayed on the stage was one which required a dramatic sense of calculated evil and appealing suavity. Milland, long a favorite in Hollywood and winner of an Academy Award "Oscar," is said to reach new heights of dramatic achievement in his portrayal.

Grace Kelly, blonde, beautiful and urbane, will be remembered for her outstanding characterizations in "High Noon" and "Mogambo," for which she won an Academy nomination. In "Dial M For Murder" Miss Kelly has been elevated to star status by producer-director Alfred Hitchcock. As Milland's wife she is the central figure in the famous strangulation scene which results in the all-important murder in the story.

Third member of the stellar triangle is Robert Cummings, no longer the brash young man of comedy roles, but now a serious-minded lover, determined to save Miss Kelly from an innocent death.

Alfred Hitchcock, whose fame was won through his taut direction of such outstanding films as "The Spiral Staircase," "Strangers On A Train," and most recently, "I Confess," is said to have filmed "Dial M For Murder" in a faithful reproduction of the international stage hit while adding only the distinctive Hitchcock directorial touches. One such familiar trademark is the appearance in the film of the famed director's portly person. But in "Dial M For Murder" he does not appear in a "live" scene. He is seen as one member of a group in a photograph of a class reunion which also shows the murder victim.

"Dial M For Murder" marks Alfred Hitchcock's introduction to the new three-dimension camera. The director, whose use of the camera in the past has won him a special niche in Hollywood's directorial hall of fame, turned to the new process with an eye toward making it work as a factor of additional realism. With his customary enthusiasm for odd camera angles, Hitchcock had cameraman Robert Burks down in an eight foot pit dug in the sound stage floor, and later the director ordered the 3-D camera hoisted to a height of 20 feet for a straight-down shot of the murder scene.

Warner Bros.' "Dial M For Murder" was written for the screen by the author of the play, Frederick Knott. The music was composed and conducted by Dimitri Tiomkin. John Williams and Anthony Dawson are featured in the film in the same roles they played in the Broadway production; the detective and the victim.

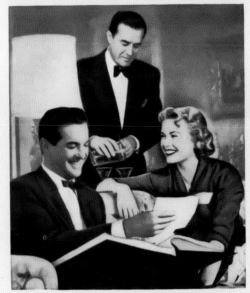

Alfred Hitchcock's "DIAL M FOR MURDER" stars RAY MILLAND (standing) GRACE KELLY and ROBERT CUMMINGS in a 3-D and WarnerColor presentation of the international stage success. Filmed by Warner Bros., "Dial M For Murder" will open at the Theatre.

*Still 804-11*      *Mat 804-2C*

---

# The Hitchcock Touch— Simple To Sinister

Alfred Hitchcock's gift for turning the commonplace into the macabre is about to show up again with eye-popping effect in "Dial M For Murder," the international stage hit filmed by Warner Bros., opening at the Theatre in 3-D and WarnerColor.

At Warner Bros., where the play was translated into the three-dimension motion picture, Mr. Hitchcock proceeded to whip it into Hitchcock form with his uncanny technique for emphasizing the horror aspects of peaceful little objects that ordinarily wouldn't scare anybody.

In "Dial M" the roly-poly director throws all his spine-freezing talents into (1) a pair of scissors (2) a door key and (3) a weather-stained raincoat. All are certainly garden-variety household articles of no evil implications.

In the hands or on the persons of Ray Milland, Grace Kelly, and Robert Cummings, however, these items are so cast as to have a life-or-death force upon everybody involved. That's the way Hitchcock figured it.

Although his desire to be a solid craftsman and a good story-teller prompt Hitchcock to rebel at the word "gimmick," this is pretty much what they are.

"You will note, though," Hitchcock himself says, "that they are invariably honest gimmicks; that is, they are not lured into the script as mere tricks to over-complicate or falsely stimulate the action. Rather, they are a vital part of the screenplay, without which, indeed, there would be no story."

In "Dial M For Murder," the key opens a London flat occupied by Milland and Miss Kelly, and its position under the carpeting on the stairs and later in the raincoat pocket of a certain gentleman, and, in short, its detailed movements throughout the picture are the basis of narratives.

And, adds the director, "although the scissors don't figure as profoundly, nor so significantly in the goings-on, who would ever allow that they would abandon their cozy position on the parlor desk and wind up quivering in somebody's unsuspecting back?"

**RAY MILLAND**
*Still 804-32*      *Mat 804-1D*

**RAY MILLAND**
*Still RM-24*      *Mat 804-1B*

# 'Dial M for Murder' Opens Here Today

*(Opening Day)*

Alfred Hitchcock's "Dial M For Murder," in 3-D and WarnerColor, opens today at the Theatre. Ray Milland, Grace Kelly and Robert Cummings star in the thriller with John Williams and Anthony Dawson featured in the same roles they played in the Broadway production.

Suspense, murder and a dangerous love affair are the ingredients of the international stage success, written by Frederick Knott, which has been brought to the screen for Warner Bros. by Alfred Hitchcock.

"Dial M For Murder" is a title of strong significance, inasmuch as it is the ringing of a telephone which is the signal for a murder. The letter "M" applies to the first letter of the London exchange, Maidavale, in which district abides the lovely young lady who is the intended victim of the sinister plot.

Music for "Dial M For Murder" was composed and conducted by former Academy Award winner Dimitri Tiomkin.

**ROBERT CUMMINGS**
*Still RC-8*      *Mat 804-1C*

## Famed Stage Hit Filmed By WB

"Dial M For Murder," the international stage success written by Frederick Knott, has been brought to the screen by Alfred Hitchcock for Warner Bros. The film, in 3-D and WarnerColor, opens at the Theatre. Ray Milland, Grace Kelly and Robert Cummings star.

Having set records for attendance in each of the cities and countries it has played, "Dial M For Murder," as a play, has traveled from Broadway to Sidney, Australia and from San Francisco to Copenhagen. At one time "Dial M For Murder" played simultaneously in New York, Chicago, London, Paris, Oslo, Copenhagen, Johannesburg, Stockholm, Sydney, Amsterdam, Wellington, and La Jolla, California. Now, through the medium of motion pictures the suspense chiller will be brought to millions more of mystery story fans.

## Grace Kelly (she's single) Expounds On Marriage

Every husband owes his wife breakfast in bed once a week, says Grace Kelly, who isn't a wife but who declares she would willingly cook a husband's oatmeal six mornings a week if she could have her toast and coffee on her own Beautyrest the seventh.

Miss Kelly expounded her theory of marital bliss during the 3-D and WarnerColor filming of Warner Bros.' "Dial M For Murder," which opens ............ at the ............ Theatre. Her theory met nothing but resistance from her male co-workers including Ray Milland, Robert Cummings, and Director Alfred Hitchcock.

Milland allowed that women should be happy to have one dinner out a week; Cummings thought their place is and always has been strictly in the kitchen; and Hitchcock said he figured his wife owed *him* breakfast in bed.

"A woman—even a wife—" persisted Miss Kelly, "has to be indulged once in a while, and the luxury of not having to answer the alarm, plug in the coffee and squeeze the orange juice is one of the simplest and nicest forms of indulgence for a housewife."

The actress also believes that simple everyday courtesies between man and mate are the basis of happy marriages and contented anniversaries.

She wouldn't go so far as to

**GRACE KELLY**

*Still 804-605*          *Mat 804-1A*

say that a promise of a weekly breakfast in bed would be reason enough for her to marry the man who would promise it, "but at least it would be a step in the right direction and an indication of what kind of a gent he is."

Until she makes a romantic connection with the right guy, Miss Kelly says she is resigned to be preparing her own bachelor-girl breakfasts. "And every Sunday morning," she said, "I hop out of bed, fix my breakfast on a tray, and then pop back between the sheets again. That's semi-luxury at least."

## Budding New Star Grace Kelly In Warners' 'Dial M for Murder'

One of the newer stars to burst on the Hollywood horizon, Grace Kelly promises also to be one of the most unusual, for she is a product of a Philadelphia finishing school and has already played opposite some of the most important stars in filmdom.

Not the least of these is Clark Gable with whom she made "Mogambo" and in which she vied with Ava Gardner for the love of the great star. Before that lovely, blonde Miss Kelly had made her debut in "High Noon" opposite Gary Cooper which won that screen luminary an Academy Award.

Today Grace Kelly has added Ray Milland and Robert Cummings to the list of top male stars with whom she has appeared. Grace is starring with Milland and Cummings in Alfred Hitchcock's "Dial M For Murder," which opens ............ at the ............ Theatre in 3-D and WarnerColor.

The 25-year-old Grace, tall and blue-eyed, was born in Philadelphia, the daughter of a prosperous building contractor. She attended school at Raven Hill Academy and Stevens School. After that, she was stricken with a fierce desire to be an actress, so she enrolled in New York's Academy of Dramatic Arts, where she spent two years learning the techniques of acting.

Today, Grace Kelly is one of the most sought-after actresses in Hollywood.

**GRACE KELLY,** next to be seen in Warner Bros.' production of Alfred Hitchcock's "Dial M For Murder," from the international stage success by Frederick Knott. Film will be seen in 3-D and WarnerColor starting ............ at the ............ Theatre.

*Still 804-602*          *Mat 804-2D*

## Special 3 Column Mat !

 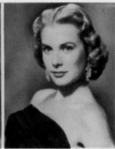 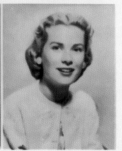

### MANY USES

1. Singly for publicity plants.
2. Together for a Sunday feature.
3. As Tie-up Stills.
4. Stills in your lobby displays.
5. Basis for Doubles Contest.
6. For finding local "Grace Kellys."

**ORDER: MAT 804-302X AND/OR STILLS 804-600, 804-652, 804-610**

### Star In Chiffon

"Sensation without revelation" was the description Alfred Hitchcock gave to the sheer chiffon nightgown shapely Grace Kelly wears in the tense murder scene in "Dial M For Murder," 3-D and WarnerColor suspense-drama opening ............ at the ............ Theatre.

Underneath the transparent gown, and part of it, was a satin, flesh-colored unit, close fitting enough to make the nightdress interesting . . . but not so much as to endanger Miss Kelly's modesty.

The gown was designed by Moss Mabry for the Warner Bros. film version of the international stage success.

---

### Red For Go!

Grace Kelly's fire-engine red skirt, completely filling the three-dimension screen, is the opening shot of "Dial M For Murder," which comes to the ............ Theatre on ............

This is Alfred Hitchcock's method of setting the scene for passion. The WarnerColor camera, pulling away from Miss Kelly's flaming gown, finds her wrapped tightly in the arms of her lover, Robert Cummings.

"In this case," Hitchcock explained, "red doesn't mean stop. It means go."

## PHONE BOOTH OR STREET SNIPES:

### PHONE STUNT

Work this one with the phone company. Telephones on shelf in lobby are so rigged that when patrons dial M, recorded voice reads following suggested message. *"You have just dialed M for Message. Now see 'Dial M For Murder' opening Friday at the Strand Theatre."*

### FREE CALL

Via newspaper cooperation send out word that first ten servicemen appearing at the boxoffice on opening day will be entitled to telephone to their parents or wives free of charge within a specfied area. Set story with your editor first.

### M For Memory—Street Stunt

Roving reporter asks passersby to name the numeral appearing with "M" on the telephone dial. First ten persons to answer "6" awarded pass prizes.

## How About the Grace Kelly Fans?

New star Grace Kelly inspires a radio or lobby contest in which entrants are asked to write in 100 words or less why they consider Miss Kelly the most versatile of Hollywood's new screen "finds." Guest tickets for winners.

NEW STAR FAN CLUB. Is there a GRACE KELLY FAN CLUB in town? If not, why not start one!

### STILLS FOR STORE WINDOWS

ORDER: "Window Stills No. 804."

**Sports Dealers**
804-618

**Evening Dress**
804-616

**Ties**
RC-20

**Formal Wear**
RM-25

**Sport Jacket**
RC-28

**Tobacconist**
RM-27

## FREE Title Sheets For Music Stores!

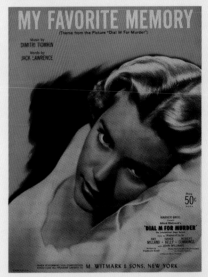

"My Favorite Memory" (this is the background theme music). Music by Dimitri Tiomkin; Words by Jack Lawrence. Order your title sheets for displays early. Write: M. Witmark & Sons, 488 Madison Avenue, New York, N. Y.

## *Fashion Editor Attention!*

### DRESSED TO KILL!

Grace Kelly, who stars with Ray Milland and Robert Cummings in Alfred Hitchcock's "Dial M For Murder," wears this street length evening dress which was designed for her by Moss Mabry, famed fashion creator. The dress is made of red Swiss imported handkerchief lace. It has a double circular skirt over three circular accordian pleated under skirts. The top of the dress is a close fitting strapless bodice. Over this, a matching short hugging bolero is worn.

**ORDER: Mat No. 804-201X**

# POSTERS

**6-SHEET**

If playing the picture in 3-D, be sure to include 3-D mention on your six-sheet date strips.

**3-SHEET**

3-D snipes available for 3-Sheet and 1-Sheet at National Screen. See box below.

**ONE-SHEET**

**AVAILABLE IN 3D**

better
let
it
ring!

Alfred Hitchcock's
"dial
M
for
Murder"

PRESENTED BY
WARNER BROS.

STARRING
RAY MILLAND · GRACE KELLY · ROBERT CUMMINGS    WarnerColor

WITH JOHN WILLIAMS WRITTEN BY FREDERICK KNOTT who wrote the International Stage Success DIRECTED BY ALFRED HITCHCOCK MUSIC COMPOSED AND CONDUCTED BY DIMITRI TIOMKIN

DIAL M FOR MURDER  Z54-244

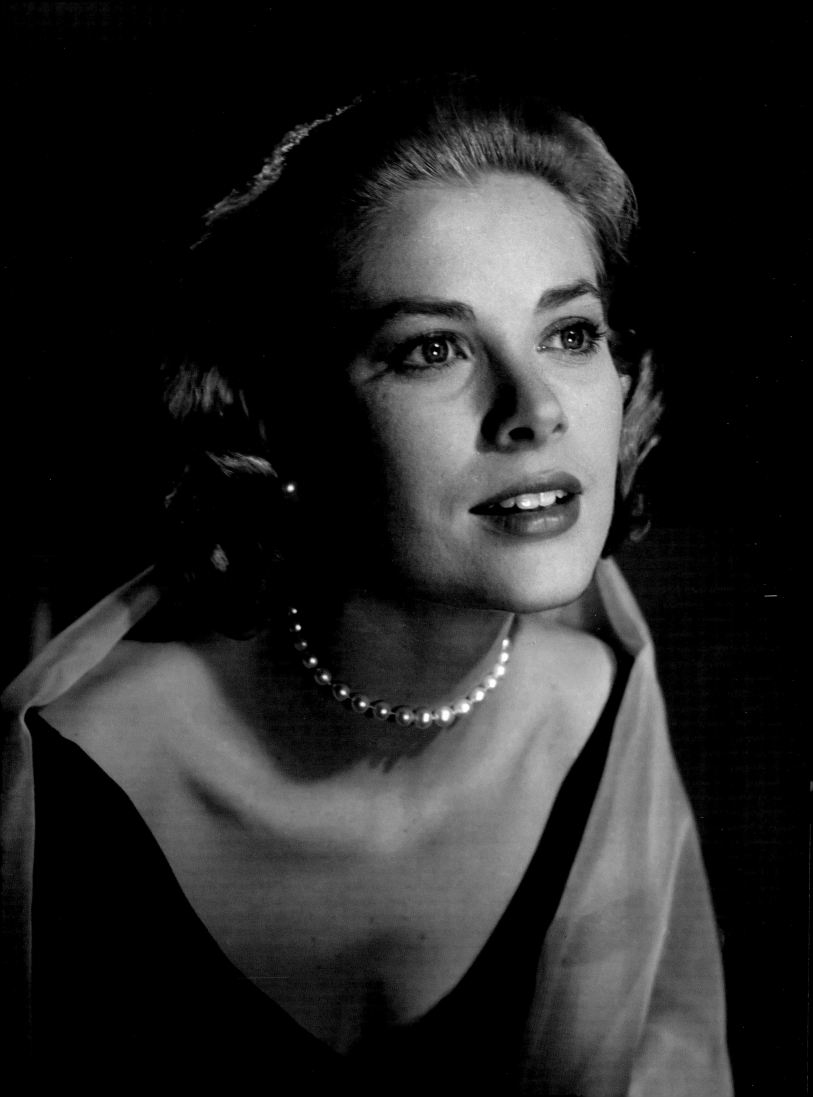

# REAR WINDOW

## 1954

Grace's first love—the New York stage—tempted her again in the fall of 1953. Jean Dalrymple, a guiding force behind New York City Center, was mounting a production of *Cyrano de Bergerac*, with Jose Ferrer reprising the title role that had won him acclaim on Broadway. Ferrer was not convinced that Grace had the theatrical experience needed for the role of Roxanne. Unfortunately, on the day of the audition, Grace had a bad cold and lost her voice, confirming Ferrer's suspicions that she was "an amateur." Ferrer cast Arlene Dahl as his Roxanne.

"I wanted her, not because of her great acting ability, but because of that discipline she appeared to have," Dalrymple said later. "And when she didn't get it, there were mentions of it in the columns . . . she was really very, very distressed. She picked herself up and went on."

But the camera loved Grace Kelly more than any stage could. Back in Hollywood, Grace's destiny was lying in wait; her work in the certified box-office hit *Dial M for Murder* resulted in two tantalizing offers. Though Grace had always been Hitchcock's first choice for the costarring role of Lisa Fremont in *Rear Window*, because of negotiations to borrow her from MGM, he could not offer her the role until nearly the start of production. Meanwhile, Elia Kazan offered her the part of Edie Doyle in *On the Waterfront* (1954), playing opposite Marlon Brando. For Grace, it was a showdown between two prestigious projects.

As soon as Hitchcock dispatched a script to her, Grace made the decision: she turned down Kazan to work with the master of suspense on *Rear Window*. The actress and the director would not only mutually benefit from the project, they would make history together.

Veteran screen star James Stewart was signed early,

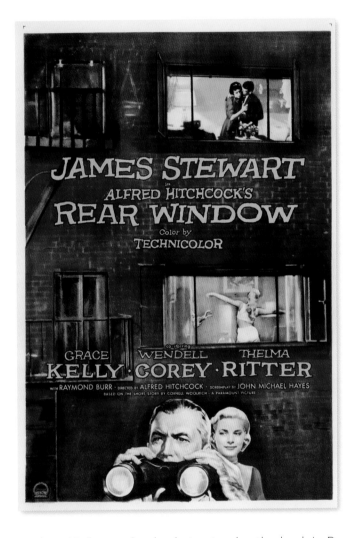

Hitchcock's first and only choice to play the lead, L. B. Jefferies, known as Jeff. Wendell Corey, who was already under contract to Paramount, was cast as the detective. Thelma Ritter was borrowed from Twentieth Century Fox to play the nurse. After Stewart, Ritter was the highest-paid member of the cast, earning $4,167 a week. MGM was paid $2,857 per week for Grace's services.

The role of the bored, wheelchair-bound photographer was perfect for the likable Stewart. Filmgoers must identify with Jeff, the everyman, as he peers into the win-

**OPPOSITE** Grace films the famous slow-motion-kiss close-up.   **ABOVE** The American poster.

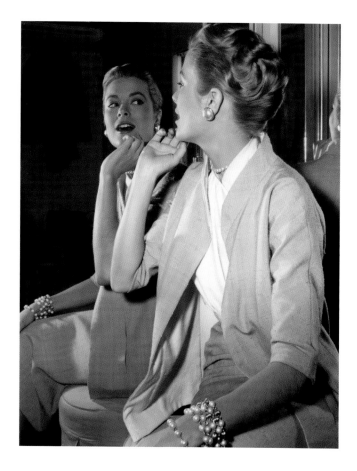

dows of the tenants in the apartment building behind his. His beautiful girlfriend, Lisa, is a key ingredient to soften and glamorize Jeff, and to enliven what could have been a set-bound thriller confined to a small apartment. When, while spying through the zoom lens of his camera, Jeff suspects that his neighbor Lars Thorwald (Raymond Burr) has murdered his wife, Lisa and Stella (Ritter) become Stewart's allies in catching the killer.

*Rear Window* began its journey as the story "It Had to Be Murder" by Cornell Woolrich (writing under the pen name William Irish), published first in the February 1942 issue of *Dime Detective* magazine. The story was republished in an anthology called *After-Dinner Story* in 1944. In 1945, B. G. De Sylva Productions purchased the rights for $9,250.

When producer Buddy De Sylva died in 1950, the rights were sold to agent and producer Leland Hayward and Broadway playwright Joshua Logan. Logan wrote the first treatment for *Rear Window* in 1952, and in April 1953, Hayward sent the treatment to his agent, Lew Wasserman. Wasserman, who also represented actor James Stewart, happened to be in the middle of negotiating a multi-

picture deal with Paramount for another of his clients, Alfred Hitchcock. Stewart and Hitchcock had wanted to work together again since collaborating on the film *Rope* (1948), and quickly latched onto *Rear Window* as their dream project. Together they formed a production company called Patron Inc. and bought the story rights from Hayward and Logan.

Screenwriter John Michael Hayes had met Hitchcock on the set of *Dial M for Murder*, where Hayes impressed the director enough to earn a shot at penning *Rear Window*. Hitchcock and Hayes read Logan's original treatment carefully, deciding what could be used and what needed revising. Hitchcock knew Grace would be his leading lady before a page of *Rear Window* was written. He told Hayes that Kelly "has a lot of charm and talent. But she goes throughout the motions as if she is in acting school. She does everything properly and pleasantly, but nothing comes out of her. You've got to bring something out of her. Bring her to life."

Hayes submitted his seventy-six-page treatment to Hitchcock in 1953. The final characters were complex, and not always likable. Confirmed bachelor Jeff could be cruel to Lisa, and she could be cunning and manipulative. Add to that Jeff's voyeurism (some might say Peeping Tomism) and Lisa's lack of moral qualms about breaking-and-entering, and a great deal of charm was required from the actors to keep the characters sympathetic. Hayes's abundant humor and snappy dialogue helped the audience to identify with Jeff and Lisa, and to balance suspense with laughs.

While he was drafting the script, Hayes spent time with Grace in order to observe her personality, and incorporated his findings into the character of Lisa. Hitchcock changed Lisa's job from actress to fashion industry professional. He used his friend, cover model–turned–executive Anita Colby, as his basis for understanding Lisa. After a successful modeling career, Colby became a top advertising saleswoman for *Harper's Bazaar* before switching to a lucrative career in Hollywood. Hayes had a closer association on which to form Lisa's character: model Mel Lawrence, his wife. Lisa was fashioned "partly out of Grace Kelly and partly out of my wife," Hayes said. "I knew some of the patois of that business."

**ABOVE** Grace in her dressing room at Paramount.

One bit of business was borrowed directly from Grace's life. When Jay Kanter moved from Los Angeles to New York in the early 1950s, he occasionally took Grace to the 21 Club in Manhattan. "They had a great sauce that you could buy, and I used to send that to her on the set of *Mogambo* in Africa, with napkins from 21," Kanter remembered. "She always got a big kick out of it." It was the inspiration for Lisa having dinner from 21 sent up to Jeff in *Rear Window*.

Hitchcock based the *Rear Window* murder on two famous cases, including that of Dr. Hawley Crippen, who murdered his wife in London in 1910 and claimed that she had gone to California. Friends later became suspicious when he let his secretary, with whom he was having an affair, wear his wife's jewelry. The pair was nabbed trying to disembark from a cruise ship after escaping and masquerading as father and son. The second case was the grisly uxoricide of Patrick Mahon, who cut his wife's body into sections after murdering her in 1924.

The character of L. B. Jefferies was modeled partly on Hitchcock himself. "If Cary Grant was whom Hitchcock wished to be," wrote film historian Susan Hallock Pollack, "James Stewart was more how Hitchcock saw himself, a slightly shy adventurer with an insatiable curiosity."

"Jimmy Stewart's problem is that he doesn't want to marry Grace Kelly," Hitchcock later told François Truffaut. "Everything he sees across the way has a bearing on love and marriage. There is the lonely woman with no husband or lover, the newlyweds who make love all day long, the bachelor musician who drinks, the little dancer whom all the men are after, the childless couple who dote on their little dog, and, of course, the married couple who are always at each other's throat, until the wife's mysterious disappearance."

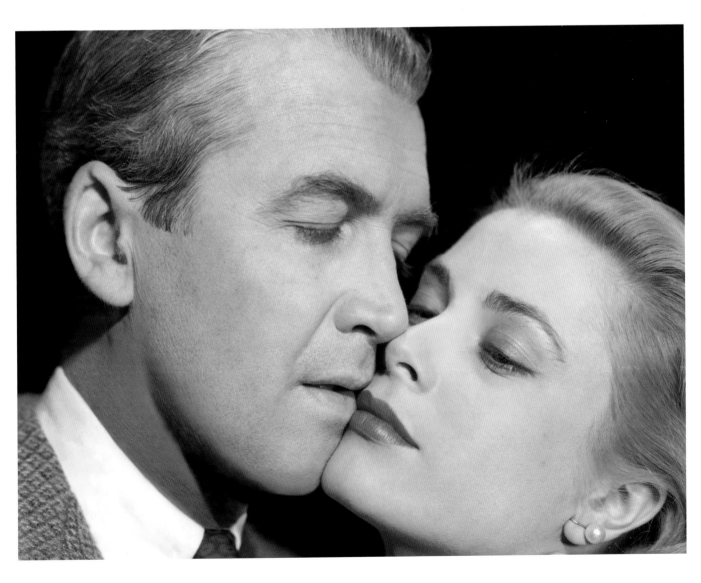

**ABOVE** James Stewart and Grace Kelly.

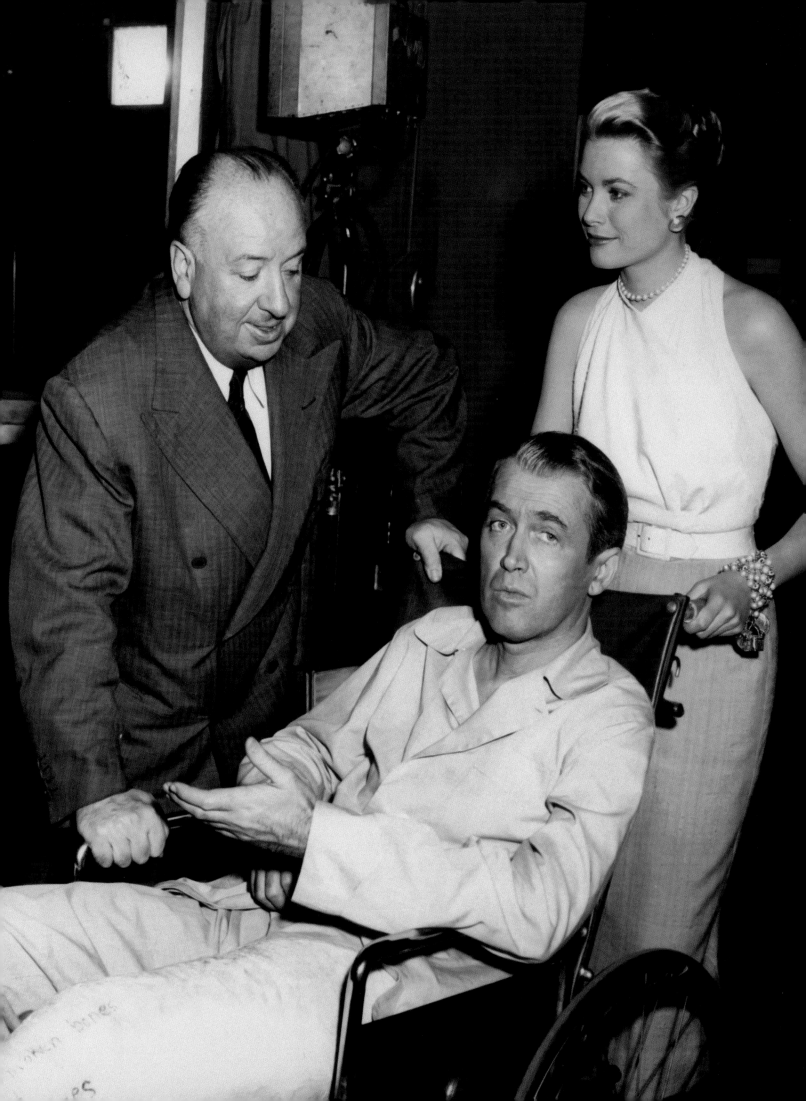

Construction began on the mammoth set on Paramount's stage 18 on October 12, 1953. Thirty-one apartments were built, eight of them (those directly across from Stewart's window) completely furnished. Fire escapes, roof gardens, an alley, a street, and a skyline were also added. The total cost was $192,087, which Paramount called the most expensive set ever built on the lot. Principal photography commenced on November 27, 1953.

When Grace Kelly first appears on the screen, she is introduced as an ominous shadow over Stewart's supine body. We see her move in for a slow-motion kiss, a kiss that has become one of Hitchcock's most iconic film moments. The intimate gesture served to quickly convey the couple's relationship to the audience. "I want to get the right important point without wasting any time," Hitchcock told Truffaut of the famous kiss. That one brief kiss took twenty-seven takes, with the cameraman slightly bumping the camera to achieve an effect of Jimmy Stewart being jarred awake. Stewart didn't mind the multiple attempts. Responding to a question about Grace Kelly's chilly demeanor, Stewart said, "If you've ever played a love scene with her, you'd know she's not cold." Stewart never hid his affection for working with Grace, saying later, "We were all so crazy about Grace Kelly. Everyone just sat around and waited for her to come in the morning, so we could just look at her, me included."

Edith Head designed Grace's stunning wardrobe. Head appreciated Hitchcock's clear idea of how the clothes would advance the story; his instruction was that Grace was to look like a piece of Dresden china, nearly untouchable. When the camera pulls back from Lisa's introduction, Hitchcock wanted the audience to know immediately that Lisa was a woman who came from wealth. "Right off the Paris plane" was how Lisa described her dress with a fitted black bodice featuring a deep off-the-shoulder V-neckline atop a full midcalf skirt, gathered and layered in chiffon tulle, with a spray bunch pattern on the hip.

In addition to looking more beautiful than she ever had on the screen, Grace was becoming a better actress under Hitchcock's direction. She worked hard to

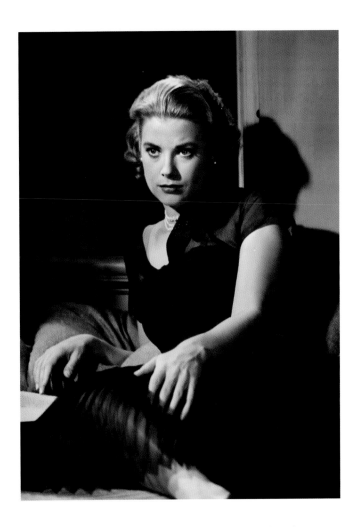

maintain her discipline and strictly follow the director's wishes. Hitchcock relied on multiple takes and cajoling Grace to get the performance he wanted from her. "She took everything so much in her stride," Jimmy Stewart recalled. "Nothing seemed to be too much for her."

In matters athletic, Grace was one step ahead of her director. Late in the film, Lisa climbs a fire escape and deftly creeps into Thorwald's apartment. "Hitchcock said to Grace, 'Now, you're going to have to go across and get into the room,'" Stewart remembered. "And Grace, without any direction, she just went over, climbed up the fire escape, climbed in one of the windows and sneaked into the door and then looked over across the way to Hitchcock and said 'Is that what you mean?' Well, everybody applauded, and she deserved it because this was exactly what Alfred Hitchcock wanted. She seemed to know the movements before Hitchcock had anything to say about it. I think Hitchcock liked that. I think everybody liked it."

In the end, Lisa's single-mindedness wins her

**OPPOSITE** Alfred Hitchcock directs his two amateur sleuths.   **ABOVE** Lisa (Kelly) confronts Jeff about his paranoia.

the man she loves. Though she offers to adapt to his photographer-on-the-go lifestyle, at the film's conclusion Jeff is the one literally unable to move, grounded more firmly than he was at the beginning of the story. And she has not changed at all. Lisa's objective, the firm goal in sight, is the brass (or gold) ring that will marry them. The sly plot point of her retrieving just such a wedding band from Thorwald is ironic symbolism. She climbs determinedly and heedlessly over an obstacle course to get that elusive ring. No, it's not her own, but it is a clever device reflecting Lisa's motivations as a character.

When principal photography finished on January 13, 1954, the shoot was fifteen days behind schedule. But

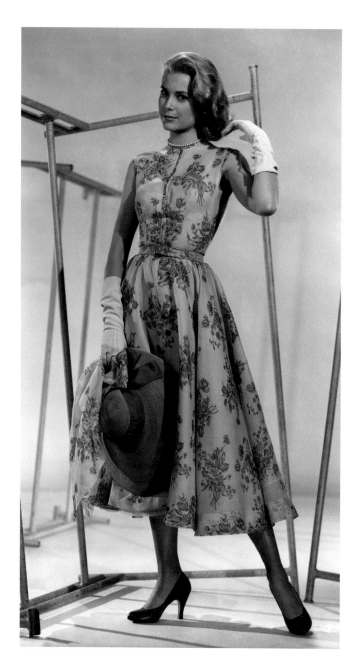

the end result was well worth it. *Rear Window* grossed $5.3 million in its initial release, making it the fifth-highest-grossing film of 1954 (coming in behind *White Christmas*, *The Caine Mutiny*, *The Glenn Miller Story*, and *The Egyptian*).

The film won several awards for achievement from the press, including *Film Daily* and *Look* magazines. But it was the public's reaction that thrilled Hitchcock the most. "I happened to be sitting next to Joseph Cotten's wife at the premiere of *Rear Window*," Hitchcock later recalled. "And during the scene where Grace Kelly is going through the killer's room and he appears in the hall, she was so upset that she turned to her husband and whispered, 'Do something, do something!'"

If *Dial M for Murder* put Grace Kelly on the map, *Rear Window* made her a bona fide star. Released in September, only four months after *Dial M*, *Rear Window* was the second part of a one-two punch that landed Grace on magazine covers and set Hollywood abuzz. "'Wham' is the word that describes filmland's new blockbuster," Hedda Hopper wrote in her *Los Angeles Times* column, adding that Grace had the whole town "in a tizzy." In their *Rear Window* review, *Look* magazine noted that Grace "tosses off electric sparks of sex and glamour." By casting her as the overtly sensuous Lisa Fremont, Hitchcock transformed the seemingly cool, restrained Grace Kelly into a sex symbol.

Today, over half a century later, *Rear Window* remains one of the most popular movies of all time. Considered one of Hitchcock's best, the thriller continues to appear at the top of greatest-film lists. Countless online articles and websites discuss the film, the sizzling screen kiss, and Grace's iconic fashions.

With *Rear Window*, Hitchcock created just the right vehicle for the public to finally understand what Grace Kelly was capable of as an actress. "As a movie director," Hitchcock said, "I have found that an actress with the quality of elegance can easily go down the scale to portray less exalted roles. But an actress without elegance, however competent she may be, can hardly go up the scale. . . . She lacks the range as an actress because she lacks the range as a person. A woman of elegance, on the other hand, will never cease to surprise you."

**ABOVE** Hitchcock wanted an ultrafeminine look for Grace in the climax of the film.

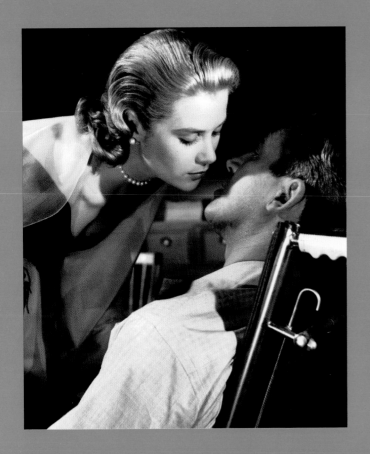

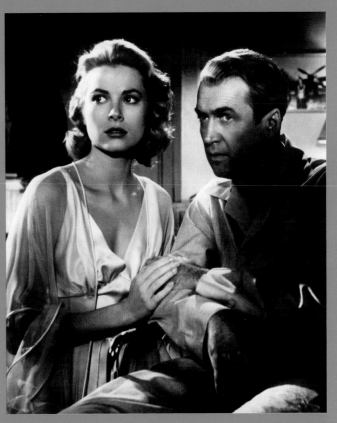

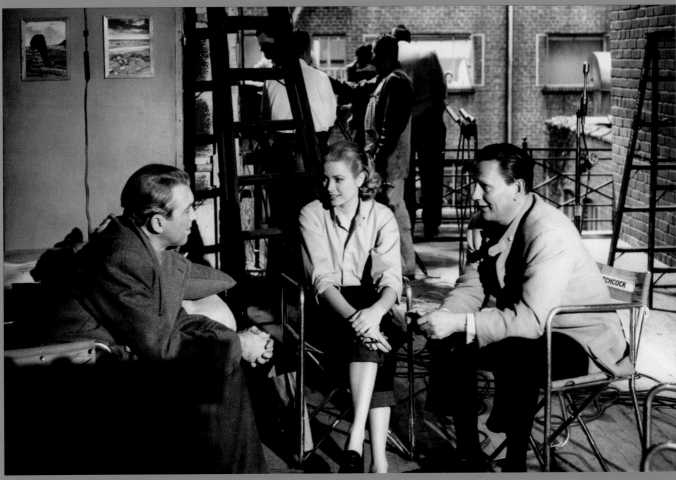

**TOP LEFT** Lisa (Kelly) greets a sleeping Jeff (Stewart). **TOP RIGHT** Screams from the courtyard startle the couple. **ABOVE** (left to right) James Stewart, Grace Kelly, and Wendell Corey on the apartment set. **OVERLEAF** Jeff's conflicted feelings about his relationship with Lisa may be causing him to believe his neighbor is a murderer.

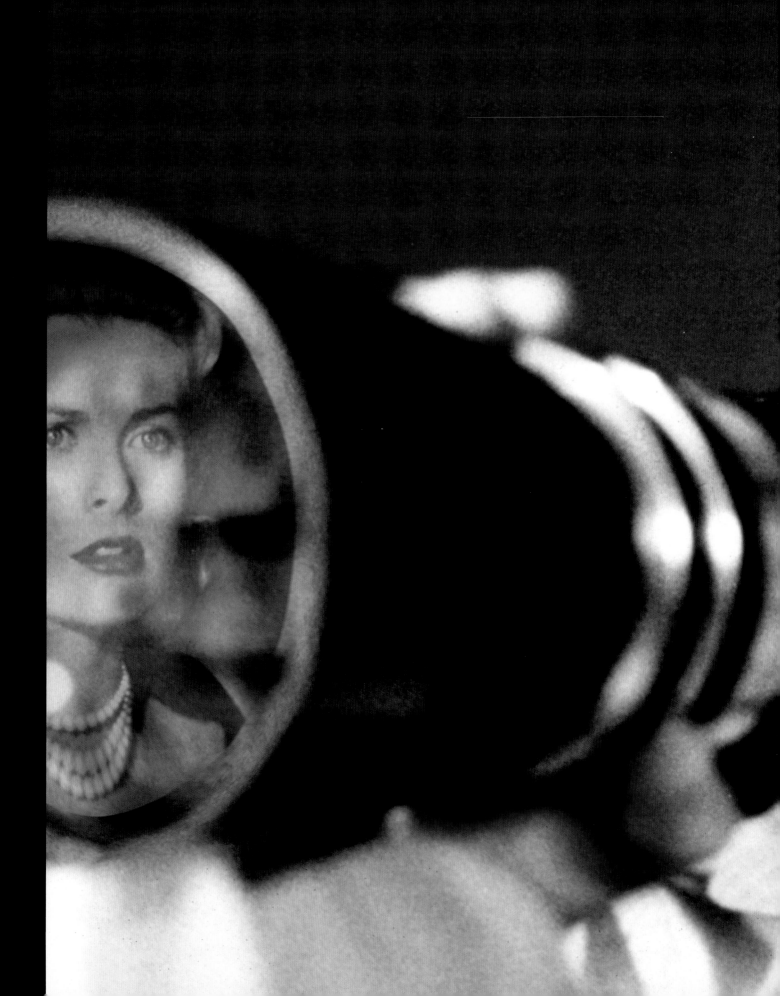

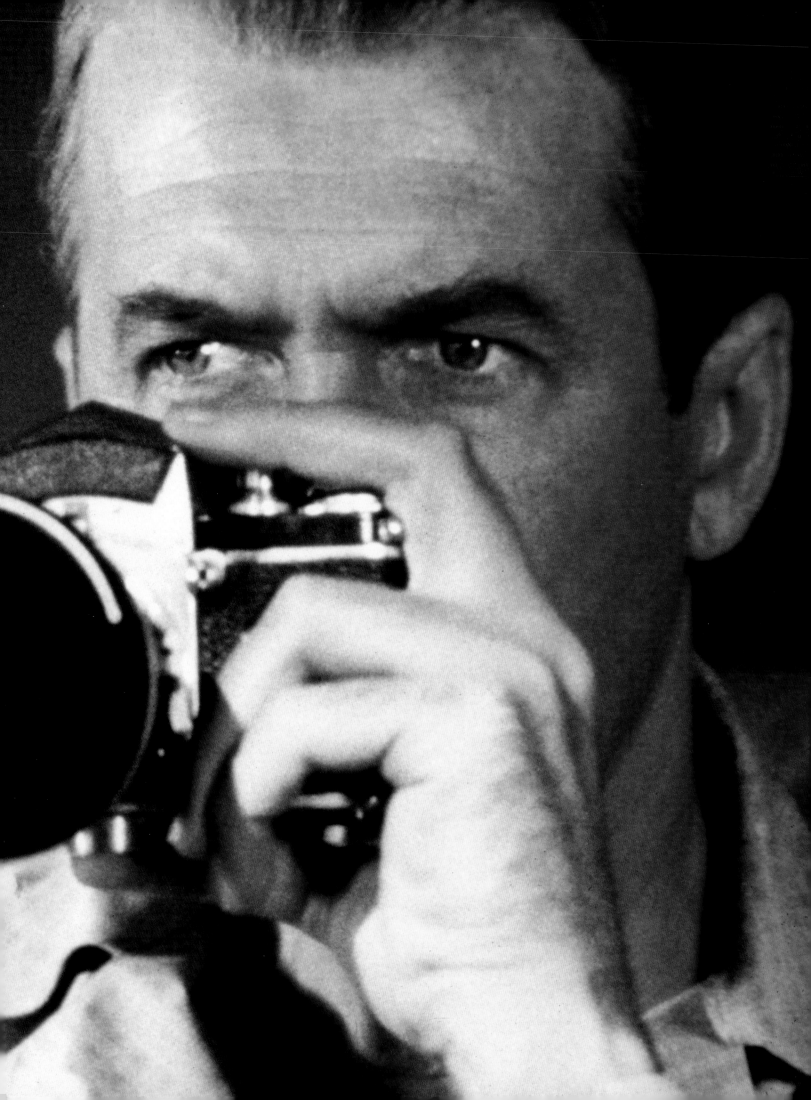

TOP Grace signs a production souvenir as a member of the "cast." ABOVE Grace gets a makeup touch-up. OPPOSITE Grace in the "preview of coming attractions" nightgown. OVERLEAF A proof sheet shows Lisa serving Jeff dinner and discussing their relationship.

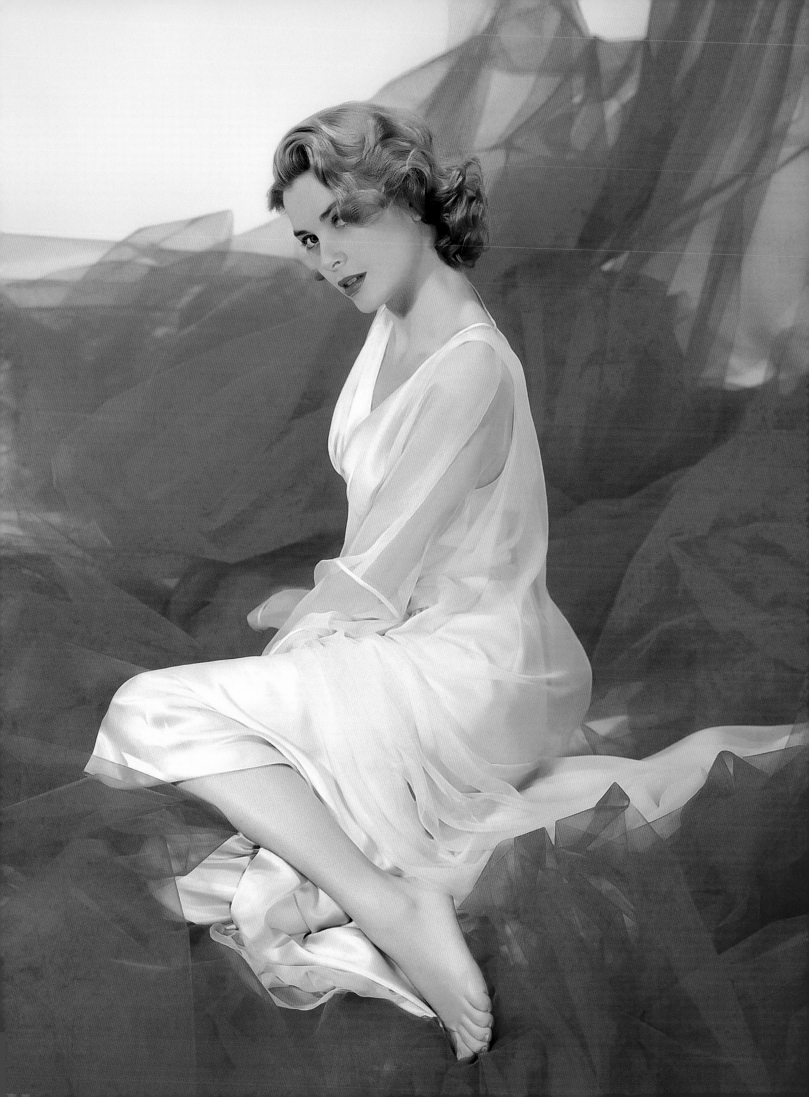

*Rear Window*

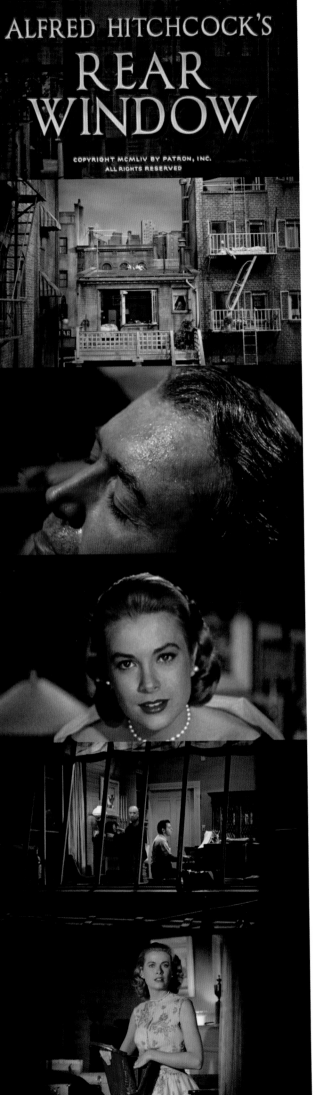

"Grace, without any direction, she just went over, climbed up the fire escape, climbed in one of the windows and sneaked into the door and then looked over across the way to Hitchcock and said 'Is that what you mean?'… She seemed to know the movements before Hitchcock had anything to say about it."

JIMMY STEWART

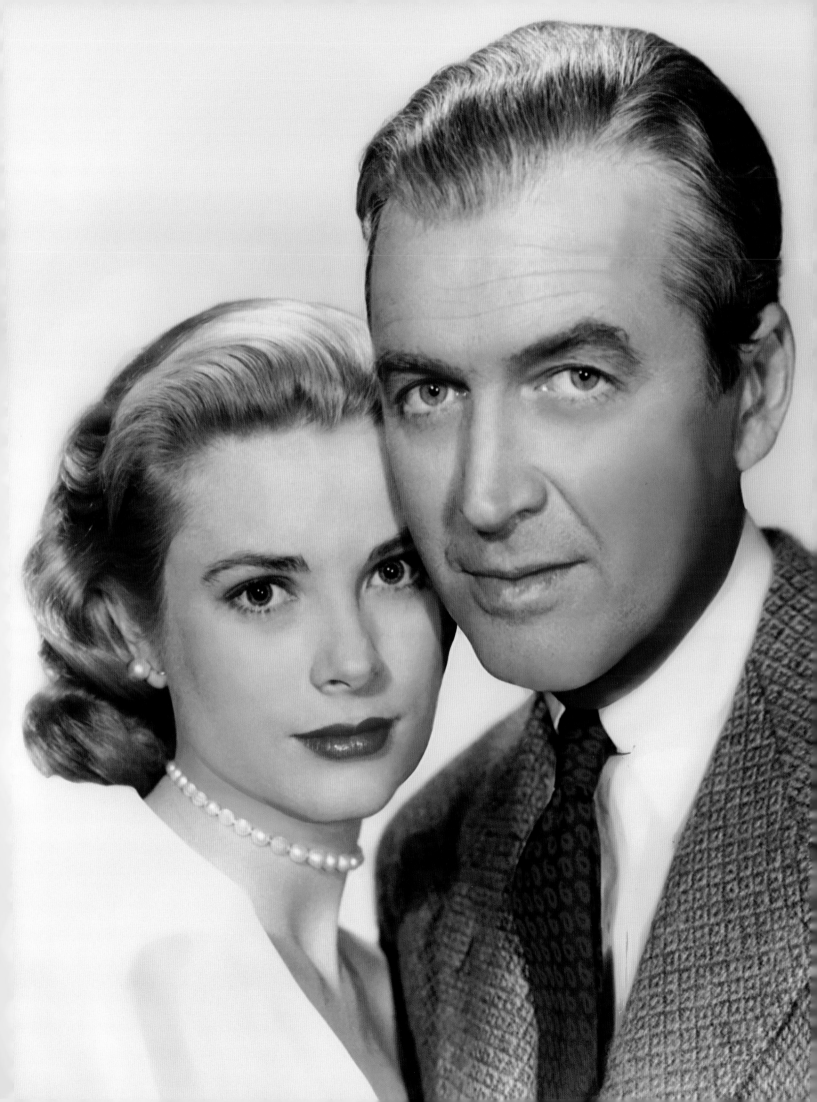

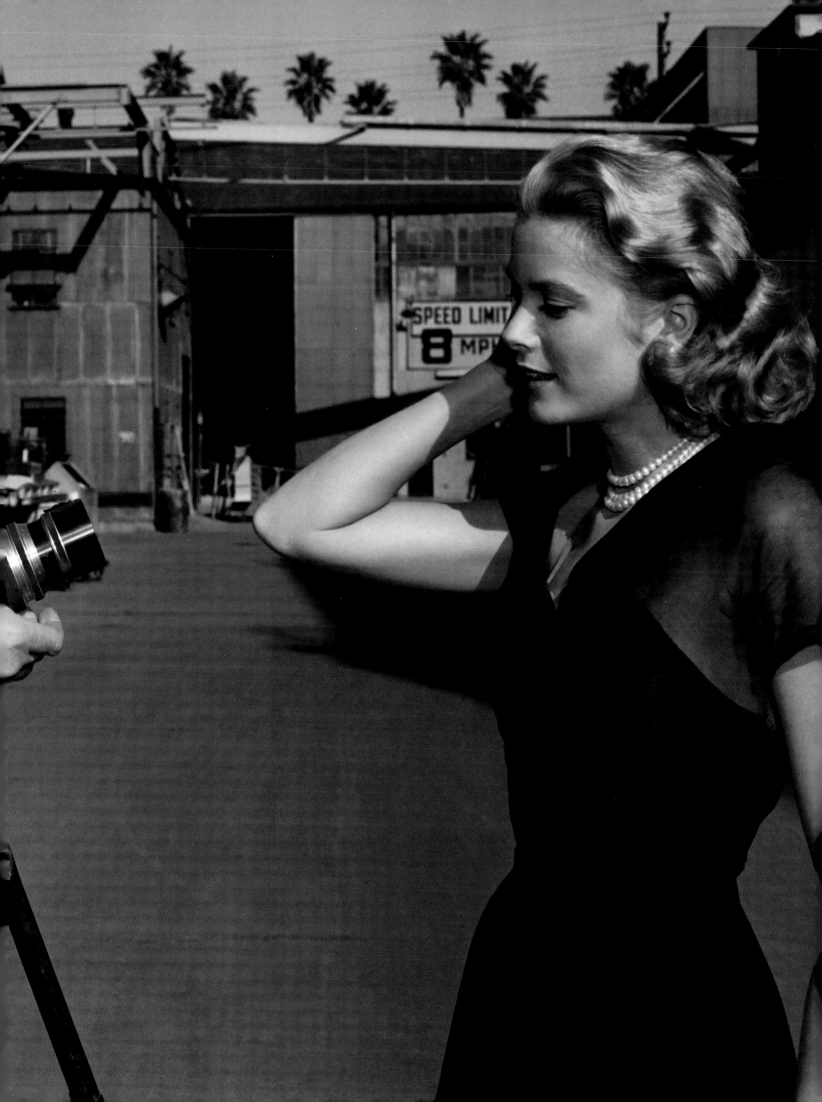

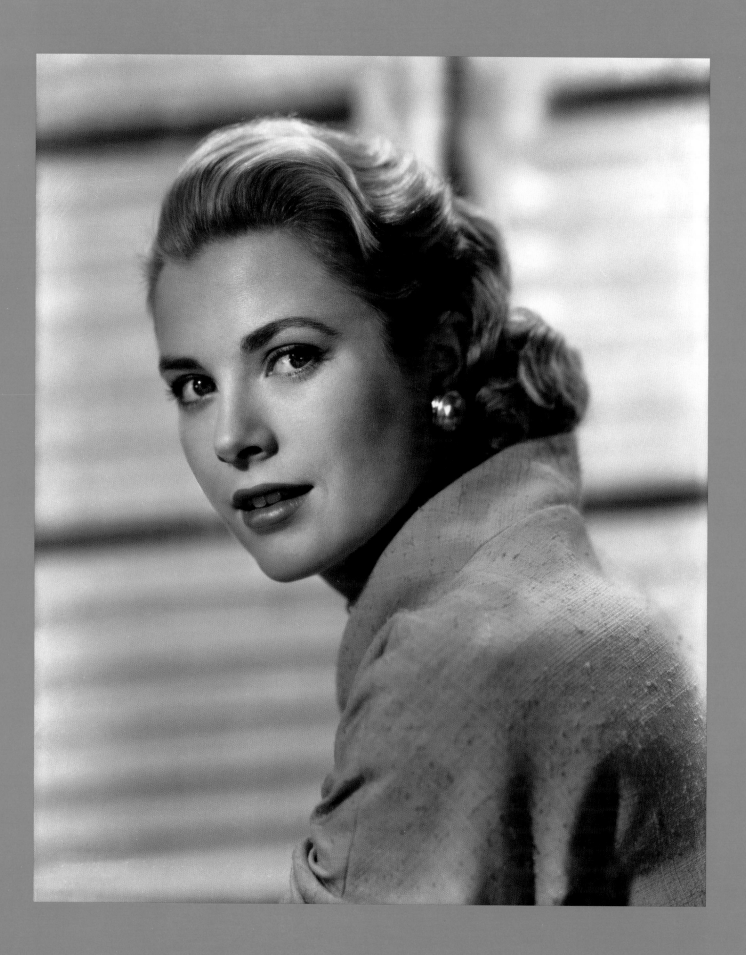

**ABOVE** Even when fighting crime, Lisa (Kelly) looks impeccable.

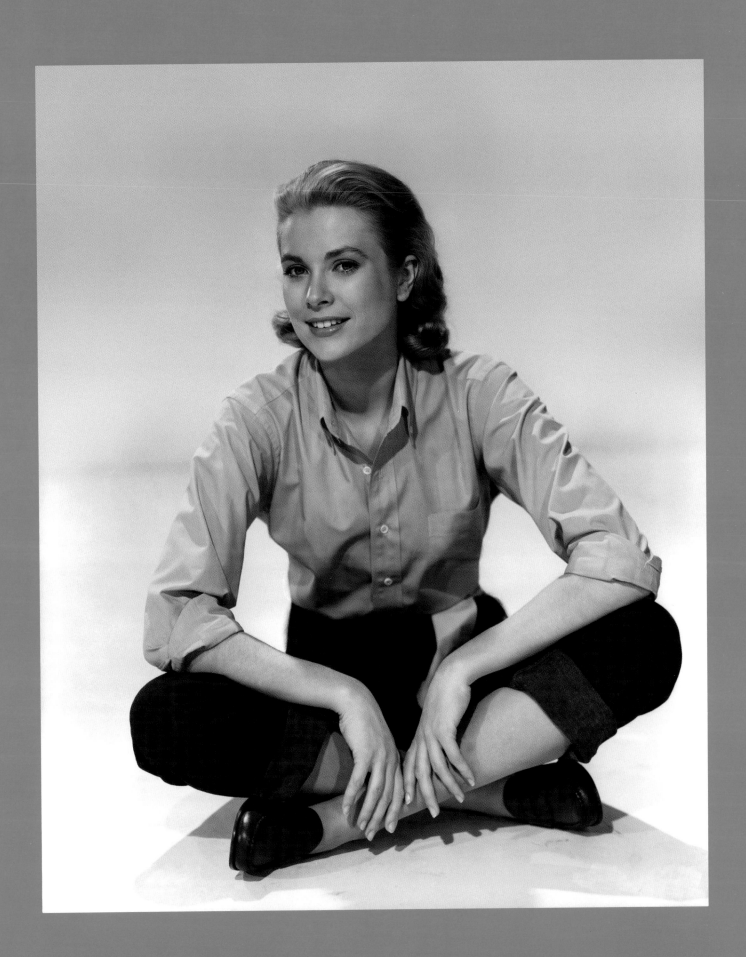

**ABOVE** Grace models a sporty look for Lisa.

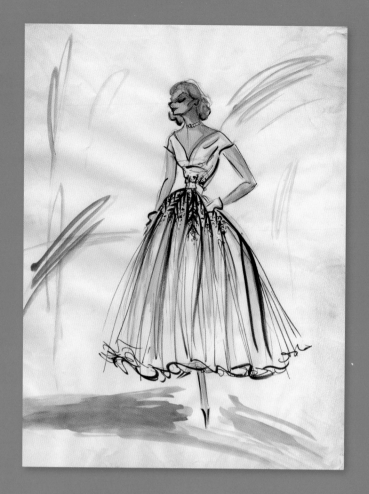

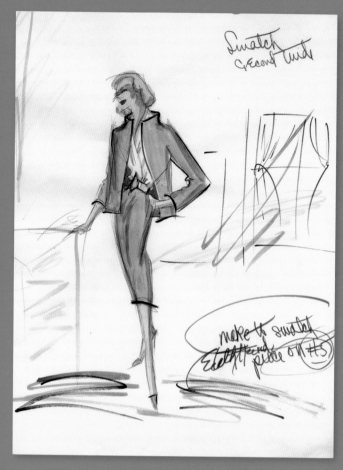

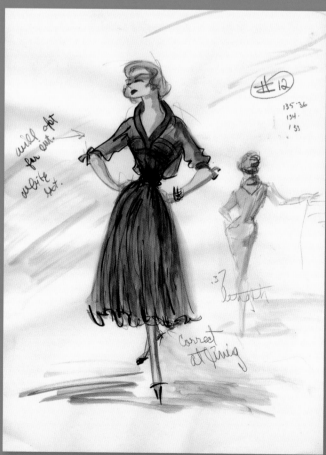

**ABOVE** Costume sketches by Edith Head's sketch artist Grace Sprague.  **OPPOSITE** Grace models the eau de Nil suit designed by Edith Head.

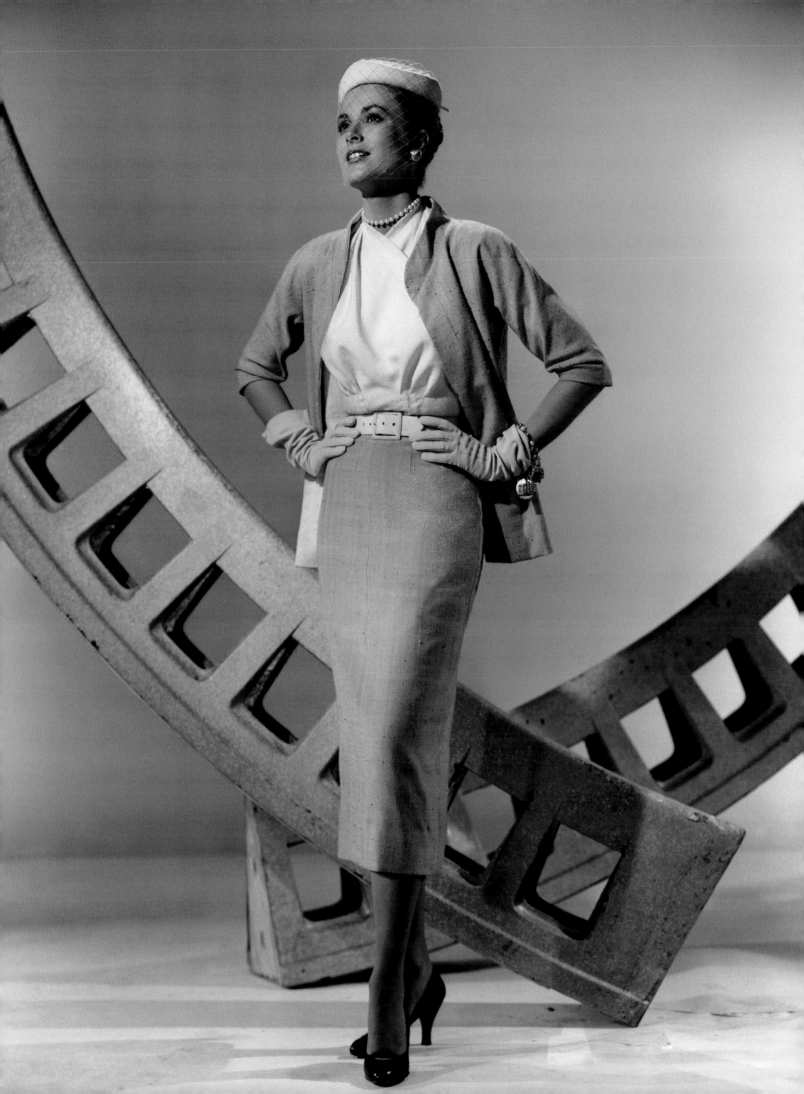

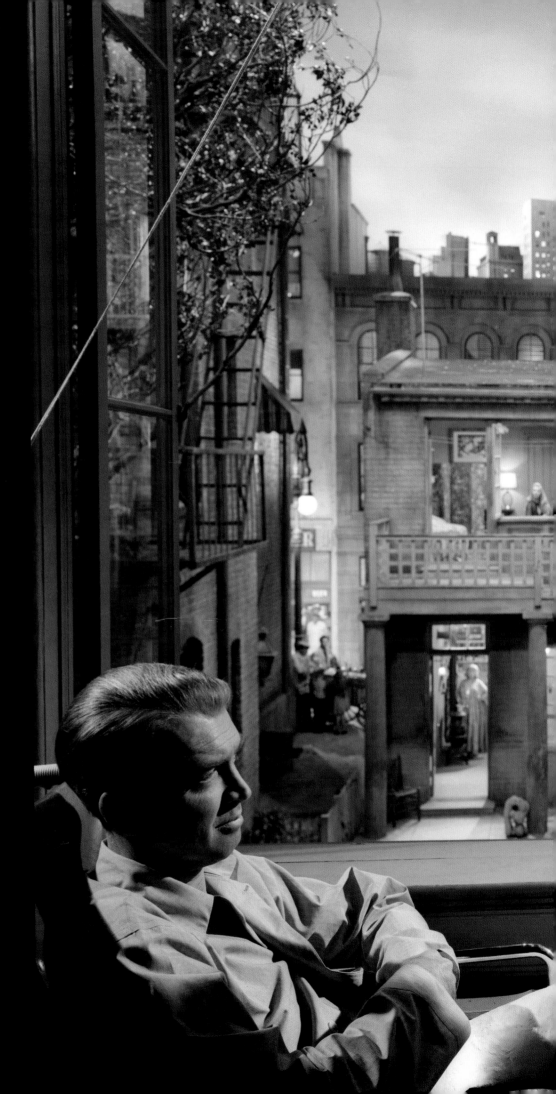

RIGHT (left to right) Jimmy Stewart, Grace, and Alfred Hitchcock overlook the expansive courtyard apartment set built inside a soundstage at Paramount.

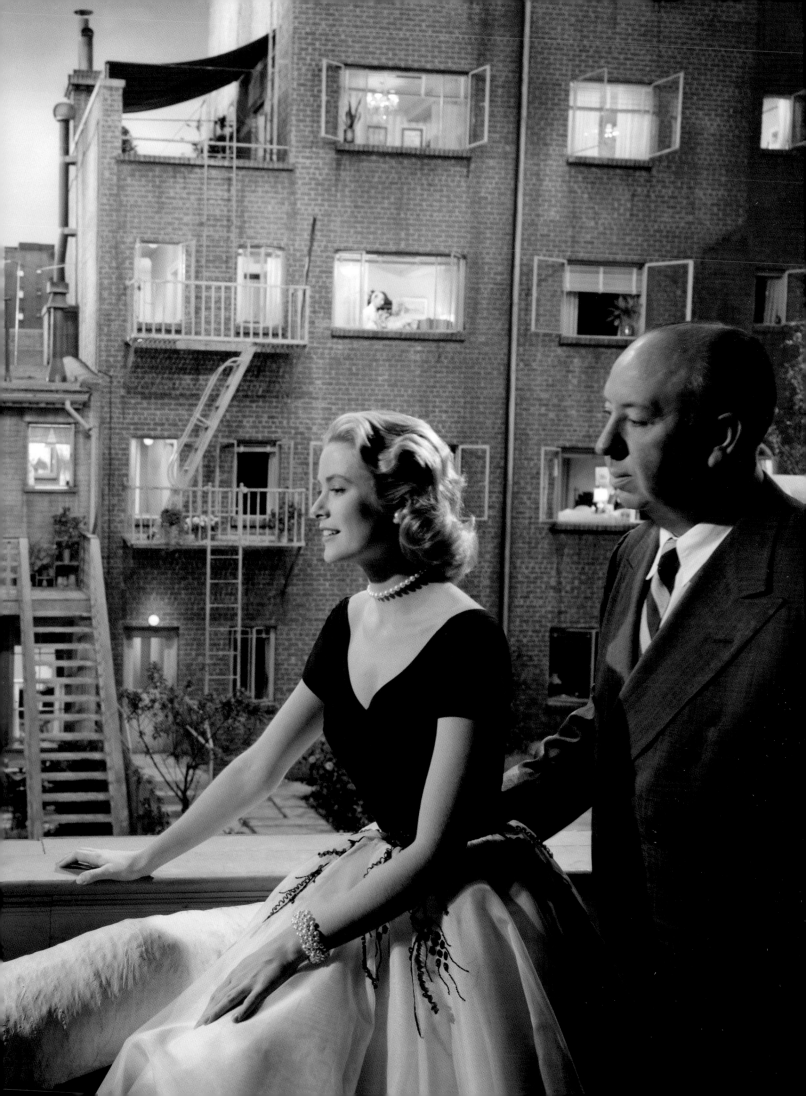

**LEFT** A rerelease poster traded on
terror inspired by Hitchcock's *Ps*
**BELOW AND BOTTOM** A press badge and
ticket for the premiere of the film

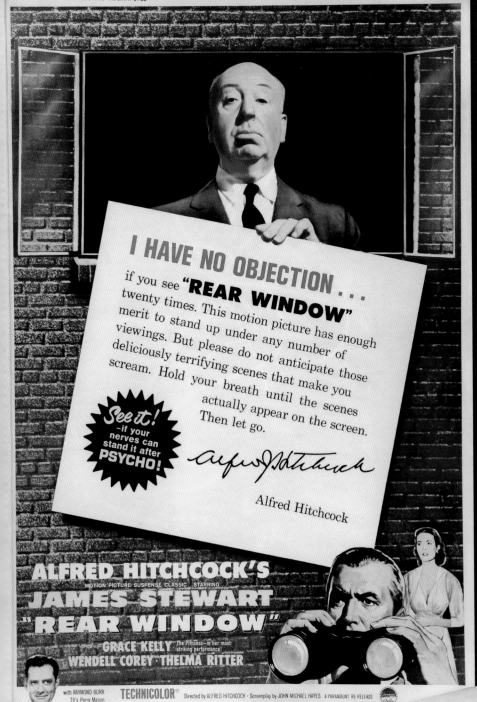

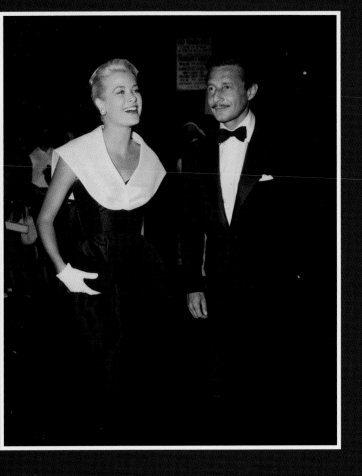

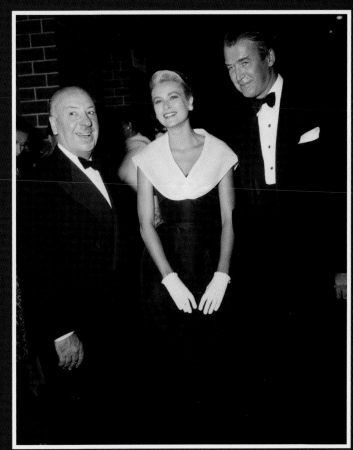

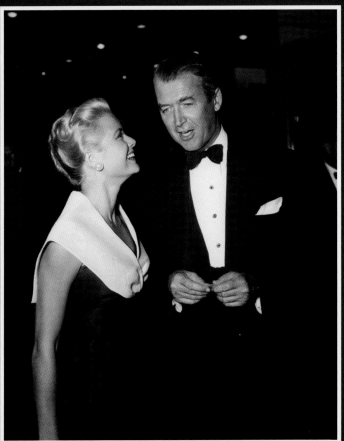

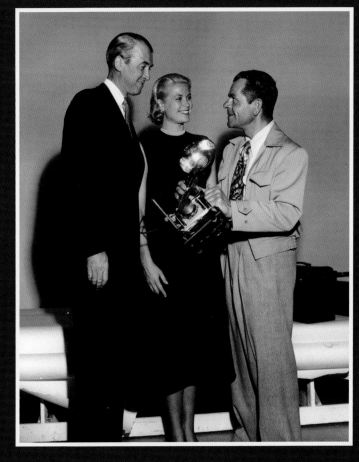

**TOP LEFT** Grace arrives at the premiere with date Oleg Cassini. **TOP RIGHT** Grace is flanked by Hitchcock (left) and Stewart (right) at the premiere. **BOTTOM LEFT** Stewart and Grace at the premiere. **BOTTOM RIGHT** Newspaper coverage of the film was assured when a

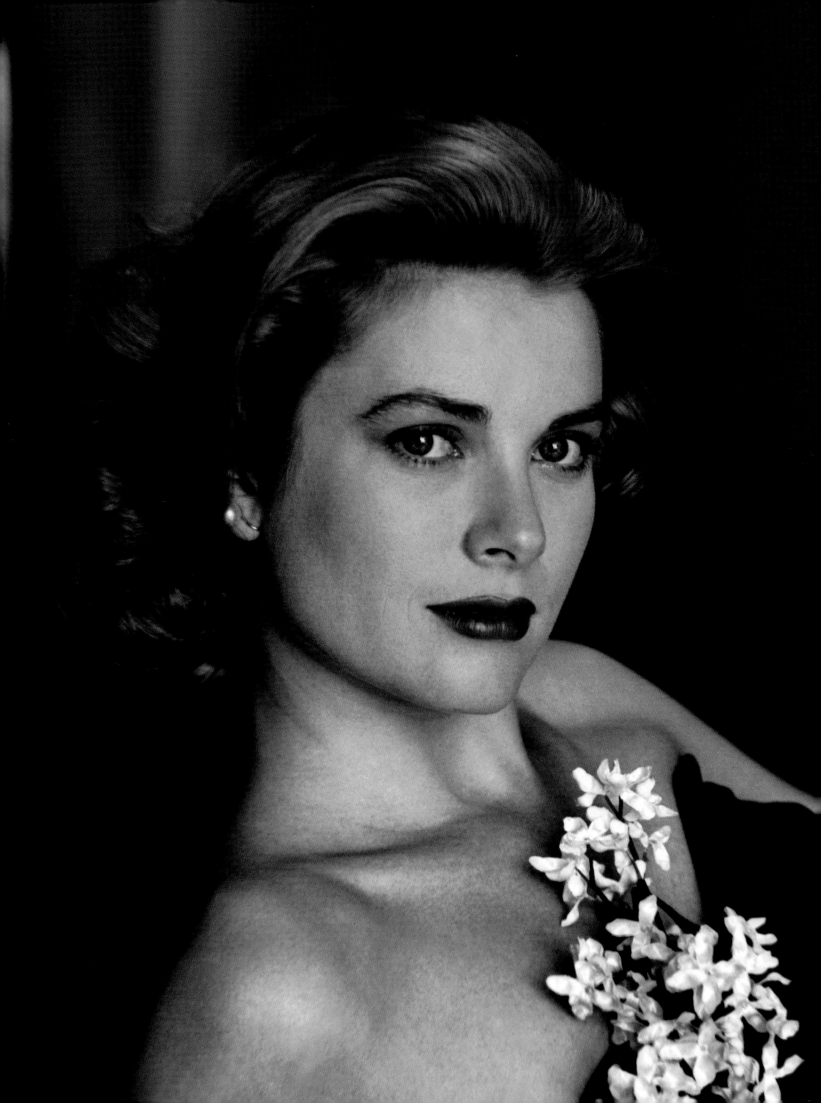

"SENSATIONALLY GOOD" —FILM DAILY

"HITCHCOCK'S BEST" —M.P. DAILY

The most UNUSUAL and INTIMATE journey into human emotions ever filmed...revealing the privacy of a dozen lives!

THE STRANGERS —Unknown... until a little dog plunged them into the spotlight of terror!

THE HONEYMOONERS — Too happy to see the terror that lurked!

MISS TORSO— Hot nights or cold, her shades were never drawn!

YOU won't be able to tear your eyes away from this window!

MISS LONELYHEARTS — Ready to risk anything for one last desperate fling!

JAMES STEWART
in
ALFRED HITCHCOCK'S
REAR WINDOW
Color by TECHNICOLOR
co-starring
GRACE KELLY · WENDELL COREY · THELMA RITTER
with RAYMOND BURR · Directed by ALFRED HITCHCOCK · Screenplay by JOHN MICHAEL HAYES
BASED ON THE SHORT STORY BY CORNELL WOOLRICH · A PARAMOUNT PICTURE

MAT 501

# PUBLICITY

# ALFRED HITCHCOCK'S 'REAR WINDOW' HAILED MASTERPIECE OF SPINE-CHILLING SUSPENSE

## SYNOPSIS
*(Not for publication)*

L. B. Jeffries (James Stewart) is a news magazine photographer, confined to a wheelchair because of a broken leg. The chair is placed at the rear window of his Greenwich Village apartment and, from this vantage point, Jeff gazes idly at the occupants of the apartments facing the courtyard. Since it is summer time and the windows are open, Jeff sees perhaps more than he should. Within a period of three days and nights Jeff is certain that one of his neighbors, a jewelry salesman, Lars Thorwald (Raymond Burr), has murdered his wife, sliced up her body and disposed of it in a flower plot in the courtyard. Although evidence he has gathered points to a correct summation on his part, Jeff has difficulty convincing those close to him that he is right. Lisa Fremont (Grace Kelly), his beautiful fiancee, would rather set their wedding date than become involved in solving a murder. His nurse (Thelma Ritter) prefers that he concentrate on getting out of the plaster cast, and Thomas J. Doyle (Wendell Corey), his detective friend, thinks Jeff's imagination is playing tricks.

As Jeff's suspicions mount, his neighbors continue their various ways of life. A musician (Ross Bagdasarian) is putting together a composition, but not without setbacks and several rousing parties. A curvaceous dancer, whom Jeff has named "Miss Torso" (Georgine Darcy), dances her provocative routines. A woman and her husband (Sara Berner and Frank Cady), who sleep on the fire escape, lower their little dog every morning from their fifth-floor apartment to the courtyard below. Then there's "Miss Lonely Hearts" (Judith Evelyn), a lonely spinster, who contemplates suicide, and "Mr. and Mrs. Honeymooners" (Rand Harper and Havis Davenport), who remain hidden in their apartment for a few days.

Suddenly, there's a scream! The little dog, belonging to the "fire escape" couple, has sniffed around the flower plot once too often and is found dead! This corroborates Jeff's suspicions further, and now Lisa takes it upon herself to go to Thorwald's apartment to look for clues. She finds incriminating evidence, but is caught in the act by Thorwald. After being almost mauled to death by the suspected murderer she permits herself to be arrested for burglary when the police finally arrive.

Thorwald traces Lisa's invasion of his home to Jeff, and goes after him viciously. Because of his broken leg, Jeff has a terrible time trying to protect himself. He is hanging from the ledge of his window when Doyle arrives and picks Thorwald off with his revolver.

Having been unable to keep his grasp on the ledge, Jeff has fallen and broken his other leg, but this time his confinement is more pleasant because Lisa is on hand to keep him company as his wife.

## CAST

| | |
|---|---|
| Jeff | JAMES STEWART |
| Lisa Fremont | GRACE KELLY |
| Thomas J. Doyle | WENDELL COREY |
| Stella | THELMA RITTER |
| Lars Thorwald | RAYMOND BURR |
| Miss Lonely Hearts | JUDITH EVELYN |
| Song Writer | ROSS BAGDASARIAN |
| Miss Torso | GEORGINE DARCY |
| Woman on Fire Escape | SARA BERNER |
| Fire Escape Man | FRANK CADY |
| Miss Sculptress | JESSLYN FAX |
| Honeymooner | RAND HARPER |
| Mrs. Thorwald | IRENE WINSTON |
| Newlywed | HAVIS DAVENPORT |

## CREDITS

Produced and Directed by Alfred Hitchcock; Screenplay by John Michael Hayes; Based on the short story by Cornell Woolrich; Color by Technicolor; Director of Photography—Robert Burks, A.S.C.; Technicolor Color Consultant—Richard Mueller; Art Direction—Hal Pereira and Joseph MacMillan Johnson; Special Photographic Effects—John P. Fulton, A.S.C.; Set Decoration—Sam Comer and Ray Moyer; Assistant Director—Herbert Coleman; Edited by George Tomasini; Costumes—Edith Head; Technical Advisor—Bob Landry; Makeup Supervision—Wally Westmore; Sound Recording by Harry Lindgren and John Cope; Music Score by Franz Waxman; Western Electric Recording.

**Running Time: 112 Minutes**

## They Saw Too Much . . .

*Mat 2D*

A murderer is being watched by James Stewart, Grace Kelly and Thelma Ritter in this absorbing, suspense-filled scene from Paramount's brand new Alfred Hitchcock thriller, "Rear Window," which is due to open next ................ at the ................ Theatre. Co-starring Wendell Corey with Raymond Burr, the Technicolor film is set against the background of New York's fabled Greenwich Village.

•

## James Stewart Tops Big Cast In Hitchcock's 'Rear Window'
*(Day Before Opening)*

The man who can take an everyday situation and turn it into a sinister episode of dread and suspense is at it again. The man, of course, is famed motion picture producer-director, Alfred Hitchcock and his latest venture into chill-filled celluloid is Paramount's Technicolor mystery thriller, "Rear Window," which is due to open next .......... at the .......... Theatre.

Starring James Stewart and co-starring Grace Kelly, Wendell Corey, and Thelma Ritter with Raymond Burr, the film is reportedly the best Hitchcock ever. Set against a background of New York's famed Greenwich Village, "Rear Window," starts off placidly enough by introducing the audience to Mr. Stewart, a world-renowned news photographer who is confined to a wheelchair with a broken leg which he suffered during the performance of his dangerous duties.

Jimmy has nothing in the world to do but wile away his time in his Village apartment until his leg heals. He is visited by the insurance company nurse, Thelma Ritter, and by his beautiful career-minded girl friend, Grace Kelly. Between these visitations Mr. Stewart idly gazes out of his window at his neighbors.

One dark night he sees what he believes to be a murder. It is then that the suspense mounts, with teeth-chattering terror fashioned in the inimitable Hitchcock manner. It reaches a crescendo pitch that rivals anything that has ever been flashed on a motion picture screen.

The heart-stopping adventure that is served up in "Rear Window" has been met by advance audiences with all of the superlatives in the book. The Hitchcock-inspired acting of the principals and the dynamic flow of excitement and humor that the master of suspense has so art-fully placed in the film has also been roundly applauded.

Written for the screen by John Michael Hayes, "Rear Window" emerges as a spine-tingling film that affords the utmost in motion picture suspense entertainment. It is eagerly awaited film-fare.

## Hitchcock's 'Rear Window' Next Big Attraction

A shrill scream shatters the stillness of the night. The sound of breaking glass and then silence. A black cat creeps silently in the courtyard below. A man with a broken leg, confined to a wheel chair with nothing to do all day but gaze out of his window at his neighbors, has reason to believe that a murder has been committed. This is the suspense-filled story line of Paramount's brand new Alfred Hitchcock thriller, "Rear Window," which is due to open next ........ at the .......... Theatre.

Starring James Stewart and co-starring Grace Kelly, Wendell Corey and Thelma Ritter with Raymond Burr, the spine-tingling tale is set against New York's fabled Greenwich Village. Photographed in color by Technicolor, "Rear Window" was written for the screen by John Michael Hayes from a story by Cornell Woolrich. Suspense-master Alfred Hitchcock directed and produced the thrill-laden film.

*(First Story)*

The saying among those gentlemen who earn their living by making motion pictures is, "If it's a Hitchcock film it's got to be good." The suspense-master's latest film, "Rear Window," is not only good, its great. A Paramount picture in color by Technicolor, "Rear Window" stars James Stewart and co-stars Grace Kelly, Wendell Corey and Thelma Ritter with Raymond Burr and it is due to open next ......... at the ........ Theatre.

Set against the colorful and exciting background of New York's famous Greenwich Village, the thrill-filled film concerns Jimmy Stewart as a photographer who is confined to his apartment due to a broken leg from a recent assignment. Throughout the entire picture he is confined to his wheel chair which is placed near the rear window of his Greenwich Village apartment. From this vantage point and with little else to do he gazes idly at the neighboring apartments and their diverse occupants.

It is then, with heart-throbbing abruptness, that Mr. Stewart becomes a witness to what he believes to be a murder. He is met with the task of convincing first, his career-girl fiancee, lovely Grace Kelly, his war-time buddy, now a detective, Wendell Corey and the insurance nurse, Thelma Ritter, that what he thought he saw actually was.

A neat, tightly knit idea, indeed, and under the expert hands of Alfred Hitchcock, "Rear Window" emerges as what advance audiences acclaim to be the most suspenseful film ever flashed on a motion picture screen. Mr. Hitchcock has utilized his settings to their utmost by pinpointing the placid every day existences of the neighbors, who do not know that some grotesque deed has been perpetrated in their midst.

It is these neighbors who afford some interesting sidelights to the film. While Stewart is not gazing into the apartment in which he believes a murder has been committed he has his eyes on the other apartment dwellers. There are such oddly assorted characters as Miss Torso, the Composer, the couple on the fire escape, Miss Lonely Hearts, and the Newlyweds. Mr. Hitchcock probes these people's actions and the result is often humorous, often tragic. It is always exciting.

Written for the screen by John Michael Hayes, "Rear Window" marks another film success for the acknowledged master of suspense, Alfred Hitchcock. It is a picture that will be met with rare excitement.

*Still 10131-10*  *Mat 1B*

James Stewart and Grace Kelly provide the romantic interest in Paramount's brand new Alfred Hitchcock suspense thriller, "Rear Window," which is due to open next ........ at the ........ Theatre. Photographed in color by Technicolor, the thrill-filled film co-stars Thelma Ritter and Wendell Corey with Raymond Burr.

# 'REAR WINDOW' SMASH SUSPENSE THRILLER DRAMATIC PROOF OF HITCHCOCK'S GENIUS

*(Review)*

For sheer thrill worthiness and dramatic suspense, "Rear Window" the brand new Alfred Hitchcock Technicolor spine-tingler which opened yesterday at the ........ Theatre runs off with all the honors. Starring James Stewart and co-starring Grace Kelly, Wendell Corey and Thelma Ritter this Alfred Hitchcock-produced and directed piece of celluloid excitement races along with the speed of a jet.

Set against a background of New York's most intriguing neighborhood, Greenwich Village, "Rear Window" is peopled with just the kind of characters that you might expect to meet in such a place. There is James Stewart, as a famed photographer who is confined to his Village apartment with a broken leg; Grace Kelly, his career girl, fiancee; Wendell Corey, Stewart's wartime buddy, now a homicide detective; Thelma Ritter, a wise-cracking insurance company nurse; and Raymond Burr, an ominous looking neighbor.

As Stewart sits in his wheel chair all he has to do to kill time is stare out of his window at his neighbors. One dark night, while wiling away his time in just such a way he hears a scuffled scream, the sound of broken glass and then a foreboding silence that sends shivers up his spine. All the more that what has occurred has been a brutal murder and he suspects one of his neighbors to be the slayer.

The tension mounts as Jimmy gets closer and closer to the solution of the mystery and then, in a true Hitchcock climax, the issue is completely and irrevocably settled.

The overall acting of the principals is superb. The danger they find themselves in is uncannily transferred to the audience, the result being that each and every moment of the film spells a grim foreboding of present danger lurking in their midst. This feeling is a tremendous tribute to Mr. Hitchcock for his superb direction and deft handling of the John Michael Hayes script.

If there ever was one, "Rear Window" is a "must see" film. Do not miss it!

## 'Rear Window' Hitchcock's Best

Alfred Hitchcock, the famed creator of suspense-filled motion pictures, whose latest delving into spine-chilling celluloid, "Rear Window," is due to open next ........ at the ........ Theatre, has given the screen more memorable moments of thrill than any other man. Such of his hits as "The 39 Steps," "The Lady Vanishes," "Foreign Correspondent," "Lifeboat," "Spellbound," "Suspicion," and "Rope," will be remembered as long as there are motion pictures.

But certainly none will be more warmly recalled through the years than his newest screen achievement for Paramount, "Rear Window,"

the most suspenseful and intimate journey into human passions ever filmed. Seen in color by Technicolor, it is the story of James Stewart and lovely Grace Kelly, two people in deadly danger because, one night, they see too much through the rear window.

You will never forget their heart-stopping adventure and their Hitchcock-inspired performances . . . nor those of nurse Thelma Ritter and detective Wendell Corey as the two who tried to stop them from getting themselves involved. You will never forget Alfred Hitchcock's "Rear Window," as gripping and exciting a thriller as ever flashed upon a screen.

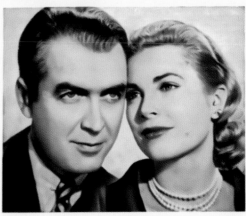
## Hitchcock's 'Rear Window' Tops In Tense, Taut Screen Thrills

*(Review)*

A creaking staircase at midnight. A shrill, blood-curdling scream that shatters the still air . . . the grim foreboding of a black cat silently creeping in a deserted courtyard . . . impending danger lurking in dark shadows. All of this is suspense at its most spine-tingling and all of this is Alfred Hitchcock's brand new Technicolor Paramount heart-stopper, "Rear Window," which had its pulse-pounding opening last night at the ........ Theatre.

Starring James Stewart and co-starring lovely Grace Kelly, Thelma Ritter and Wendell Corey with Raymond Burr, "Rear Window" is the most suspenseful and intimate journey into human passions ever filmed. The taut, tensely told tale is set against the colorful background of New York's colorful Greenwich Village and concerns James Stewart as a photographer with a broken leg confined to a wheel chair in his Village apartment.

While his shattered bones are healing he has nothing to do all day but watch his neighbors through his rear window. From this vantage point one dark night Mr. Stewart sees what he believes to be a hideous murder. When Jimmy attempts to convince his career-minded girl friend, Grace Kelly, the insurance nurse Thelma Ritter, or his old war-time buddy, now a detective, Wendell Corey, that what he thought he saw actually was, he is met with utter disbelief.

It is then Jimmy's rigorous duty to prove that a foul deed has been committed, find the murderer and convince his friends. In addition he has to do all of this from the confines of a wheel chair. What occurs from then on in is a feverish treat of thrills and excitement that has had no screen rival.

In the inimitable Hitchcock manner, "Rear Window" races from one unexpected event to another, ultimately reaching a crescendo that is literally nerve-shattering. The inspired acting of the principals reaches an incredibly realistic point, the result being that the audience is transported into the midst of the violent danger that is flashed on the screen.

As written for the screen by John Michael Hayes and superbly produced and directed by Alfred Hitchcock, "Rear Window" emerges not just as magnificent entertainment alone, but as an experience; an experience that will be warmly recalled for many years to come. The motion picture has reached a new high with the production of "Rear Window." Those who had a hand in its making deserve a warm round of applause.

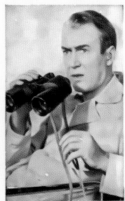
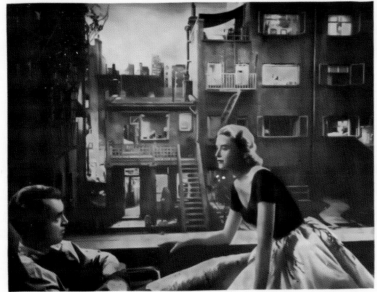

## Suspense Formula Pays Off Big For Alfred Hitchcock

There are not many people in this wise old world of ours who can resist the temptation of peeking through a lighted window, with blinds up, to see what's going on inside. Those who can stifle this almost reflexive impulse are either tremendously disciplined in etiquette or they are less than human.

Next to the instincts of self-survival and love, curiosity is perhaps the most compelling. Alfred Hitchcock, master of suspense, who has sent more tingles up more spines than any director in the business, capitalizes on this human instinct in his brand new Technicolor thriller, "Rear Window," the Paramount picture which is due to open next........at the ........ Theatre.

In "Rear Window," James Stewart portrays a photographer for a national picture magazine who is confined to a wheel chair with a broken leg for the entire film. With little else to do he wiles away his hours by gazing out of the rear window of his Greenwich Village apartment. What he sees is a courtyard below and the windows of more than thirty apartments opposite him and the occupants therein.

At first Jimmy's interest in his neighbors is merely rudimentary. Idly, he watches a composer struggle with a melody. He sees a thwarted spinster lady, designated as "Miss Lonely Hearts," attempt to get a man. He sees a voluptuous young dancer rehearse her grinds and gyrations while dressed in leotards. He calls her "Miss Torso." He sees many other neighborhood characters, distinguished by nothing much of anything.

There is one couple, however, that piques his interest. A jewelry salesman and his wife, a bed-ridden invalid, who spend most of their time in constant wrangling. Their quarrels grow in intensity as the story progresses. One morning Stewart looks in at their apartment and notices that the bedroom is empty and that the bedding is rolled up. Later that day he sees two moving men arrive for a big trunk which is tied with a stout rope. He notices the salesman make repeated trips to the courtyard carrying a heavily-loaded aluminum case and return with the case empty. He sees him cleaning the case and also cleaning a set of knives. The wife has disappeared and Jimmy is in a word, curious! His curiosity is shared with the audience, as "Rear Window" is taut and tense with the tantalizing mystery of whether or not a murder was committed, how and by whom.

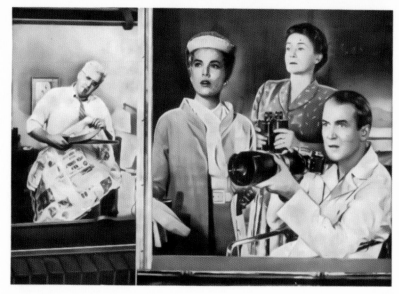

Mat 3B

A fiendish murderer feels unseen eyes prying on his privacy in this scene from Alfred Hitchcock's brand new Technicolor Paramount suspense thriller, "Rear Window," which is due to open next......at the......Theatre. The principals involved in this tense journey into human passions are James Stewart, Grace Kelly, Thelma Ritter and Raymond Burr.

•

## Star Sits It Out In 'Rear Window'

James Stewart, whose screen portrayals in the past have been for the most part those of the action variety, literally sits it out in Alfred Hitchcock's brand new Paramount Technicolor suspense thriller, "Rear Window," which is due to open next......at the...... Theatre. In this exciting journey into human passions, Jimmy portrays the role of a famed still photographer who is confined to a wheel-chair due to a broken leg. With nothing to do all day long he wiles away his time by looking out of his rear window at the neighbors.

One dark night, while gazing from this vantage point, Jimmy sees what he believes to be a murder. From then on in, "Rear Window" moves along at a mile-a-second pace and Jimmy participates in this most suspenseful of all screen thrillers from the confines of his wheel chair.

## Production Notes

"Rear Window" is James Stewart's second motion picture both for Paramount and for Alfred Hitchcock. Mr. Stewart's first for the Paramount studio was his magnificent portrayal of the clown in Cecil B. De Mille's epic circus story, "The Greatest Show On Earth," and his initial assignment under the aegis of Mr. Hitchcock was the powerful suspense drama, "Rope," several seasons back.

___

Thelma Ritter, who co-stars in "Rear Window" with James Stewart, Grace Kelly, and Wendell Corey, has been nominated for Academy Award honors as the best supporting actress on three different occasions.

___

Alfred Hitchcock, the producer-director of "Rear Window," always takes a role in one of his films. "Rear Window" is no exception as the great suspense-master portrays the role of a tailor who is seen briefly, giving a fitting entirely in pantomime.

___

The diverse characters who are probed by Alfred Hitchcock's roving directorial eye in "Rear Window" are tabbed with such descriptive names as "Miss Lonely Hearts," "The Song Writer," "The Newlyweds," "The Couple on the Fire Escape," "Miss Torso" and "Miss Sculptress."

___

"Rear Window," the brand new Alfred Hitchcock suspense thriller, has been heralded as Mr. Hitchcock's most spine-tingling drama to date. As Mr. Hitchcock has brought more memorable moments of suspense to the screen than any other film-maker, "Rear Window" shapes up as a film that is eagerly awaited.

___

"Rear Window" is, by technical standards, probably the most difficult film ever made. Not only is the main character of the film, James Stewart, confined to a wheel chair during the entire length of the film's dynamic action, but there is only one set for the film which is a suspense-laden story that races from one unexpected event to another with lightning-like speed.

___

Although Alfred Hitchcock is known as the master of suspense, romance is not neglected in his thrill-laden films. In "Rear Window" Mr. Hitchcock directs several romantic sequences involving James Stewart and Grace Kelly that are heralded as the most ardent ever flashed on the screen.

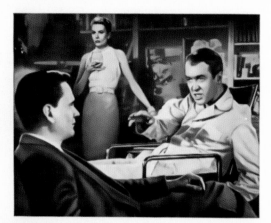

Still 10331-152                    Mat 2C

"It's murder," James Stewart tells police Lieutenant Wendell Corey, as Grace Kelly looks on, in this scene from Alfred Hitchcock's brand new Paramount Technicolor suspense drama, "Rear Window," which is due to open next........at the........Theatre.

# LOBBY AND FRONT IDEAS

Pull them in by the dozens with the highly effective and easy to build lobby and front displays suggested here. Geared to stimulate plenty of patron and passerby interest, they should help make your "REAR WINDOW" engagement a long-remembered box-office winner.

## BROADWAY THEATRE FRONT

Sparking "REAR WINDOW's" New York world premiere was this dazzling theatre front, one of the most spectacular ever seen on Broadway. Both sides of the Rivoli Theatre were completely flanked with simulated walls containing window cut-outs, imitations of the actual set used in the film. You can make your "REAR WINDOW" engagement the biggest thing on Main Street by following New York's easy-to-duplicate example. Make your front of compoboard and fill in the window openings with colored cut-outs of star blow-ups.

## 'WINDOW' SHADOW BOX

Here's a novel "on-the-beam" lobby display in which a blinking electric bulb illuminates a shadow box simulated to appear like a "rear window." Cover the shadow box with transparent cellophane and paint building bricks on the surrounding area. Letter the cellophane with the film's title, and superimpose the following copy on the brick area: *"Alfred Hitchcock's Greatest Suspense Shocker!"*

## AD BLOW-UP'S A NATURAL

Ad #501, seen on the cover of this pressbook, has all the makings of a startling lobby piece. Blow it up to 40 x 60 proportions and install in your inner lobby, along with a playdate snipe, a full week before your "REAR WINDOW" opening. After your engagement has begun, move your ad blow-up out front and display it there for the balance of your run.

---

## THEATRE TRAILER

The intriguing "REAR WINDOW" trailer is permeated with the gripping suspense that makes the film the year's most exciting mystery. Order yours TODAY from your nearest branch of

## NATIONAL SCREEN SERVICE

---

# 'REAR WINDOW' PHOTO CONTEST

Sound off the good news of your "REAR WINDOW" playdate with a grand-scale "REAR WINDOW Photo Contest," worked in conjunction with a local newspaper, in which readers are invited to submit photographs taken by themselves from their own 'rear windows.'

Publicize your photo competition via special ad slugs and a rousing round of newspaper releases, all crediting Jimmy Stewart's photographer's role in "REAR WINDOW" as the contest's competition. Entrants should be instructed to mail their photos to the newspaper photo editor, who should judge the entries for their originality and subject value.

After the winning "rear window" photo is selected, it should be published in the cooperating newspaper together with the ten runners-up. In addition, the winning photos could be displayed, along with "REAR WINDOW" credits, in a special lobby exhibit and in the main window of a publicity-conscious department store. Prizes could include a promoted camera for the grand winner and proportionately valuable merchandise for the runners-up.

## Classified Teasers

For quick results at small cost nothing beats classified teaser ads, and the specially prepared lines suggested here are tailored to make "REAR WINDOW" the town's hottest news.

---

YOU'LL FEEL LIKE SCREAMING AT WHAT YOU SEE THROUGH JAMES STEWART'S "REAR WINDOW" AT THE GEM THEATRE TONIGHT!

"REAR WINDOW," ALFRED HITCHCOCK'S GREATEST SUSPENSE SHOCKER IS COMING TO THE GEM THEATRE! WATCH FOR IT!

DON'T LOOK NOW BUT PLENTY OF EXCITEMENT'S COMING YOUR WAY IN "REAR WINDOW!" NEXT AT THE GEM THEATRE!

WHAT WOULD YOU DO IF YOU THOUGHT YOU SAW A MURDER COMMITTED FROM YOUR "REAR WINDOW?" SEE WHAT JAMES STEWART DOES AT THE GEM THEATRE NOW!

ALFRED HITCHCOCK, THE MASTER OF SUSPENSE, COMES THROUGH WITH "REAR WINDOW." THE GREATEST THRILLER OF THEM ALL! SEE IT AT THE GEM THEATRE NOW!

---

## National Co-op

The manufacturers of Van Heusen shirts are backing "REAR WINDOW" with a gala full-page, four-color ad, scheduled to appear in the November edition of Esquire Magazine. Showmen can make the most of this by contacting local dealers and arranging for window displays.

## Music Tie-up

"Lisa," the lilting new tune whose melodious strains serve as the background music for "REAR WINDOW," has all the makings of a top hit parade winner. With lyrics written by Harold Rome and music by Franz Waxman, "Lisa" has been published by Paramount Music Corporation, 1619 Broadway, New York 19, N. Y., which is making available gratis song covers to all who request them.

## Binocular Bally

Here's a talk-starting bally stunt that's bound to leave a beneficial mark on your box-office. On opening day, send a conventionally clad man through the shopping streets carrying a large pair of binoculars. Two signs, one on the man's back and one dangling from his field glasses, should proclaim, *"I'll be peering into James Stewart's 'REAR WINDOW' at the Gem Theatre tonight!"*

## Inquiring Reporter

Make local newspaper readers take notice and start thinking of your playdate by having the inquiring reporter ask the following question of the man in the street: *"James Stewart thinks he has discovered a murder in 'REAR WINDOW,' the new Alfred Hitchcock thriller now at the Gem Theatre. What is the most interesting view from your rear window?"*

# HOLDOVER ADS

2 COLS. x { 37 LINES . . . 75 LINES
            3 inches . . . 6 inches

MAT 202

3 COLS. x { 100 LINES . . . . . . . 300 LINES
            7 inches . . . . . . . . 21 inches

MAT 307

NOW
THE MOST
EXCITING SPOT
IN TOWN!

2 COLS. x { 150 LINES . . . 300 LINES
            11 inches . . . 22 inches

MAT 207

# POSTERS

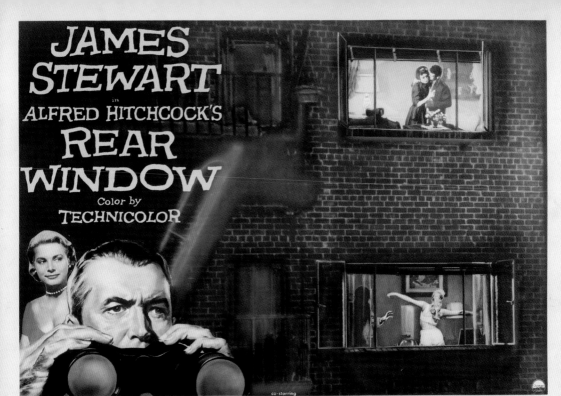

# JAMES STEWART

### in

# ALFRED HITCHCOCK'S
# REAR WINDOW

### Color by
### TECHNICOLOR

co-starring

# GRACE KELLY · WENDELL COREY · THELMA RITTER
with RAYMOND BURR · Directed by ALFRED HITCHCOCK · Screenplay by JOHN MICHAEL HAYES
BASED ON THE SHORT STORY BY CORNELL WOOLRICH · A PARAMOUNT PICTURE

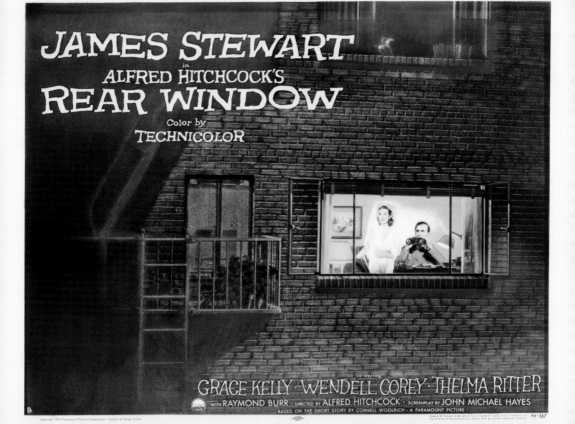

# JAMES STEWART
### in
## ALFRED HITCHCOCK'S
# REAR WINDOW
### Color by
## TECHNICOLOR

co-starring

## GRACE KELLY · WENDELL COREY · THELMA RITTER
with RAYMOND BURR · DIRECTED BY ALFRED HITCHCOCK · SCREENPLAY BY JOHN MICHAEL HAYES
BASED ON THE SHORT STORY BY CORNELL WOOLRICH · A PARAMOUNT PICTURE

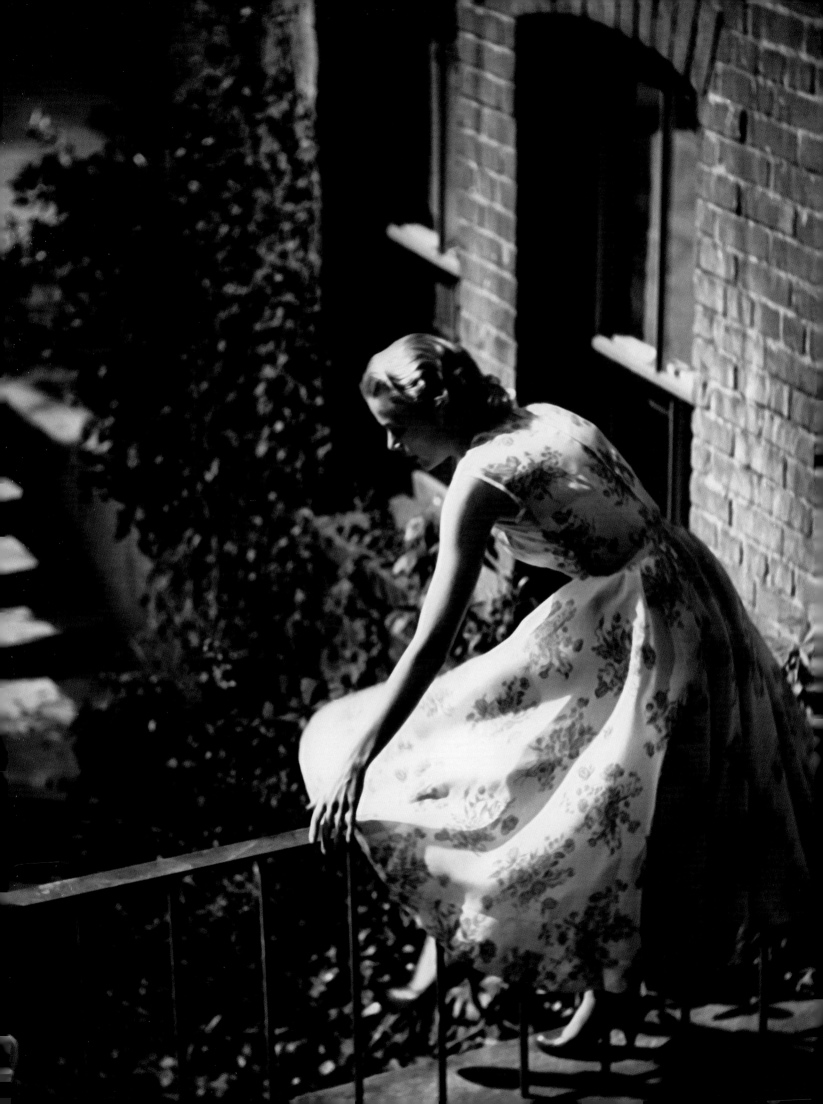

# DANGEROUS FEMALE

## GRACE KELLY IN *REAR WINDOW*

### BY SLOAN DE FOREST

Rear Window is often cited as the archetypal Alfred Hitchcock classic, and Grace Kelly as Lisa Fremont is the spark that ignites the film. From her stunning, unforgettable introduction where she practically kisses the camera (a close-up that assistant director Herbert Coleman called "the most beautiful shot of a woman I've ever seen in my life") to her purring "preview of coming attractions" line, Grace charms *Rear Window* to life with beauty, elegant wit, and woman-in-danger thrills. Plus, she looks divine scaling a fire escape in a floral-patterned organdy dress and heels.

But beneath the sparkling exterior is a dark side. Lisa Fremont represents Hitchcock's deliciously sinister outlook on romantic love, the irresistible yet impossible-to-tame power that tortures our hero, photographer L. B. "Jeff" Jefferies (James Stewart), from the confines of his wheelchair. As he sits in his Greenwich Village flat with a broken leg and no TV set, Jeff watches varied scenes unfold through his neighbors' windows. Each neighbor seems to represent a different stage of love or marriage gone awry, echoing Jeff's fears and conflicts regarding his girlfriend, Lisa. Isn't the force that draws Jeff to Lisa the same force that leads Lars Thorwald (Raymond Burr) to commit murder? That drives Miss Lonelyhearts to near suicide? That lures the newlyweds into a marriage they aren't ready for, one that is likely to fail? The scenarios Jeff spies send a clear message: to a single man, any woman—even a "perfect" one like Grace Kelly—is a ticking time bomb waiting to explode and drown him in sea of agonies: the hot apartment, the garbage disposal, the nagging wife.

When Jeff suspects Thorwald has killed his bed-ridden wife and chopped her body up into pieces, the

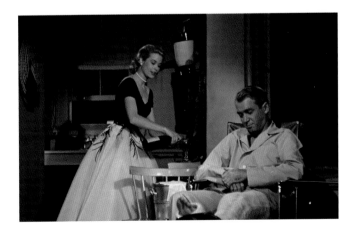

**OPPOSITE** To solve a neighborhood murder, Grace Kelly as Lisa Fremont climbs a fence in a stylish dress and high heels.

123

horror he feels is magnified because it mirrors his own deep-seated, irrational desire to be rid of Lisa. Hitchcock plays with this theme by casting as Mrs. Thorwald an actress who bears more than a passing resemblance to Grace Kelly. Viewed from across the courtyard with her cream-colored satin nightgown, her lithe figure, and her short, wavy blond hair, Anna Thorwald could be Lisa Fremont's low-rent doppelgänger. Ironically, through the lens of Jeff's binoculars, the woman is the invalid. In Jeff's relationship, he is the incapacitated party.

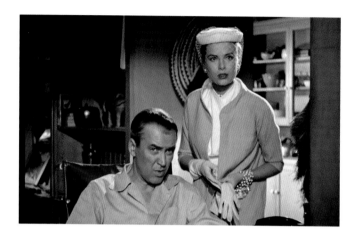

"It Had to Be Murder," the original Cornell Woolrich short story upon which *Rear Window* was based, features no major female characters. Yet Hitchcock and screenwriter John Michael Hayes added not one but two strong women to the story, Lisa and Stella (Thelma Ritter), Jeff's nurse. Stella serves to reinforce Lisa's needs in a direct, no-nonsense manner. "I'm just not ready for marriage," the gray-haired bachelor stammers, to which Stella shoots back, "That's abnormal." When Stella advises Jeff to marry Lisa, he snaps, "She pay you much?" Stewart's character seems to believe that both women (perhaps all women) are in league against him, conspiring to rob him of his freedom by trapping him into marriage.

So something deep within Jeff resists Lisa. Well, as much as any man can possibly resist her, which is not much. He willingly accepts her embraces, but refuses to marry her and tries to break off the relationship. Unlike the stereotypical midcentury woman who might insist her husband settle down in the suburbs, Lisa is willing to travel with him and live his unconventional lifestyle instead. But Jeff feebly blusters, "It'd be the wrong thing,"

when she offers to accompany him on his globe-trotting assignments. Why?

Ancient folklore often characterized sexually alluring females as dangerous vampires that fed their desires on unsuspecting men. But is there more beneath the surface than simply Jeff's primal fear that a woman will ensnare him with her charms, ultimately enslaving and thereby emasculating him? Is there more than the standard reluctance to sacrifice his independence by entering into a permanent partnership? The more likely source of Jeff's resistance is a phenomenon that was simmering just below the Eastmancolor facade of the 1950s—the power struggle between the sexes. Jeff is an old-school man. He returned from World War II to find that women had glided through professional doors that had previously been open only to men. Suddenly, as evidenced by the femme fatale character in film noir at that time, women's increased power and independence threatened the typical postwar male.

Lisa represents the new, self-sufficient breed of working women who emerged during the war, many of whom retreated back to the domestic front in the late 1940s and early 1950s when the soldiers returned. Hitchcock and Hayes could have easily written James Stewart's love interest as a passive piece of arm candy, or even a cloying also-ran like Barbara Bel Geddes in *Vertigo* (1958). But *Rear Window*'s creators took the trouble to make Lisa a strong-willed professional woman. She has the demeanor of a wellborn lady, meaning her job is probably not a necessity but a choice. Lisa has her own money, her own career, and is used to getting her own way.

The precise nature of Lisa's job is never stated in the film. Though viewers and critics commonly refer to her as a "socialite" and "model," Lisa rushes to and from meetings all day, lunches with power agent Leland Hayward, informs newspaper columnists, and consults with high-level *Harper's Bazaar* execs. With this kind of daily agenda, she must be more than a socialite, and must wield a great deal more power than a typical model. She may have started as a model but now appears to hold a prominent position in the fashion industry.

In a 1998 *New York Times* analysis of Grace Kelly's

*Rear Window* fashions, journalist Ariel Swartley writes, "Kelly plays a powerful New York fashion editor, one of the few executive positions open to women in the 1950s. And that power is a bone of submerged contention between Stewart and his prospective fiancée." Lisa's "skirts with their yards of rustly organza" may convey femininity, Swartley observes, but "serve as an unsettling reminder that one of the fundamental prerequisites of power is the ability to control appearances."

And if there's one thing Lisa knows, it's "how to wear the proper clothes," that is, to control her appearance at all times, in all circumstances. She refers to makeup, perfume, and jewelry in vaguely military terms, as "basic equipment," and reminds Jeff that surprise is a woman's "most important element of attack." In a role reversal rare for the 1950s, Lisa sweeps in from work, dressed to the nines and chattering about her job while Jeff sits at home all day in his pajamas. She chooses when to "attack," deciding to spend the night without consulting him or anyone else.

An enticing hybrid of the two female noir character types—the deadly femme fatale and the innocuous girlfriend/wife—Lisa generates double the sparks of either of these pure types alone. In her introductory scene, she swoops down on the protagonist like a seductive bird of prey while he sleeps, vulnerable, his broken leg rendering him incapable of escape. From that moment, they are locked in a combative dance: she advances, he retreats, but surrender is inevitable.

No wonder Jeff is uneasy. Ogling Miss Torso from across the yard seems a much safer alternative.

"I need a woman who's willing to go anywhere and do anything and love it," Jeff explains. (The subtext sounds alarmingly like: go anywhere *he takes her* and do anything *he tells her*.) He convinces himself that he wants a little buddy, a rough-and-tumble traveling companion, because this imaginary good-natured gal would be easier to control. But what he really wants is Lisa. He is simultaneously drawn to and intimidated by her power, an internal conflict that could be easily resolved if he would retool his old-fashioned concepts of masculinity and femininity. Lisa *can* go anywhere and do anything and love it, as she proves to him during the course of the film. The core of Jeff and Lisa's problem is that, because he feels threatened by her, he insists on underestimating her. As if accepting a woman as beautiful, desirable, and empowered would somehow diminish his manhood.

From the beginning, Jeff accuses Lisa of being "too perfect," which in this case means because she looks so pretty, blond, and flouncy, she couldn't possibly be strong, brave, and adventurous too. This common misconception has been an obstacle for women since the earliest recorded history. As feminist writer and professor Annette Kolodny notes, "Even in our supposedly most 'advanced' societies, women's capacities are still judged as inherently inferior to the capacities of men." Kolodny wrote that in the year 2000, so it's probably safe to assume it goes double for the 1950s. Often, the prettier (and blonder) a woman looks, the more passive, weak, impractical, and incapable the average man assumes her to be.

In *Rear Window*, Jeff not only underestimates his glamorous girlfriend, he criticizes and belittles her throughout the film. He rolls his eyes in exasperation when she serves him a perfect dinner. He barks "Shut up!" and "Simmer down!" when she expresses her opinions in an argument. He derides her fashionable clothes and footwear. "Those high heels, they'll be great in the jungle," he scoffs. Flash forward a few reels and Lisa is climbing the back of a building in high-heeled pumps and calf-length dress. How many men could manage such a feat? For the jungle of New York City, Lisa's high heels prove to be sufficient equipment.

Most *Rear Window* analysts agree that Lisa's desire to become Jeff's wife is what drives her actions. About halfway through the film, she transforms into a daring sleuth, willing to risk life and limb to sneak into Thorwald's apartment and nab that gold wedding band—the ultimate prize—to show Jeff she's marrying material. What often goes unmentioned is that Lisa is genuinely in her element when she becomes invested in the unfolding mystery. She grows so excited by the thrill of chasing down a murderer that she can't even keep her mind on her work. After her first "assignment" of checking the name on the mailbox, she is sincerely disappointed when Jeff requires no more sleuthing for the night. Obviously, she isn't pretending just to impress her boyfriend.

As if she didn't face enough criticism from Jeff, Lisa must contend with the police detective Lieutenant Doyle (Wendell Corey), Jeff's crusty army buddy who helps investigate Thorwald. Typically, when a male detective or policeman relies on hunches, it means he has a sharp and perceptive mind. When a woman has the same kind of hunch, it must be labeled "feminine intuition," which is what Doyle calls Lisa's theory that Mrs. Thorwald would not leave her wedding ring behind if she took a trip. Doyle also disregards Lisa's clever deduction that the woman posing as Mrs. Thorwald at the train station was probably Lars Thorwald's lover.

When Lisa turns sleuth, it's about more than just solving a mystery or winning a husband; it's about showing her male detractors what she's made of inside, that she and her whole gender are more than just aesthetically pleasing playthings. It's also about proving her hunches correct. Furthermore, she acts in order to satisfy her own personal sense of intrigue. Lisa is smart, curious, intuitive, and resourceful—she was born to play detective.

In taking it upon herself to explore Thorwald's apartment for evidence of the murder, Lisa turns the tables on the expected movie clichés. Usually in films and television it's the girlfriend/wife character who tries to talk the male protagonist out of rash, dangerous actions. Here, Lisa proves to be the risk-taker, opposing a double standard the TV Tropes wiki calls "Men Act, Women Are." The trope goes like this: "While male characters will be directly involved in the action, or manipulating the action behind the scenes in a comprehensive way, female characters, when they do take action, often take it in the form of inspiring, motivating, or nagging a male character to do something." Because Stewart's character is confined to a wheelchair, by necessity Grace Kelly's Lisa becomes an exception to this rule. Seizing an opportunity, she makes the sudden decision to venture into the killer's lair, thus becoming the "legs" of the protagonist, and essentially—as Hitchcock and Peter Bogdanovich agreed in their 1963 interview—the "dominant partner in the relationship."

Of course, her acts of derring-do serve a dual purpose. She does succeed in demonstrating her tough side to Jeff; he reserves his sincerest praise for when Lisa gets arrested for breaking and entering. "Gee, I'm proud of you," he says, beaming with respect and admiration.

**ABOVE** Lisa lights up a cigarette in *Rear Window*, one of the few times audiences saw Grace Kelly smoking.

All she has really done is prove she was the kind of woman he wanted all along, only he was too stubborn to see it. There had been dissent between Jeff and Lisa, almost to the point of breaking up. Once Lisa gets into the crime-solving spirit, the couple is united by their sense of mystery and adventure.

Engulfed in and distracted by the murder investigation, Jeff and Lisa make an effective team. Jeff puts some of his resentment on hold and accepts Lisa's help and guidance, though he still becomes defensive when she implies that he is the weaker party. "Jeff, if you're squeamish, just don't look," she calmly advises when she and Stella plan to dig up body parts in the garden. Jeff vehemently denies it, though he is shown to be squeamish in an earlier scene when Stella serves him breakfast while casually discussing Mrs. Thorwald's bloody, dismembered corpse.

Alfred Hitchcock and John Michael Hayes based the character of Lisa on Grace Kelly's own personality (adding a few elements from Hayes's wife, who had worked in the fashion industry). As both men got to know Grace, they sensed a bold determination beneath the cool exterior. They understood that she possessed a powerful will of her own, and was a risk-taker.

In Hitchcock and Hayes's post-*Rear Window* collaboration, *To Catch a Thief* (1955), they ramped up the fire-beneath-the-ice dynamic even further by making Grace's character, Frances, a closeted naughty girl with a fetish for bad boys and a lust for danger. Again breaking all the rules for the typical female love interest, Grace is the one who takes all the chances, maneuvering a treacherous mountain road in her speeding convertible and aggressively pursuing the shady Cary Grant. She essentially blackmails Grant into becoming her lover, threatening to expose his secret identity unless he comes to dinner in her hotel suite. Hitchcock once stated that Grace's character would rather Grant had committed the crime in the end, because "it's more exciting" to her.

Though Hitchcock may have created empowered women for Grace to play, he was not enlightened enough to give Lisa Fremont too much credit. In the Bogdanovich interview, Hitchcock dismissed Lisa as being one of a variety of New York women who are "like men." Clearly steeped in the sexist stereotypes of his era, Hitch equated being active, assertive, and independent with being manly. Like Jeff, the director seems to have been conflicted about powerful women—attracted to but also threatened by them. Whether on purpose or by accident, Hitchcock and Hayes succeeded in crafting something of an early second-wave feminist prototype in Lisa Fremont, predating *The Feminine Mystique* by nearly a decade.

At the end of *Rear Window*, Lisa's "feminine intuition" is proved correct. Without her, there would have been no evidence of Thorwald's murder. In fact, without her and Stella's intervention, the investigation probably would have ended with Lieutenant Doyle's declaration that "there is no case." Lisa proves to be much more than Jeff's girl Friday; she acts on behalf of the weakened hero, stepping into his shoes and using her own mind to solve the mystery.

In the film's finale, Jeff is sound asleep in his wheelchair with two broken legs while Lisa, dressed in sensible, casual clothing, puts down a copy of *Beyond the High Himalayas* and sneaks a peek at an issue of *Bazaar* instead. This scene could be (and often is) interpreted as Lisa surrendering to Jeff's wishes—or appearing to, at least. But Hitchcock gives Lisa the upper hand by giving her the final shot. If, as Bogdanovich and Hitchcock have stated, Jeff is "impotent" with one broken leg, his two casts now render him a virtually helpless invalid. Lisa, on the other hand, has never looked stronger or sturdier. She keeps watch over Jeff as he lies vulnerable, and for the first time we see her in jeans instead of a skirt. Now who's wearing the pants in the relationship?

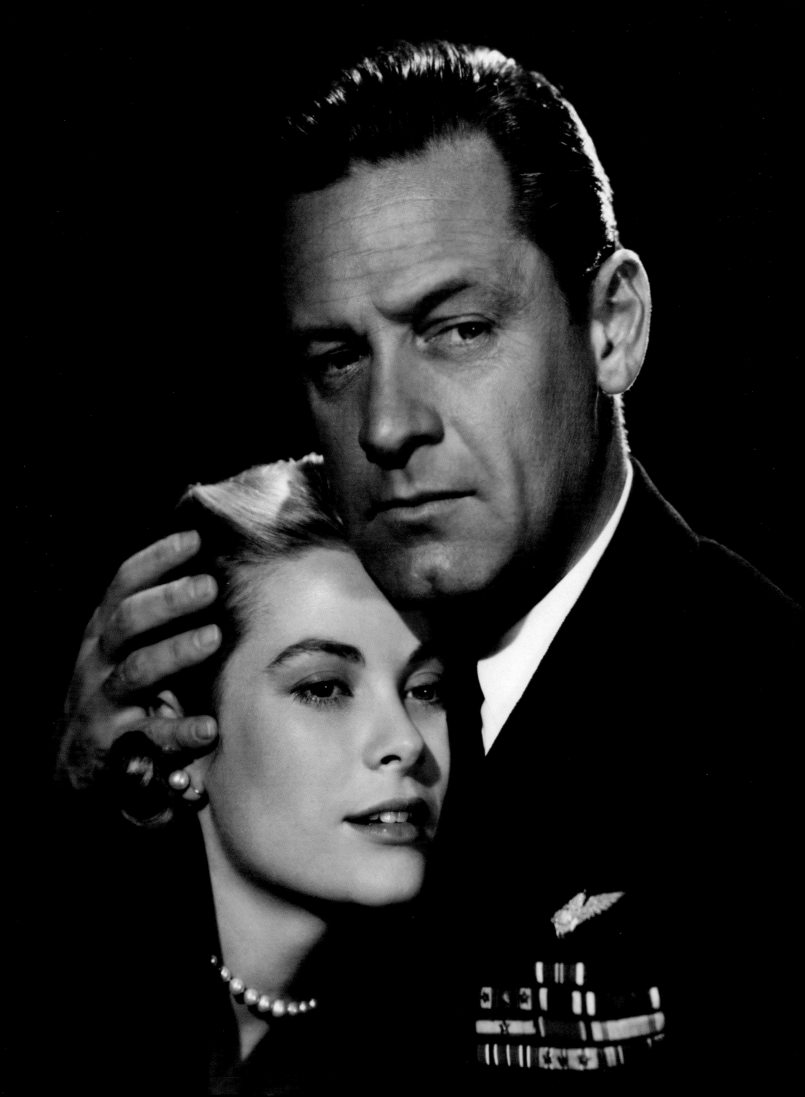

# THE BRIDGES AT TOKO-RI

## 1954

After four years of steady effort, Grace Kelly had become the hottest up-and-coming actress in the movies. But she remained philosophical, even cautious, about her success. "I've been very lucky and I know it," she told a reporter in 1954. "Once in a while that happens to someone in Hollywood, and it's happened to me. I'm hot at the moment. But how long it will last I don't know." Her fame brought a whole new wave of admirers, many of them male.

In early 1954, designer Oleg Cassini, the ex-husband of actress Gene Tierney, saw *Mogambo* with his friend Bobby Friedman in New York. Though Cassini felt that Ava Gardner dominated the film, he was instantly smitten with Grace. Later, leaving the theater, Cassini declared to Friedman, "That girl is going to be mine!" The two men then went to dinner at Le Veau d'Or, a French restaurant on East Sixtieth Street. As they sat talking about the film, Cassini became aware that just to his right sat Jean-Pierre Aumont and his date for the evening—Grace Kelly.

Cassini arranged an introduction to Grace, and for a week anonymously sent her flowers until she agreed to a date. But before anything serious happened, Grace tried to halt his advances. "I started with the worst handicap a man can have, when he courts a woman," Cassini said. "[It] is that she was really in love with someone else. She was in love with Ray Milland—a beautiful looking man, a Welshman, a good actor and she was entranced by him."

Before Cassini could make any significant romantic advancement, Grace returned to the West Coast for another film. MGM loaned her to Paramount for *The Bridges at Toko-Ri*, a Korean War drama based on James Michener's best-selling novella. She rented a small apartment on Sweetzer Avenue in West Hollywood, but Grace never felt at home in Los Angeles. Grace's agent

John Foreman also represented actress Rita Gam, who was staying at the Beverly Hills Hotel while making *Sign of the Pagan* (1954). Foreman knew that both women were feeling slightly displaced, and suggested they meet for coffee.

"Grace let me in, and there she was—she was wearing the same Philadelphia skirt, the same sensible shoes, the same tied-back hair—except now she was becoming a very valuable property," Gam remembered. "I had no idea that her background was one of opulence. I thought of her as a co-worker—an actress. Then, out of the clear

**OPPOSITE** Grace Kelly and William Holden.   **ABOVE** The Italian film poster.

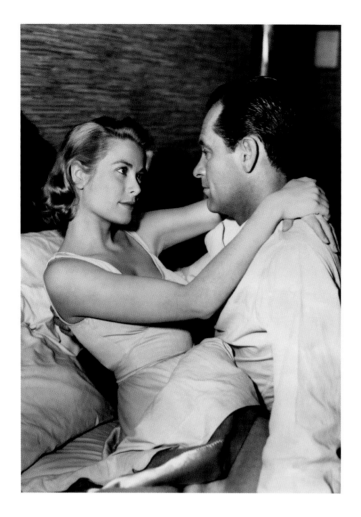

Harry Brubaker. An attorney and naval reserve officer, Brubaker is pulled back into active duty for a dangerous mission in Korea. Grace is his wife, Nancy, who visits her husband with their children during a three-day leave in Tokyo. Though the role was not a large one in terms of screen time, it was crucial to the story of servicemen at all ranks and the people who wait for them to come home. Grace has one scene in particular that displays her progress as a dramatic actress: a powerful yet subtle internal reaction when she faces the reality that her husband might not make it home from the mission.

If Ray Milland still occupied Grace's thoughts, his memory would soon be erased by William Holden. Grace had already established a pattern of falling in love with many of her leading men, and Holden was no exception. Though he was married to Ardis Ankerson Gaines—better known as the actress Brenda Marshall—that didn't prevent Holden from engaging in an affair with Audrey Hepburn when they had filmed *Sabrina* in late 1953. Once Hepburn was out of the picture, Holden began a relationship with his new beautiful blond costar.

Grace hoped her family would approve of her relationship with Holden, but she must have known how unlikely their consent would be. If Ray Milland, a man separated from his wife, had not won the Kellys' approval, they were not about to accept a very married man with three children. Like her romances with Gable and Milland, Grace's fling with Holden would be short-lived. However, Holden told friends *The Bridges at Toko-Ri* was his favorite filmmaking experience because of his relationship with Grace.

*The Bridges at Toko-Ri* was released in December 1954 to critical acclaim and solid box office. The Technicolor CinemaScope film intercut the use of large-scale models with authentic battle footage, which helped it to win an Academy Award for Best Special Effects. Though the *New York Times* called Grace "briefly bewitching," her role was not large enough to make a major impact on her career. But she had established a relationship with Perlberg and Seaton, who would be key players in her future success as an actress.

blue sky and very directly, openly and warmly, she said 'Would you like to share the flat?'"

Gam later surmised that the invitation to share the apartment may have arisen "because she was having a little bit too much exposure in the press in a negative way because of her propensity to like her male costars." Jean Dalrymple believed there was more to it, saying of Grace, "She was really a family person. She didn't like to be alone."

Producers of *The Bridges at Toko-Ri*, William Perlberg and George Seaton, had to pay considerably more than Hitchcock had spent to borrow Grace—her bankability had skyrocketed, and MGM now saw her as a star with serious drawing power. But since Metro had no suitable scripts for her and the shooting schedule of *Bridges* was so short, the studio agreed to the loan. "Perlberg and Seaton were very fond of Grace," said Jay Kanter. "They were good for her too."

William Holden, one of Paramount's handsomest and most popular male stars, was cast as navy lieutenant

**ABOVE** Grace Kelly and William Holden.  **OPPOSITE** Grace with director Mark Robson.

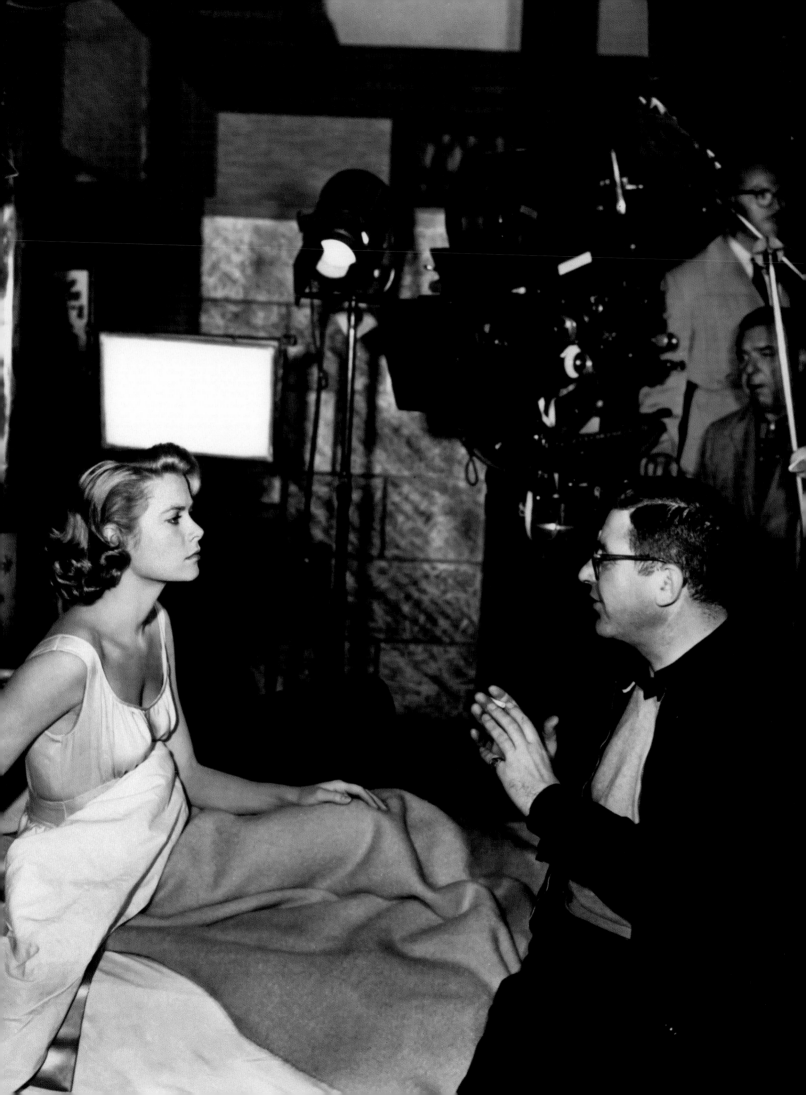

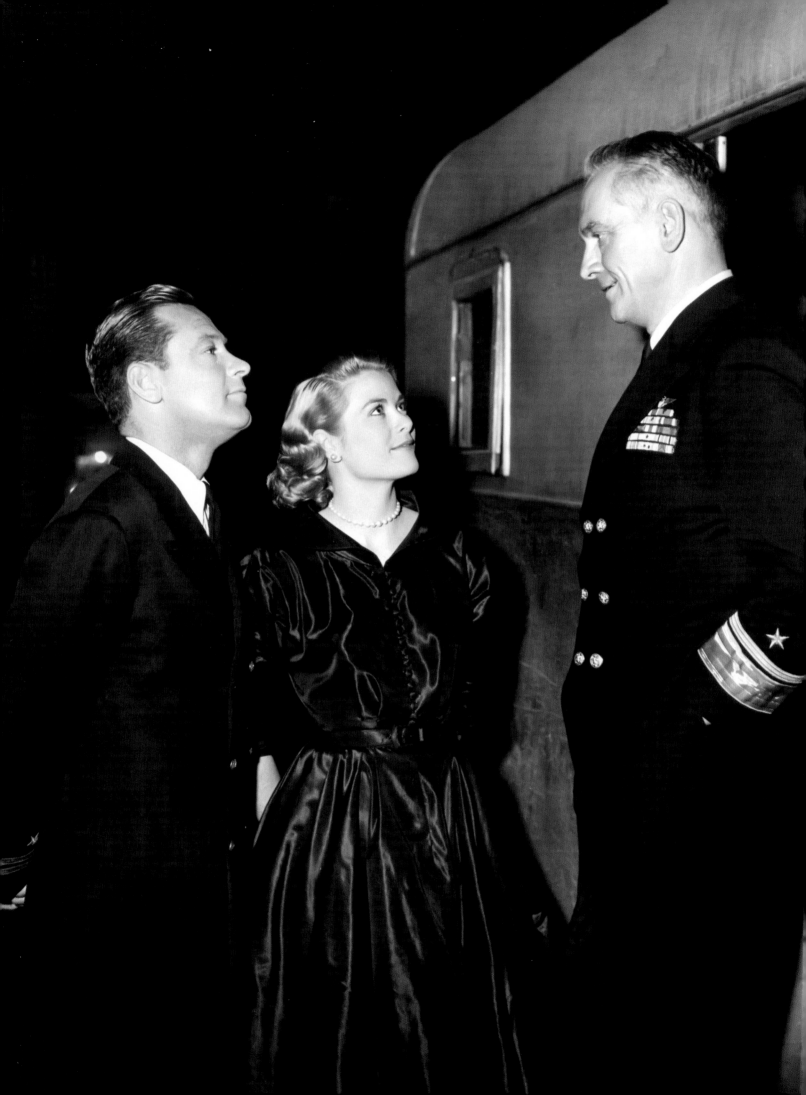

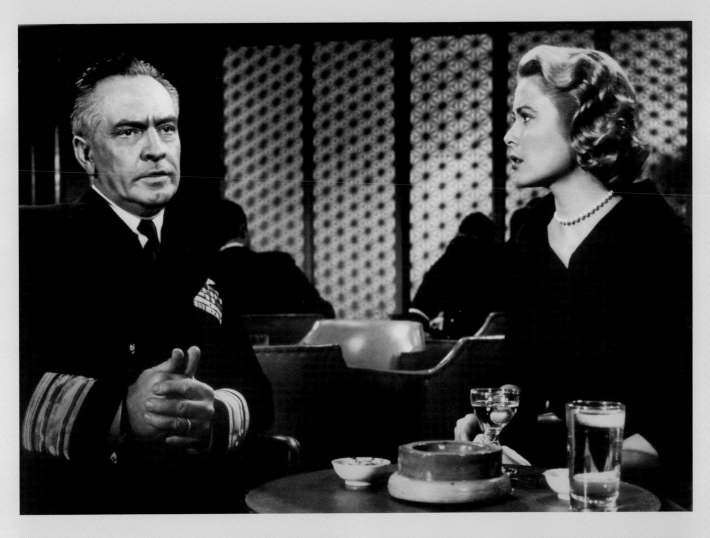

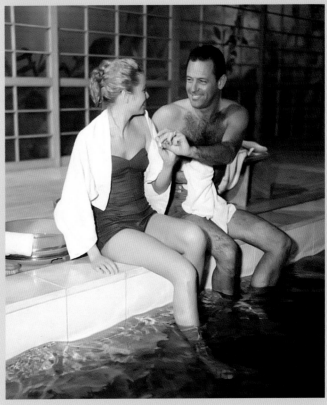

**OPPOSITE** Off camera, Grace is flanked by William Holden (left) and Fredric March (right). **TOP** Rear Admiral Tarrant (March) confronts Nancy (Kelly). **BOTTOM LEFT** Grace as Nancy Brubaker. **BOTTOM RIGHT** Grace filming the bathhouse scene with Holden.

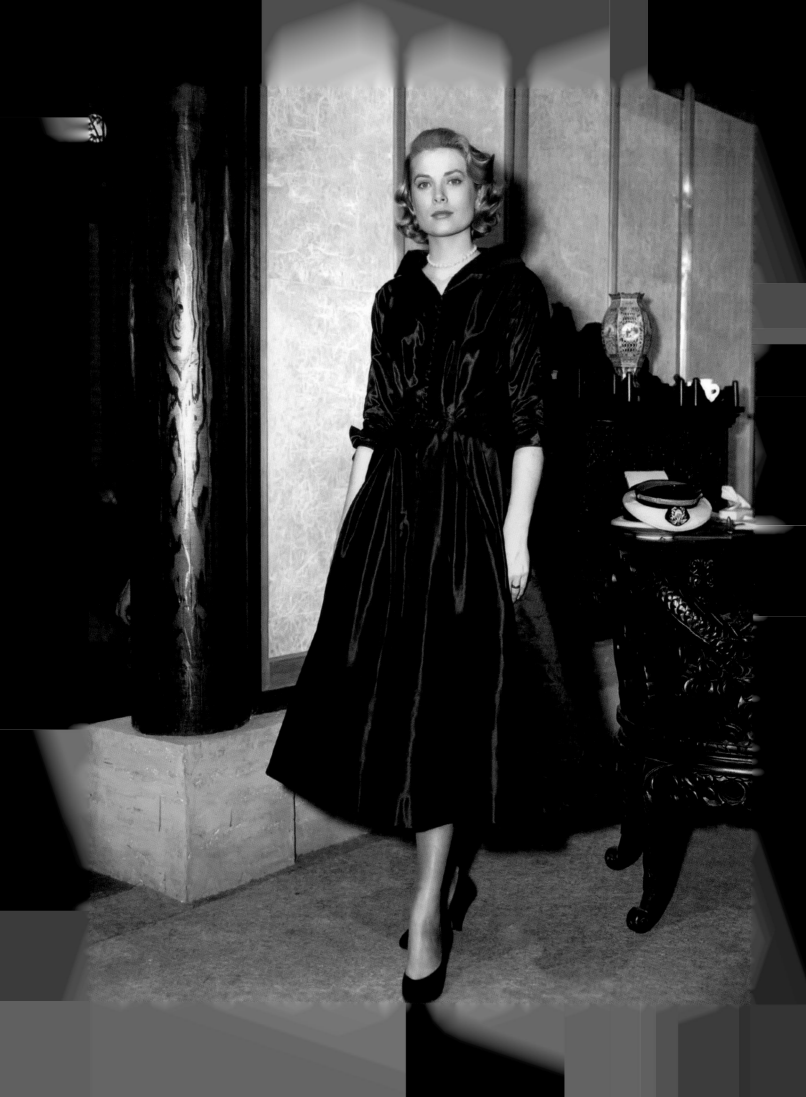

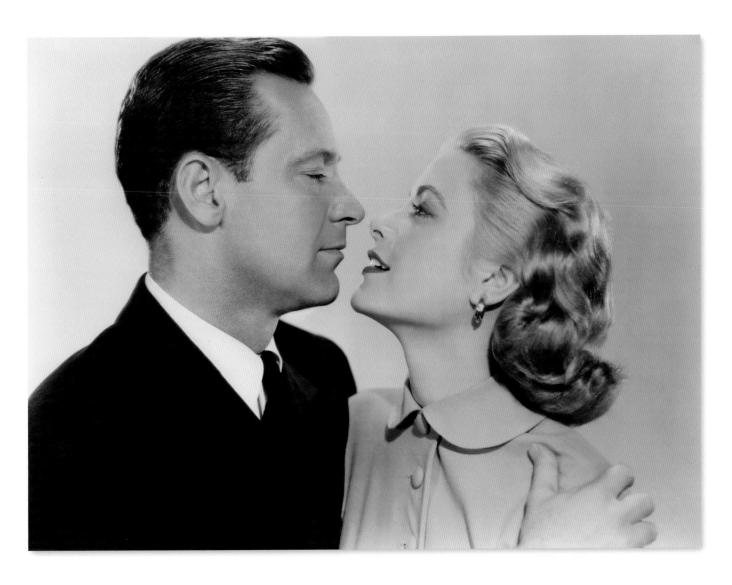

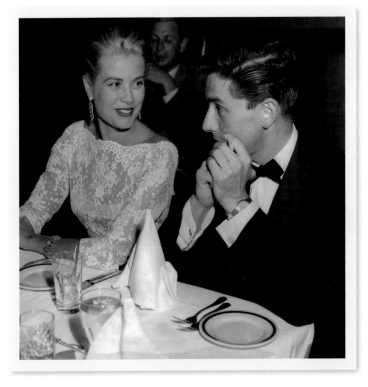

**TOP** Hand-colored publicity still.   **BOTTOM LEFT** Sheet music for the film's "Love Theme."   **BOTTOM RIGHT** Grace with her agent Jay Kanter.

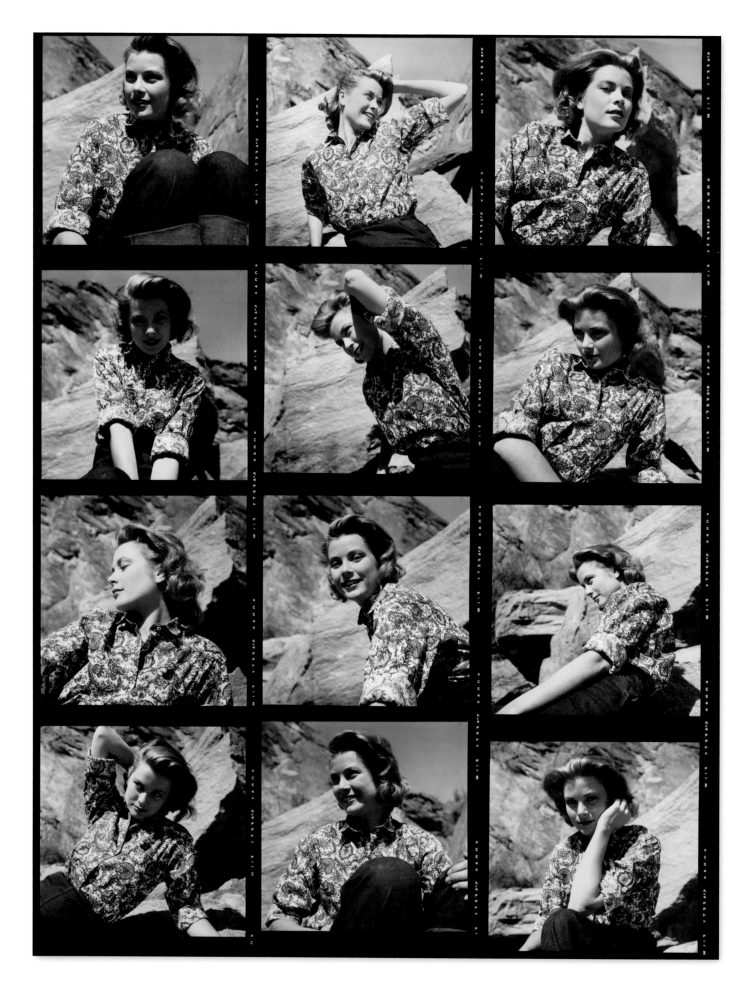

**ABOVE AND OPPOSITE** Grace traveled to Palm Springs with Paramount photographer Bud Fraker for new publicity photos.

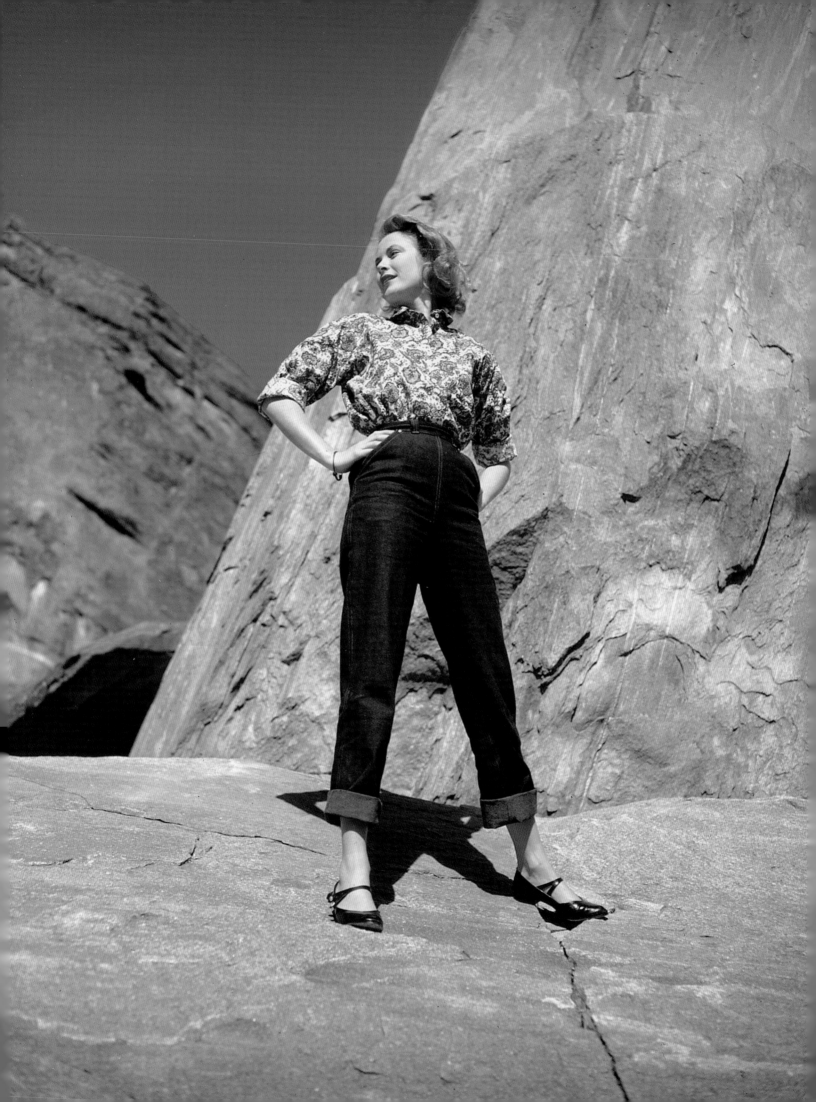

"I think the thing that most people forget is that when all of this is happening to Grace, this extraordinary excitement about her career being generated and roles with the world's most famous leading men and the world's most respected directors, she was just a girl in her early twenties."

JUDITH BALABAN QUINE

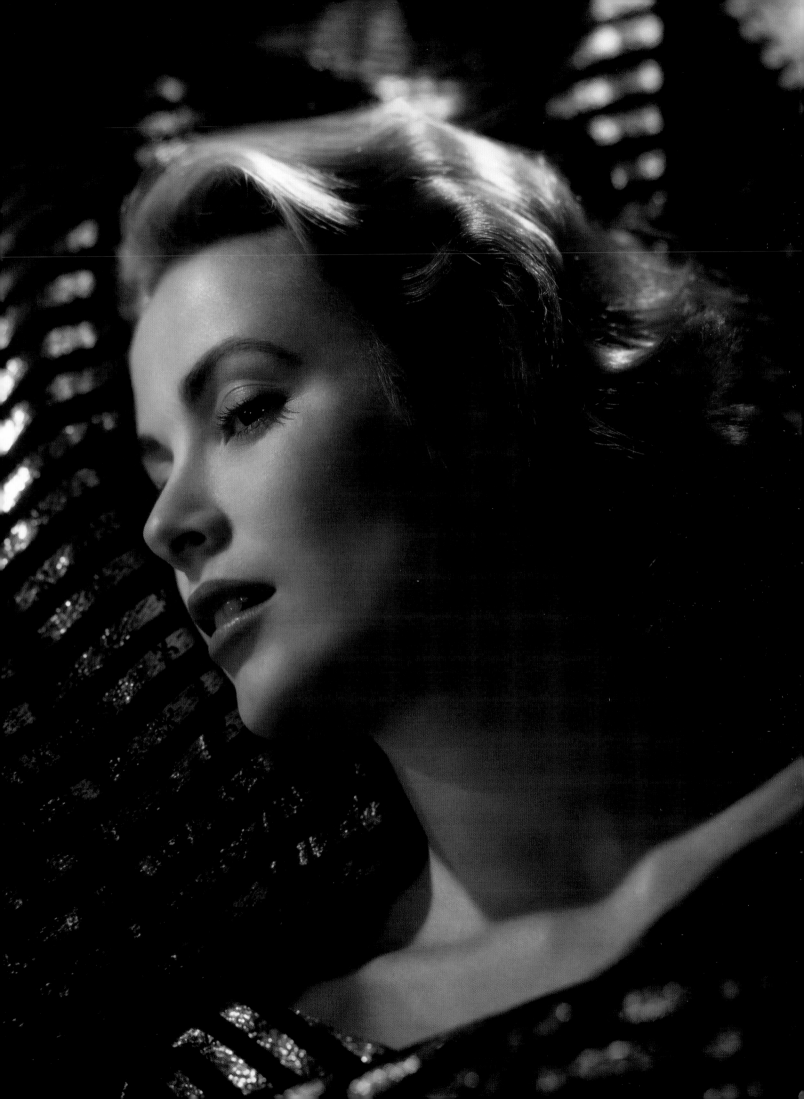

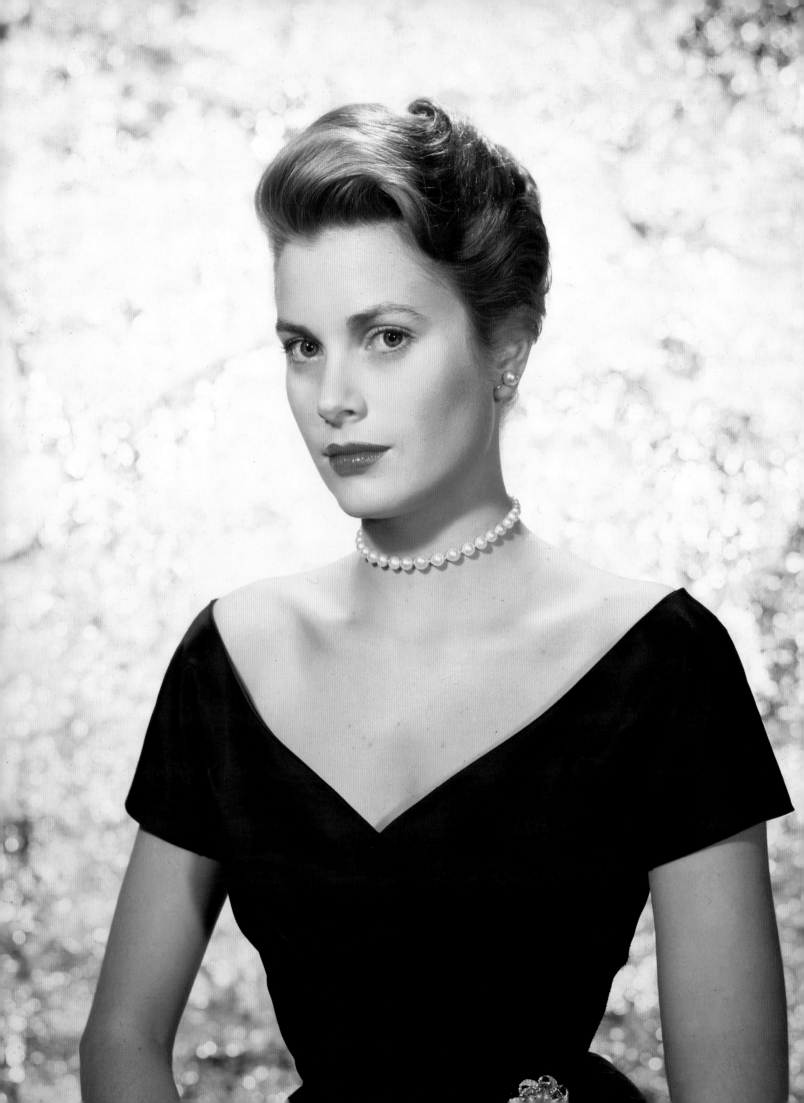

# THE COUNTRY GIRL

## 1954

By late 1954, Grace's career as a Hollywood ingénue was on fire. Now all she needed was a substantial role in a major dramatic film—one that would show the world what she was truly capable of as an actress and establish her as more than just a pretty face.

MGM considered using her for a supporting role in the musical biopic *Deep in My Heart* (1954). "They wanted me to be Sigmund Romberg's wife," Grace said, "but I didn't want to be typed that way. And when William Perlberg wanted to borrow me for *The Country Girl*, the studio's attitude seemed to be, 'We don't know what Grace Kelly's got, but if other studios want her, there must be something—so we'll use her!'" It would set off a battle of wills that Grace was determined to win.

The play *The Country Girl* premiered on Broadway on November 10, 1950. Theatrical legend Uta Hagen starred as Georgie Elgin, the wife of a washed-up, alcoholic actor (Paul Kelly) who tries to prop her husband up long enough for him to wage a successful comeback. (Grace had even auditioned for a small part in the play but lost it.) Georgie Elgin was a plum role for an actress—not glamorous but heroic and emotionally charged. When William Perlberg and George Seaton bought the property to bring it to the screen, agents all over town campaigned for their clients' participation. Academy Award-winner Jennifer Jones was a top contender.

When Jones's husband, David O. Selznick, informed the producers that Jennifer would be unable to make the film because she was pregnant, both producers had the same replacement in mind: Grace Kelly. Bing Crosby was not convinced, and suggested the producers approach Greta Garbo instead. Having just worked with Grace on *The Bridges at Toko-Ri*, the producers had faith in her.

But Bing Crosby had contractual approval of his

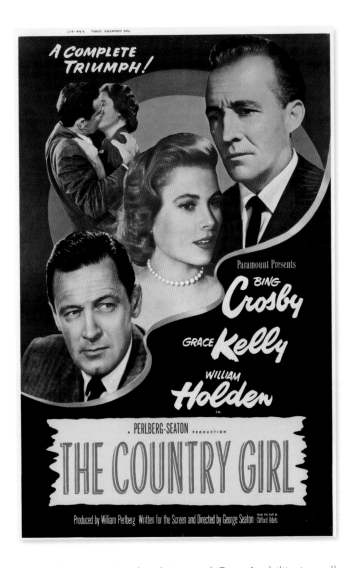

costar. Because Crosby distrusted Grace's ability to pull off the challenging role, he knew his performance would need to carry the entire film. "The part of Frank Elgin was the toughest kind of role for an actor of Crosby's limited depths," said Judith Balaban Quine. "It required him to play himself, an alcoholic with little self-esteem." Perlberg and Seaton made a deal with Crosby—Grace would be replaced if she failed to live up to his expectations. Crosby accepted the bargain, and Grace's *Bridges* costar

William Holden was cast as director Bernie Dodd, who also falls for Georgie.

There was still a problem: MGM would not approve the loan-out. According to Holden, Grace "called the heads of MGM and she said, 'It's my understanding, gentlemen, that you've refused to loan me out to Paramount for the production of *Country Girl.*' And they said, 'That's right, Grace.' She said, 'Well, I'm terribly sorry to hear that. I tell you what I will do, I'll give you my address, so you'll know where to send your Christmas cards.' And twenty minutes later, she had the part."

In truth, Grace did not negotiate her own release to Paramount. However, she advised her agent to make it clear to MGM that she was perfectly happy to quit films and return to the New York stage until her contract expired. MGM would not risk losing one of its biggest stars, even if Grace had only made one picture for them. They agreed to the loan provided that Seaton and Perlberg paid $50,000, and that Grace would immediately begin filming the adventure drama *Green Fire* as soon as *The Country Girl* wrapped. By wielding

her current popularity—and applying a bit of stubborn willpower—Grace won the coveted role.

Once again, Edith Head took charge of Grace's wardrobe. "Though we often had to work hard with some stars to create an illusion of great beauty," Head recalled, "I had to take one of the most beautiful women in the world and make her look plain and drab." Head used brown wool clothes, cardigan sweaters, and low-heeled Capezio shoes to make Grace appear dowdy. Some of Grace's friends were perplexed at her desire to play such a role. "Nobody understood at all," said Judith Balaban Quine. "I mean, why would this gorgeous creature want to be seen in an old tacky sweater with her hair pulled back in a bun, looking haggard?"

Oleg Cassini remembered the eyebrows Grace raised in Hollywood by deglamorizing herself. "Her insistence on an unglamorous appearance during this time was a matter of concern," Cassini said. Grace told him, "But I want to be taken seriously. Producers won't if they think I'm some glamour girl." Little did Hollywood realize that Grace had always dressed very casually off-stage, unashamed to be seen in her glasses and loafers. "One evening Grace would appear in a décolleté or strapless dress," said Judith Balaban Quine, "her hair coiffed immaculately, her makeup subtle yet enticing. The next time we would meet, granted in a less formal setting, Grace would be wearing her 'sensible' shoes."

When questioned about her looks in an interview, Grace responded, "When I'm asked to evaluate myself, I frankly don't know how. It's very difficult. How can I give an honest opinion? I don't like to talk about myself as a person. I've never spent much time thinking about myself anyway."

Cassini convinced Grace that her career would be more impactful if she made a conscious effort to appear fashionable off the screen as well as on. "You are becoming a major star, and should be a leader in fashion also," he told her. Within a year of Cassini's advice, Grace's simple, refined elegance became the latest style. *Modern Screen* observed: "Overnight, producers have stopped searching for busty beauties. They're trying instead to find girls with the 'Grace Kelly quality.' . . . Following the Grace Kelly trend, the starlets are making the change

**ABOVE** Georgie (Kelly) expresses her displeasure to Frank (Crosby). **OPPOSITE** Behind the scenes, Crosby autographs a record for his co-star.

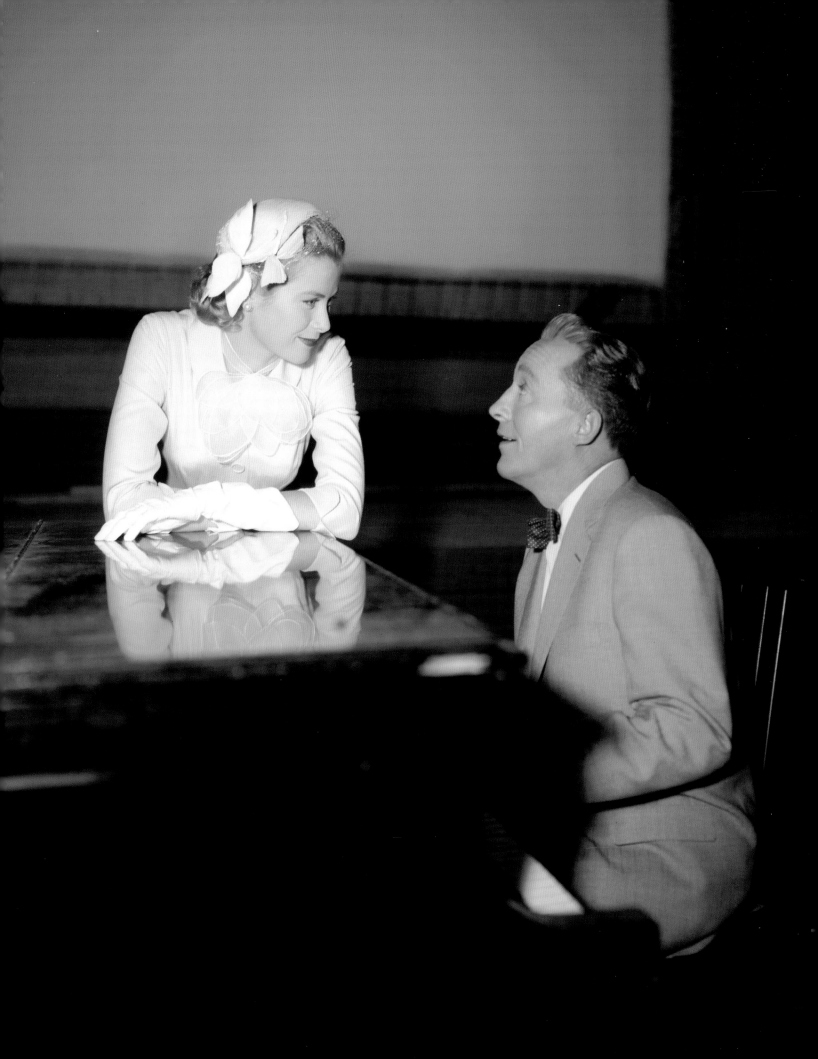

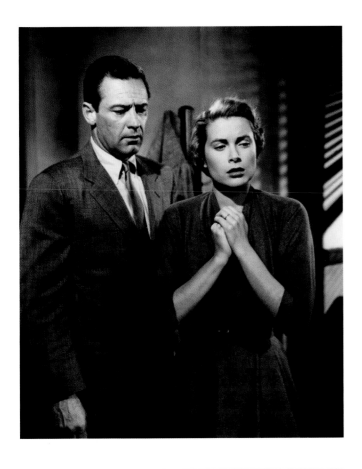

from the sultry look to the well-scrubbed look. . . . And as a badge of success, the cashmere sweater is replacing the mink stole."

George Seaton, for one, saw the talent underneath the glamour. In an interview at the time, he said, "The important thing about Grace—and it's often overlooked—is that she is first and last a great actress. People rave about her beauty. Okay. She is beautiful. They speak of her culture and charm. Okay. With that I go along too. But the outstanding fact with me is that Grace Kelly is tops as an actress."

Soon, even Bing Crosby became a believer. A widower at the time he made *The Country Girl*, Crosby not only embraced Grace as a costar but as a potential wife. Following what was becoming a predictable routine, Grace began dating Crosby; he even asked her to marry him. This time, Grace's mother approved (Crosby was Catholic and widowed, not divorced), but Grace was not seriously in love with him. She rejected Crosby's proposal and they remained on friendly terms.

When *The Country Girl* was released, the critical raves for both Bing Crosby and Grace Kelly were overwhelming. Both stars dug deep to deliver exceptional against-type performances. *New York Times* critic Bosley Crowther applauded the work of all three leads, praising Crosby's "unsuspected power," Kelly's "quality of strain and desperation," and Holden's "stinging yet oddly tender" portrayal. Archer Winsten of the *New York Post* said, "Kelly extends her range down to the bottoms of un-glamour, dead-faced discouragement. She gives everything a great actress could."

For this performance, Grace was awarded the Golden Globe for Best Actress in a Drama, the National Board of Review Award for Best Actress (which included her work in *Dial M for Murder* and *Rear Window*), and the New York Film Critics Circle Award for Best Actress (again including *Dial M for Murder* and also *Rear Window*). The actress who had fought to be taken seriously was overcome with gratitude. But there was still one more award left to win.

OPPOSITE Kelly and Crosby in costume for the flashback scene. TOP Bernie Dodd (Holden) expresses his feelings for Georgie (Kelly). ABOVE Grace in costume on the Paramount lot. OVERLEAF (from left) Producer William Perlberg, director George Seaton (gesturing), cinematographer John F. Warren (standing), Bing Crosby, Grace Kelly, and William Holden.

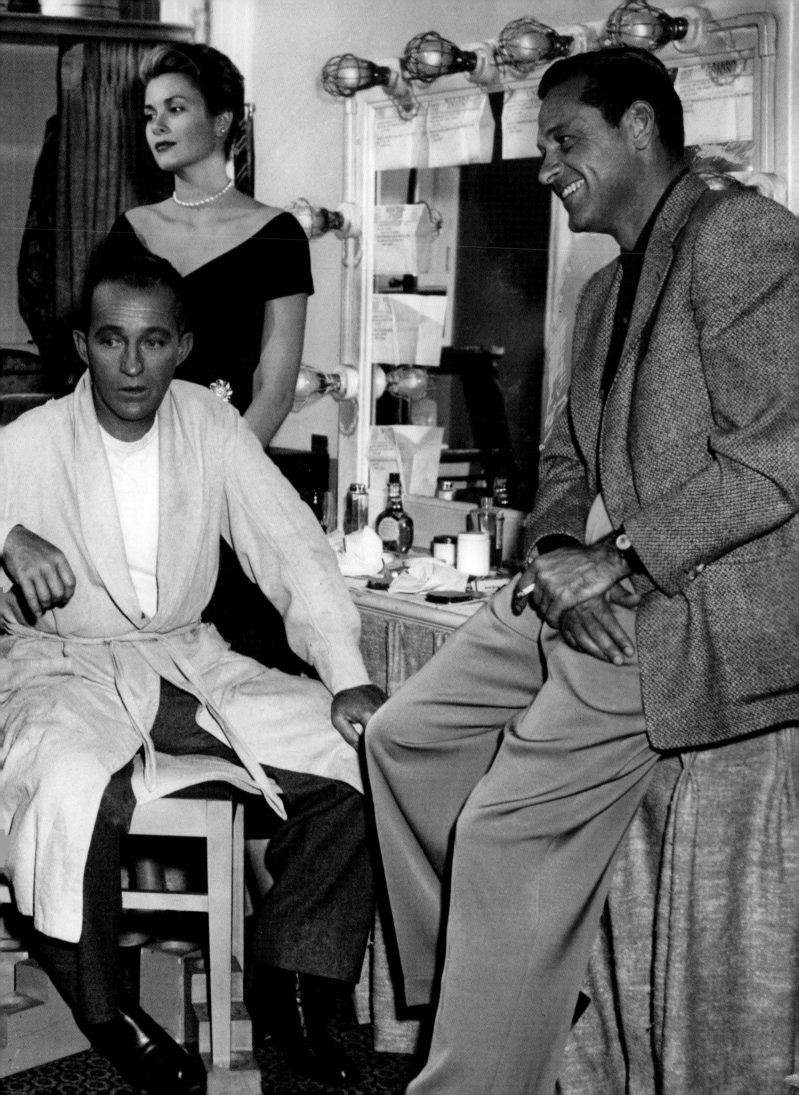

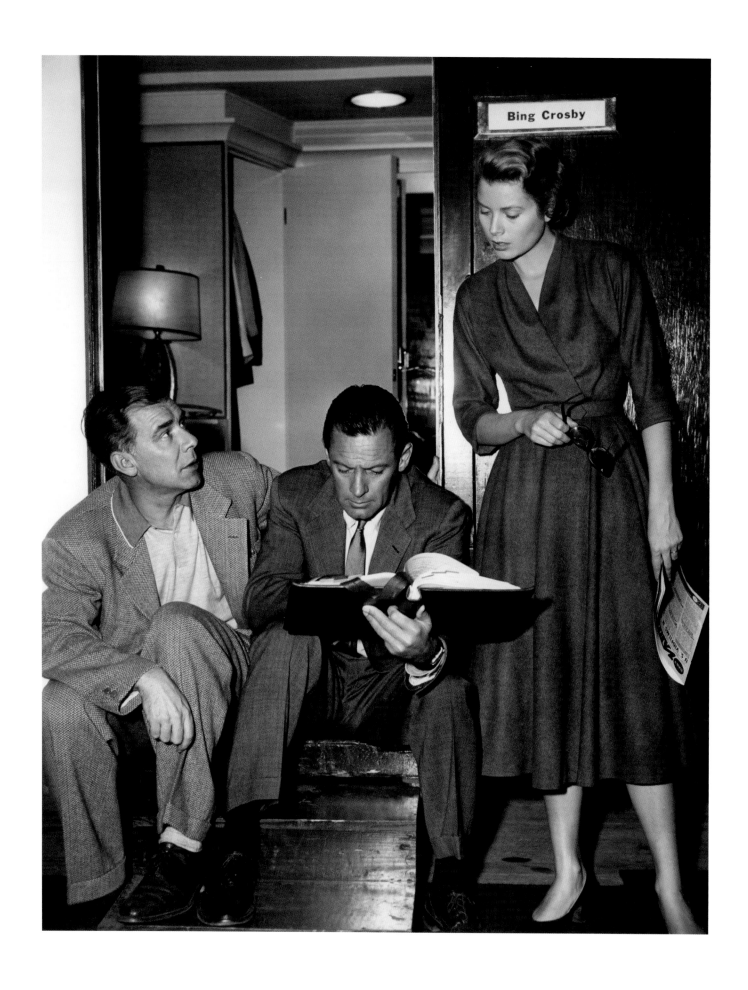

**ABOVE** (left to right) Director George Seaton, William Holden, and Grace Kelly. **OPPOSITE** Grace studies her script.

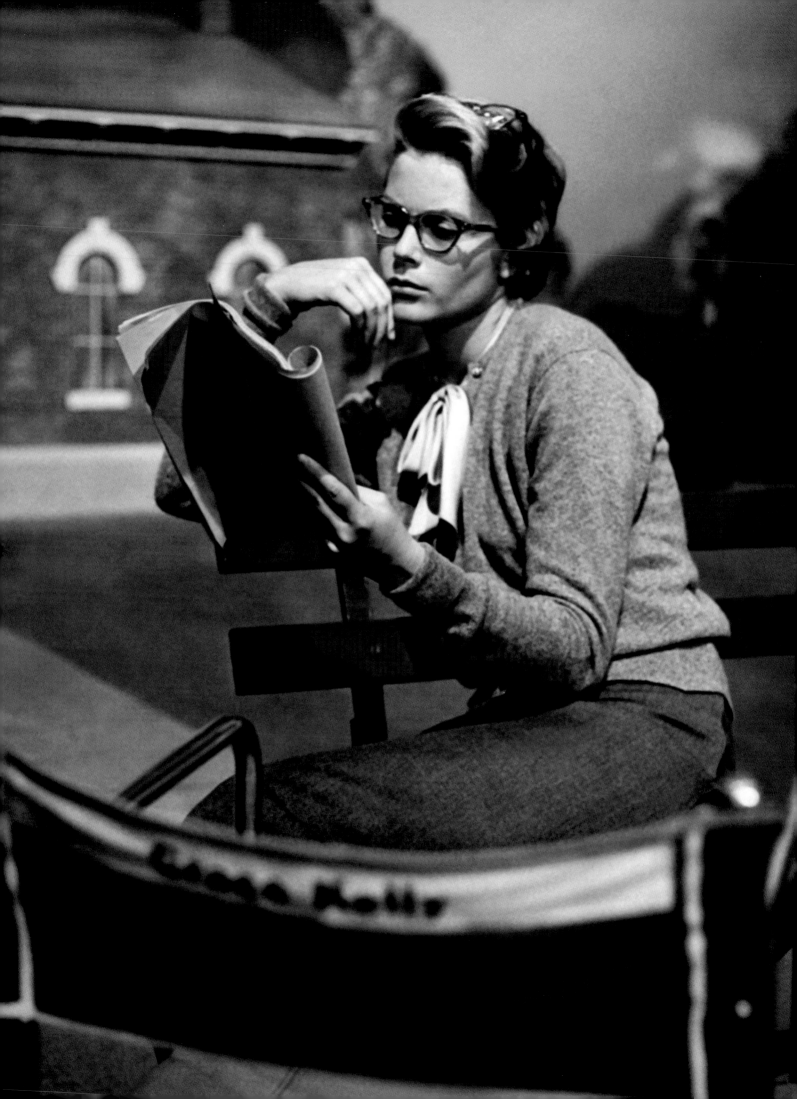

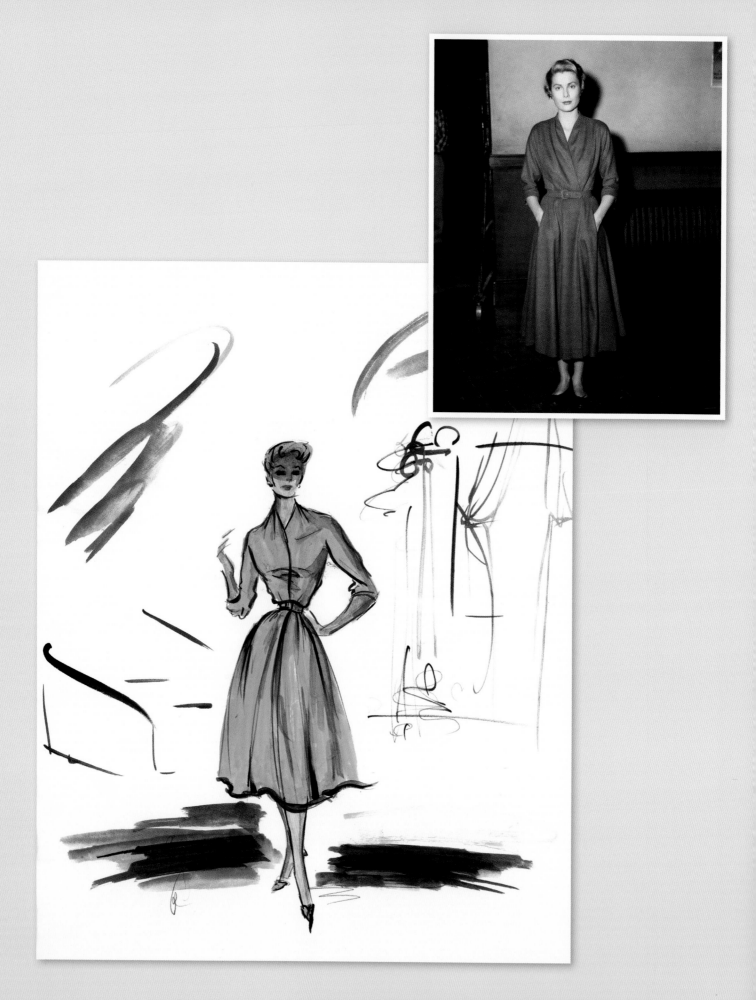

**ABOVE** A costume sketch done by Edith Head's sketch artist Grace Sprague. **TOP** A wardrobe test of the same outfit. **OPPOSITE** Grace with makeup supervisor Wally Westmore.

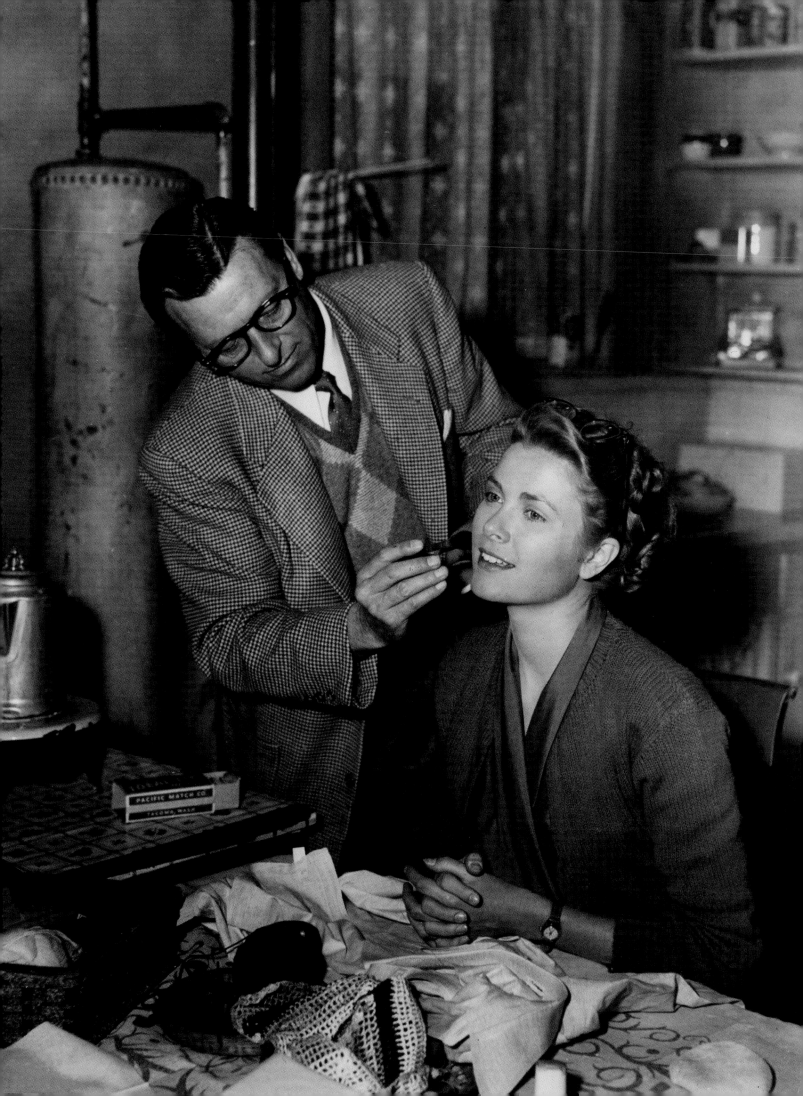

# "THE COUNTRY GIRL"

To Benefit the
UNITED STATES
OLYMPIC FUND

ED 2186                                                    ED 2186

**BING CROSBY**
sings selections from the Paramount Picture
**THE COUNTRY GIRL**

DECCA
RECORDS
EXTENDED PLAY 45
HI-FI

IT'S MINE, IT'S YOURS
(The Pitchman)

THE SEARCH IS THROUGH

DISSERTATION ON
THE STATE OF BLISS
(Love and Learn)
with Patty Andrews

THE LAND AROUND US

A Perlberg-Seaton Production
starring
BING CROSBY · GRACE KELLY
WILLIAM HOLDEN

Printed in USA

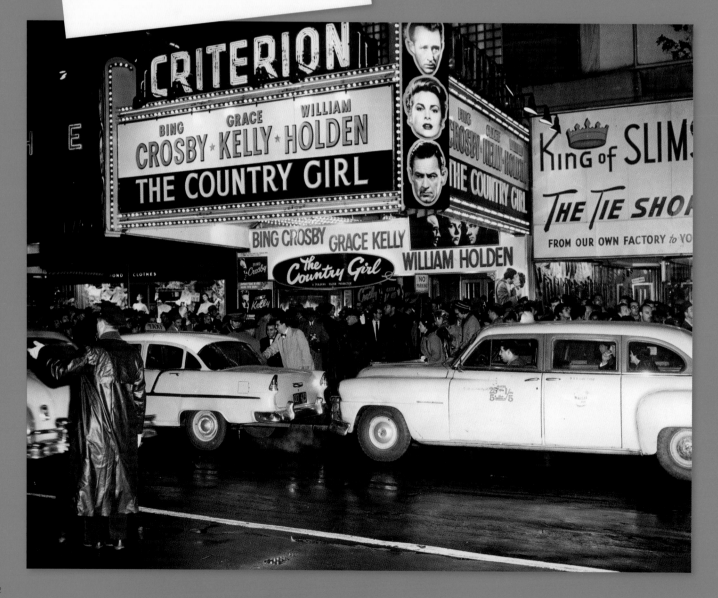

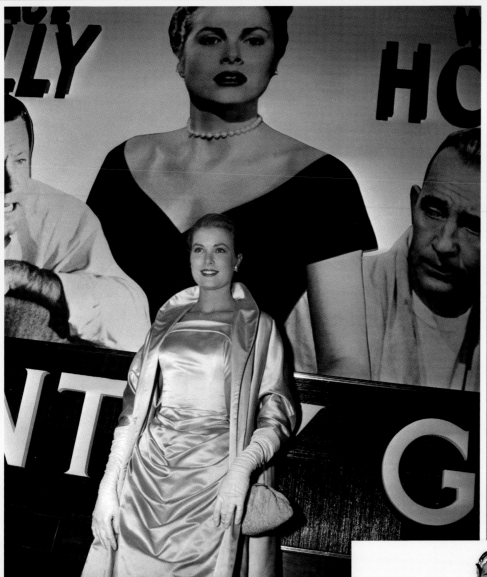

OPPOSITE TOP LEFT program for the Los Angeles premiere. OPPOSITE TOP RIGHT The soundtrack album. OPPOSITE BOTTOM The marquee outside the Criterion Theatre in New York City. TOP Grace arrives at the Criterion Theatre for the premiere. ABOVE A police pass for the West Coast premiere. RIGHT Sketch for the gown Grace wore to the New York premiere by Edith Head's sketch artist Grace Sprague.

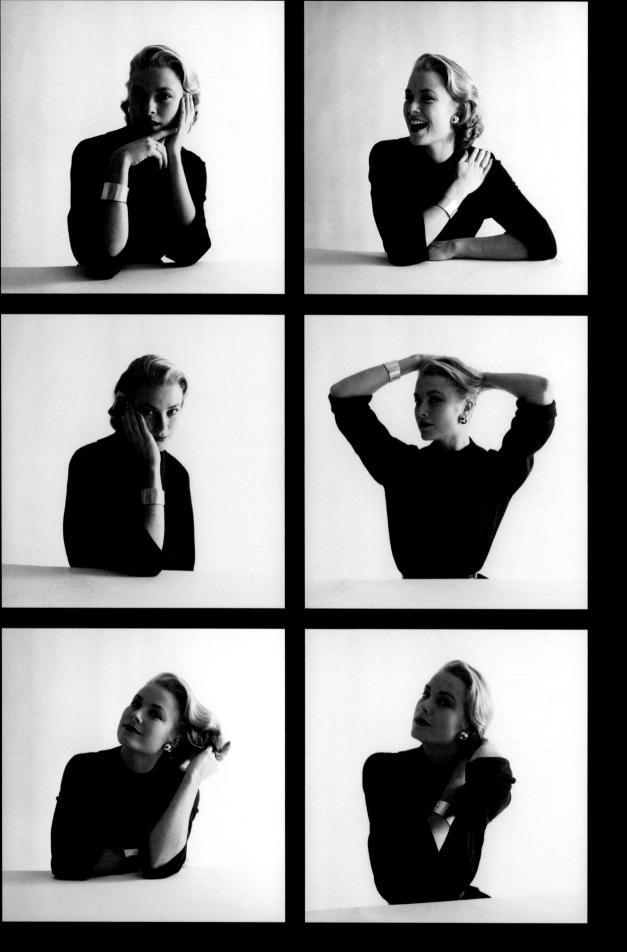

**ABOVE AND OPPOSITE** Portraits by Mark Shaw. As Grace's star rose, she was photographed for magazines by the world's most important editorial photographers.

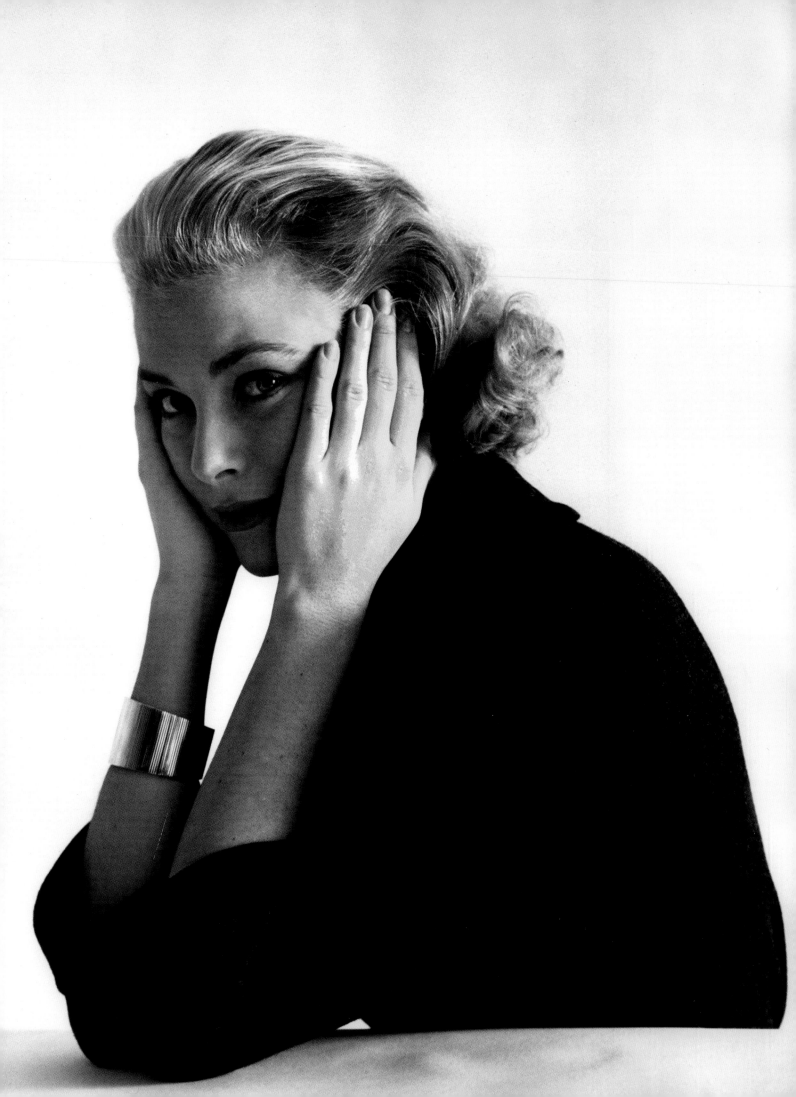

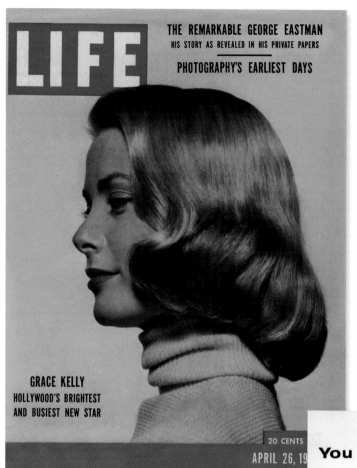

**LEFT** Grace's first appearance on the cover of *Life* magazine.
**BELOW LEFT** Bing Crosby on a date with Grace. **BELOW RIGHT** A tie-in
ad for Lux Toilet Soap. **OPPOSITE** Grace photographed by Cecil
Beaton in her Sweetzer Avenue apartment in Los Angeles.

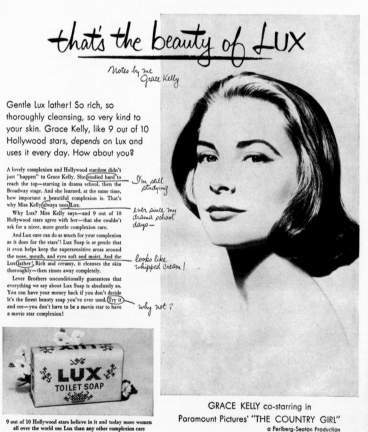

# Green Fire

## 1954

Nineteen fifty-four was shaping up to be a monumental year in the life of Grace Kelly. Though her stage acting career had not flourished, she had found Hollywood success on a grand scale. Her dreams were coming true so rapidly that she barely had a moment to stop and react.

"She was tired when she started," Lizanne LeVine later said of the film *Green Fire*. "She had done about six pictures in a row and she had to go to South America. She did do it, in order to get the part in *The Country Girl*." That was the deal Grace had made with MGM; as soon as *The Country Girl* wrapped, she started on *Green Fire*. It "wasn't one of her favorite films," according to LeVine.

British adventure-film star Stewart Granger was cast as Rian Mitchell, an engineer who discovers a lost emerald mine in Colombia, and Grace was given the role of Catherine Knowland, a plantation owner who nurses Mitchell's wounds after he is attacked. Paul Douglas plays Vic Leonard, a man hoodwinked by Rian into helping him mine the emeralds. Even though Rian's greed results in the death of Catherine's brother (John Ericson) and the near destruction of her coffee plantation, somehow Rian and Catherine end up together.

The action-romance film genre was so popular that almost no actor escaped appearing in one during the 1950s. But Grace understood keenly when reading a script whether she would be acting a role or merely reacting to events around her. *Green Fire* was the latter—and Grace was never interested in merely being window dressing. "A film like *Green Fire*, that absolutely made her blazing mad," Rita Gam recalled. "She said, 'This is not what I wanted to be an actress for.'"

In the spring of 1954, Grace was sent on location to the coastal Colombian towns of Cartagena and

Barranquilla. Oleg Cassini, who was still courting her, offered to accompany her, but Grace refused.

The cast was perplexed by the chosen location. "Everywhere was dusty, dirty, and swarming with flies, and God knows why we went there as I didn't see any emerald mines, which was the theme of our story," Granger said. "When we came back to Hollywood for the interiors, we matched up some missing exterior shots in the hills off Mulholland Drive and you couldn't tell the difference. A wasted trip." In 1957, Grace remembered

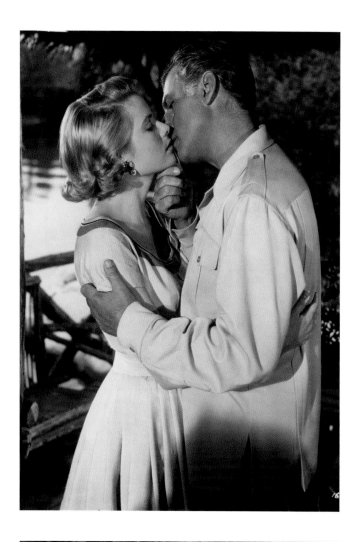

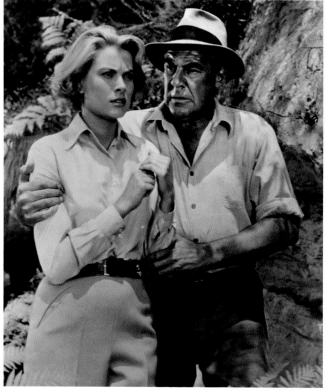

the trip as "a wretched experience. Everyone knew it was an awful picture, and it dragged on in all the heat and dust because nobody had any idea of how to save it."

Even worse, the production ran behind and Grace worried that she wouldn't finish in time to make it to the South of France to begin work on her next Hitchcock feature, *To Catch a Thief*. *Green Fire* director Andrew Marton was willing to shoot Grace's scenes first so she could be released on time, but the production manager refused to alter the plan. Luckily, Grace had an ally in Stewart Granger, who threatened to "get sick" and create costly production delays unless the production manager changed the schedule. Grace was thankful and thrilled to discover she would finish in time for *To Catch a Thief*.

The final scene Grace shot required her and Granger to be soaked in a torrential downpour while sharing a passionate kiss. While Grace had always been slender during her film career, being projected on a fifty-foot screen magnifies even the smallest flaws; actors are frequently unnerved by the process. Grace's chief concern, Granger remembered, was over how her derriere looked on film. "For me, it was the most delicious behind imaginable," Granger wrote, "but it did stick out a bit and she was very self-conscious about it." Granger decided to "help" Grace out by covering her soaking-wet behind with his hands. "She was so delighted at finishing the film that she didn't even object."

*Green Fire* turned a small profit in its U.S. release. Reviews were tepid, though critics admired the beauty of the film's locations and stars, enhanced by lush CinemaScope and vivid Eastmancolor. Bosley Crowther of the *New York Times* sensed that Granger and Kelly did their best given the mediocre material, saying they performed "with agreeable romantic enthusiasm and an average measure of credibility."

Philip K. Scheuer of the *Los Angeles Times* enjoyed *Green Fire* for what it was, an "entertaining, old-fashioned adventure melodrama." But even the critics were starting to lobby for MGM to put Grace to better use. "The role could have been filled by any of several of the studio's contractees," wrote Scheuer of Grace's part. "It is about time her home lot took her out of the jungle."

**TOP** Catherine (Kelly) is romanced by Rian Mitchell (Stewart Granger). **ABOVE** When Catherine is betrayed, Rian's friend Vic Leonard (Paul Douglas) steps in. **OPPOSITE** After making several films in a row, Grace was exhausted during filming.

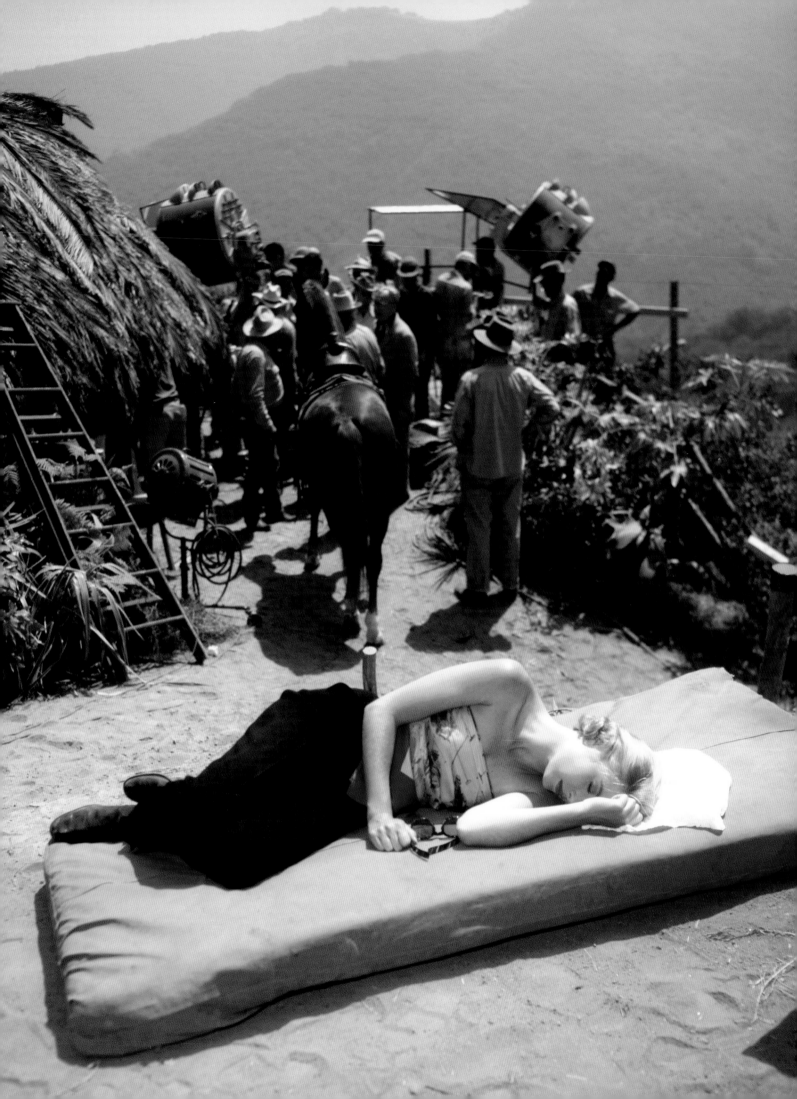

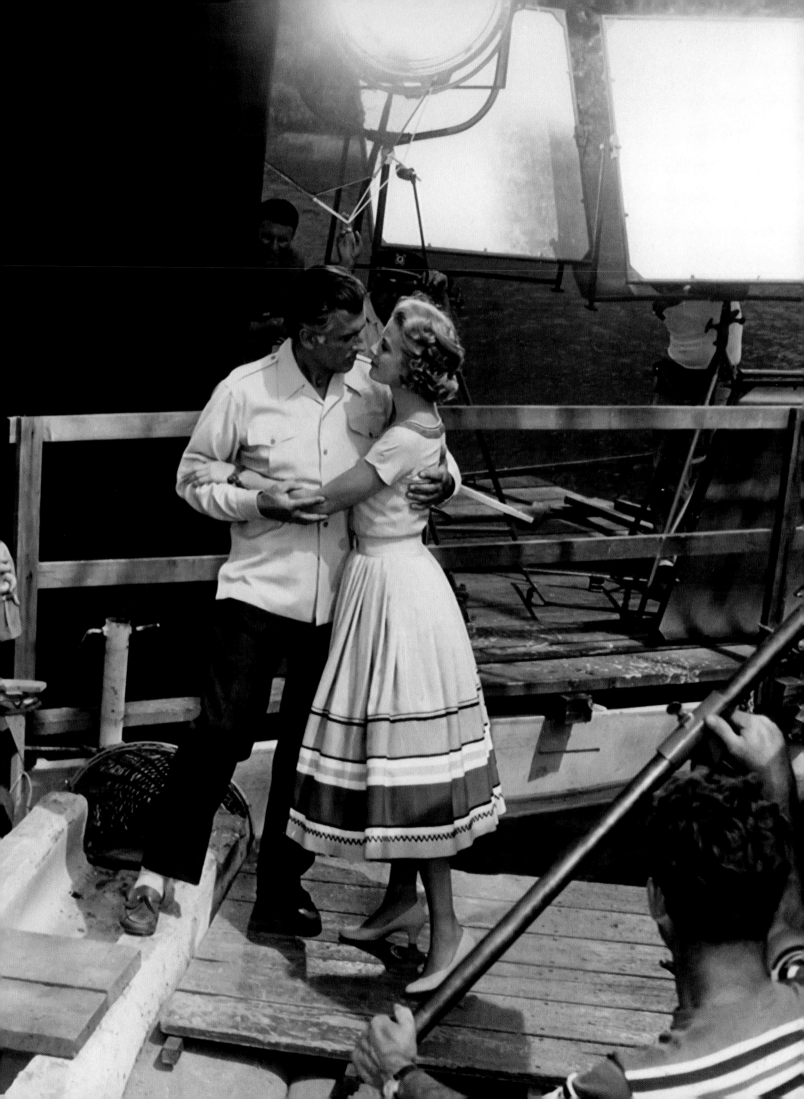

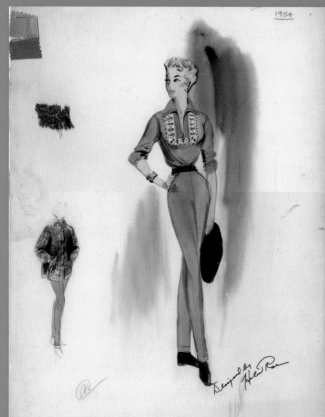

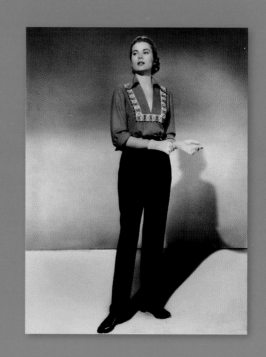

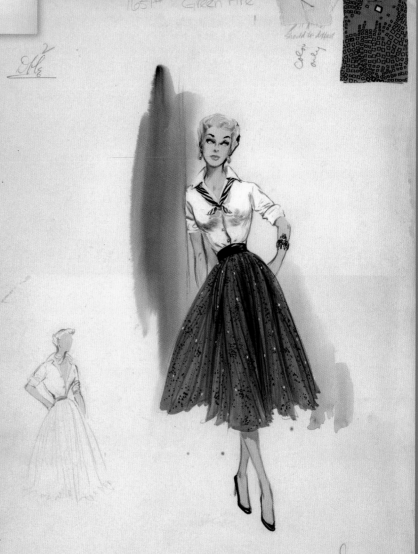

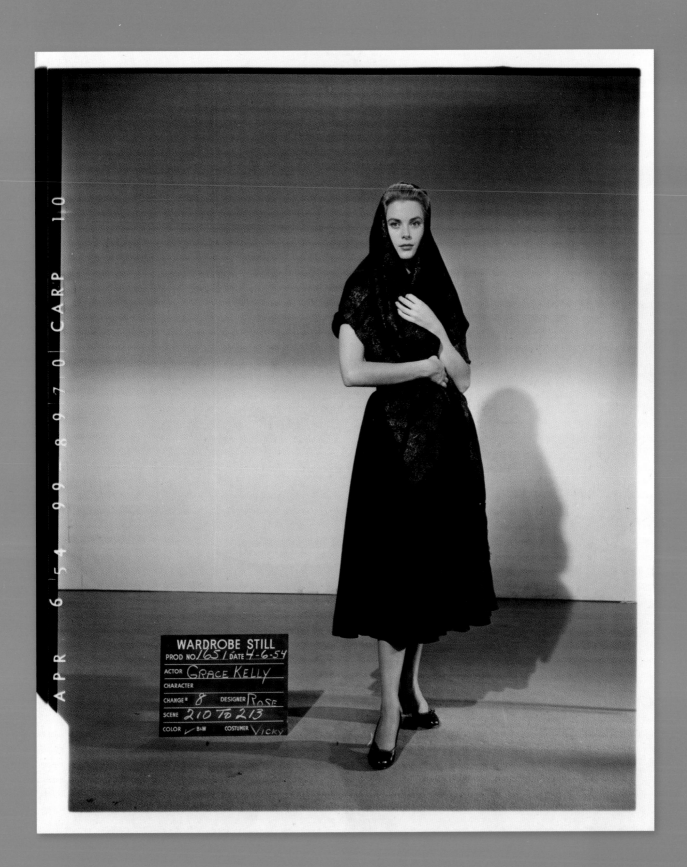

On the image, handwritten text on a wardrobe still slate:

**WARDROBE STILL**
PROD NO 1651 DATE 4-6-54
ACTOR Grace Kelly
CHARACTER
CHANGE# 8 DESIGNER Rose
SCENE 210 to 213
COLOR ✓ B&W COSTUMER Vicky

Vertical edge text: APR 6 54 99 8 9 7 0 I CARP 110

**PREVIOUS SPREAD** Producer Armand Deutsch (seated in front of camera) watches Granger and Kelly rehearse. **OPPOSITE AND ABOVE** Costume designs by Helen Rose.

# Hitch Your Wagon To A Great New Star

GRACE KELLY is the beautiful young M-G-M star who's got what it takes—and your 'take' will be upped if you promote her in your exploitation for "Green Fire"! In much less than two years she's Hollywood's most talked about star, having scored her first big hit in M-G-M's "Mogambo", which won her an Academy Award nomination. "Dial M for Murder", "Rear Window", "The Bridges at Toko-ri" and "The Country Girl" followed. Now she returns triumphantly to her home studio in "Green Fire"—and it's got the kind of action and romance that fans go for in a big way. Spread the word!

## LOBBY KUDO

Art shown at right is on the 6-sheet, 3-sheet and 1-sheet. Either cut it out, mount it and add line "In 'Green Fire'" as shown, or work from special photograph of same for a larger and sharper job (#LM 36237 from NSS). In addition to plugging Grace in your lobby, place standee over your marquee during "Green Fire" engagement.

CONGRATULATIONS! Gorgeous GRACE KELLY for another Exciting Performance in "GREEN FIRE"

## FASHION PROMOTION

Grace Kelly has a stunning tropical wardrobe designed by M-G-M's Helen Rose to wear in "Green Fire". Now is the height of the resort season in women's specialty stores and department stores. Each of these stores has a separate section in which they promote resort fashions, hence they will go for a "Green Fire" tie-in promotion. Plan a whole section of window displays —fashions similar to those Grace Kelly wears. Spot blow ups of stills shown at the right in these windows together with your credits. Too, try to get store to salute the film in a full page newspaper ad similar to the type that have been appearing in the New York dailies: "The . . . . Store salutes M-G-M's stunning new film 'Green Fire' in tropical Color and Cinema-Scope. See our colorful tropical resort fashions (etc.)". Order these stills from NSS (top to bottom at right): Grace Kelly 6190; Grace Kelly 6193; Grace Kelly 6223; Grace Kelly 6195; Grace Kelly 6187; Grace Kelly 6191; Grace Kelly 6194.

## INTERVIEW RECORD

A transcription interview with Grace Kelly, leading lady within 18 months to Clark Gable, James Stewart, Bing Crosby, William Holden and now, Stewart Granger is available. Miss Kelly tells of her fabulous rise through stage, summer stock and TV shows to comet-like stardom in '54, and of a romantic trip to the emerald mines of Colombia for "Green Fire". Order the transcription from your M-G-M field man.

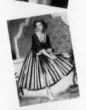

## GREATEST BARRAGE OF COVER BREAKS EVER

Wow! Covers of Grace Kelly have appeared within the last 10 months on the following magazines: LIFE, LOOK, NEWSWEEK, RED-BOOK, MODERN SCREEN. Furthermore, the lovely new star is gracing the cover of LOOK's January 11th issue. The Grace Kelly name is now a household one. Get together the issues cited above (your library should oblige), blow 'em up and use them on a 40 x 60 lobby teaser with the following sign: "Soon! The screen's most popular new star, GRACE KELLY, in M-G-M's great new adventure hit, 'Green Fire' co-starring (etc.)." For the record, here are the exact dates of cited magazines: LIFE— April 26, 1954; LOOK—June 15, 1954 and January 11, 1955; NEWSWEEK—May 17, 1954; REDBOOK—November, 1954; MODERN SCREEN—December, 1954.

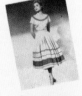

## KELLY BALLY

There are 503 "Kelly" listings in the Los Angeles phone book, which indicates a proportionate number in every city. With Grace Kelly the "hottest" new film personality run following: (1) Announce a Monday matinee with free admission to all girls named Kelly. (2) Hold a Kelly night with merchandise prizes or some other award in the name of Grace Kelly to the prettiest girl named Kelly. (3) Have local critic ask a "Kelly", perhaps a popular girl or athlete of local high school or college, to write a guest review of "Green Fire". (4) Have local Irish society have a Kelly party at your theatre, in which all local Kellys are feted by the group with songs, dances, prizes.

## PROMOTE HER WITH TIE-IN STILLS

Spot the following stills as suggested to cash in on the current blaze of Grace Kelly popularity, making sure that your playdate credits appear prominently in each instance: Earrings (jewelry stores): Grace Kelly 6239; Horseback riding (local riding academies): 1651x31; Rolleiflex camera (photography stores): 1651x13; Coffee (restaurants, food stores): 1651x35; Coca-Cola (travel terminals, candy stores): 1651x37; Negligees (women's specialty stores): Grace Kelly 6232.

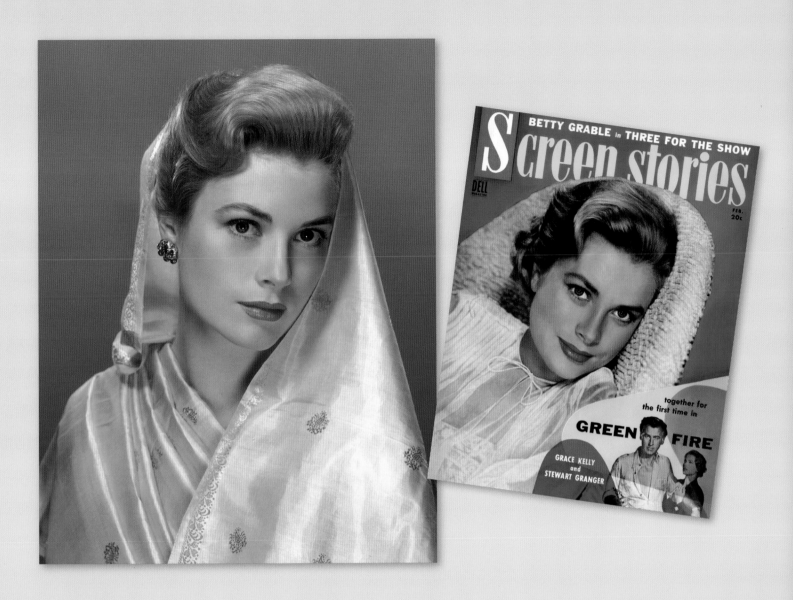

# EXCITING NEW TITLE THEME SONG!

M-G-M pre-sells "Green Fire" by launching the title song just before the film's release. Lyrics are by Jack Brooks and music by Miklos Rozsa, Academy Award winning composer. It's timed for you to cash in on the song's popularity. Both the sheet music and the M-G-M disc are now in stock at your local music stores. Plan a full window display in both record store and sheet music store dispersing same with a liberal collection of "Green Fire" stills and your credits. It is also important for you to get the disc spun by all local disc jockeys—not just once, but often. Too, try to get tie-in plug when record is played. Robbins Music Corp. of 799 Seventh Avenue, New York 19, N. Y. is the sheet music publisher. Dean Parker is the recording artist on the M-G-M disc, issued in both 78 and 45 r.p.m. Get everybody singing the "Green Fire" song in your town!

OPPOSITE The campaign manual for the film touted Grace's extensive press coverage and interest in her fashions.
TOP LEFT An MGM portrait. TOP RIGHT *Screen Stories* magazine carried a summary of the film. ABOVE MGM hoped for a hit with the film's title theme, but the song did not catch on with the public.

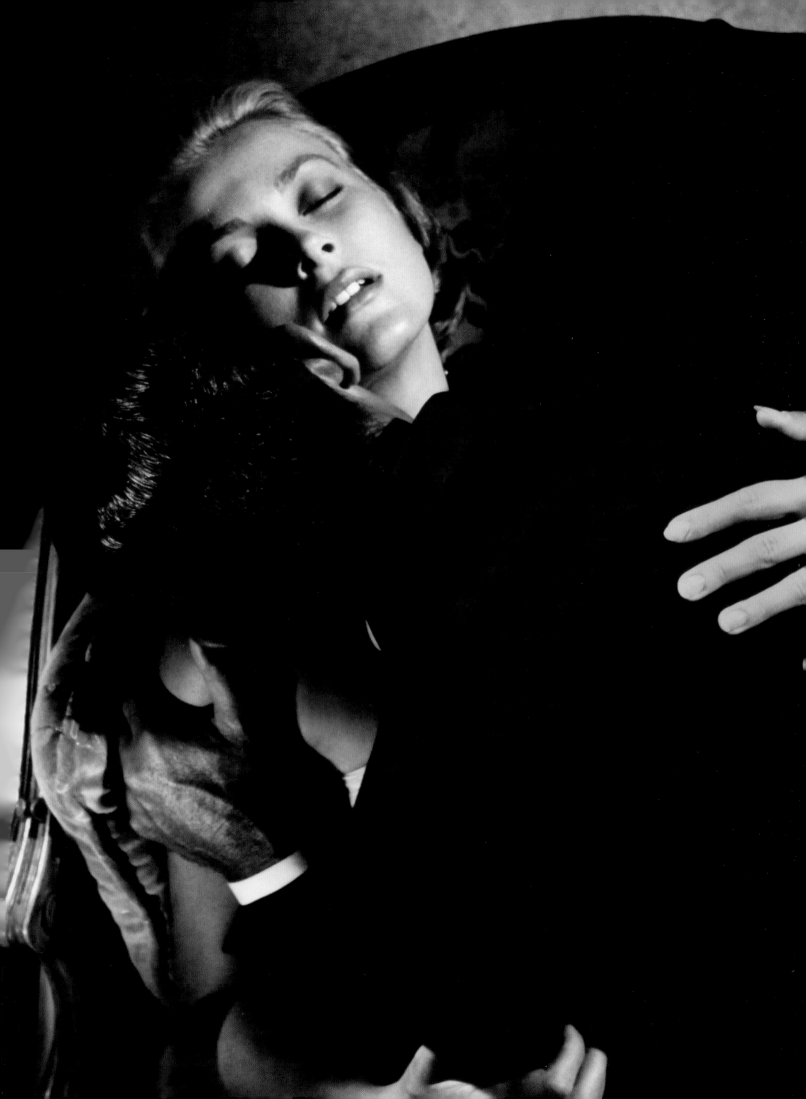

# To Catch a Thief

## 1955

"Before Hitch, Grace was a girl," said Judith Balaban Quine. "By the time she returned from Europe after making *To Catch a Thief*, Grace had become the movie star version of the ideal fifties woman—and she knew it."

The vehicle that would drive Grace Kelly from girl to woman—and solidify her image as the epitome of mid-century glamour—began as the novel *To Catch a Thief* by David Dodge. The title was derived from the proverb "Set a thief to catch a thief," and the story focused on John Robie, a retired jewel thief-turned-resistance fighter. When a new series of copycat jewel robberies is committed, Robie must go undercover to clear his name. He meets Maude (changed to Jessie in the film) Stevens and her attractive, headstrong daughter, Francie, who are carrying $72,000 worth of insured jewelry, and the plot thickens.

Alfred Hitchcock snatched up the screen rights in December 1951. In 1953, the director set to work to bring the novel to the screen, envisioning Cary Grant as his John Robie. Coincidentally, Grant announced his retirement from films around the same time. But Hitchcock wasn't worried; he felt he could still catch his old *Suspicion* (1941) and *Notorious* (1946) leading man.

Just as Hitchcock began production on *Rear Window*, he dispatched screenwriter John Michael Hayes to the Riviera to research *To Catch a Thief*, telling him to keep Cary Grant and Grace Kelly in mind while he worked out story concepts. As in *Rear Window*, once again Hitch would cast Grace as the assertive female in pursuit of the male.

Grace was eager to reunite with the master of suspense but had one reservation about making the film. "She thought the character was very cold, and she didn't want to come off that way," Jay Kanter said. "I had read

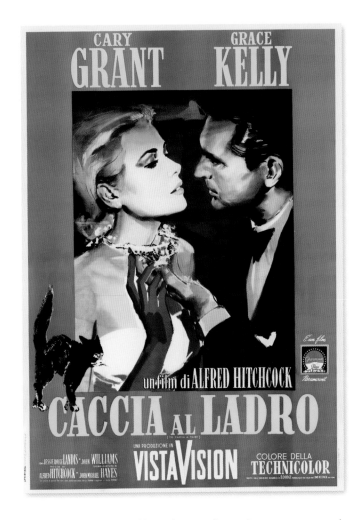

the script, and I told her that, as far as I was concerned, so far she'd struck it rich with Hitchcock—why stop here? And again, there was another huge costar in it."

Hitchcock snared Cary Grant by promising him 10 percent of the film's gross, yet as travel arrangements were made for cast and crew in April 1954, Grace was still negotiating with MGM to be in the film. But she felt so certain about *To Catch a Thief* that she hired a French tutor while making *Green Fire* in Colombia; she even told Edith Head to start designing her costumes. Finally, MGM agreed to lend Grace to Hitchcock a third

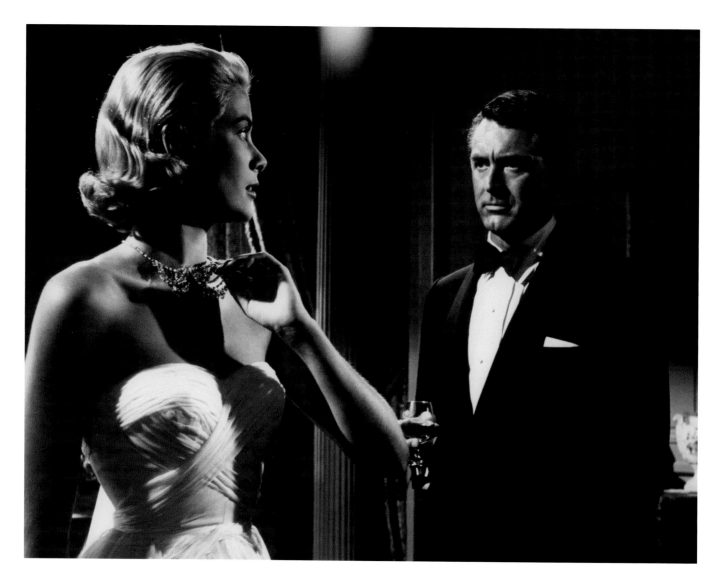

time, for $50,000. She officially joined the cast in the nick of time: barely a month before shooting began in France in the summer of 1954.

Grace was still being pursued by Oleg Cassini, her frequent escort at public events. To the press, Grace insisted she and Cassini were only friends and that she had no desire for a serious relationship with the "ardent, witty, charming, and intelligent escort," as *Modern Screen* described him in a 1954 article. "At the moment my career is getting most of my attention," Grace told the magazine. "Certainly I'm interested in marriage . . . but I don't think I could mix them at this particular time."

Grace, however, was not a woman who liked to be without a male companion. As she readied for the journey to France, Grace mailed Cassini a postcard that simply said, "Those who love me shall follow me." She flew to Cannes with her hairdresser Lenore Weaver on

May 28, and—after a delay in renewing his passport—Cassini joined her a week later at the Carlton Hotel (the production's headquarters). They spent an afternoon floating on a raft in the Mediterranean, and Cassini spoke frankly about his feelings. He confided to Grace that he cared for her deeply, and now the nature of the relationship was for her to decide.

Cassini believed this to be a turning point for them, but the following day Grace's attitude changed completely. She told Cassini she must focus on the production schedule and would have no more time for him. When he protested, she considered having the unit manager ask him to leave the hotel. "I cannot have my work disturbed. Even the man I marry will have to realize that," she told him.

The next day they patched things over, and Oleg Cassini stayed in France for two months. As he and

**ABOVE** Frances Stevens (Kelly) makes John Robie (Grant) an offer she believes he can't refuse. **OPPOSITE** Grace as the world-weary heiress.

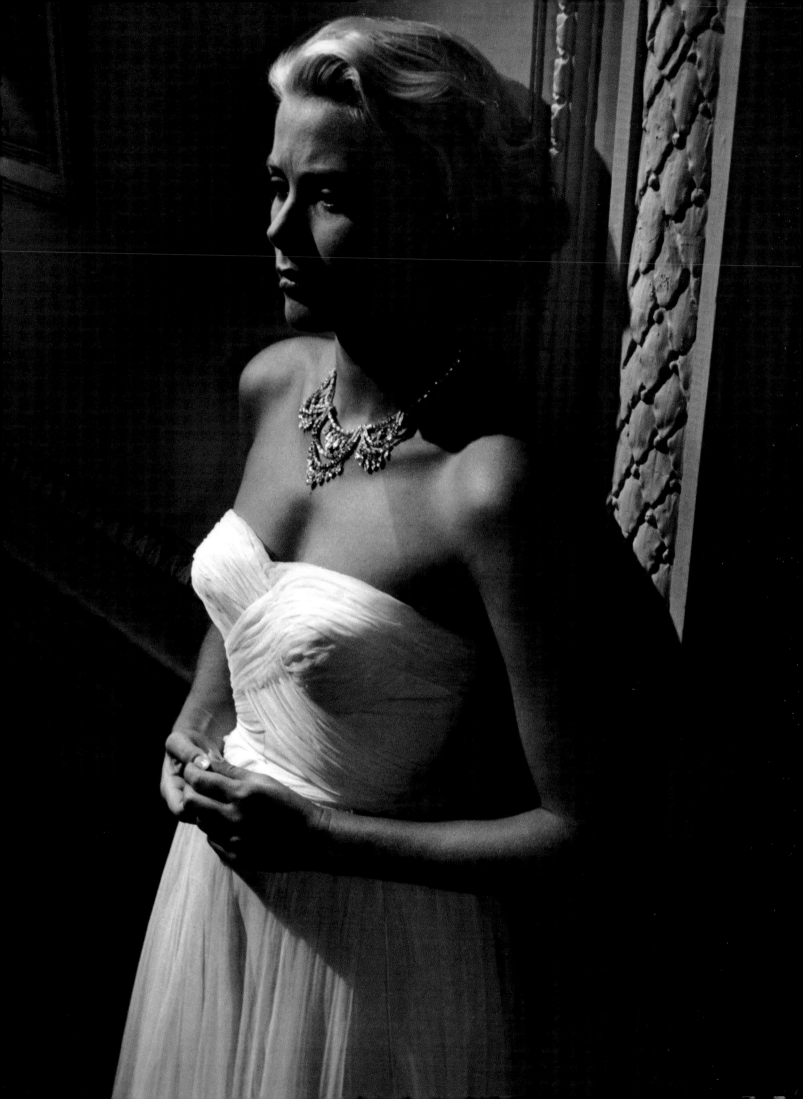

Grace. She knew what I was saying every minute. Her concentration is astonishing."

Hitchcock once described Grace Kelly as a "snow-covered volcano." No character she played typified that better than Frances Stevens in *To Catch a Thief*. Both Grace and Frances were paradoxes—ladylike and in control on the outside, but on the inside aggressive yet scared of their feelings. "What Grace brought, as an actress, was the actual young woman of the '50s into a vision of glamour," said Judith Balaban Quine. "It was a very proper era, in a way—a very prim era. Underneath that, of course, there was always the sense of flirtatiousness of young women and a sense of fun."

And Frances has plenty of fun. The playgirl daughter of an oil heiress, Francie tools around the Riviera in her convertible, always dressed impeccably, trading saucy double entendres with a dashing ex-cat burglar. "What do you get a thrill out of most?" Robie asks. "I'm still looking for that one," Francie purrs, eyeing him with a suggestive Cheshire-cat smile. Grant and Kelly sizzle together on-screen as she vies for his affection with Danielle Foussard (Brigitte Auber), a tenacious teenager with a crush on Robie. In what would be their final collaboration, Hitchcock, screenwriter Hayes, and Grace Kelly went out with a stylish bang.

"It was a happy set," remembers Bernard Wiesen, who was brought in by Paramount as a second assistant director (uncredited) owing to the large number of extras. Wiesen was impressed with Hitchcock's legendary efficiency when filming. "He didn't give directions to his actors on the set. He would just make sure they knew their marks. I asked him why, and he gave me his famous answer: 'Actors should be treated like cattle.' That line became folklore, but he really said it. The truth was that long before they got to the set, everybody knew what he wanted and they did it. Hitchcock hired who he wanted, and he knew what they were capable of doing."

"Grace Kelly was always factual about herself as an actress," wrote biographer Gwen Robyns. "It was one of her most appealing traits. Neither vain nor suffering false modesty, she was aware of all her faults, including the fact that she disliked the left side of her face. . . .

Grace swam, sunbathed, gambled, shopped, and went to church together every Sunday, they grew more and more inseparable. The couple often socialized with Alfred and Alma Hitchcock, and Cary Grant and his wife, Betsy Drake. When Hitchcock was asked by the press about Cassini's constant presence, he answered, "This is out of the realm of picture-making. I wasn't even aware she knew the fellow until he arrived in Cannes. She hasn't talked to me about him; she doesn't discuss him with anyone." Grace, as usual, kept her private life to herself and her laser focus on her acting.

Cary Grant, for one, was impressed with his costar's ability. "When she's playing opposite someone, she's actually listening," Grant said of Grace. "Many actresses never do. They just keep wondering about their looks. I have a little trick I use from time to time. I interrupt myself in the middle of a rehearsal line and I say to the actress playing the scene with me, 'What was I saying?' Most of them can't tell me. They weren't listening. Not

**ABOVE** Upon seeing Grace in the gold ball gown, Alfred Hitchcock (left) remarked, "Grace, there's hills in them thar gold!" **OPPOSITE** Grace on location in France. **OVERLEAF** Cary Grant (left) and Grace under the watchful eye of Hitchcock (foreground center, back to the camera).

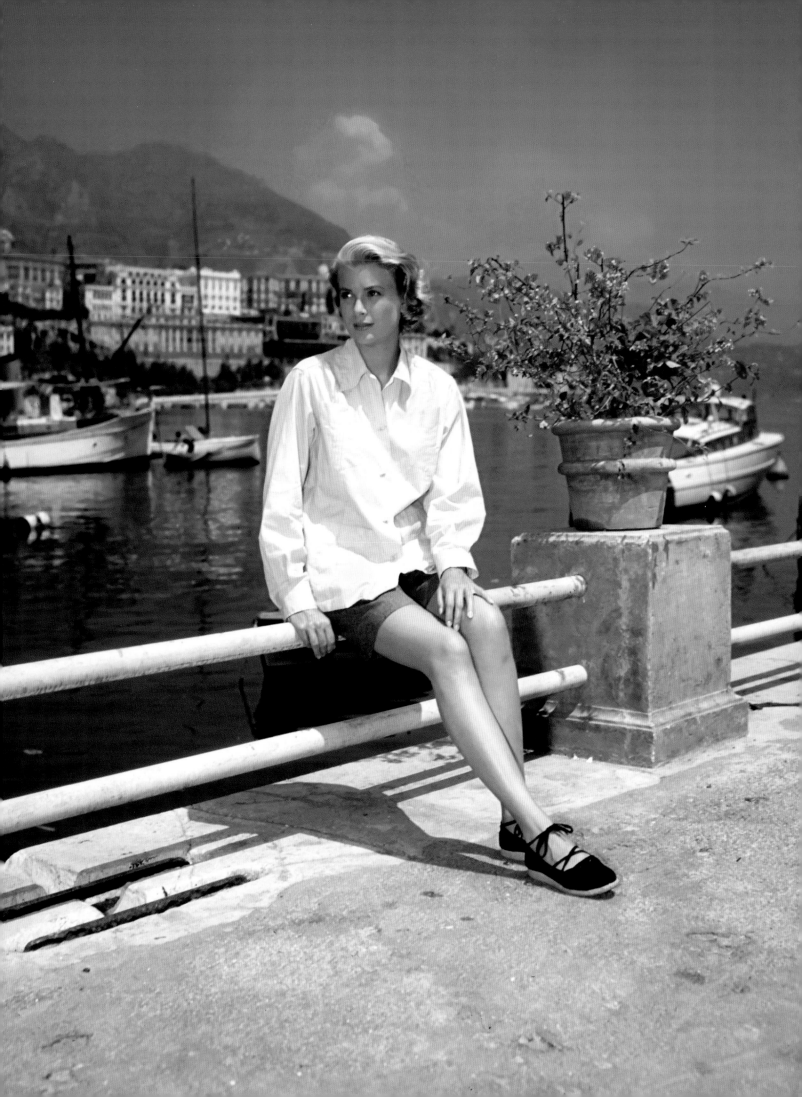

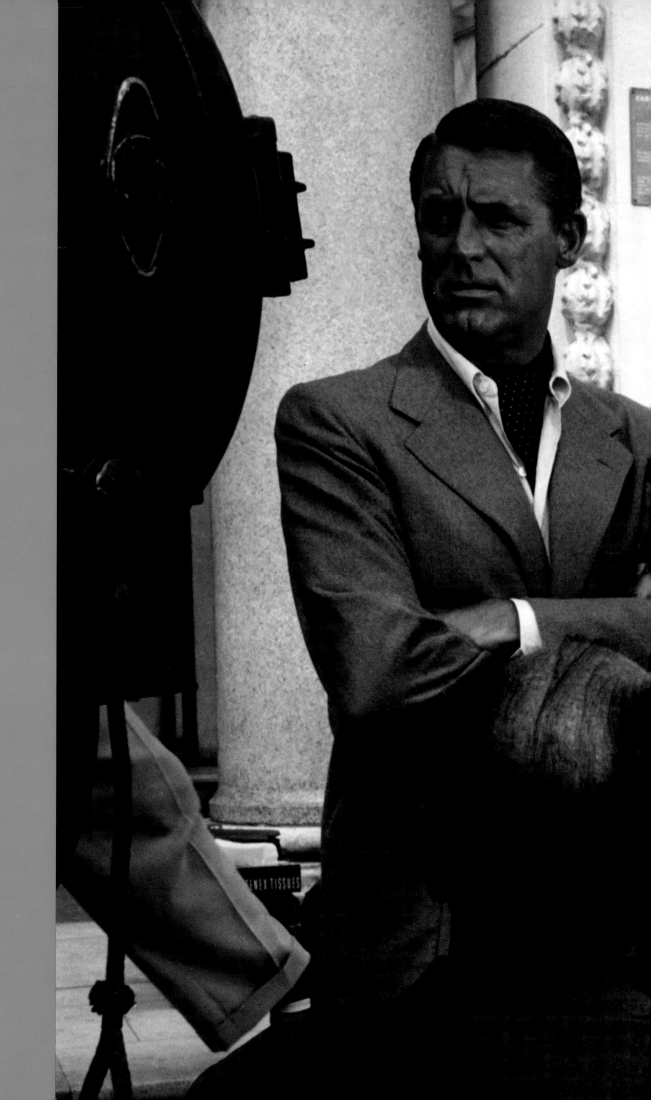

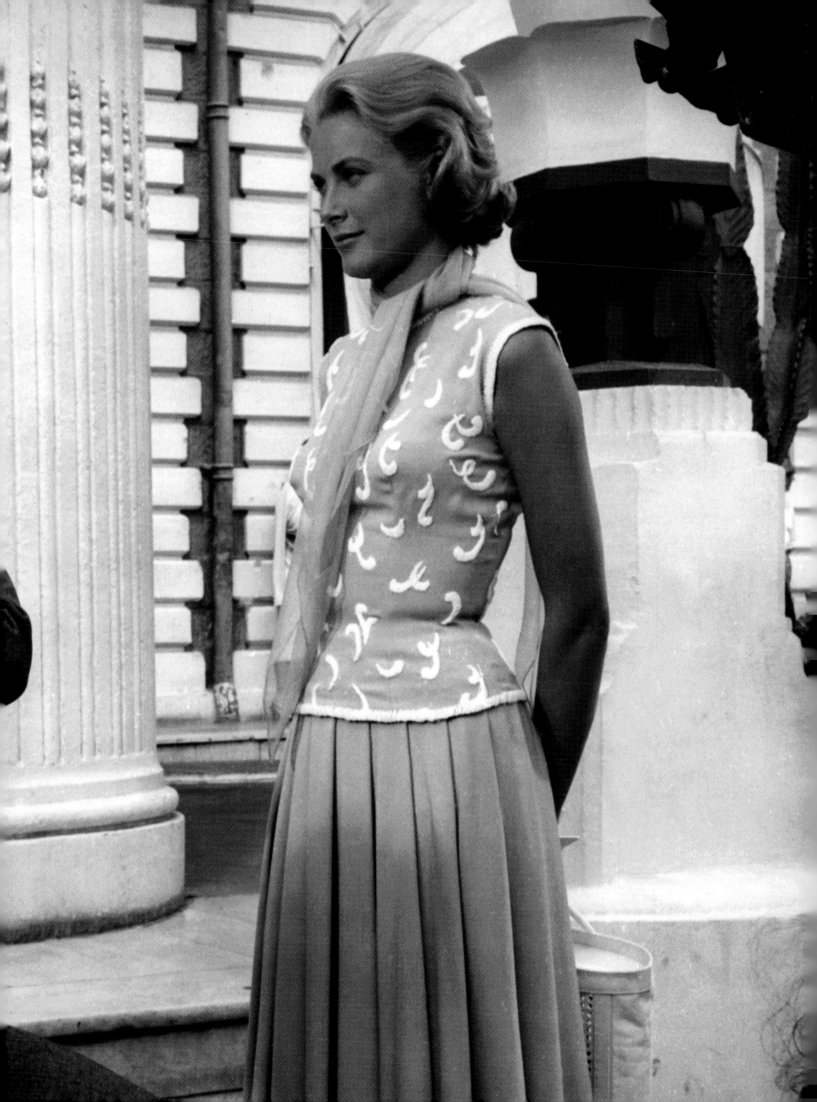

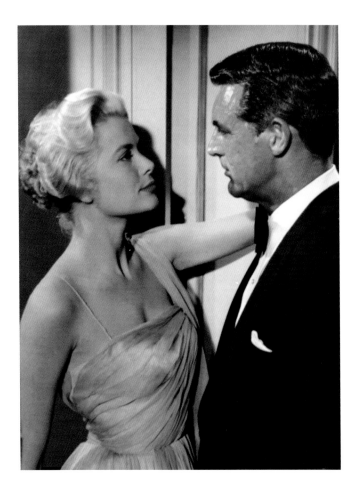

Though too wholesome-looking to be mysterious, she settled instead for a fragile, tantalizing perfection that occasionally irritated women, but never men. And this is what appealed to Hitchcock." Hitchcock himself always claimed he was drawn to "the subtlety of her sex," meaning that he felt Grace "conveyed much more sex than the average sexpot. With Grace, you got to find it out. You got to discover it."

Cassini once asked Grace if she ever thought that Hitchcock had sexual fantasies about her. "She did say to me that sometimes she had a feeling that he liked her, very specially," Cassini said. "But it was a very mental thing with him. It might have been a frustrated sexual appeal, if he had a sexual fantasy for her, well so much the better. I think she considered that a plus that would help her performance because he could put more care, more feeling on it."

One night near the end of their stay, at a restaurant in Cannes, Grace finally agreed to make a life with Cassini. "I was tremendously happy at that moment and flattered that she wanted to marry me. I was filled with pride

and love, and was entirely enraptured by her," Cassini said. Almost immediately after their engagement, Grace began making mental plans for the wedding. She told Cassini she would write to her parents with the news, though she cautioned her fiancé that he did not fit her father's image of the ideal son-in-law.

While Cassini hoped to earn the Kellys' approval, Grace was closer to her destiny than she knew. On one of their days off, Cary Grant, his wife, Betsy Drake, John Michael Hayes, and Grace took a tour of Monaco. The group ended up outside the royal palace of Rainier III, the prince of Monaco. Grace, peering through the locked gates to try to get a glimpse of the gardens, said to Hayes, "I wonder if we could find some way to get in?" Hayes suggested that perhaps the production office could contact Prince Rainier and arrange a tour during her stay. But location photography finished before any tour was arranged.

Filming on the Riviera wrapped on June 25, 1954. Cassini and Grace traveled separately back to America. Grace felt if they kept up the appearance of propriety, chances of her parents' approval would be better. She needn't have bothered.

When Grace arrived in New York, Cassini took Grace and her mother out to lunch. "Well, here we are," Cassini joked as they shared a cab, "the unholy trio." Mrs. Kelly was not amused. "You, Mr. Cassini, may be unholy. I can assure you that Grace and I are not." That was only the beginning of the jabs. Mrs. Kelly told Cassini emphatically that the family did not view him as suitable marriage material for Grace. The meeting quickly dwindled into a replay of similar scenes when the Kellys had scorned their daughter's choices in men.

"Grace was fighting to try to become a 1950s-'60s-'70s [woman], into the female explosion of women being independent," said Rita Gam. "And Mrs. Kelly and Mr. Kelly were pulled right back there to 'Girls obey their parents, girls behave a certain way,' and it was an enormous conflict in Grace's life."

Though Grace bristled against her parents' control, she always relented in the end. Cassini had been married twice before, to cough syrup heiress Merry Fahrney and to actress Gene Tierney. "My father did not like Oleg,"

**ABOVE** Frances (Kelly) bids a passionate good night to John (Grant).

Lizanne LeVine said later, "only because he was divorced. . . . It was one of the things you did not do. You did not marry a divorced man." Once again, Grace said nothing and made no plea to her parents on Oleg's behalf. She continued to see Cassini, though they dined in most nights at Grace's apartment to avoid photographers.

By this time, Grace's name was hot copy. Movie magazines like *Photoplay*, *Modern Screen*, and *Motion Picture* ran cover stories with tantalizing titles like "The Whole Town's Talking About Kelly!," "Grace Kelly: The Girl Who Dares to—," "Ice-Cold Kelly: Does She Have a Heart?," and "Hollywood's New Garbo." She was seen as exclusive and aloof because she disliked giving interviews. Grace's press agent, Rupert Allan, did most of the crafting of Grace's public image. Since she was seen so much with Cassini, the press went wild speculating if Cassini was worthy of the world's newest shining star.

Grace and Oleg considered eloping, but Cassini knew an elopement would invite hostility from the press and her parents, as it had when he eloped with Gene Tierney. He abandoned the idea. It would be a decision that would help to doom their relationship. Cassini said later, "We both hesitated, and the moment was lost."

Grace returned to Los Angeles to complete scenes for *To Catch a Thief* in late June. The exterior of the Côte d'Azur villa where the film's climactic rooftop scene takes place had been re-created on Paramount stages 14, 15, and 16. It was there that Cary Grant and Brigitte Auber, both former acrobats, enacted their game of cat-and-mouse on rooftops eighty feet in the air. Scaffolding was built around the stage so the cameras could photograph from above. When shooting on the Paramount lot finished on August 10, 1954, Hitchcock had brought the production in just slightly under budget, at a cost of $2,784,053. It would earn nearly four times that much in box-office returns.

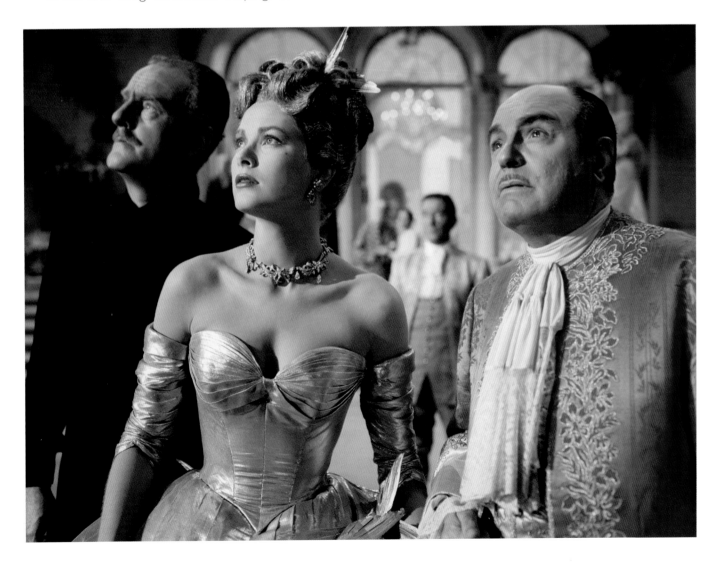

**ABOVE** Hughson (John Williams), Frances (Kelly) and Commissaire Lepic (René Blancard) watch the scuffle on the roof.

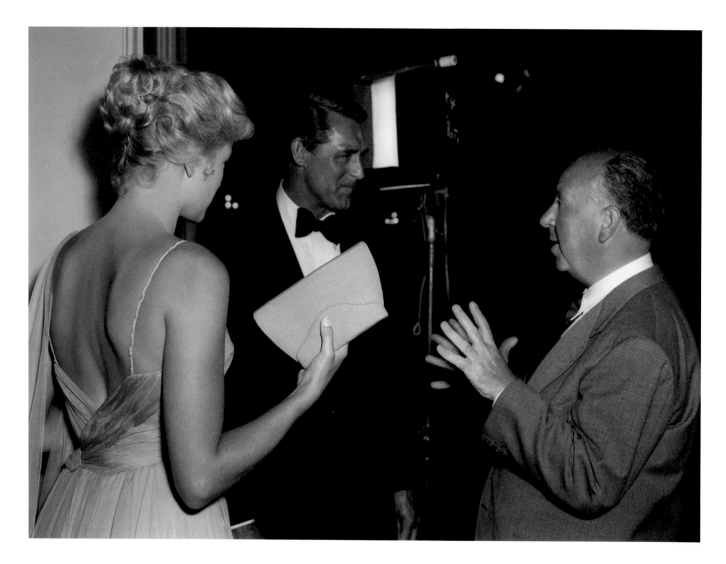

*To Catch a Thief* was an immediate smash with the public, though reviews were mixed. Despite their criticisms—the plot was thin; the director chose style over substance—reviewers couldn't help admitting they enjoyed the ride. The *Los Angeles Times* blamed any shortcomings on the enchanting location of the French Riviera, "a lazy, laissez-faire thing that apparently captivated the director as much as it will audiences in the soft, beguiling hues of its Technicolor and VistaVision." The *Times* called Cary Grant "every bit the catch he seems to be," and declared Miss Kelly "the epitome of chic."

From Grace's sky-blue chiffon dress to her striking black-and-white beach ensemble and the lustrous ivory strapless gown she wears in the fireworks scene, Edith Head outdid herself, draping the suntanned star in the finest fabrics. Head described the fancy masquerade ball at the end of the film, in which Grace wears a stunning Louis XV dress of delicate gold lamé, as the most expensive costume scene of her career. "Hitchcock told me that he wanted her to look like a princess," said Head. "She did." But Grace struggled to get in and out of the confining costume, causing delays. Assistant director Daniel McCauley banged on Grace's dressing-room door one day, telling her that Hitchcock was waiting. When she arrived on the set, rather than admonishing his star, Hitchcock took one look and said, "Grace, there's hills in them thar gold!"

"When people ask me who my favorite actress is," Edith Head said, "and what my favorite film is, I tell them to watch *To Catch a Thief* and they'll get all the answers." Cary Grant felt the same way. Though *Thief* was their only chance to work together, he later called Grace "the most memorable and honest actress I've ever worked with" in a long, distinguished career.

ABOVE Hitchcock (right) directs the first meeting between Frances (Kelly, left) and John (Grant, center). OPPOSITE Grace takes a break on the Paramount soundstage. OVERLEAF Frances (Kelly) watches John emerge from the water.

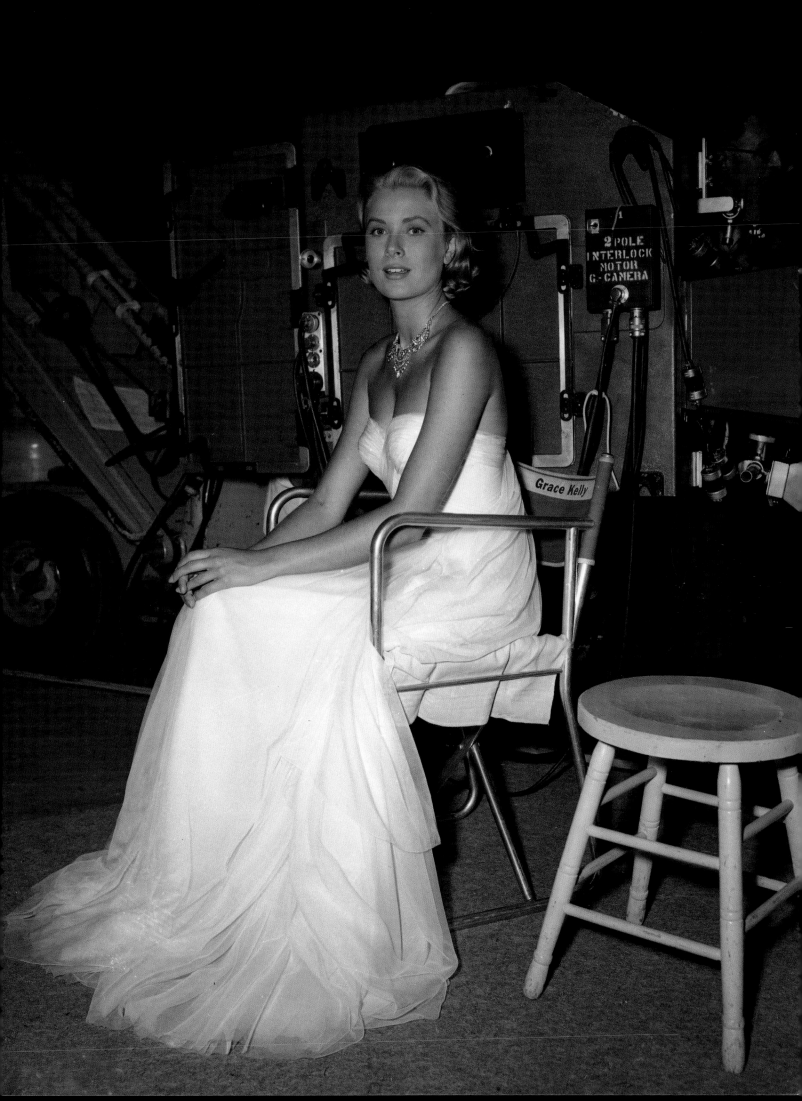

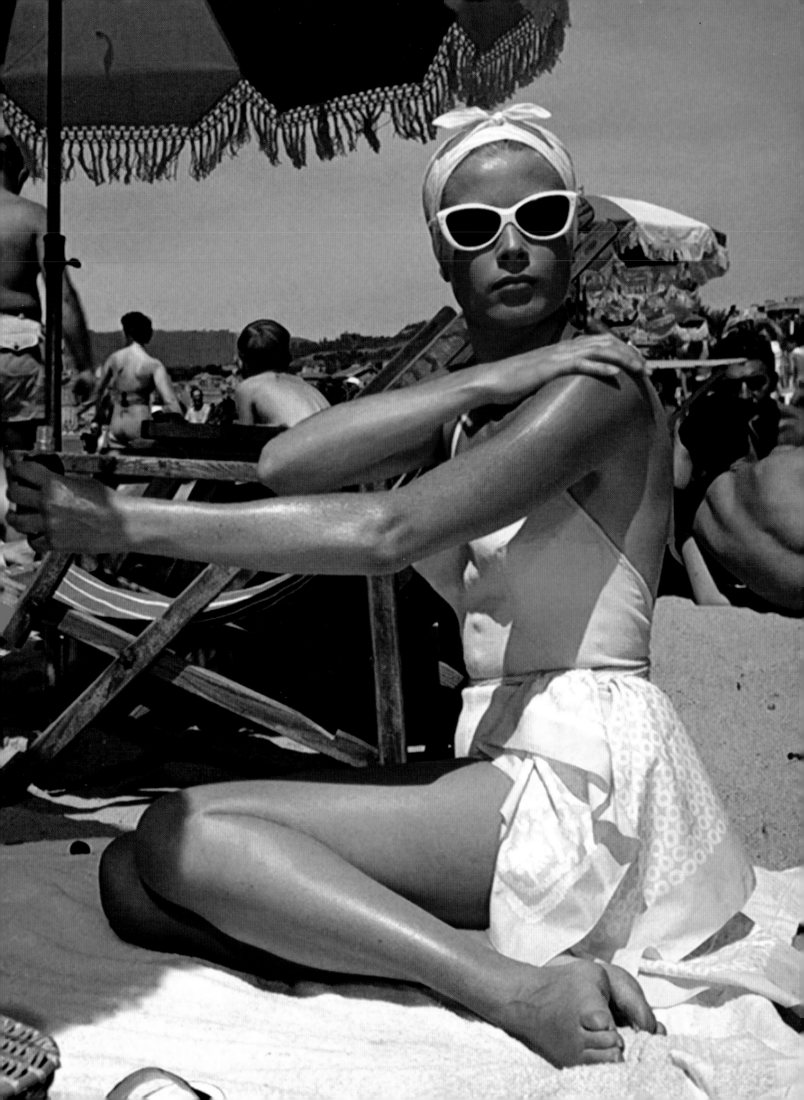

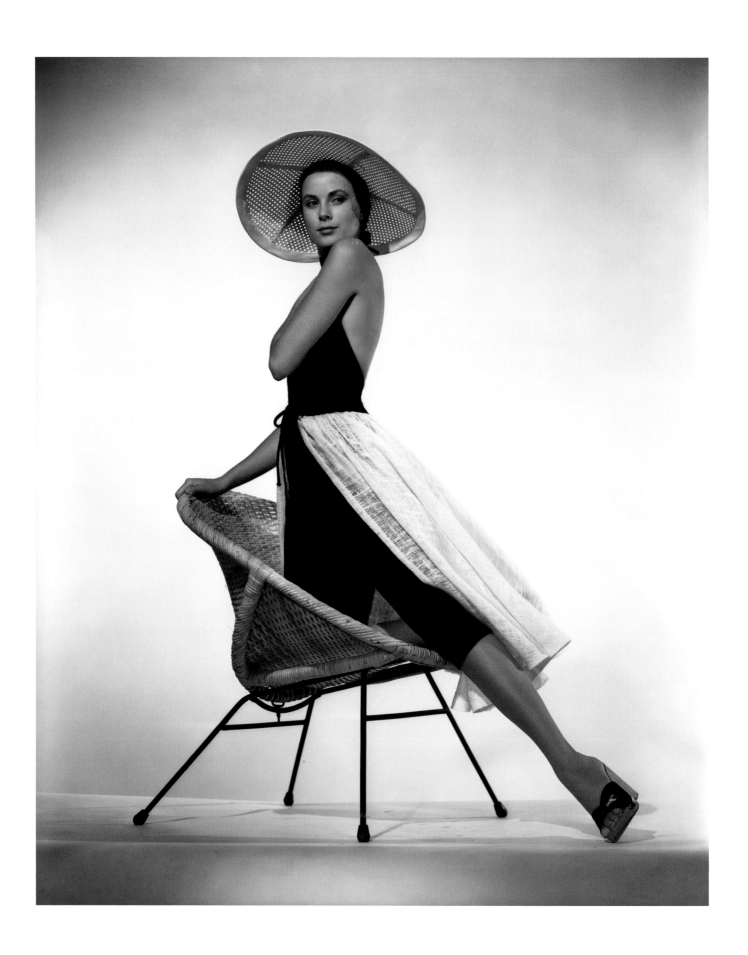

**ABOVE** Hitchcock wanted an outfit that would turn heads in the hotel lobby.

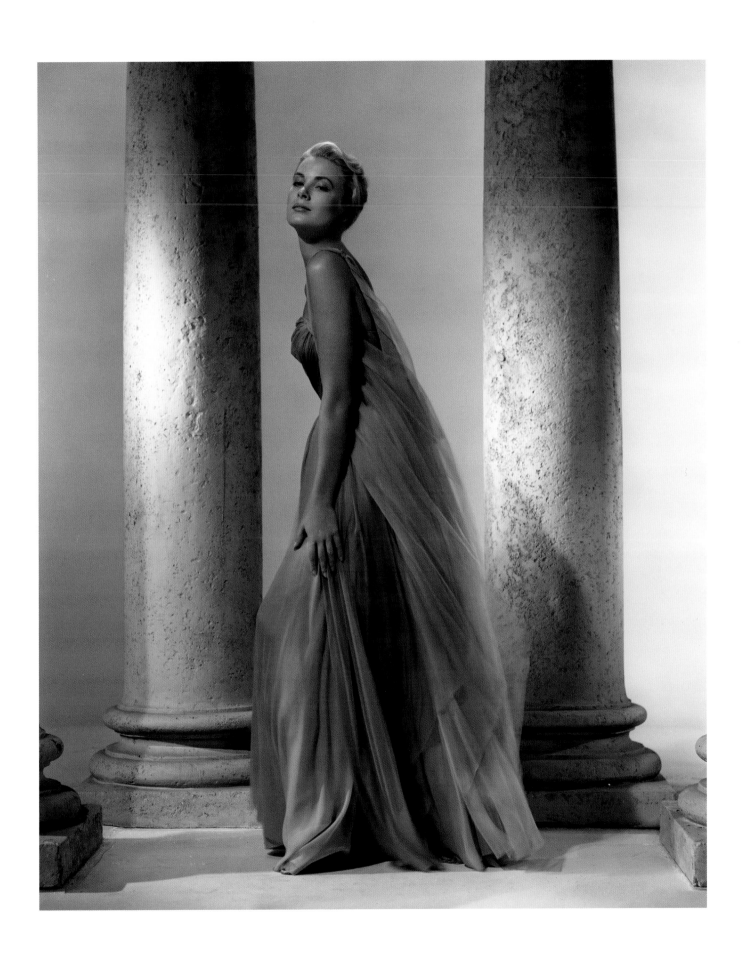

ABOVE Grace in the gown of blue draped chiffon. OVERLEAF LEFT Grace consults with costume designer Edith Head (right).
OVERLEAF RIGHT Costume sketches for Grace by Edith Head's sketch artist Grace Sprague.

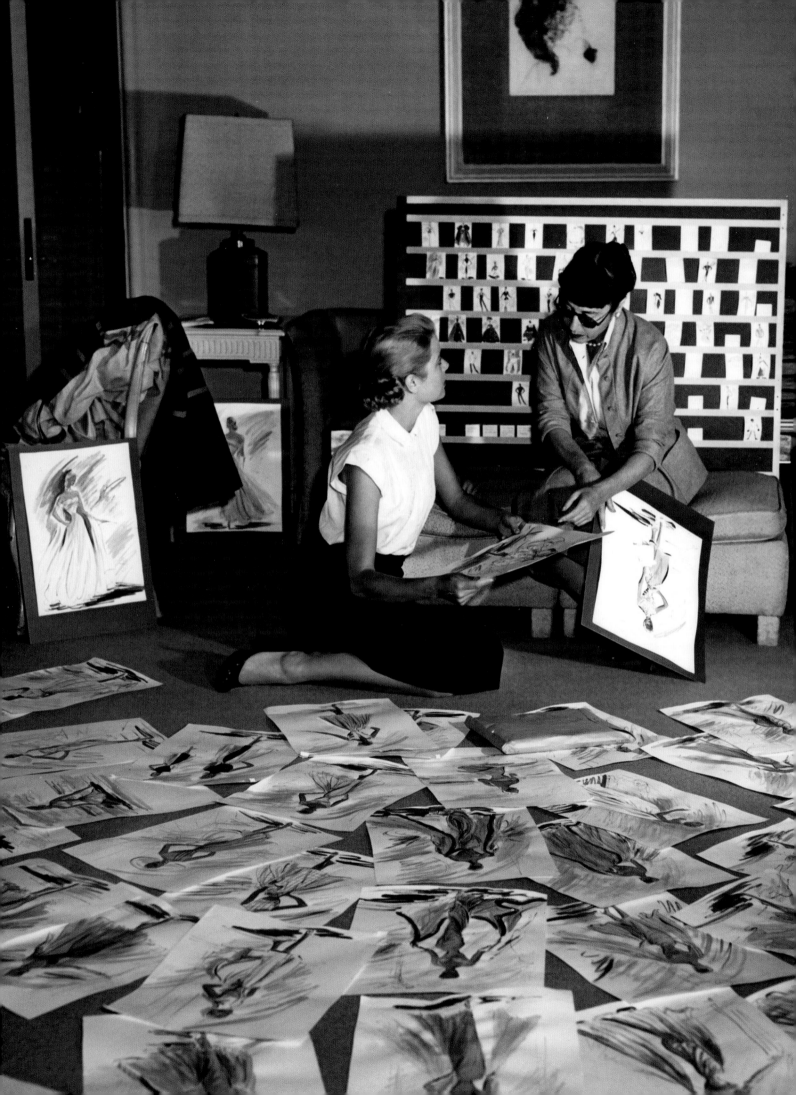

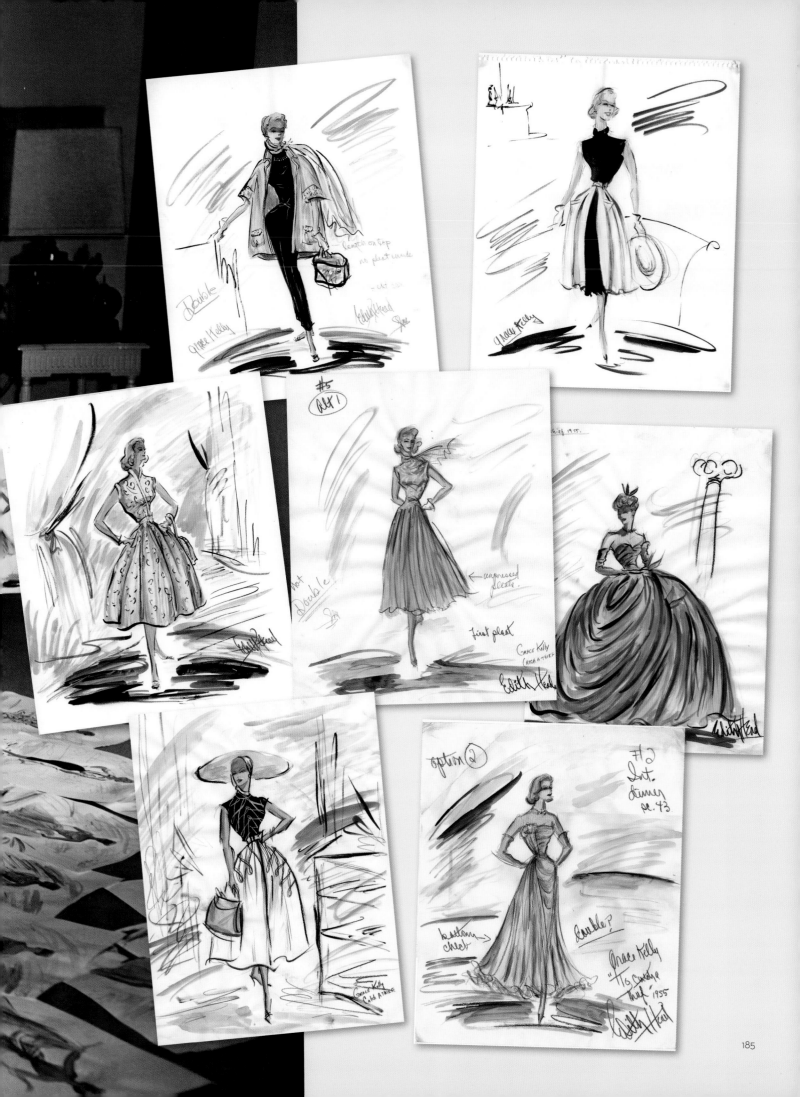

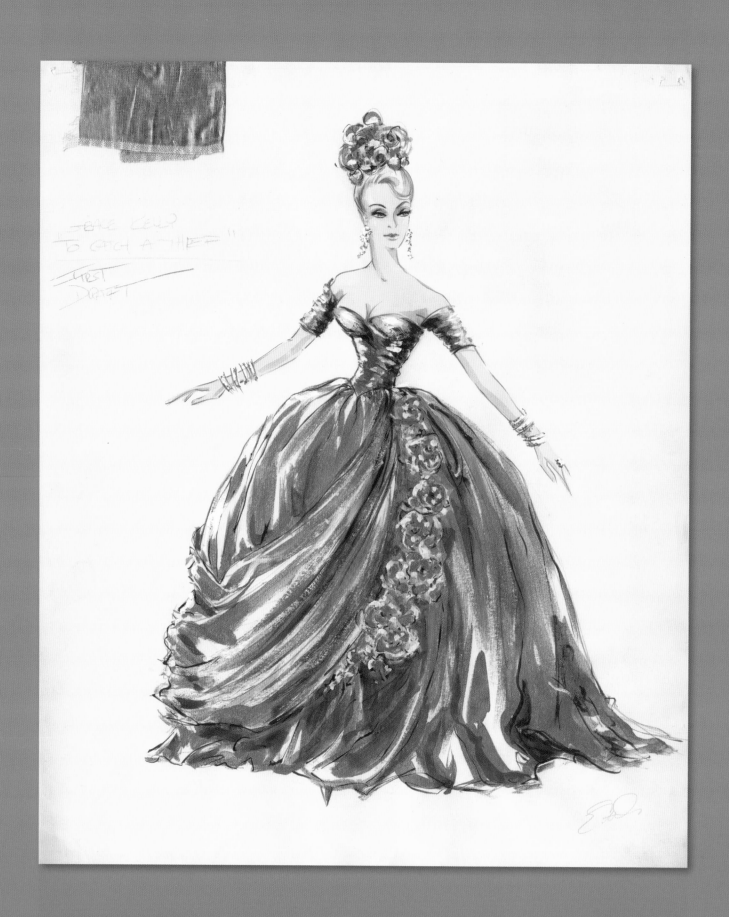

**ABOVE** The first draft sketch of the gold ball gown. **OPPOSITE** Hitchcock requested that Edith Head make Grace look like a fairy princess for the ball.

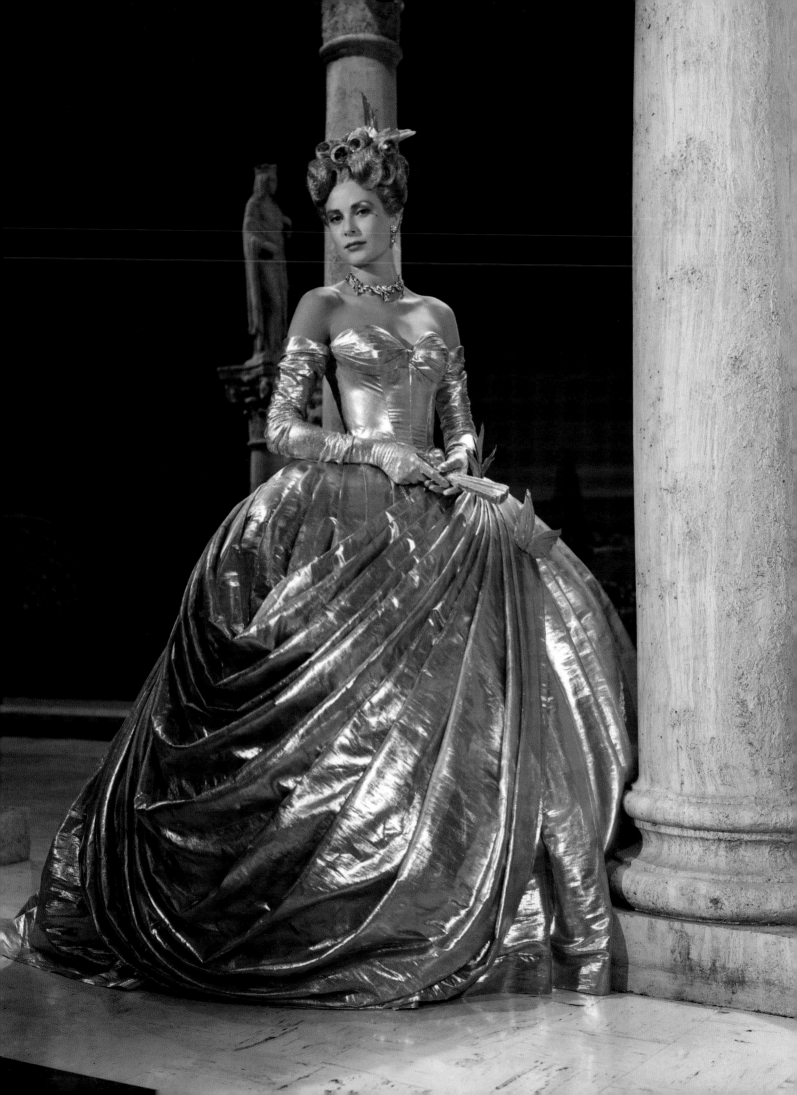

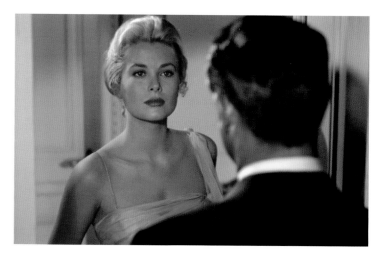
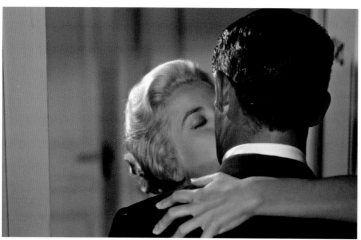
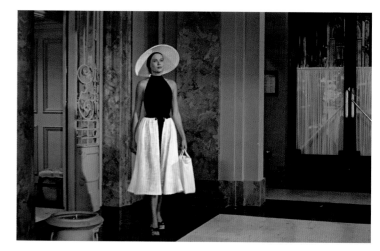

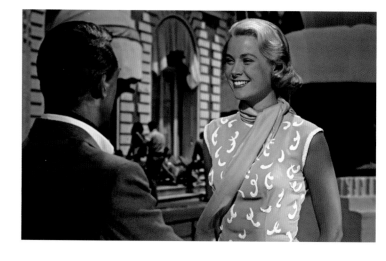
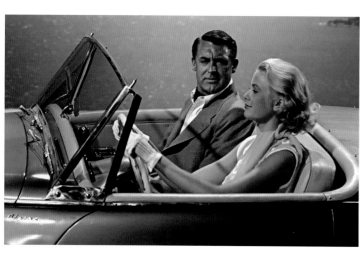
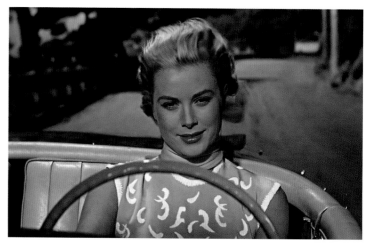

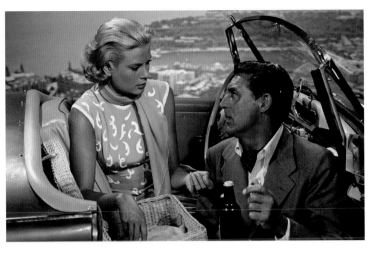
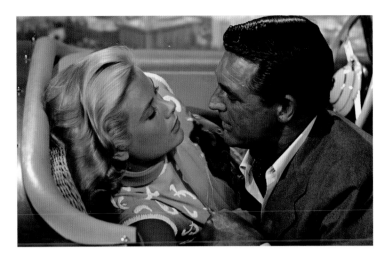
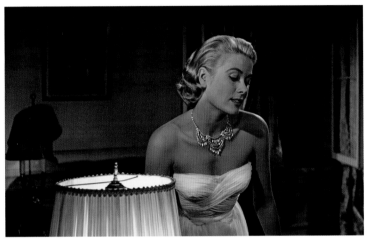
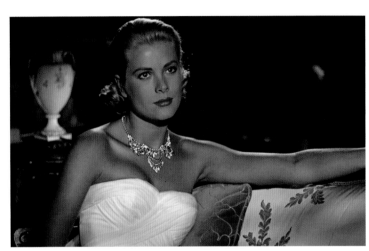
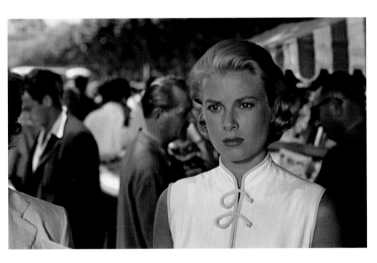
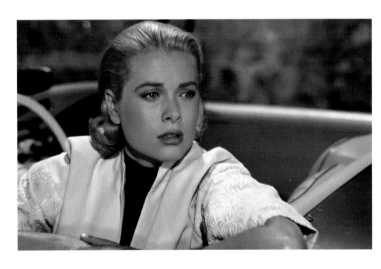
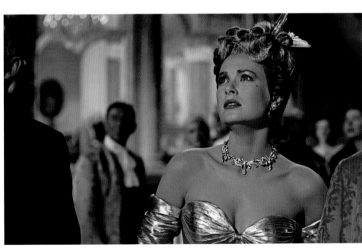
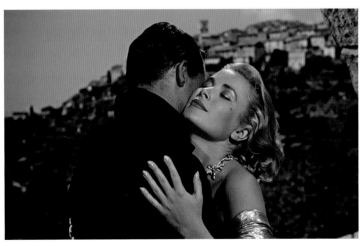

"[Grace] had a lot of beaus and boyfriends who were actors and human beings, dress designers and this and that. But there wasn't this one person who could fulfill this childhood image that a great many of us have about wanting that one man in our life to be special—and really to be the old prince on the white charger."

RITA GAM

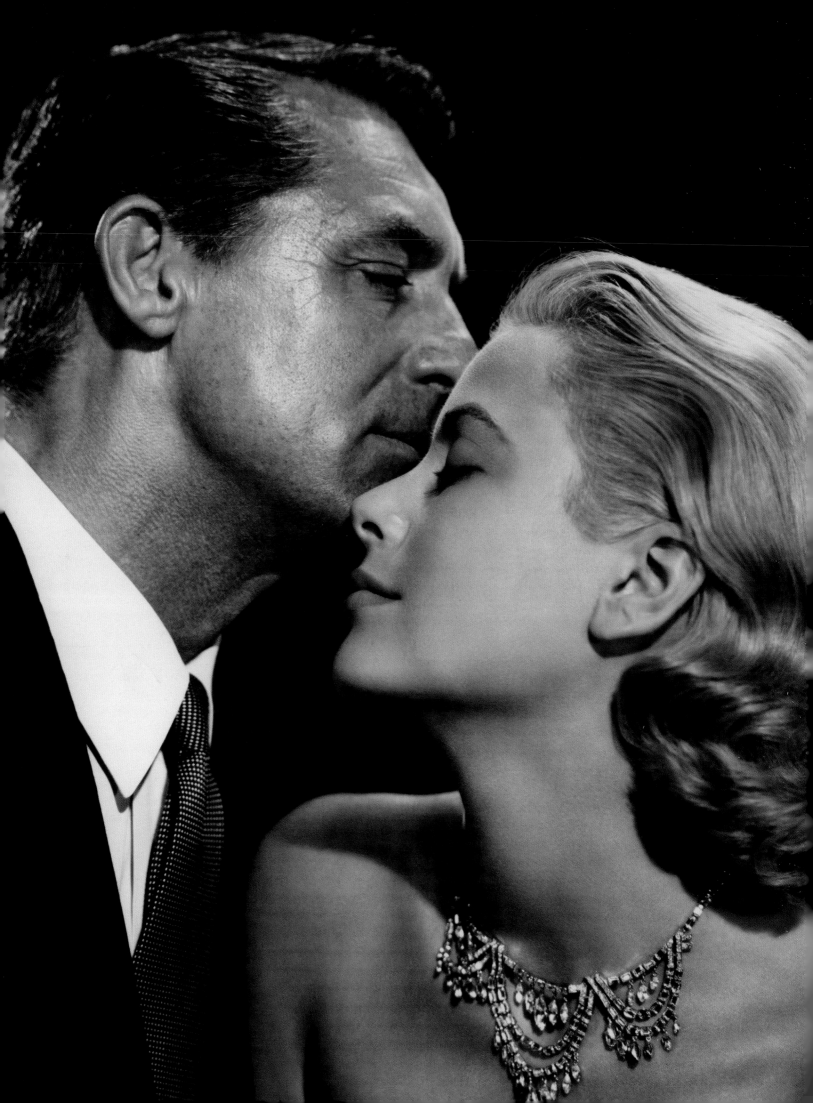

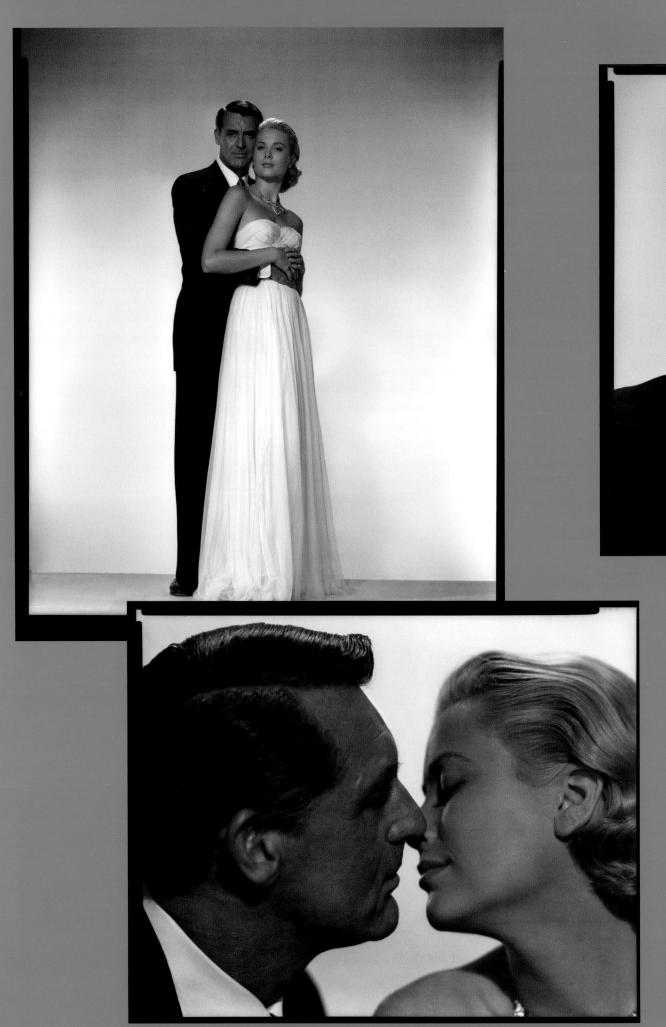

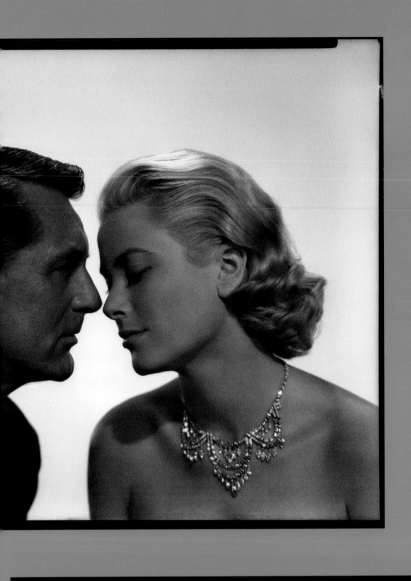

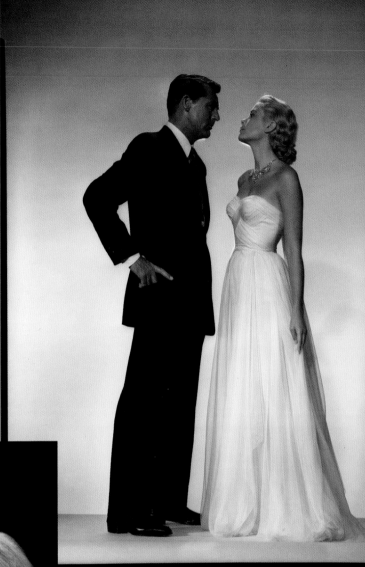

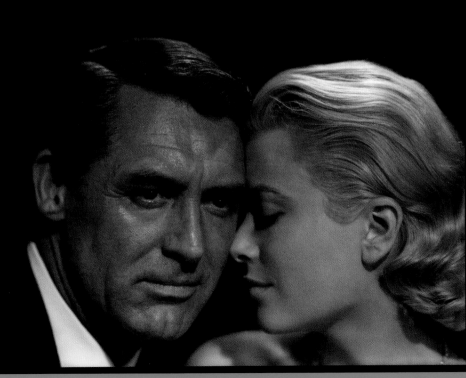

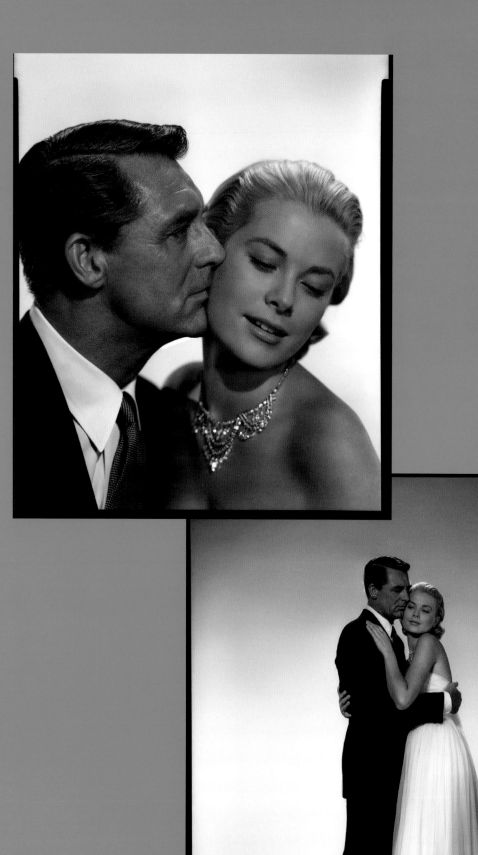

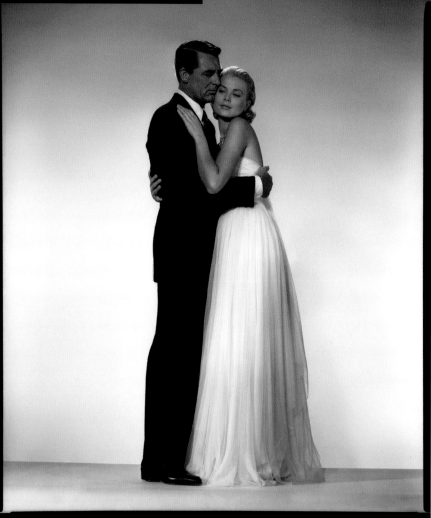

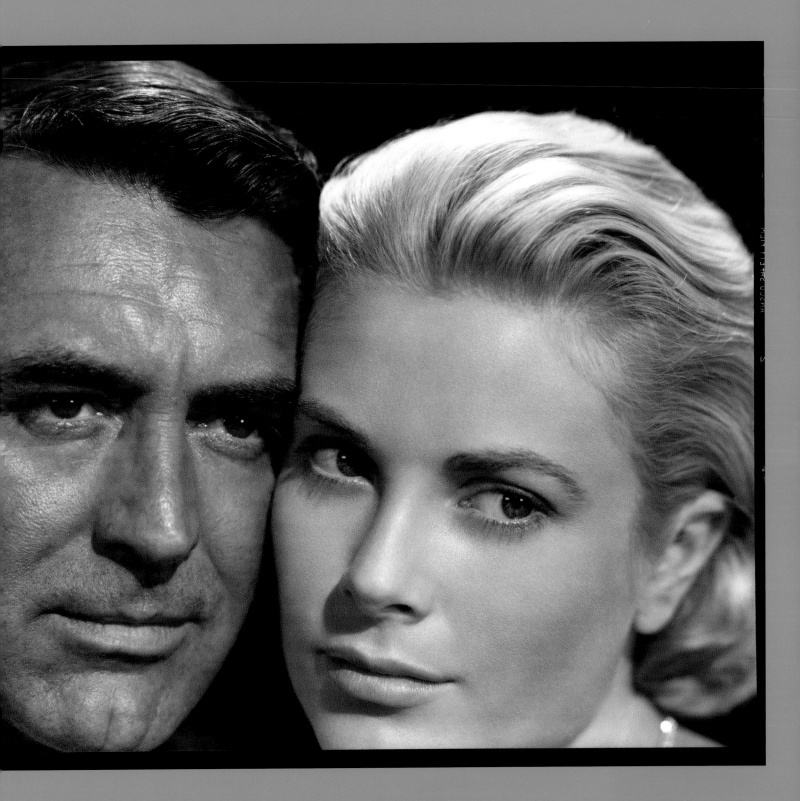

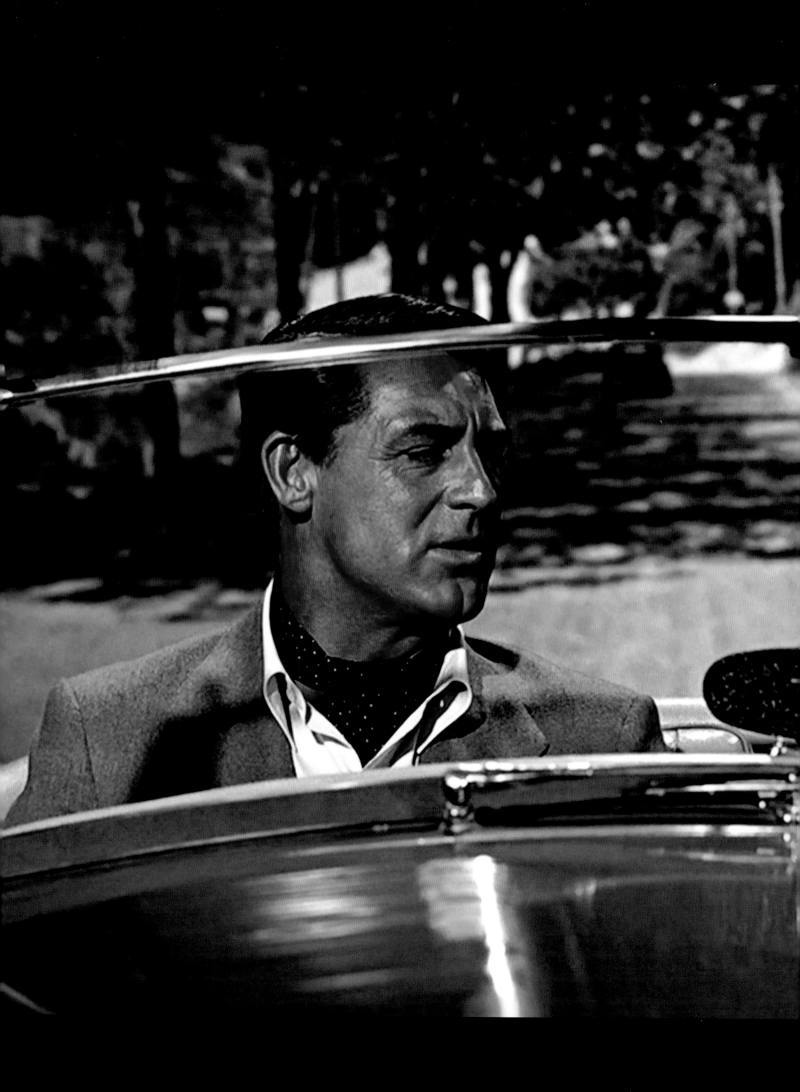

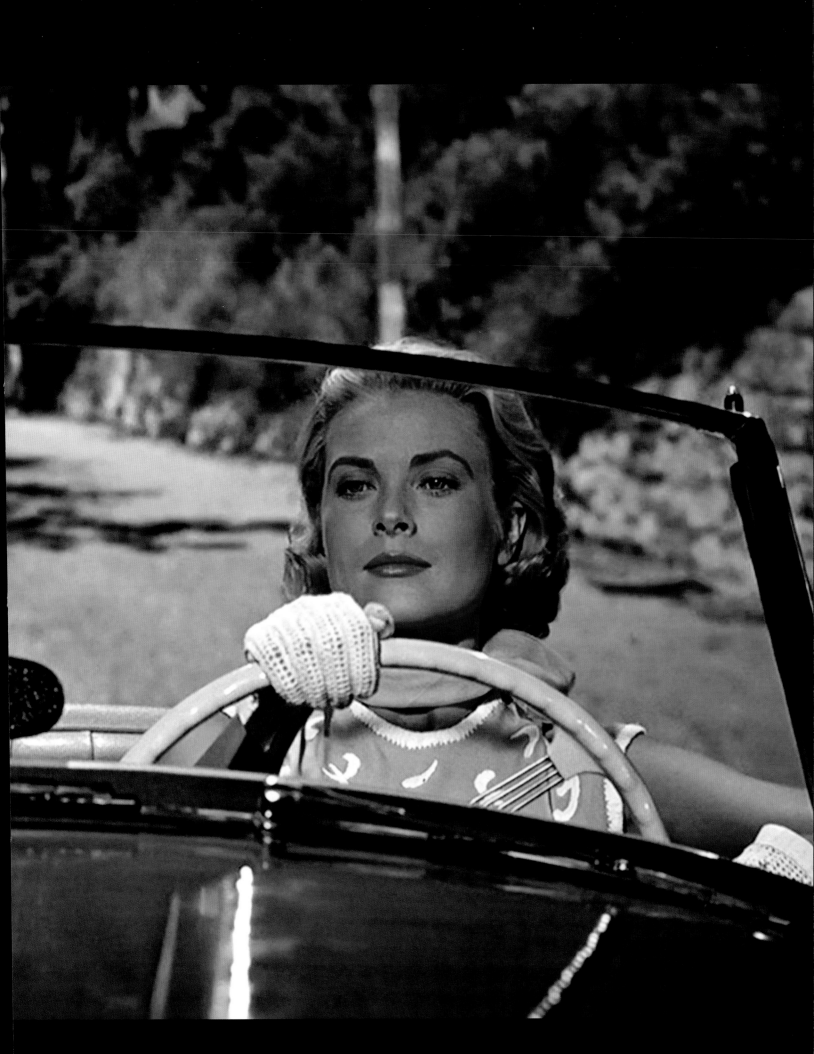

PRECEDING SPREAD Frances (Kelly) takes John (Grant) for a hair-raising ride. TOP LEFT AND RIGHT Paramount photographer Bud Fraker captured the quintessential "fire under the ice" in this portrait session with Grace to promote *To Catch a Thief*. RIGHT A rare behind-the-scenes photo of Grace enjoying a laugh during her session with Fraker. OPPOSITE Grace in a gown of white draped chiffon by Edith Head.

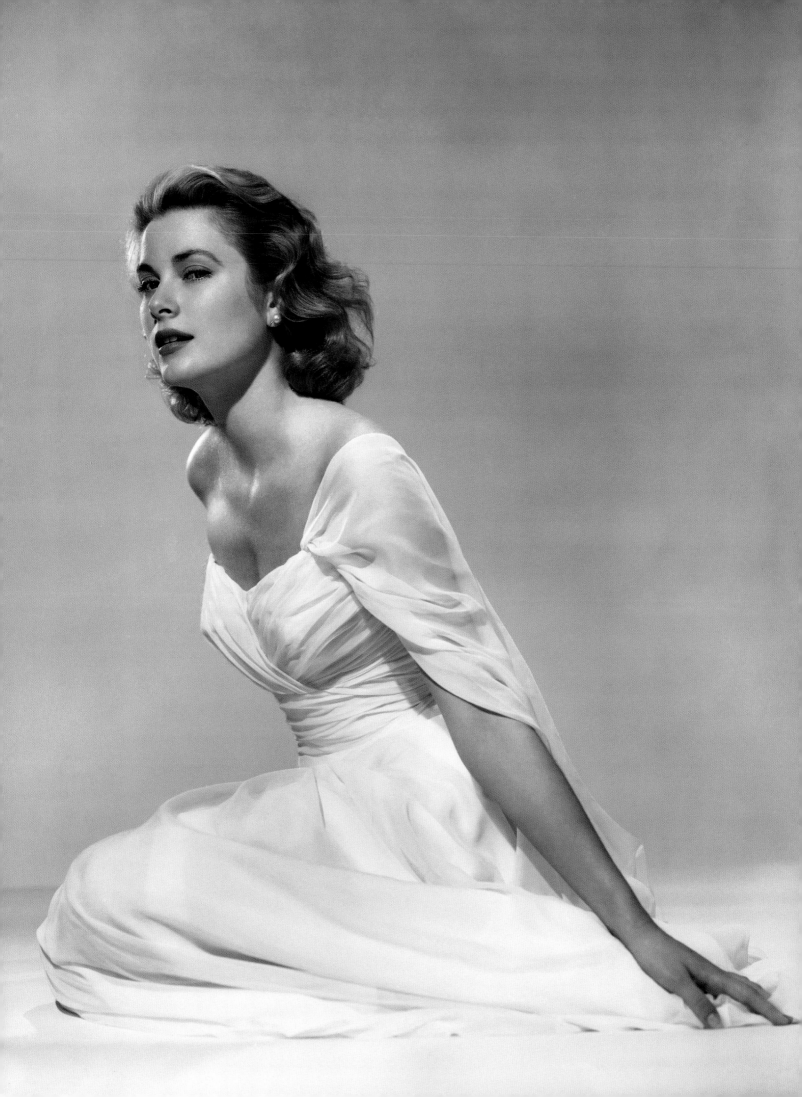

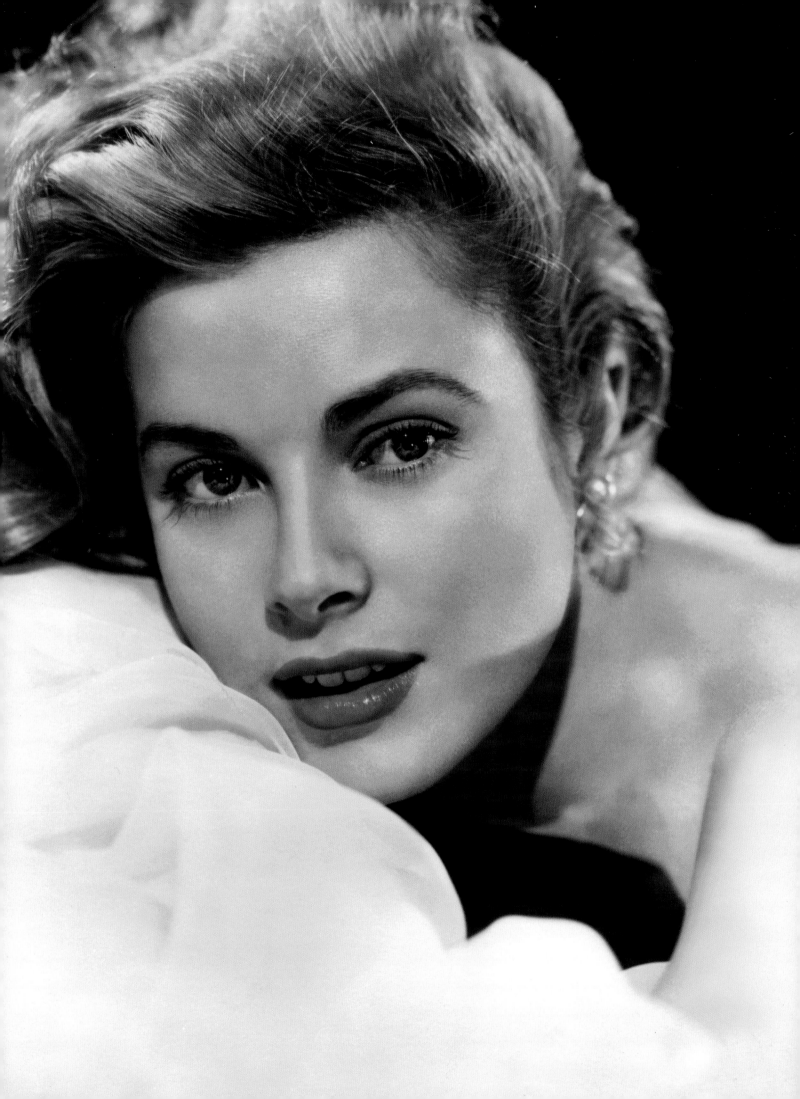

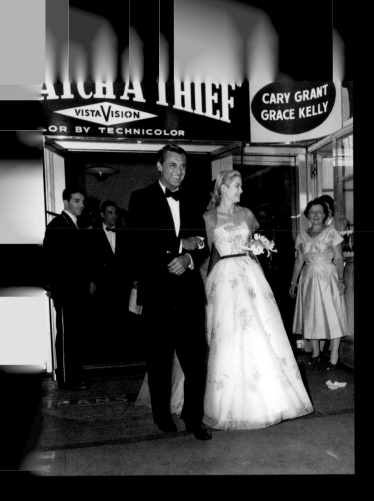

# PARAMOUNT PICTURES CORPORATION

## WEST COAST STUDIOS

5451 Marathon Street, Hollywood 38, California

Your No._____

_____

To _____

## RENTAL INVOICE

Date_____

Prod. No. _11511_____

Set or Job No._____

Account No._____

Ordered By

| | Stock No. | DESCRIPTION | RENTAL VALUE | 1st WEEK RENTAL | 2nd WEEK RENTAL | 3rd WEEK RENTAL | 4th WEEK RENTAL | OTHER WEEKS | RETURN DATE |
|---|---|---|---|---|---|---|---|---|---|
| 1 | | | | | | | | | |
| 2 | 2476J-1 – 1 Neck, chain of rect. rhines, 3 loops of rect. Double | | | | | | | | |
| 3 | rhines with grad. pear shape drops. | | | | | | | | |
| 4 | | | | | | | | | |
| 5 | | | | | | | | | |
| 6 | | | | | | | | | 75 — |
| 7 | X | | | | | | | | |
| 8 | | | | | | | | | |
| 9 | | | | | | | | | |
| 10 | | | | | | | | | |
| 11 | | | | | | | | | |
| 12 | 2476J-2   1 Bracelet, 2 rows of round grad rhine | | | | | | | | |
| 13 | 2 bow knots of tiny rhines & baguettes. | | | | | | | | |
| 14 | X | | | | | | | | |
| 15 | | | | | | | | | |
| 16 | | | | | | | | | 25 — |
| 17 | | | | | | | | | |
| 18 | 2476J-3 – 1 pr. Earrings, 2 loops of rhine – 1 round, | | | | | | | | |
| 19 | X   + 1 baguettes, 2 ends up. | | | | | | | | |
| 20 | | | | | | | | | |
| 21 | | | | | | | | | 20 — |
| 22 | Ret. 7/6/54 | | | | | | | | |

312-A — X-67

Rec'd for_____

Approved_____     By_____

**ABOVE** A Paramount rental invoice for the rhinestone necklace used to entice John Robie (Grant). **OPPOSITE** A portrait of Grace wearing the necklace.

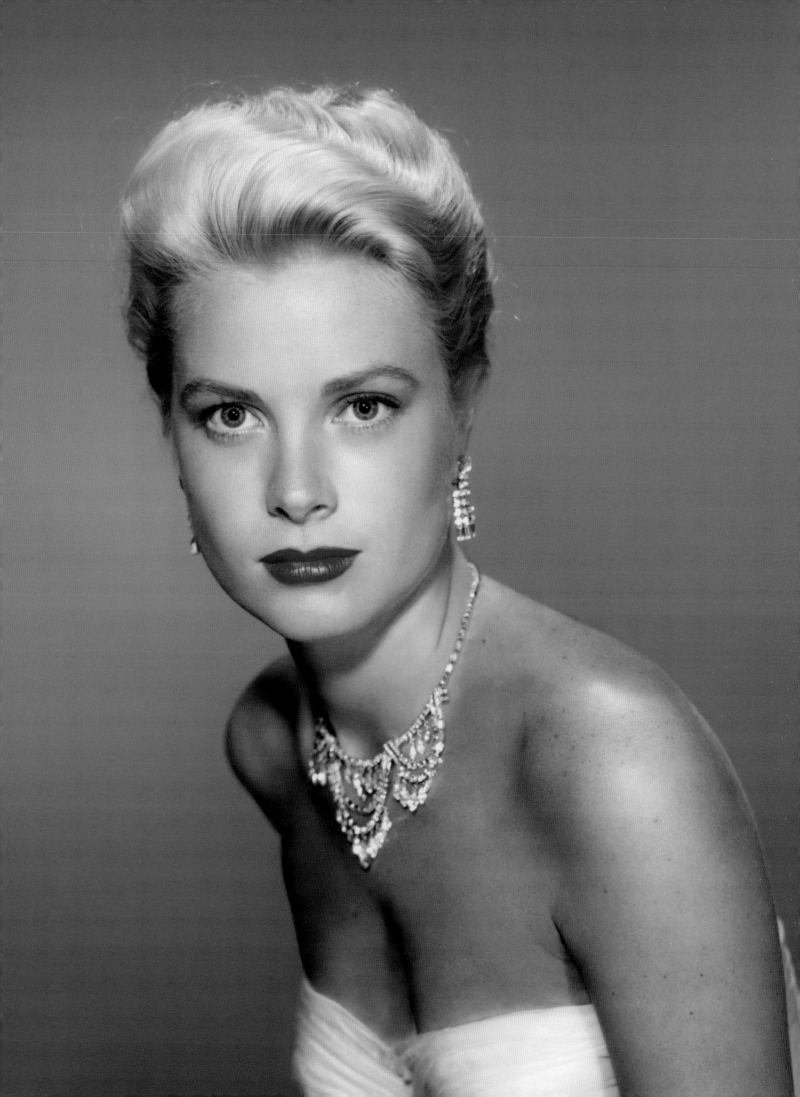

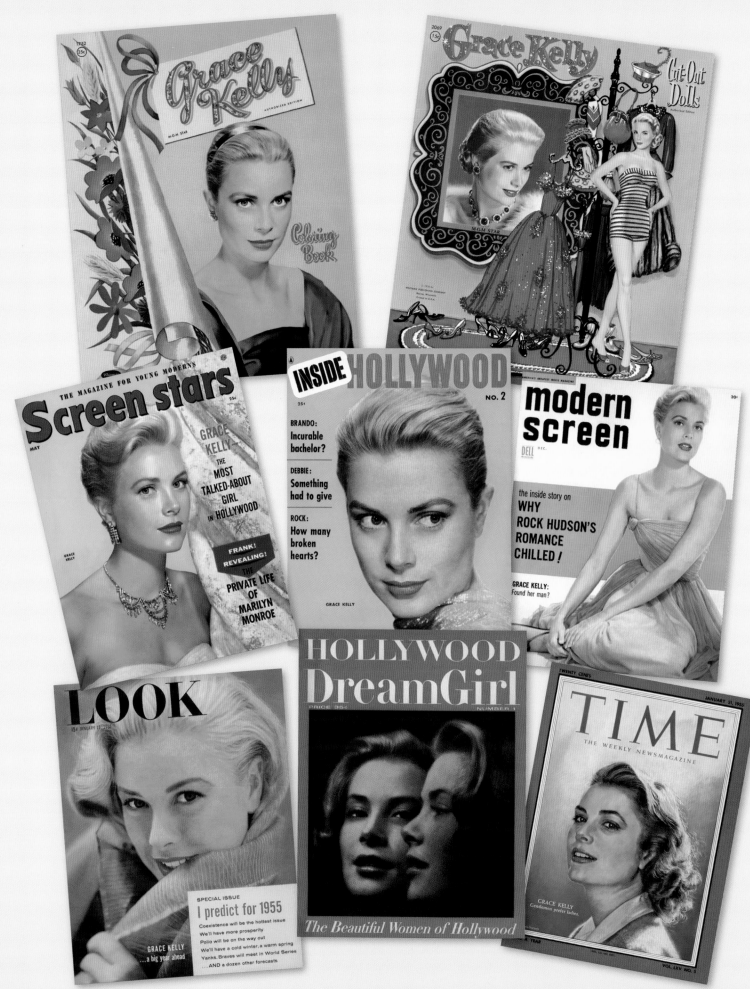

**ABOVE** During 1955, Grace appeared on the cover of many national magazines and even inspired a coloring book and book of paper dolls for youngsters. **OPPOSITE AND FOLLOWING PAGES** Paramount's showmanship manual helped exhibitors market the stylish thriller. **PAGE 211** Alternate American poster for *To Catch a Thief*.

# PUBLICITY

Still No. 11511-131

Cary Grant and Grace Kelly set off fireworks as a new and sizzling romantic team in Alfred Hitchcock's rocket-paced thriller, "To Catch A Thief," The VistaVision, Technicolor suspense drama, arriving........ at the ........ Theatre, was filmed mostly on the fabulous Riviera.

Still No. 11511-23

Lovely Grace Kelly sets her sights for Cary Grant, despite her suspicions that he is a hunted jewel thief, in Alfred Hitchcock's great new suspense thriller, "To Catch A Thief." The VistaVision, Technicolor drama, due ...... at the ....... Theatre, introduces Grant and Miss Kelly as a sizzling romantic team in a spine-tingling yarn of danger and intrigue.

## CARY GRANT, GRACE KELLY EXCITING STAR DUO IN HITCHCOCK THRILL FILM 'TO CATCH A THIEF'

(First Story)

Get set for a spine-chilling dive into the shocking realm of violence, danger and intrigue. The master of the suspense film, Alfred Hitchcock, is coming your way with another tension-loaded drama, another superlative cast, and another fabulous setting.

Titled "To Catch A Thief," the Paramount thriller, arriving........ at the........ Theatre, stars Cary Grant and Grace Kelly in the rocket-paced story of a reformed jewel thief forced to call upon every criminal skill at his command to save his own life. Set and filmed in the most famous and exciting of the world's glamour spots, the fabled French Riviera, "To Catch A Thief" has already been hailed for its pure chilling power, intriguing plot and heart-stopping suspense as a film with the power of "Rear Window."

Cary Grant portrays a retired Raffles who is living respectably on the Riviera when a series of burglaries reminiscent of his former technique break out. Knowing the police will immediately suspect him, jail him and ask questions afterwards, he is forced into hiding and an undercover quest for his imitator. In the course of his unorthodox sleuthing, he meets the rich, lovely and spoiled Grace Kelly and conceives the dangerous plan of using her and her diamond-laden mother as bait. He is set to catch a thief, and Miss Kelly has other ideas. She is set to catch Grant, and according to glowing advance reports, the romantic sparks that fly between these two are enough to up the already torrid Riviera climate another twenty degrees. Some of the comment on one particular scene between this terrific romantic combination leads us to predict it'll make you forget every other love scene in your memory.

Top this with the incredibly beautiful VistaVision, Technicolor photography of the world's most breathtakingly lovely areas, plus a gripping, relentlessly exciting yarn, and "To Catch A Thief" promises to be the best of Alfred Hitchcock — and that's the best there is!

### 'Hitchcock Touch' Sparks New VistaVision Thriller

"The Hitchcock touch," that magical talent for using every aspect of motion picture making to create suspense, lightning-like reality, has been brought to the peak of perfection in the master's latest thriller, "To Catch A Thief." Camera technique, choice of background, color, and the tricky business of editing, coupled with uncanny direction of a great cast and a gripping story will place this tension-packed film among Hitchcock's best—and among the best there is!

Grant, cast as the reformed jewel thief who is forced to call upon every criminal skill at his command to save his own life, carries an aura about him that spells adventure, romance and the ability to handle the most unusual and dangerous situation. And as the lovely but spoiled rich American who sets her sights for Cary and turns out to be his most formidable opponent, Grace Kelly is a triumph of perfect casting. In VistaVision and Technicolor, the action flashes among the sweeping vistas of the fabulous Riviera, with Hitchcock creating some of the most breathtaking scenes ever filmed in an unforgettable yarn of danger and intrigue.

The choice of stars for "To Catch A Thief," which opens ........at the ........ Theatre, couldn't have been more perfect. Cary

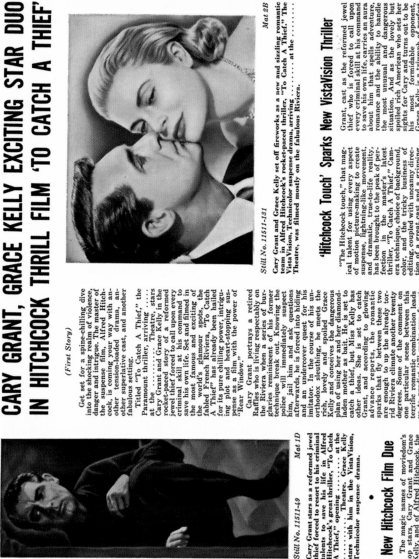

Still No. 11511-49                     Mat 1D

Cary Grant stars as a reformed jewel thief forced to resort to his criminal talents to save his life in Alfred Hitchcock's great thriller, "To Catch A Thief," opening .......... at the ......... Theatre. Grace Kelly stars with him in the VistaVision, Technicolor suspense drama.

### New Hitchcock Film Due

The magic names of moviedom's top stars, Cary Grant and Grace Kelly, and of Alfred Hitchcock, master of the suspense film, head the billing of Paramount's "To Catch A Thief," arriving ........ at the ........ Theatre. The tension-packed drama, filmed in VistaVision and Technicolor on the Riviera, has been hailed as another unforgettable Hitchcock gem.

### Two Great Stars Click As Romantic Twosome In Hitchcock Thriller

A new and sizzling romantic team has been born. Starring in Alfred Hitchcock's great new thriller, "To Catch A Thief," Cary Grant and Grace Kelly promise to make the movie-goer forget every other pair of lovers in memory.

The VistaVision, Technicolor suspense drama, due ....... at the ....... Theatre, has Grant cast as a reformed jewel thief living on the Riviera, and Miss Kelly as a lovely but spoiled rich American who sets her sights for Cary. Comments from advance audiences over one love scene in particular have tabbed it as one of the most torrid ever filmed and certainly the most unusual!

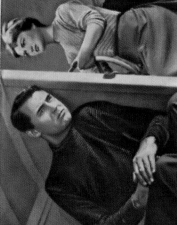

Still No. 11511-62                      Mat 2D

Reformed jewel thief Cary Grant attempts to elude police, who suspect him of reopening his criminal career, in this tense scene from Alfred Hitchcock's suspense-loaded drama, "To Catch A Thief," filmed on the Riviera, due ....... at the ....... Theatre. The VistaVision, Technicolor thriller, co-stars Grace Kelly and presents Brigitte Auber, above, charming French import.

---

## SYNOPSIS

(Not for publication)

John Robie (Cary Grant), an American known as "The Cat," because of his stealthy method of stealing jewels, has reformed and is leading a respectable life in his beautiful villa on the French Riviera. Suspicion falls on him when thefts committed in a cat-like manner take place in the area. Determined to clear his name by finding the real thief, he eludes the police and hurries to Cannes to contact Bertani (Charles Vanel), who had worked with him in the French underground and is now owner of a fashionable restaurant. With Bertani's help, Robie is spirited away in a motor boat driven by pretty Danielle Foussard (Brigitte Auber), an attractive French girl with a yen for Robie.

According to a scheme worked out by Bertani, Robie is sought out at a flower market in Nice by H. H. Hughson (John Williams), inspector for the insurance firm covering the stolen jewels. Hughson furnishes Robie with a list of wealthy jewel owners in the locality. With this information Robie hopes to catch his imitator at work. On the list are Mrs. Stevens (Jessie Royce Landis) and her beautiful daughter, Francie (Grace Kelly).

Americans vacationing in France. Soon after Robie meets them, another cat-like theft occurs. Again, the police are on the hunt for Robie! Francie, the restless, thrill-hunting American heiress who shocked even the blasé international set with her pursuit of him,

"To Catch A Thief," opening tomorrow at the ......... Theatre, is the relentlessly exciting tale of mystery, the French underworld called "The Cat" and the notorious man of mystery, the once highly successful jewel thief who is forced upon every criminal skill at his life in order to save his own life, and Grace Kelly is cast as the lovely but spoiled Grace Kelly who sets her suspicions that he is despite her suspicions that he is hunted by the police. Together, they make a new romantic team that has already been tabbed as one of the most torrid the screen has ever held, and directed by the great master of terror and tension, Alfred Hitchcock, a fresh adventure exciting the most...

drives Robie with a list of wealthy jewel owners in the locality. With this information Robie hopes to catch his imitator.

At the scene of another prospective theft victim, the real thieves accidentally kill one of their own men. The police are satisfied that the murdered man is "The Cat," but Robie is not. Certain that "The Cat" will be after a big haul the following night at a lavish costume ball catered by Bertani, Robie prevails upon Francie and her mother to attend the affair. Using them as bait to flush the real cat from cover, he does some sleuthing on his own. After a hair-raising pursuit, Robie exposes the real "Cat." Now, free from suspicion, Robie and Francie are happily reunited.

## CAST

| | |
|---|---|
| John Robie | CARY GRANT |
| Frances Stevens | GRACE KELLY |
| Mrs. Stevens | JESSIE ROYCE LANDIS |
| H. H. Hughson | JOHN WILLIAMS |
| Bertani | CHARLES VANEL |
| Danielle | BRIGITTE AUBER |
| Foussard | JEAN MARTINELLI |
| Germaine | GEORGETTE ANYS |
| Claude | ROLAND LESAFFRE |
| Mercier | JEAN HEBEY |
| Lepic | RENE BLANCARD |

## CREDITS

Produced and Directed by Alfred Hitchcock; Screenplay by John Michael Hayes; Based on the novel by David Dodge; Color by Technicolor; Director of Photography—Robert Burks, ASC; Technicolor Color Consultant—Richard Mueller; Art Direction—Hal Pereira and Joseph MacMillan Johnson; Second Unit Photography—Wallace Kelley, ASC; Special Photographic Effects—John P. Fulton, ASC; Process Photography—Farciot Edouart, ASC; Set Decoration—Sam Comer and Arthur Krams; Edited by George Tomasini, ACE; Assistant Director—Daniel McCauley; Makeup Supervision—Wally Westmore; Sound Recording by Harold Lewis and John Cope; Music Scored by Lyn Murray; Second Unit Director—Herbert Coleman; Costumes—Edith Head; Dialogue Coach—Elsie Foulstone; Western Electric Recording.

## Running Time: 106 Minutes

---

## Suspense Mounts In Hitchcock Film 'To Catch A Thief'

(Day Before Opening)

The shrill scream of a terror-stricken woman, the silent prowling of a cat on the gold-plated Riviera rooftops while a fortune in diamonds is stolen, and the newest and most suspense-loaded Hitchcock thriller is under way. Titled "To Catch A Thief," it presents a superb pair of stars in Cary Grant and Grace Kelly, a rocket-paced, gripping story of danger and intrigue, and the incredibly beautiful setting of the fabled French Riviera.

"To Catch A Thief," opening ...... at the ....... Theatre, is the relentlessly exciting tale of mystery, the French underworld called "The Cat" and the notorious man of mystery, the once highly successful jewel thief who is forced upon every criminal skill at his own life, and Grace Kelly is cast as the lovely but spoiled Grace Kelly who sets her suspicions for him despite her suspicions that he is hunted by the police. Together, they make a new romantic team that has already been tabbed as one of the most torrid the screen has ever held, and directed by the great master of terror and tension, Alfred Hitchcock, a fresh adventure exciting the most he has ever presented.

Filmed in the gorgeous spectacle of VistaVision and color by Technicolor, "To Catch A Thief" has been called a feast for all the senses. The sweeping vistas of the Riviera, the riot of color of the flower market at Nice, the rugged, craggy beauty of the ancient Cornish Road, the beaches estates, villas and hidden-away restaurants have all been captured as only the VistaVision lens can. With an outstanding supporting cast of Jessie Royce Landis, John Williams, and a group of top flight French players, "To Catch A Thief" promises the most thrilling film fare possible.

One of the most explosive romantic teams in years is Cary Grant and Grace Kelly, starred together in Alfred Hitchcock's greatest suspense romance, "To Catch A Thief," now at the ........ Theatre.

## Cary Grant and Grace Kelly Romantic TNT In Hitchcock Thriller "To Catch A Thief"

Every so often a motion picture event of unusual importance takes place, and the applause of moviegoers everywhere is its reward. Just that sort of event is the pairing of Cary Grant and Grace Kelly as the stars of Alfred Hitchcock's great new thriller, "To Catch A Thief."

The personable pair have been cast perfectly as a suave jewel thief and an adventure-hunting heiress in the gripping tale of danger and intrigue now at the ........ Theatre, but it is clear now that something beyond that has happened. A new romantic team to match the greatest in screen history has been born, and audiences across the nation have been busy placing two new names alongside Barrymore's and Garbo's.

One love scene in particular between Grant, the perfect man-of-the-world, and Grace Kelly, the golden girl of every man's dreams, has been called the most explosive in memory. Under the magic of "that Hitchcock touch," and in the breathtaking reality of the Vista-Vision, Technicolor photography, it bids well to become a milestone.

## Surefire Stars Deliver Three Hits For Hitchcock

Alfred Hitchcock, the great master of the suspense tale, has a reputation for discovering new stars, but he also makes spectacular use of the tried-and-true. His newest and greatest thriller for Paramount, "To Catch A Thief," now at the ........ Theatre, has as its superb principals, Cary Grant and Grace Kelly, both of whom have now made three memorable films for him.

Grant starred in the outstanding hits, "Suspicion" and "Notorious," and Miss Kelly in "Dial M For Murder" and "Rear Window." Each of these was a movie milestone, but Alfred Hitchcock's favorite stars and the VistaVision and Technicolor cameras have made "To Catch A Thief" an entertainment adventure to top them all.

This is the gripping, tremendously exciting film by which all suspense tales will be measured from now on.

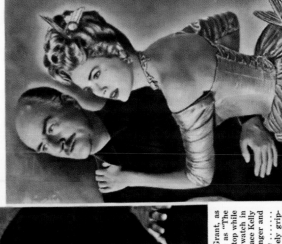

## THE MYSTERIOUS 'CAT' INTRIGUES LOVELY LADY WITH THE JEWELS IN SUSPENSE MASTER HITCHCOCK'S NEW FILM HIT "TO CATCH A THIEF"

POISED TO POUNCE! Cary Grant, as the notorious jewel thief known as "The Cat," crouches on a Riviera rooftop while Grace Kelly and John Williams watch in fear and suspense. Grant and Grace Kelly star in the Hitchcock tale of danger and romance, opening ........ at the ........ Theatre. A powerful and intensely gripping story, filmed on the Riviera in stunning magnificence of VistaVision and color by Technicolor, it establishes the two stars as the most explosive romantic team the screen has seen in years.

## Hitchcock Magic At Thrilling Best In Superb Film "To Catch A Thief"

(Review)

Alfred Hitchcock's new suspense thriller, "To Catch A Thief," is a film with a grip of steel encased in an incredibly beautiful glove of colorful and breathtaking photography. Sparked by the starring talents of the most explosive team to hit the screen in years, Cary Grant and Grace Kelly, this "best of the best" tale of danger and intrigue grabs you from the instant it opens and holds on until it has shaken the last ounce of tension from you.

It is universally accepted that Hitchcock is the all-time master of the suspense story, but with the film that opened yesterday at the ........ Theatre, the master has surpassed even himself. Every angle of that magical talent known as "the Hitchcock touch" has been explored to create a tale of rare visual beauty, lightning-like movement and dramatic, taut reality. Aided this time by the VistaVision, Technicolor camera, Hitchcock has made "To Catch A Thief" the standard by which the suspense story will be measured from now on.

The setting is the world's most glamorous playground, the French Riviera; the chief characters: a notorious but actually reformed Riviera resident, in danger of his life from an imitator who has copied all his tell-tale burglary techniques; then give the heiress a fabulous collection of diamonds and have "The Cat" decide to use her as bait in his desperate attempt to find his imitator. Top that with the most incendiary romance the screen has ever known, and then make the lady suspicious of "The Cat's" intentions and you have a conflagration that almost sets the screen on fire.

As "The Cat" and the lady, Cary Grant and Grace Kelly are two most exciting personalities enmeshed in a web of danger spun by Alfred Hitchcock with uncanny skill. It will catch you too and hold you tight for the most thrilling movie experience you've ever had.

### 'To Catch A Thief' Due

Suspense master Alfred Hitchcock's greatest film, "To Catch A Thief," will be the next attraction at the ........ Theatre. Cast in the starring roles of a notorious jewel thief and a thrill-hunting heiress are Cary Grant and Grace Kelly. The gripping tale of danger and intrigue was filmed in VistaVision and Technicolor amid the glittering splendour of the fabulous French Riviera.

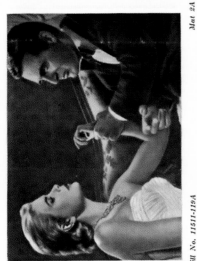

Cary Grant stars with Grace Kelly in Alfred Hitchcock's new VistaVision, Technicolor thriller, "To Catch A Thief," now at the ........ Theatre. The tension-packed tale was filmed on the fabulous Riviera.

Cary Grant and Grace Kelly are entangled in a web of danger and romance in Alfred Hitchcock's greatest suspense thriller, "To Catch A Thief." The VistaVision, Technicolor drama, opening ........ at the ........ Theatre, presents a tension-packed story in an incredibly beautiful and exciting setting.

## Hitchcock Delivers Sensational Thriller In "To Catch A Thief"

(Review)

From "39 Steps" to "Rear Window" the name, Alfred Hitchcock, has meant the last word in suspense story wizardry, but yesterday at the ........ Theatre, the master surpassed even himself with his newest tale of danger and intrigue, "To Catch A Thief." With a superb starring cast of Cary Grant and Grace Kelly, a VistaVision, Technicolor production that is stunning in its magnificence, and a taut, lightning-fast and gripping screenplay by John Michael Hayes of "Rear Window" fame, this suspense romance is certain to become the model by which all others will be measured from now on.

Taken from the novel by David Dodge, "To Catch A Thief" is the tension-packed story of a reformed jewel thief forced to use all his criminal skills to catch the imitator who threatens his hard-won respectability, and of the lovely, thrill-hungry heiress who finds him an irresistible magnet despite her mistrust of his motives. As the thief and the heiress, Cary Grant and Grace Kelly are a tremendously exciting addition to the special few of the screen's great lovers. Their inspired performances will become your own film treasure, and their impassioned story forever burned in your memory.

The setting of "To Catch A Thief" is the world's most glamorous playground, the French Riviera, and through the magic of the VistaVision and Technicolor cameras you're there as surely as if Monte Carlo were moved to your local theatre. The riot of daylight color and the subtle mystery of the Riviera nights, uncannily a part of the whole fabric of the film, will make you understand the full meaning of "the Hitchcock touch."

Top-flight performances by John Williams, Jessie Royce Landis and a supporting group of delightful French players round out a completely breathtaking film. This is Alfred Hitchcock at his best, and that's the best there is!

Academy Award Winner Grace Kelly stars with Cary Grant in Alfred Hitchcock's great suspense romance, "To Catch A Thief," opening ........ at the ........ Theatre. The VistaVision, Technicolor thriller was filmed amid the breathtaking vistas of the Riviera.

### Grace Kelly Graces New Hit

Grace Kelly, whose memorable performance in "The Country Girl" brought her an Academy Award and the applause of the world, has added a new and equally striking portrait to her list of screen roles. Starred with Cary Grant in Alfred Hitchcock's great new thriller, "To Catch A Thief," Miss Kelly is cast as the lovely, thrill-hungry heiress whose pursuit of jewel thief Grant sets the Riviera ablaze, and the gripping tale of danger and intrigue, due ........ at the ........ Theatre, presents Miss Kelly and Grant as the most explosive romantic team the screen has seen in years.

All eyes are on lovely Grace Kelly as she voices her suspicions that Cary Grant is a hunted jewel thief in this tense scene from Alfred Hitchcock's "To Catch A Thief." Grant and Miss Kelly star in the VistaVision, Technicolor thriller, due ........ at the ........ Theatre, and noted players Jessie Royce Landis and John Williams have top featured roles.

# SPARK YOUR CAMPAIGN WITH SHOW-SELLING STILLS

## CAPTION STILLS FOR WANT-TO-SEE TEASER SERIES

POISED FOR HITCHCOCK THRILLS "TO CATCH A THIEF"

THE PEAK OF HITCHCOCK SUSPENSE "TO CATCH A THIEF"

READY TO SPRING INTO HITCHCOCK ACTION "TO CATCH A THIEF"

TOPS IN HITCHCOCK EXCITEMENT "TO CATCH A THIEF"

There are a number of interesting and exciting stills of Cary Grant as "The Cat" that can be utilized effectively for windows around town; for lobby displays; for teaser ads. Captioned as shown here, they dramatize in a flash the Hitchcock suspense and thrilling action in "TO CATCH A THIEF." It is urged that you use these quick attention-getters in as many ways as possible; they'll pay off for you at the box-office. Stills shown above are Nos. 11511-19, 11511-44, 11511-48 and 11511-47.

## GRACE KELLY FASHION STILLS OPEN THE WAY TO STORE WINDOWS ⬆

The stunning wardrobe designed by Edith Head for beautiful Grace Kelly is going to elicit "oohs" and "ahs" from your female patronage. Here is the kind of glamour that sells tickets to the women of any town. Any department store would go for a display of these stills along with their own most glamorous clothes, using a tie-in line such as: FOR THE MOST BEAUTIFUL CLOTHES IN BOSTON SHOP AT WHITE'S . . . FOR THE MOST BEAUTIFUL CLOTHES ON THE RIVIERA SEE GRACE KELLY IN ALFRED HITCHCOCK'S "TO CATCH A THIEF" . . . A PARAMOUNT PICTURE AT THE BIJOU THEATRE.

*Still #P4056-110 — a dramatic beach ensemble in black and white; still #P4056-115 — wrap-around informal morning dress of embossed cotton; still #P4056-109 — afternoon dress of white silk trimmed with orange cording; still #P4056-113 — diaphanous evening gown in striking shades of blue, Grecian style.*

## BLOW-UP OF MYSTERY FIGURE CAN DRAMATIZE STILL BOARD

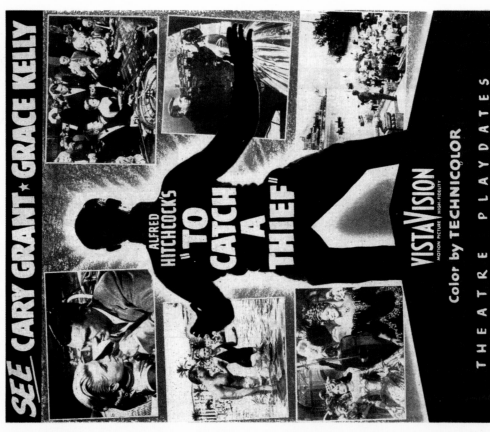

SEE CARY GRANT ★ GRACE KELLY

ALFRED HITCHCOCK'S "TO CATCH A THIEF"

VISTAVISION MOTION PICTURE HIGH-FIDELITY

Color by TECHNICOLOR

THEATRE PLAYDATES

An eye-stopping display can be made by blowing up still #11511-46 of Cary Grant as "The Cat" and using it as the basis of an unusual still-board for your lobby. The dramatic position of the figure lends itself to title treatment as shown for your center piece. Surround it with highlight scenes #11511-119, #11511-76, #11511-24, #11511-52, #11511-30, #11511-18, #11511-21 and #11511-27 and you will have a highly effective and interesting ticket-seller for "TO CATCH A THIEF."

## STUNTS and BALLYS

### DIRECTIONAL MARKERS

The title "TO CATCH A THIEF" suggests a number of directional markers and sidewalk stencils for the area in which your theatre is located, as follows: THREE BLOCKS AHEAD "TO CATCH A THIEF"; TURN RIGHT "TO CATCH A THIEF"; AROUND THE CORNER "TO CATCH A THIEF"; FOLLOW THE ARROWS "TO CATCH A THIEF" etcetera, using all directions that lead to your house.

This could apply to transportation vehicles with signs like: THIS WAY "TO CATCH A THIEF" or HOP ABOARD "TO CATCH A THIEF."

### JEWEL GIVE-AWAY TEASER

For a novel, inexpensive give-away you might get some loose rhinestones for insertion in envelopes reading: BAIT "TO CATCH A THIEF"—SEE HOW THE WORLD'S MOST FABULOUS JEWELS ARE USED "TO CATCH A THIEF" IN THE ALFRED HITCHCOCK PRODUCTION "TO CATCH A THIEF" STARRING CARY GRANT AND GRACE KELLY ...... THEATRE.

### BALLY MAN ON SKATES

The title suggests a bally man on roller skates or a scooter displaying a sign reading: I'M ON MY WAY "TO CATCH A THIEF" ........ BIJOU THEATRE.

### DON'T TELL THE ENDING

As with all Hitchcock productions, "TO CATCH A THIEF" builds to a surprise finish. You might capitalize on this with a lobby sign reading: SEE "TO CATCH A THIEF" FROM THE BEGINNING ...AND DON'T TELL YOUR FRIENDS THE ENDING!

### LOBBY PEEP SHOW

The sizzling romance between Cary Grant and Grace Kelly in "TO CATCH A THIEF" will be the talk of your town. Dramatize this aspect of the picture by rigging up a peepshow still display in your lobby. Use stills #11511-13, #11511-141, and #11511-139 in an illuminated shadowbox arrangement, with peepholes cut out for the viewers. Copy for the outside of this box could read: TAKE A LOOK! GORGEOUS GRACE KELLY SHOWS HOW "TO CATCH A THIEF."

### TRAVEL MAGAZINE STUFFERS

Filming of "TO CATCH A THIEF" took place on the gloriously beautiful French Riviera, glamour playground of the world. Cooperating newsstand dealers might permit you to stuff Holiday Magazine and other travel publications with "TO CATCH A THIEF" heralds, which get over this angle.

## COVER OF THEME SONG CAN KEY MUSIC TIE-UPS

A lovely ballad called "Your Kiss" has been adapted from the background music written for "TO CATCH A THIEF" and is published by FAMOUS MUSIC CORPORATION, 1619 BROADWAY, NEW YORK 19, N. Y. Song covers which feature a clinch of the two exciting stars—Cary Grant and Grace Kelly—sell the romance in this great suspense film. They are obtainable from the publishers for display purposes in music stores.

## Air France Tie-up Ad In National Magazines

An excellent tieup has been consummated between Alfred Hitchcock, Producer-Director of "TO CATCH A THIEF," and Air France, the world's largest airline. Air France will run the ad reproduced here in the following nationally-read magazines: Esquire; Holiday; New Yorker; Time.

Reproductions of the ad are available from Air France for use as displays. Contact your local travel agent for window displays.

## CLASSIFIED ADS

Make use of your classified ad columns to sell the mystery and excitement of "TO CATCH A THIEF." Here are a few suggested ads that might also be used in Personal columns and as teaser ads:

Cary Grant: I know who you are and why you have TO CATCH A THIEF. I love you anyway and want to help you. Grace Kelly, Bijou Theatre.

Cary Grant: It isn't easy TO CATCH A THIEF by yourself. Please let me help. I love you. Grace Kelly, Bijou Theatre.

Cary Grant: What you want to do is too dangerous alone. You must let me help you TO CATCH A THIEF. I love you. Grace Kelly, Bijou Theatre.

Cary Grant: They know about the trap you've set TO CATCH A THIEF. Be careful. I love you. Grace Kelly, Bijou Theatre.

## LIVE RADIO SPOTS

### 50-words:

It's explosive...Alfred Hitchcock's new and greatest achievement — "To Catch a Thief" starring those two most exciting screen personalities, Cary Grant and Grace Kelly! It's a web of romance and suspense filmed in fabulous Monte Carlo...in vivid VistaVision and glorious Technicolor! See Paramount's "To Catch a Thief"...starts Thursday, Bijou Theatre.

### 35-words:

It's the danger affair of the year! Alfred Hitchcock's "To Catch a Thief" filmed in Monte Carlo ... starring Cary Grant and Grace Kelly ... in VistaVision and Technicolor. Never such suspense...such romance! Paramount's "To Catch a Thief" ... Thursday, Bijou Theatre.

### 20-words:

See Alfred Hitchcock's "To Catch a Thief" starring Cary Grant and Grace Kelly! Paramount filmed it in Monte Carlo in VistaVision and Technicolor. Thursday, Bijou Theatre.

**It's Hitchcock... It's Monte Carlo...
It's Cary Grant and Grace Kelly!**

CARY GRANT

GRACE KELLY

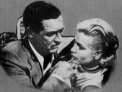

in

ALFRED HITCHCOCK'S

## TO CATCH A THIEF

Color by
TECHNICOLOR

with JESSIE ROYCE LANDIS · JOHN WILLIAMS

**VISTAVISION**
MOTION PICTURE HIGH FIDELITY

Directed by ALFRED HITCHCOCK
Screenplay by JOHN MICHAEL HAYES
Based on the novel by David Dodge

A Paramount Picture

TO CATCH A THIEF Z55-257

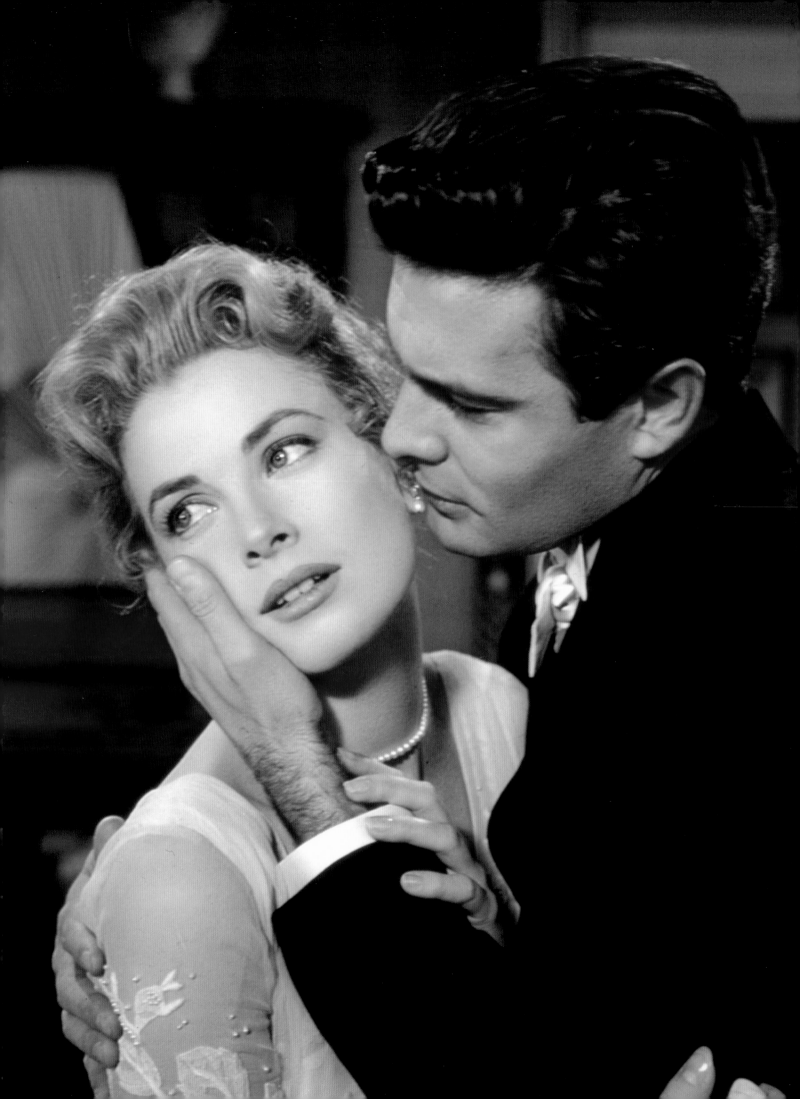

# THE SWAN

## 1956

To Catch a Thief had elevated Grace Kelly to the top of the list—literally. *The Motion Picture Herald* named her the top moneymaking female star of 1955, and in February of that year Grace was announced as a Best Actress Academy Award nominee for *The Country Girl*. MGM, however, still had no great plans for her. The studio considered Grace for several roles, including the western *Jeremy Rodock* starring Spencer Tracy; a remake of the 1934 romance *The Barretts of Wimpole Street*; and the swashbuckler *Quentin Durward* with Robert Taylor. Of the latter, Grace said, "All I'd do would be to wear thirty-five different costumes, and look pretty and frightened." She decided to accept none of the above.

Grace had her own starring vehicle in mind. She hoped MGM would bring Ferenc Molnár's *The Swan: A Comedy in Three Acts* to the screen. Grace had performed it for television in 1950, so she knew the role was right for her. But on March 7, 1955, MGM announced it was suspending Grace for ignoring two summonses to appear for work on *Jeremy Rodock*, in which she would have played a former saloon hostess named Jocasta Constantine. Grace told the press she was "terribly upset" about the suspension. "I'm not trying to be difficult or temperamental. I just don't feel right for the part." The film was eventually made—without Grace—as *Tribute to a Bad Man* (1956) with James Cagney and Irene Papas as the dance-hall girl.

MGM's timing couldn't have been worse. Grace and Judy Garland were the favored actresses to take home the Oscar statuette in a matter of weeks, and now Grace's home studio had suspended her. MGM quickly did an about-face and announced that it had lifted the suspension; Grace was not required to commit to any production.

The 27th Academy Awards were held at the RKO Pantages Theatre in Hollywood on March 30, 1955. Grace (nominated for *The Country Girl*) was competing against Judy Garland (*A Star Is Born*), Audrey Hepburn (*Sabrina*), Jane Wyman (*Magnificent Obsession*), and Dorothy Dandridge (*Carmen Jones*). Garland, who had never won an Oscar, had much of Hollywood rooting for her that night. After some turbulent years, she had turned in a remarkable comeback performance in *A Star Is Born*.

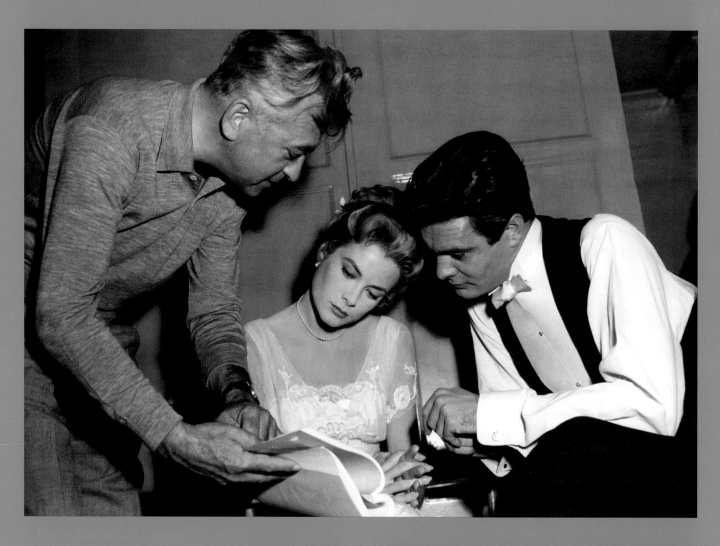

**TOP** Behind the scenes, Grace is flanked by Alec Guinness (left) and Louis Jourdan (right). **ABOVE LEFT** *Paris Match* magazine arranged for Grace to meet Prince Rainier of Monaco. **ABOVE RIGHT** Grace at the Cannes Film Festival.

But Grace, between her work at MGM and Paramount, had made plenty of money for plenty of people, and was well liked in the industry.

Still, Judy Garland seemed the favorite to win. When William Holden was handed the Best Actress envelope and called Grace Kelly's name, nobody was more surprised than Grace. In her ice-blue satin Edith Head gown, accessorized with white opera gloves, drop pearl earrings, and tiny yellow roses in her upswept hair, the ever-poised Grace nearly lost her legendary cool. She clutched the award and stammered slightly as she delivered a brief speech. "The thrill of this moment keeps me from saying what I really feel. I can only say thank you with all my heart to all who made this possible for me. Thank you." Visibly overcome with emotion, Grace broke into tears as she left the stage.

Following the after-show party at Romanoff's, Grace took her Oscar back to the Bel-Air Hotel. "There we were," Grace said later, "just the two of us. It was terrible. It was the loneliest moment of my life." Even with the highest film-industry accolade to her credit, John B. Kelly Sr.'s daughter failed to earn his admiration. "I can't understand it," he told one reporter. "All this fuss about Grace. Sure, she's a lovely girl, but I never thought she was the beauty of the family. You should see my other daughter, Peggy. Now she's the one I'd have thought would come in for all this attention." As Judith Balaban Quine wrote about both herself and Grace, "We daughters who didn't want to develop exactly as our fathers saw fit were mysteries to them. It wasn't that we weren't loved. It was just that we had chosen the wrong way, a way they couldn't understand."

After a much-needed vacation in Jamaica—during which a young photographer named Howell Conant snapped some soon-to-be-iconic photos of Grace emerging from the water—Grace was off to head the U.S. delegation to the Cannes Film Festival in May. Pierre Galante, a journalist at *Paris Match* magazine, had an idea for a photo story—movie queen Grace Kelly meets real-life Prince Charming, Rainier of Monaco. When Galante (the husband of actress Olivia de Havilland) made the suggestion to Elias Lapinère, who was representing Grace for publicity there, it was agreed that the meeting would make a great photo opportunity. "I still don't see why it's so important for me to meet the Prince," Grace told him, "but if you think it's a good idea, I'll do it."

The morning of the meeting, a strike by France's electricity workers had left Grace's hotel without power; Grace arrived to meet Galante with wet hair and wearing her one dress that did not require ironing—a black taffeta number with huge roses on it and an enormous full skirt. Judith Balaban Quine had advised her friend never to wear that particular dress unless she was going to a costume party "as a pear wrapped for Christmas." But Grace was unconcerned, as she felt few people would see the photos. On the forty-mile trek to Monaco, Grace received a quick lesson in royal protocol. "She asked whether he spoke English, and whether she should curtsy," Galante said. "She was unsure about all that."

Prince Rainier arrived at the meeting late, which only left time for him to show Grace his private gardens and zoo. "We went to see the grounds and we let them walk ahead to give them privacy," Galante recalled. "After the tour of the grounds, the prince stopped by a cage. Inside was a tiger he had been given by the Emperor of Indo-China. Rainier patted the tiger on the head as if it were a puppy. She was very impressed and something clicked between them." On the drive back, Galante asked Grace what she thought of the prince. Grace said she thought he was "charming," and said nothing else about him. "She was as impassive as ever," Galante said.

In Cannes, Grace was reunited with old flame Jean-Pierre Aumont. "Each of us was very glad to see the other again," Aumont said, "me because I thought she was adorable, and she because I was the only French person she knew." Grace and Aumont rekindled a spark, spending romantic days together holding hands, all captured by the paparazzi and splashed across European newspapers.

When the festival was over, Grace traveled with Aumont back to Paris. The couple even discussed the possibility of marriage. On June 25, 1955, Lizanne married Donald LeVine, with Grace as her maid of honor. "When the baby sister was getting married, she had to think about 'Well, I want to get married too,'" Lizanne said. But as usual, Grace could not convince her parents that

Aumont, a Jewish widower, was a suitable partner.

Once back in the United States, Grace did what any well-brought-up girl would do—she wrote a note to Prince Rainier thanking him for the tour. Rainier was pleasantly surprised by the gesture, and by the summer of 1955, the pair was corresponding regularly. They were both quiet people in person who seemed to be able to express themselves better in letters.

Meanwhile, Grace and producer Gant Gaither persuaded MGM to make *The Swan*. After weeks of discussions and negotiations, Grace got her wish. Head of production Dore Schary gave *The Swan* the green-light—he even oversaw the production himself, replacing Gaither as producer and ordering all departments to "spare no effort or expense," according to the film's trailer. Because it had been her suggestion, Grace felt a great sense of responsibility for the film's success. British playwright John Dighton was brought on to develop the script, with Charles Vidor directing.

Grace plays Princess Alexandra, the awkward but beautiful cousin of Crown Prince Albert, who is considering her for his wife. Jessie Royce Landis was once again cast as Grace's mother, Princess Beatrix. Rex Harrison and Joseph Cotten were considered for the role of Prince Albert, but the part went to Alec Guinness, in his first American film. Louis Jourdan won the role of the handsome tutor Dr. Nicholas Agi, a commoner, who stands in the way of everything Alexandra's relatives hope to accomplish by marrying Alexandra to Albert.

"There was an innate aristocracy—elegance— about her," Louis Jourdan said of Grace. "Not only in comportment and manners, but also in thinking and being. It has been a cliché to say that Grace Kelly looked like a princess. But she did. There was another element in Grace Kelly that was all-important. She had this extraordinary sense of humor. Not only, and first of all, about herself—never taking herself seriously."

Grace and Guinness discovered a mutual love of practical jokes. Grace would sneak off to the telegraph office and send passionate love notes to Guinness and sign them mysteriously "Alice." One night, Guinness paid a hotel porter to slip a Native American tomahawk into Grace's bed, setting off a running joke that lasted for years. "Out of this extraordinarily withdrawn, glamorous, glacial personality poured forth this sense of the ridiculous that only the British could really appreciate, or a five-year-old child," Rita Gam said of Grace's sense of humor.

In the final moments of *The Swan*, Prince Albert explains to Princess Alexandra how royalty is set apart from commoners. "Think what it means to be a swan: to glide like a dream on the smooth surface of the lake," he tells her, "and never go to the shore. . . . There she must stay, out on the lake: silent, white, majestic. Be a bird, but never fly. Know one song, but never sing it until the moment of death. And so it must be for you, Alexandra: cool indifference to the staring crowds along the bank. And the song? Never."

**ABOVE** Director Charles Vidor (left) and Grace greet Alec Guinness at the airport.   **OPPOSITE** Grace felt great pressure for *The Swan* to succeed.

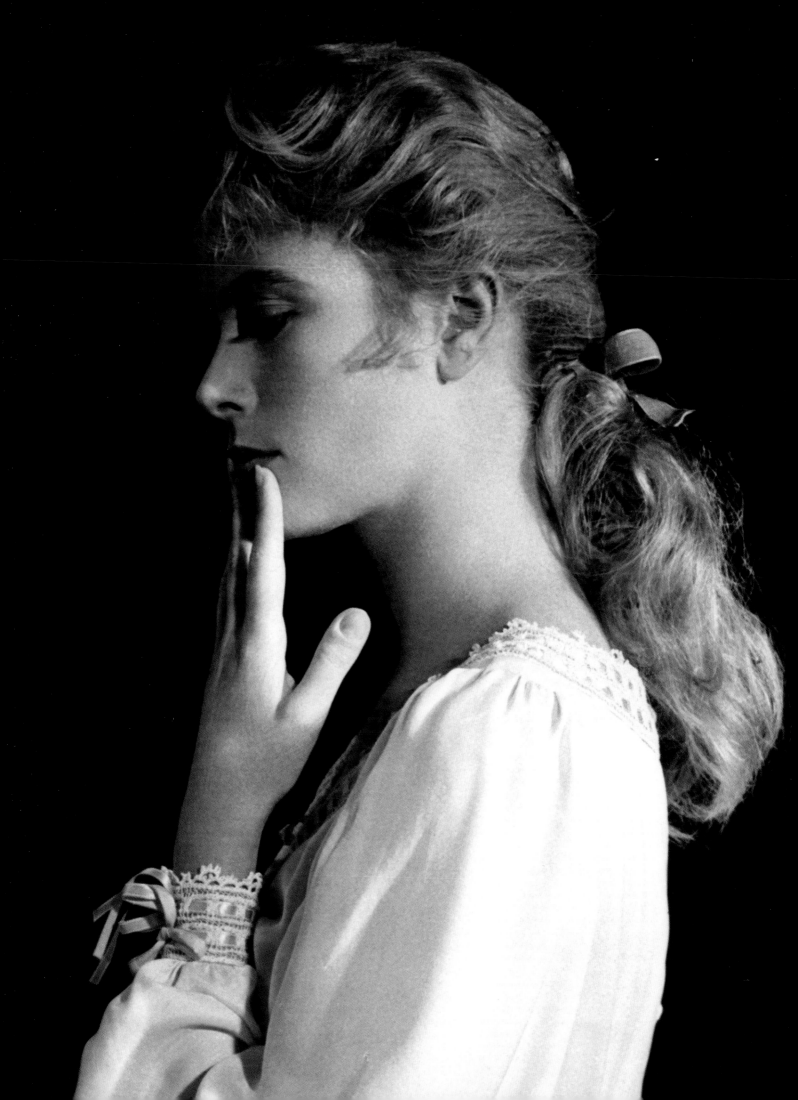

**RIGHT** Louis Jourdan and Grace Kelly.

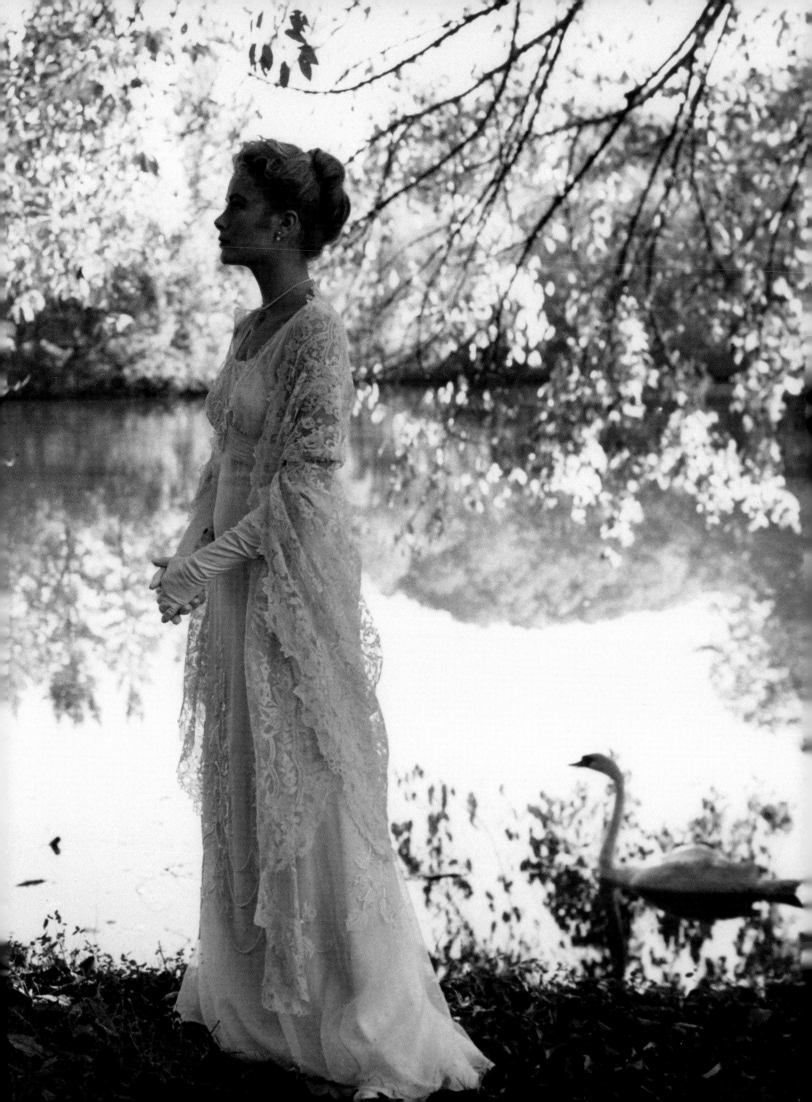

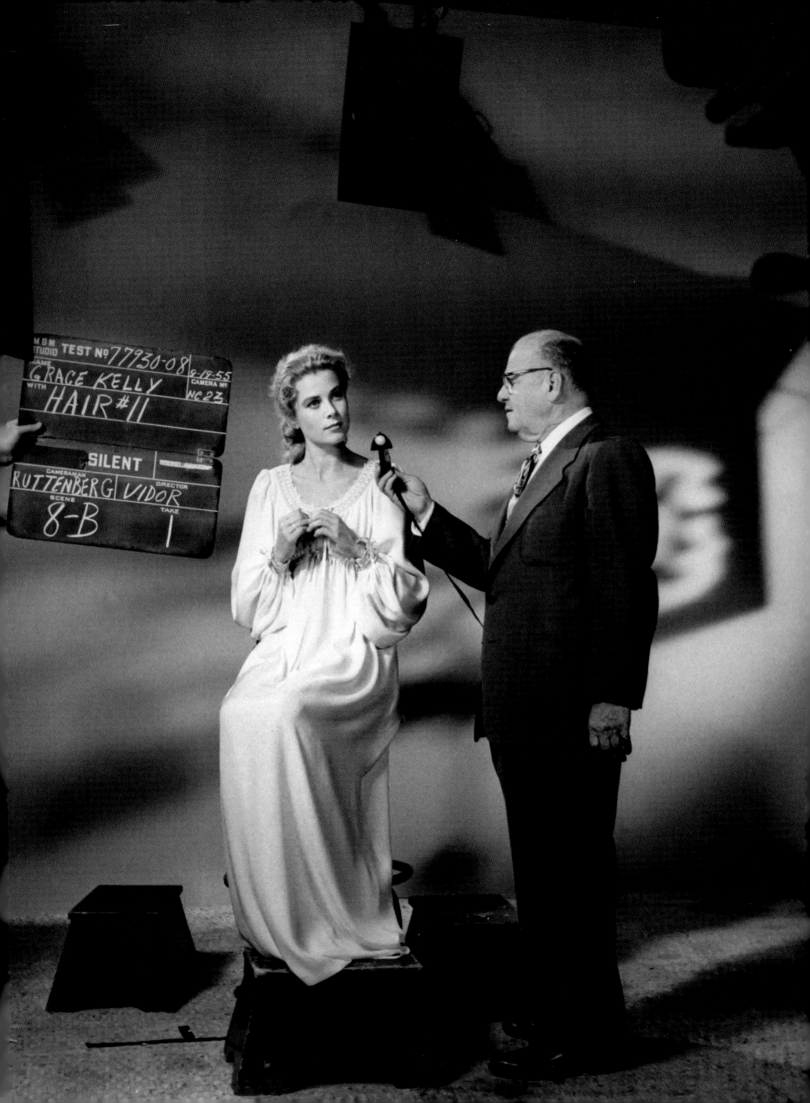

MGM STUDIO TEST Nº 77930-08 | 9-12-55

NAME GRACE KELLY | CAMERA Nº

WITH HAIR #11 | NC 23

SILENT

CAMERAMAN RUTTENBERG | DIRECTOR VIDOR

SCENE 8-B | TAKE 1

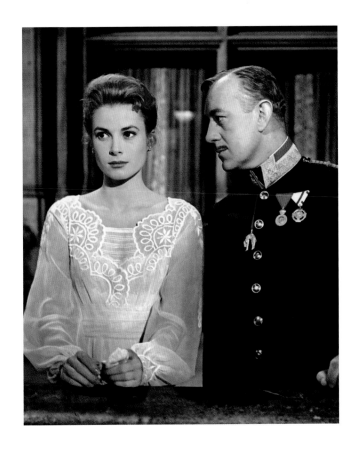

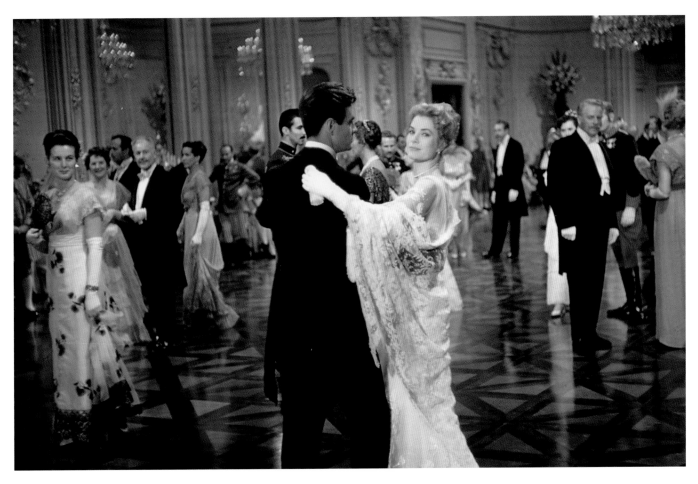

**OPPOSITE** Cameraman Joe Ruttenberg gauges lighting of Grace for hair test. **TOP LEFT** Prince Albert (Guinness) explains the expectations put upon the swan to Princess Alexandra (Kelly). **TOP RIGHT** A behind-the-scenes laugh. **ABOVE** Dr. Nicholas Agi (Jourdan, dancing with Grace) is used to elicit jealousy in Prince Albert

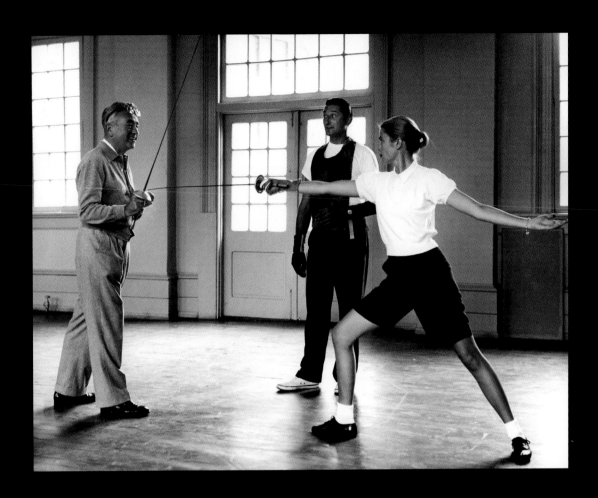

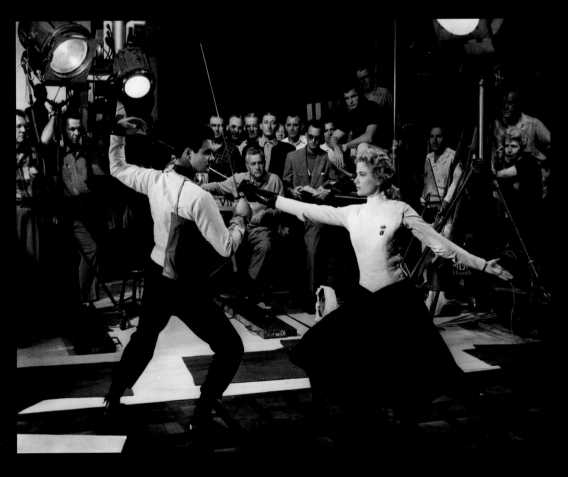

OPPOSITE Grace fencing on set. TOP Grace practices fencing with director Charles Vidor (left).
ABOVE The film crew watches Louis Jourdan and Grace rehearse.

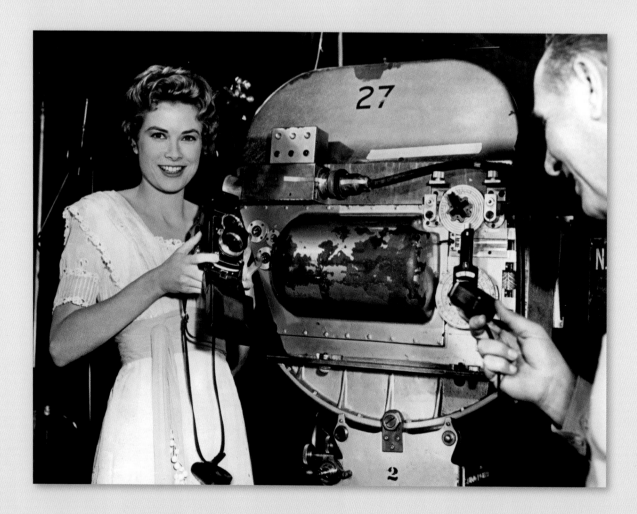

**TOP LEFT AND RIGHT** Wardrobe tests. **ABOVE** Grace turns the tables on cinematographer Robert Surtees.

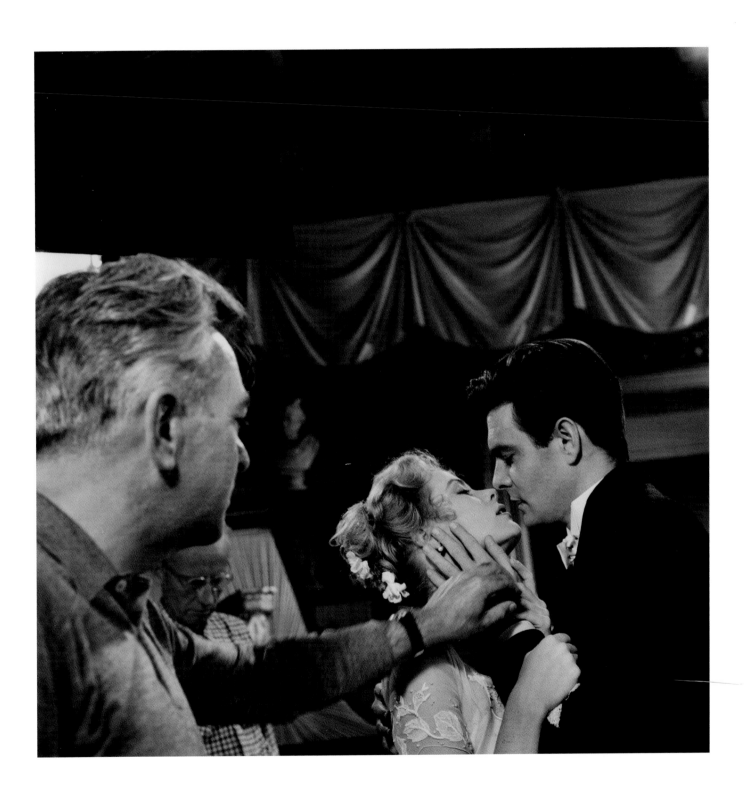

ABOVE Charles Vidor directs Grace and Louis Jourdan.

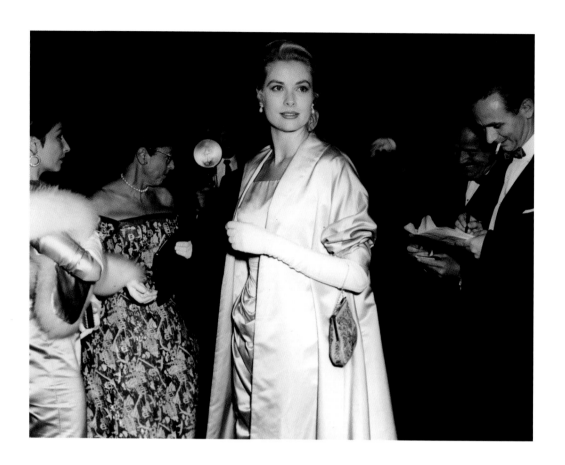

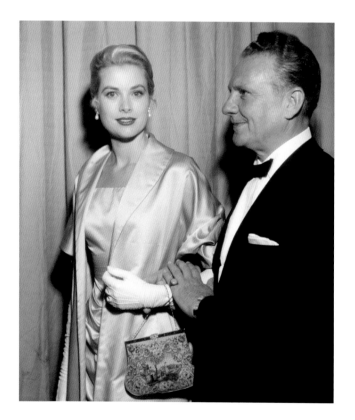

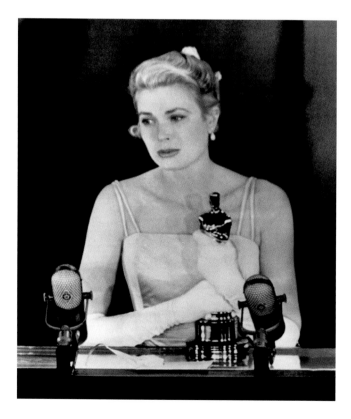

**TOP** Grace arrives at the awards with (from left) Zizi Jeanmaire and Edith Head. **ABOVE LEFT** Grace was escorted to the ceremony by Paramount producer Don Hartman. **ABOVE RIGHT** Grace accepts the Academy Award onstage.

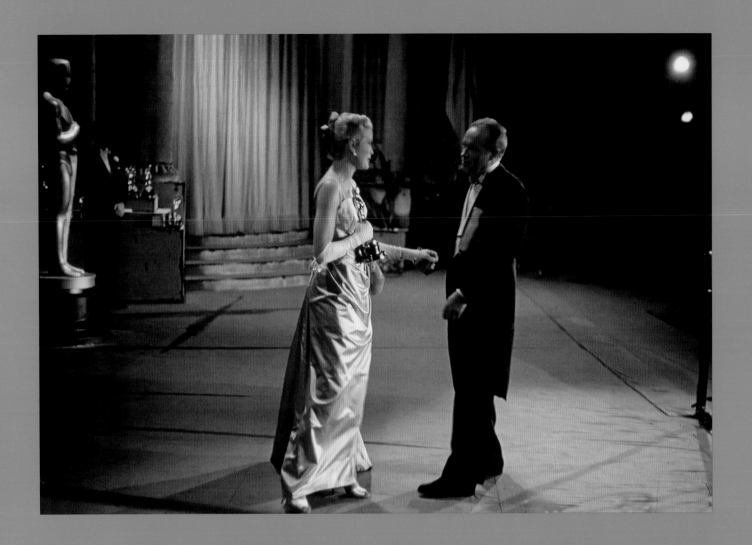

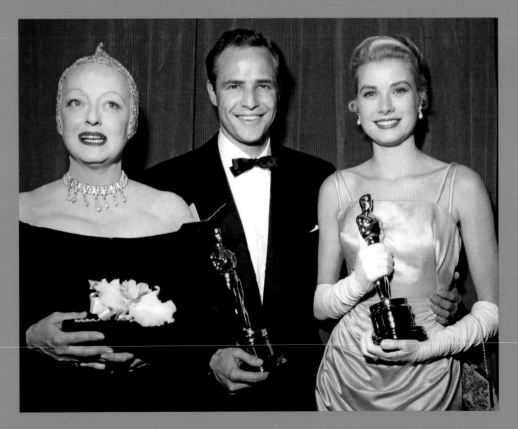

**TOP** Grace with master of ceremonies Bob Hope.   **ABOVE** Grace backstage with presenter Bette Davis and Best Actor winner Marlon Brando.

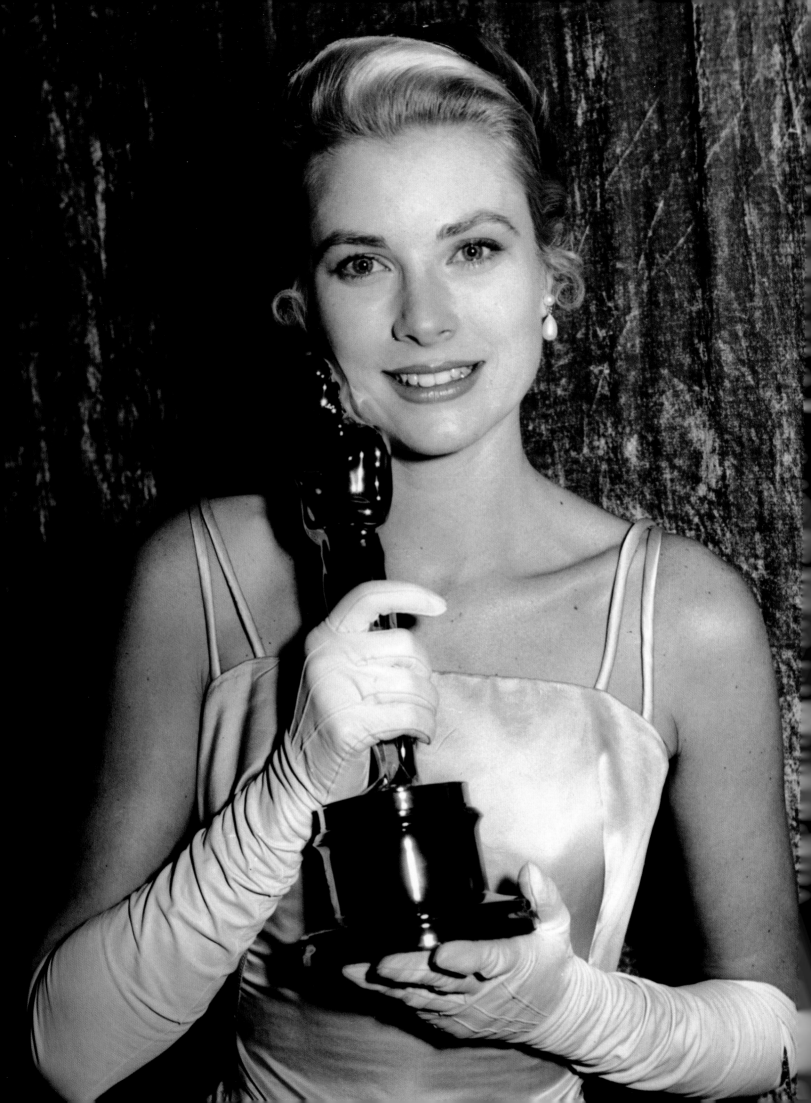

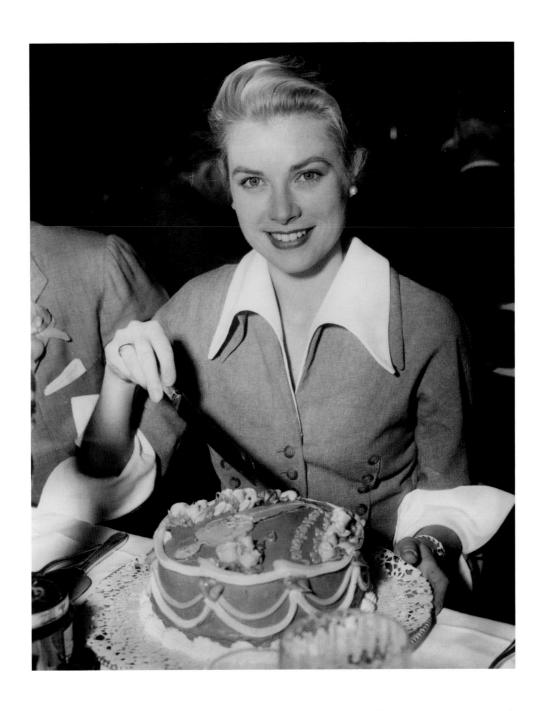

"There was an innate aristocracy—elegance—about her. Not only in comportment and manners, but also in thinking and being. It has been a cliché to say that Grace Kelly looked like a princess. But she did."

LOUIS JOURDAN

**OPPOSITE** Grace poses with her award.   **ABOVE** Grace cuts a congratulatory Oscar cake.

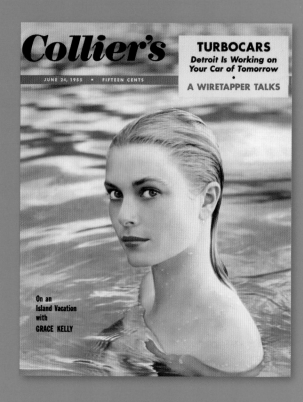

On an
Island Vacation
with
GRACE KELLY

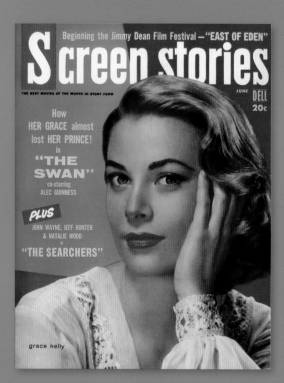

**TOP LEFT** Grace's post-Oscar treat was a vacation in Las Vegas. Grace is pictured at the Hotel Sahara with Ray Bolger, Betsy Drake, and Cary Grant. **TOP RIGHT** Grace was featured on the cover of *Collier's* after her Oscar win. **ABOVE** Promotions for the film included magazine covers and advertising tie-ins. **OPPOSITE** An MGM portrait used to promote *The Swan*.

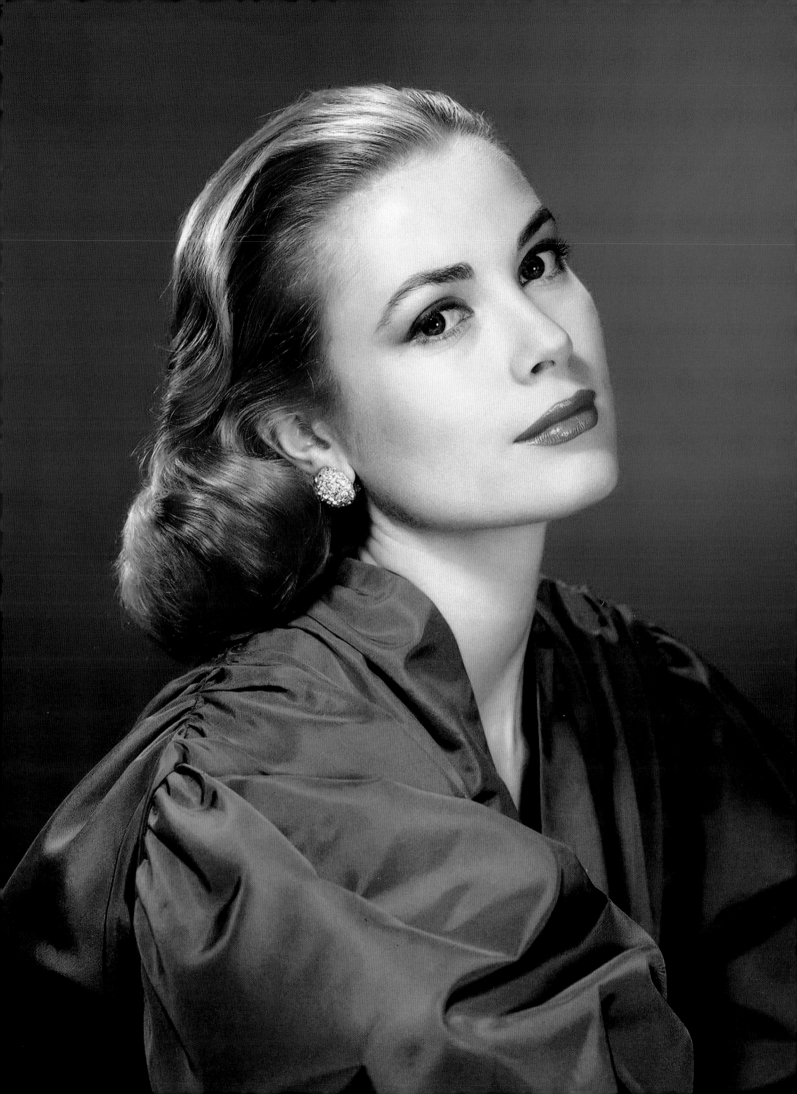

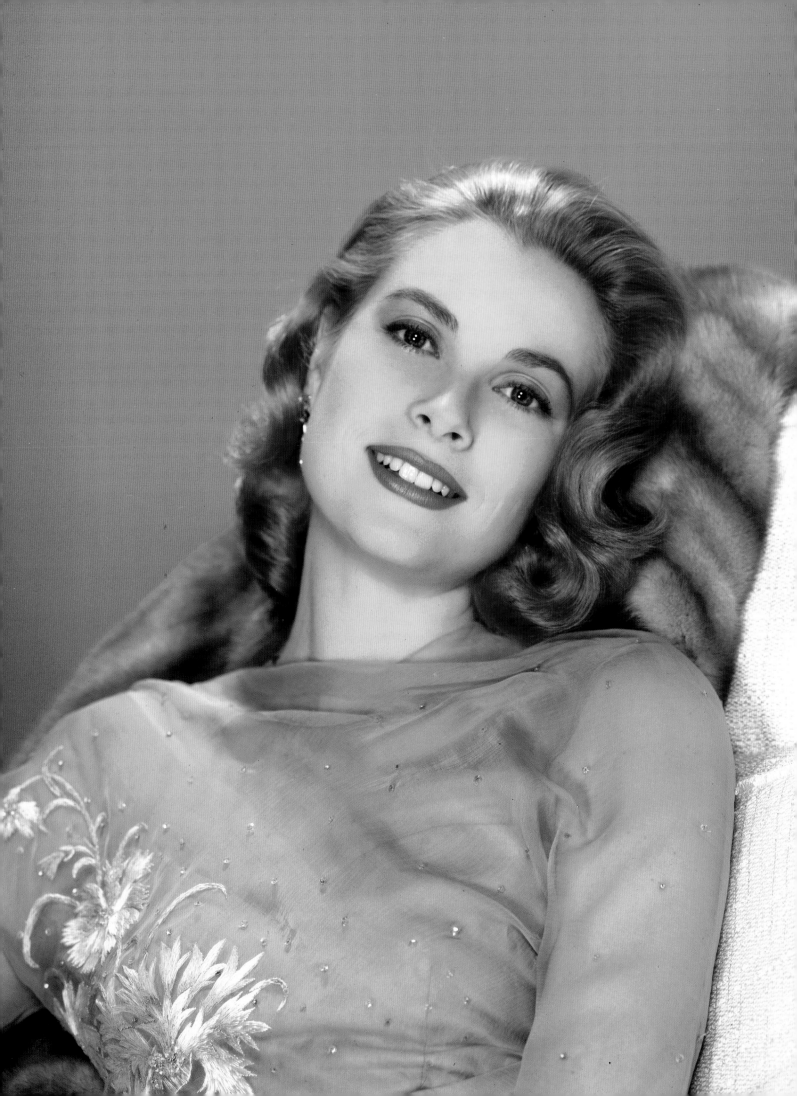

# HIGH SOCIETY

## 1956

Just before filming on *The Swan* wrapped in December 1955, Grace received word that Prince Rainier was coming to the United States for an appointment in Baltimore. The prince asked if he could visit Grace and her family in Philadelphia for Christmas. Grace had told none of her friends or family about her correspondence with Rainier. "At one point," Grace said later, "I almost didn't go home for Christmas, even though the prince was to visit us. I made up my mind I wouldn't go. And then—I can't remember how it happened—I just went and bought a plane ticket anyway."

On Christmas Eve, Prince Rainier and his traveling companions headed over to the Kelly home for their annual holiday party. At first, Grace was nervous about her family, but Rainier spent the entire evening talking to Grace. Later, the couple went to Peggy's house, where they played cards and talked until two a.m.

For two days, Grace and Rainier were "away from all public focus, walking in the woods, driving through the mountains and talking about life and values—and they fell in love," Judith Balaban Quine said. As in a scene from a movie, Grace had found her prince. They both seemed to sense—almost instantly—that they were right for each other. Rainier proposed, and Grace immediately accepted. "Everything was perfect," Grace said of their time in Philadelphia. "When I was with him, I was happy wherever we were, and I was happy with whatever we were doing. It was a kind of happiness—well, it wouldn't have mattered where we were or what we were doing, but I'd have been happy being there and doing it."

Though Peggy and Lizanne were surprised by the sudden engagement, Grace's excitement was palpable, and the Kellys welcomed Rainier to the family without ceremony. "Don and I were at our own little apartment,

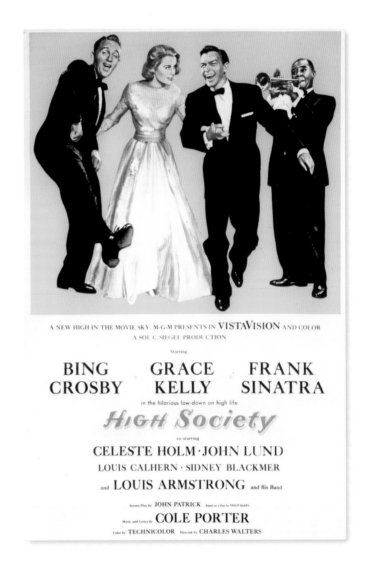

A NEW HIGH IN THE MOVIE SKY. M-G-M PRESENTS IN VISTAVISION AND COLOR
A SOL C. SIEGEL PRODUCTION

starring

**BING CROSBY** · **GRACE KELLY** · **FRANK SINATRA**

in the hilarious low-down on high life

*HIGH Society*

co-starring

**CELESTE HOLM · JOHN LUND**

LOUIS CALHERN · SIDNEY BLACKMER

and **LOUIS ARMSTRONG** and His Band

Screen Play by JOHN PATRICK    Based on a Play by PHILIP BARRY

Music and Lyrics by **COLE PORTER**

Color by TECHNICOLOR    Directed by CHARLES WALTERS

and we asked them over for dinner," Lizanne remembered. "He fit in very well—even helped with the dishes. Rainier, when we first met him, I think might have been a little shocked with us when we'd say 'Come on, Rennie,' you know. But he just fit into the family beautifully."

"If I'd met the prince two or three years earlier," Grace said a year after her marriage, "perhaps I might not have married him—at least not so soon. But we came together at the right time. It couldn't have been any different. It

**TOP AND BOTTOM LEFT** Grace rehearses with Frank Sinatra and director Charles Walters. **ABOVE RIGHT** Grace and Rainier announce their engagement.

had to be that way. It seemed right, and it felt right, and that was the way I wanted it."

At long last, here was a match that earned the approval of Grace's parents. "When she finally told us that she'd marry Rainier, well, he wasn't from Hollywood," John B. Kelly Jr. said later. Unlike Oleg Cassini and her film-colony dates, the prince "seemed to check out fine . . . I guess it was almost a sense of relief."

After her whirlwind Christmas romance, Grace rushed back to New York to take singing lessons for her next film, a musical version of Philip Barry's play *The Philadelphia Story*, called *High Society*. With breathless excitement, Grace broke the news of her engagement to all her friends, including Oleg Cassini. "I have made my destiny," she said. Cassini told her, "One of the reasons I believe you're marrying this man is because this is the best script that you ever received in your life. You will be a star for years to come." Jean-Pierre Aumont received the news in a telegram. "I answered that I was delighted," Aumont said. "I was sincere. I've always thought that Grace was born to be a princess."

Jay Kanter was the first to understand what the news meant for Grace's career. "I was astounded," Kanter said. "I was very pleased for her. And then suddenly the news came, well, this would kind of put a damper on her acting career and a shadow of gloom fell over my face. But at the same time, I realized that this was what she wanted." Grace told friends that she felt unsure of what her career would hold for her in the future, but that life with Rainier would allow her to raise her children properly and with security.

On December 30, Grace held a party at her New York apartment so that her friends could meet Rainier. "They were really wildly in love and that was patently obvious to everybody from the moment it began," Judith Balaban Quine said. "They were both these wonderfully attractive people that had all this romantic charm, intelligence and wit, and coziness. And they were just adorable together."

In January 1956, the official announcement came and the press had a field day. Later, when *The Swan* was released, the life-imitating-art angle made for better publicity than what anyone could have planned. "In his

wildest, most ecstatic dreams," the *Los Angeles Times* wrote, "no studio press agent could have timed the two events so perfectly: the betrothal of Grace Kelly to a prince, Alec Guinness, in a film, and to a Prince, Rainier, in real life."

Filming for *High Society* began at MGM in Culver City mid-January 1956. Production was put on the fast track to allow Grace to be in Monaco in time for the wedding in mid-April. Grace slipped easily into society girl Tracy Lord's shoes, having embodied her onstage when she graduated from the American Academy of Dramatic Arts in 1949. Her *Country Girl* costar Bing Crosby filled the role of C. K. Dexter-Haven, Tracy's ex-husband, and Frank Sinatra was cast as Mike Connor, a reporter from *Spy* magazine. It marked the historic first on-screen pairing of Crosby and Sinatra. Louis Armstrong and Celeste Holm rounded out the cast.

Legendary composer Cole Porter wrote fourteen new songs for *High Society*, nine of which were used in the film. Grace and Bing Crosby would sing a duet, the ballad "True Love," for which it was assumed Grace would be dubbed by a professional singer. However, Grace had appeared in stage musicals before, and had been brushing up on her vocal skills for the film. She pled her case to Dore Schary and musical director Johnny Green, and was allowed to record the song. When Cole Porter heard it, he wrote to Green, saying, "I can't tell you how surprised I am at the singing of Miss Grace Kelly." Grace now added singing to her illustrious list of accomplishments; "True Love" would sell a million copies, and Grace and Bing were each awarded gold records.

Grace's Tracy Samantha Lord was a very different character from the one that Katharine Hepburn had portrayed in the 1940 film *The Philadelphia Story*. If Hepburn was fire, Grace was ice. "I tried to find the point where [Tracy's] haughtiness was a cover for insecurity and for the pain she felt over her father's behavior," Grace said. Tapping into feelings about her own father, Grace used her upbringing as a basis for a flawed but likable three-dimensional character.

MGM gifted Grace with her *High Society* wardrobe. They also offered the services of costume designer Helen Rose and her staff to create the dresses for the wedding

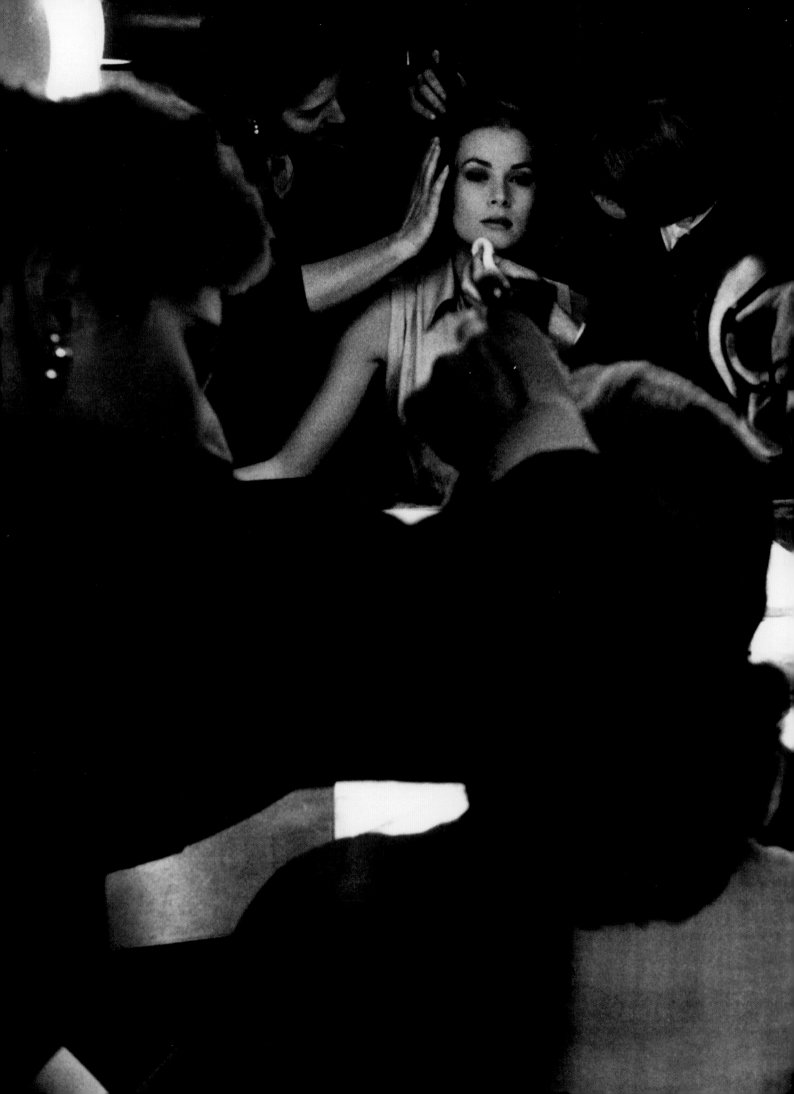

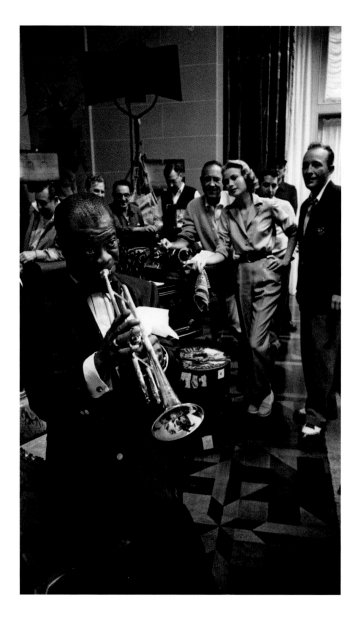

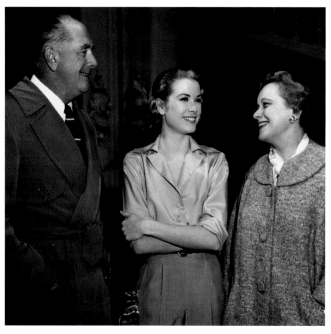

in Monaco. "I explained to Helen the kind of line and look I wanted, with *gros de Londres* skirt and lace blouse, and as usual, she came up with something that far surpassed my imagination and hopes," Grace said. When the estimate for the dresses went to the studio heads, Rose was afraid she would be fired. But publicity man Howard Strickling assured everyone that Metro would recoup its costs in publicity. Three dozen seamstresses worked for over six weeks on the gowns, which were made in secret behind partitions in the MGM wardrobe department.

Rainier had rented a house in Bel-Air to be near Grace. He spent days watching the cast and crew work harmoniously on *High Society*, none of them fully aware that this would be Grace's last film. "In Hollywood, his bride-to-be was no longer the delicate, removed beauty who floated through a crowd," said Judith Balaban Quine. "Here she was one of the gang. He was her prince on a white charger and he was going to rescue her from all this. He could not possibly have known that what he was taking her from made her the very person he loved. She did not know it either."

Wives of princes typically did not pursue their own careers, but Grace was hopeful that her work in Hollywood might continue. Dore Schary held a luncheon in Rainier's honor at the studio, hoping that if the prince viewed MGM favorably, Grace might be allowed to continue making movies. The guest list included director Chuck Walters, Celeste Holm, Rainier and Grace, and Rainier's father, Prince Pierre, who had come to Los Angeles to meet Grace. Someone at the luncheon asked Rainier how big Monaco was, and when the prince replied, Dore Schary blurted out, "That's not even as big as our back lot!" Celeste Holm said she knew right then that Grace would never be allowed to make another film in Hollywood.

Rainier had already made up his mind that Grace would not continue her career. When reporters asked Grace if she was retiring from films, she replied that the decision was up to the prince. For all of her independence and willfulness, Grace Kelly was still a product of her upbringing and her era; well-bred 1950s ladies married, had children, and let their husbands run the household. They did charitable work and planned parties, but did not

**TOP** The cast and crew watch Louis Armstrong. **BOTTOM** Grace's parents visit the set. **OPPOSITE** Grace looks over Louis Armstrong's autobiography.

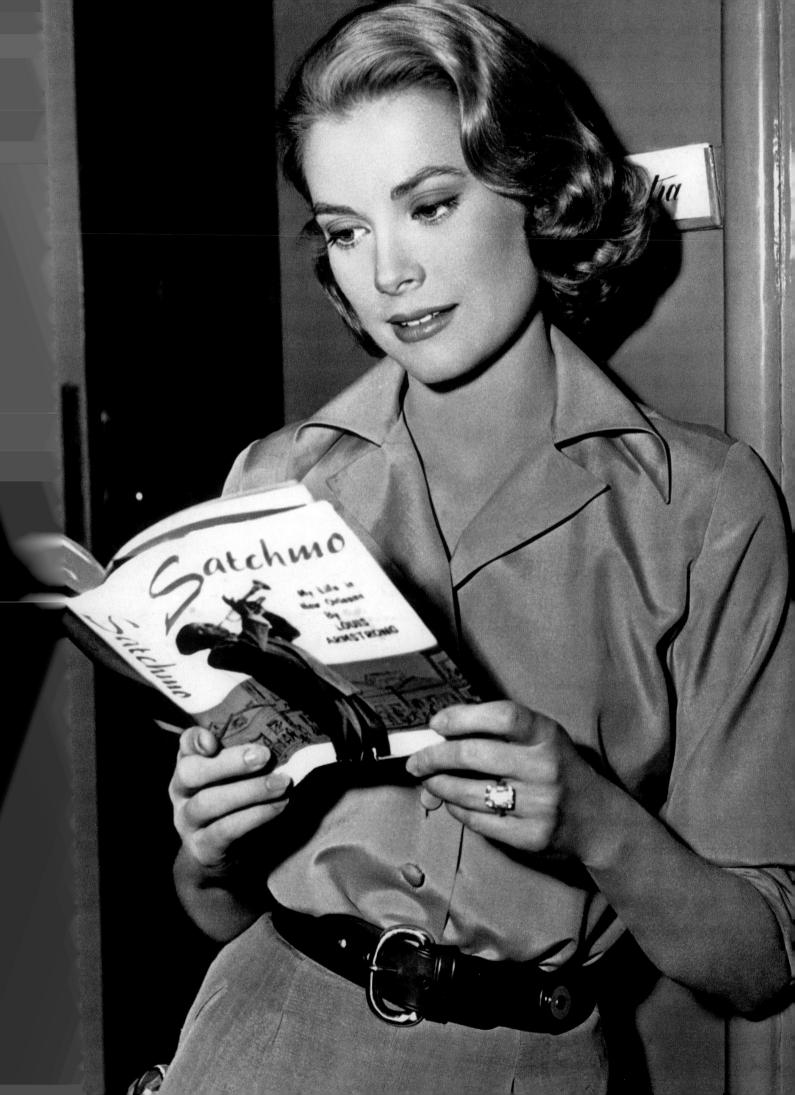

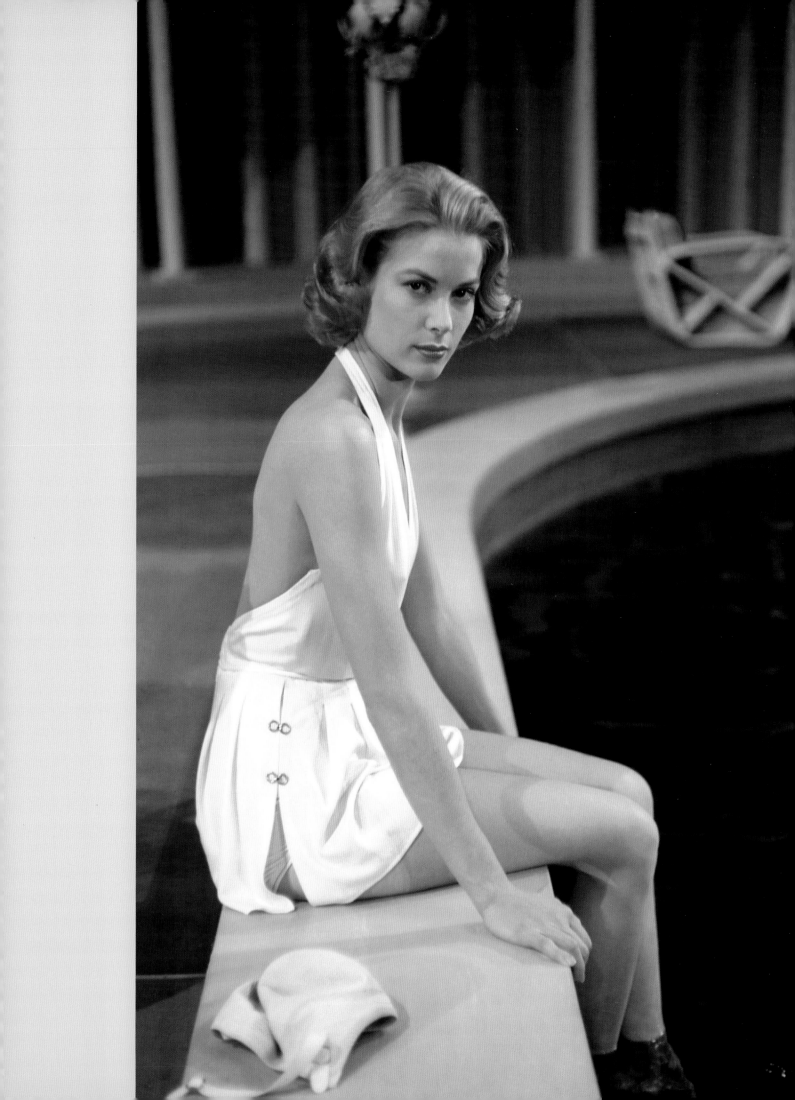

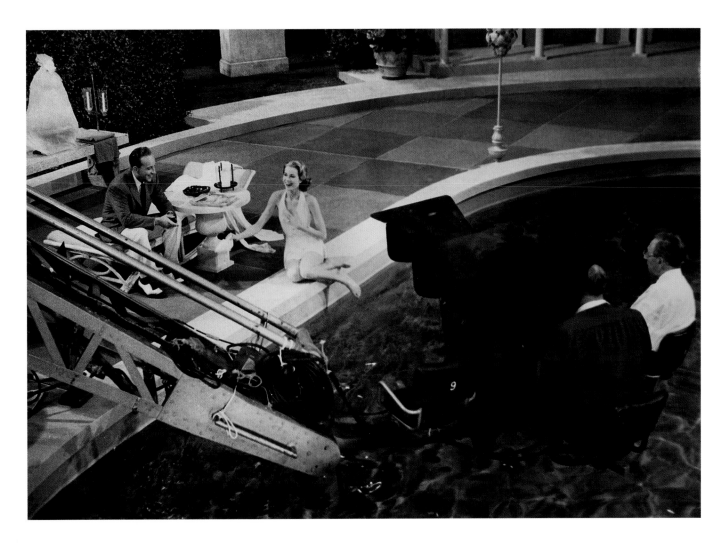

earn their own money. This was the way things were done, and had always been done. Grace made little attempt to rebel against such a time-honored system.

MGM had been readying Grace's next film *Designing Woman*, based loosely on the life of Helen Rose. "We had to tell MGM that *High Society* would be the last picture and not bother to send any more scripts," Jay Kanter said. "They didn't take it too well. There was still time left on her contract." *Designing Woman* would be made in 1957, with Lauren Bacall in the role planned for Grace.

*High Society* finished on time and on budget at $2.7 million. Grace Kelly's only venture into musical comedy was a box-office smash and one of the top ten highest-grossing films of 1956. Having won her Oscar and found an ideal husband, Grace had nothing left to prove when she made *High Society*—and she lets loose like never before. She even plays a few comedic drunk scenes with gleeful abandon in what *Variety* would label "her most

relaxed performance." Oscar-winning *Marty* director Delbert Mann said of Grace: "The sense of style—high comedy performance that she gave in *High Society* [was] vastly different from anything she had ever done before." The film remains a beloved classic, a delightful final note in Grace's filmography.

Grace's last official appearance in Hollywood was on March 21, 1956; at the Academy Awards she presented the Best Actor Award to Ernest Borgnine for *Marty*. "Before we all knew it, she was gone," Jimmy Stewart remembered. "She had made this extraordinary, luminous climb to the absolute top apex of the industry," Judith Balaban Quine said of Grace. "She could have called the shots from then on. Then she was finally in a position not to have to argue about the films she wanted to do. People would have bought things for her. People would have planned productions around her. They would have done anything, and she fell in love and she said, 'Bye.'"

**OPPOSITE** Grace was styled to look like a goddess on a pedestal for the swimming scene.  **ABOVE** Behind the scenes with Bing Crosby.
**OVERLEAF** Grace with John Lund.

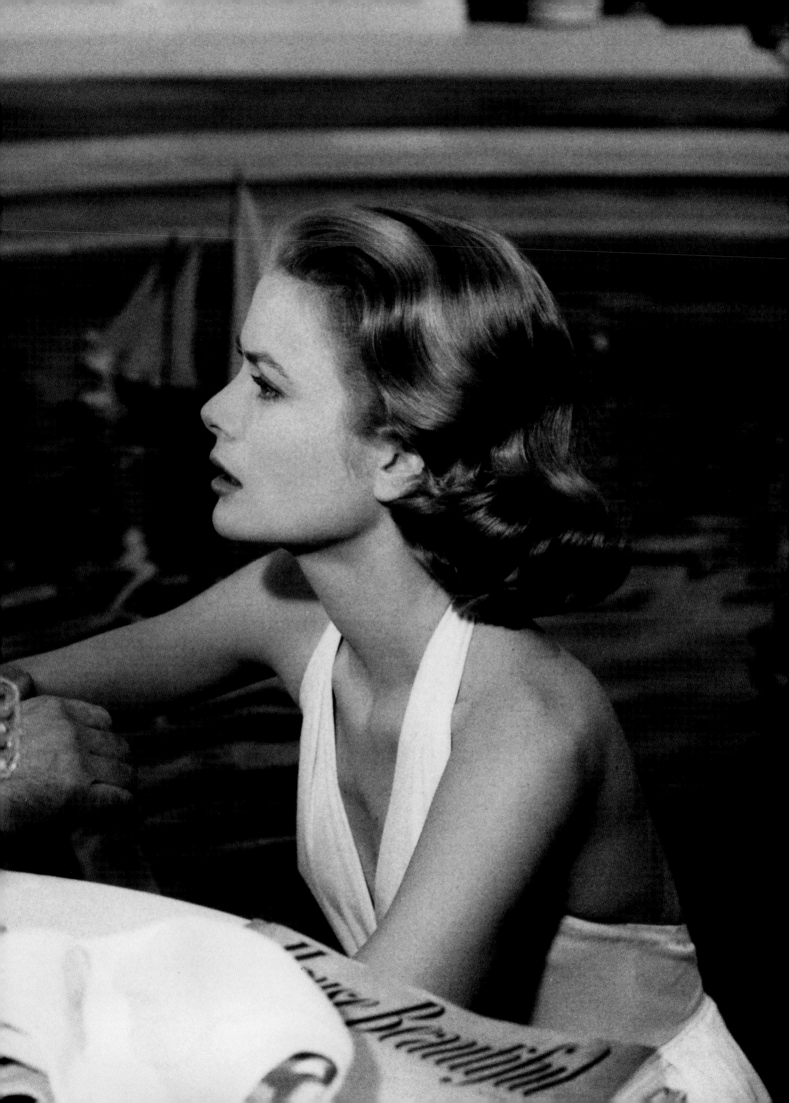

"HIGH SOCIETY"
A Metro-Goldwyn-Mayer Picture

56/250

**TOP** Grace with Lydia Reed.   **BOTTOM LEFT** Grace and Frank Sinatra.   **BOTTOM RIGHT** A portrait sitting with MGM photographer Clarence Sinclair Bull.

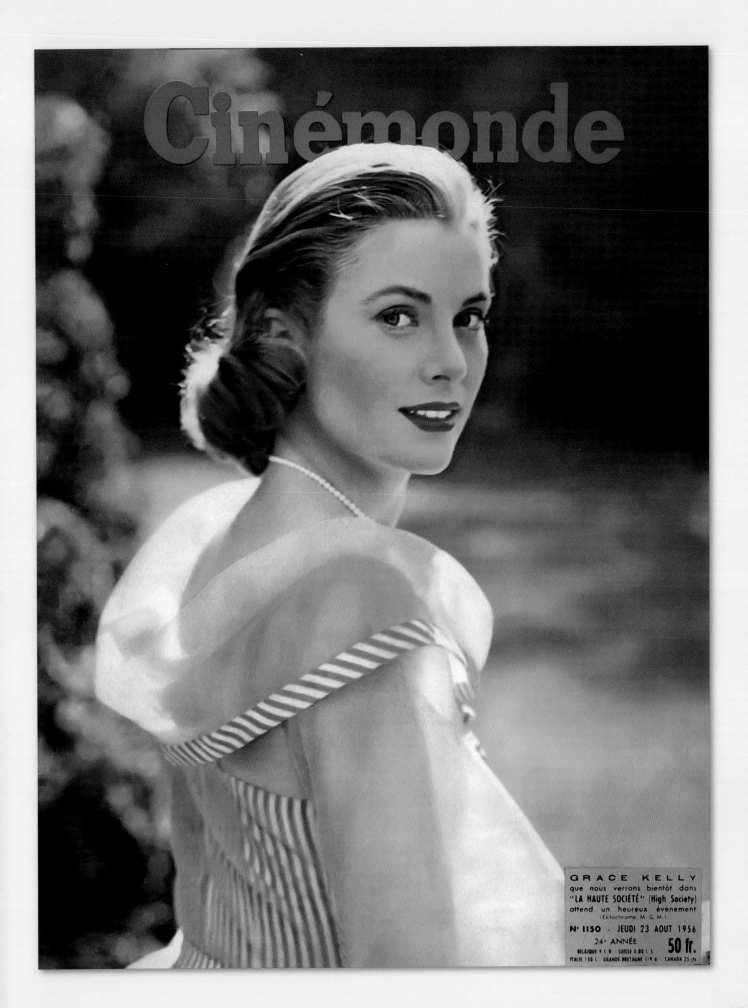

**Cinémonde**

GRACE KELLY
que nous verrons bientôt dans
"LA HAUTE SOCIÉTÉ" (High Society)
attend un heureux événement
(Ektachrome. M. G. M.)

N° 1150 · JEUDI 23 AOUT 1956
24ᵉ ANNÉE                    **50 fr.**
BELGIQUE 9 f. B. · SUISSE 0.80 f. S.
ITALIE 150 L. · GRANDE-BRETAGNE 1/9 d. · CANADA 25 cts

**ABOVE** Grace on the cover of *Cinémonde*, August 1956.

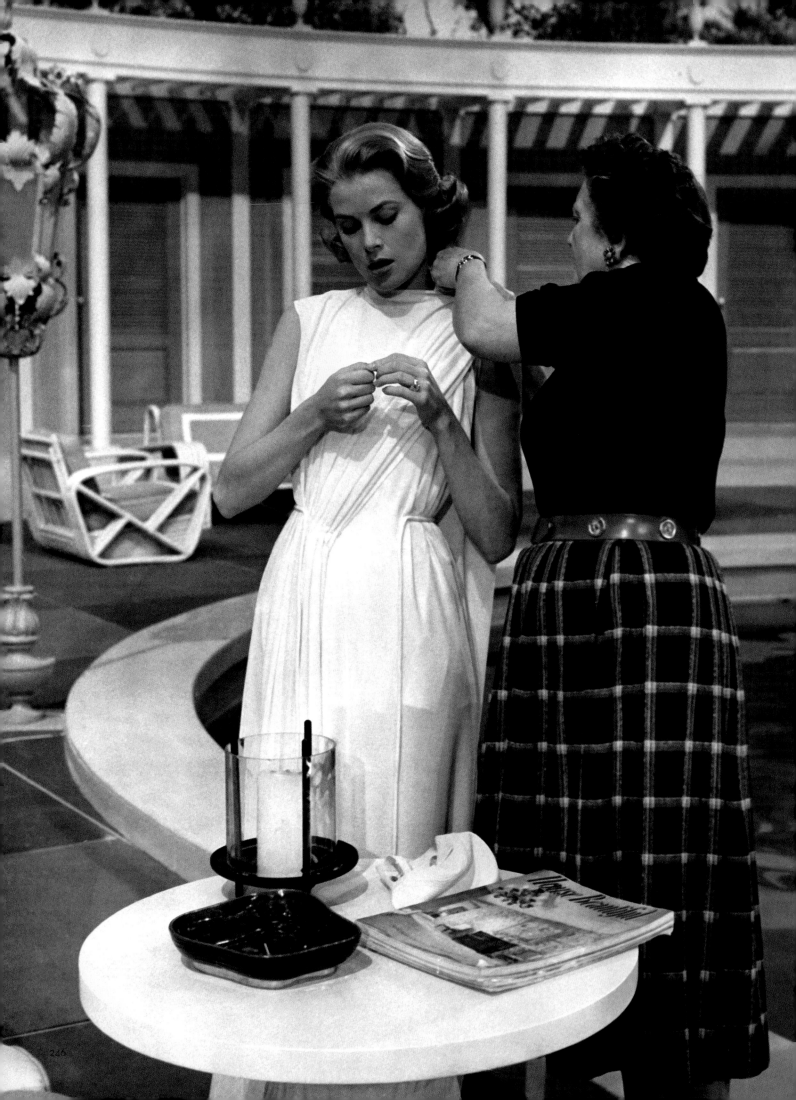

**OPPOSITE** A costumer tends to Grace.  **ABOVE** Makeup test for the honeymoon scene.

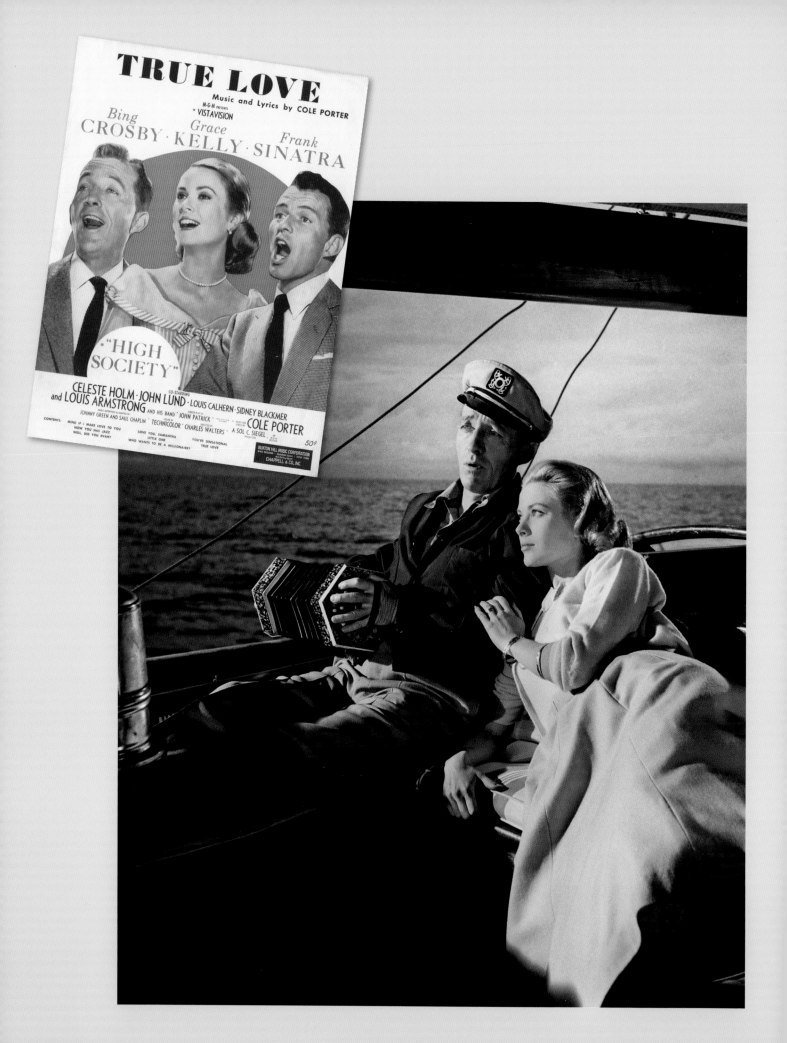

**ABOVE** Grace and Bing Crosby sing "True Love."   **INSET ABOVE** Sheet music for "True Love."

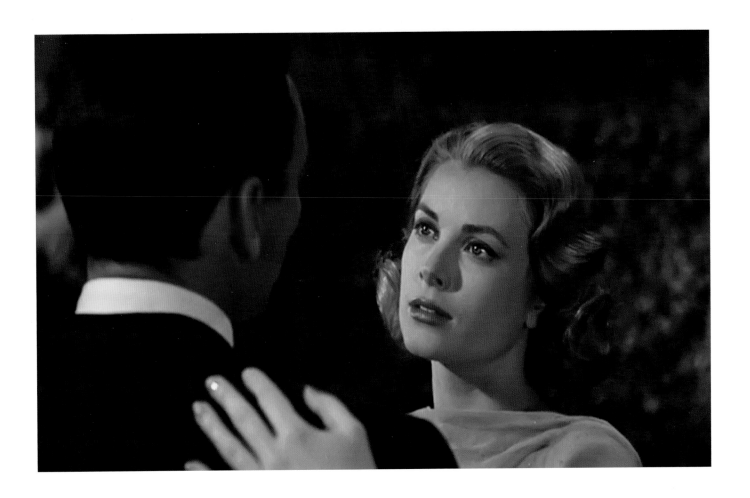

"Rather like a schoolgirl, she [Grace] said, 'Mr. Walters, could I wear my engagement ring in the picture?' He said, 'Well, I don't know, let's see it.' Well, it was a skating rink. And we said, 'Oh, Grace!' And she said, 'It is sweet, isn't it?' Well, sweet was hardly the description."

CELESTE HOLM on making *High Society*

**ABOVE** Grace with Frank Sinatra.

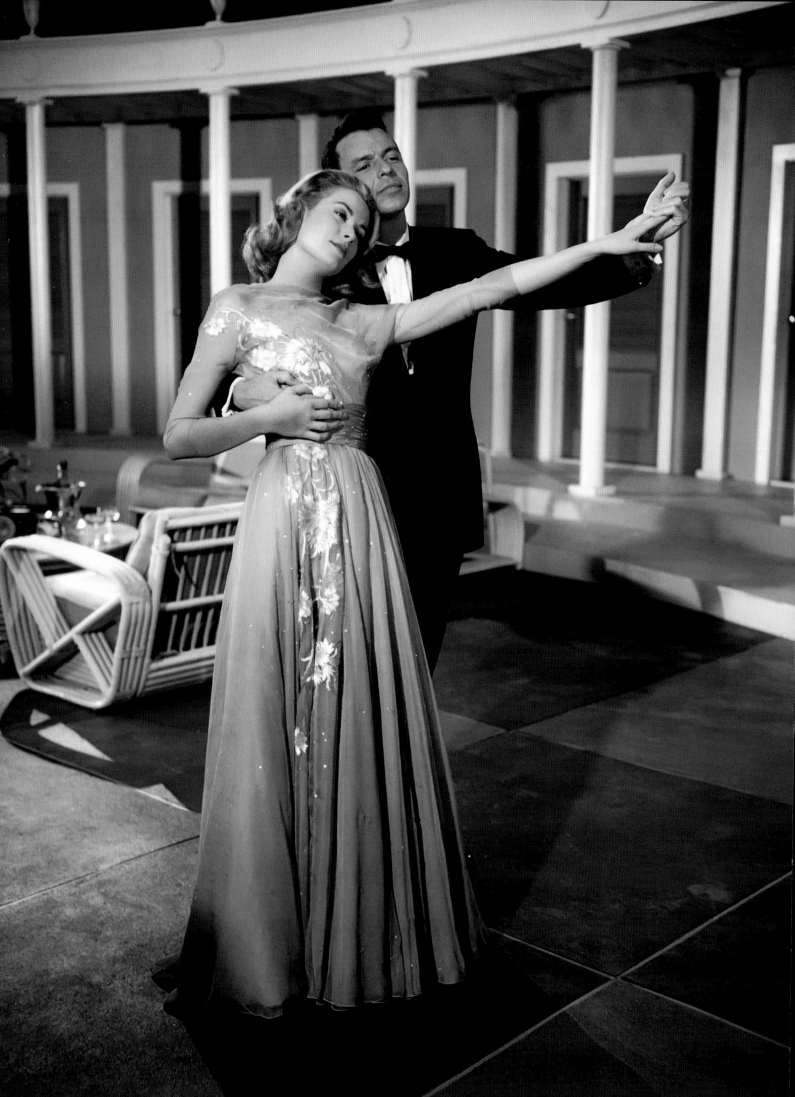

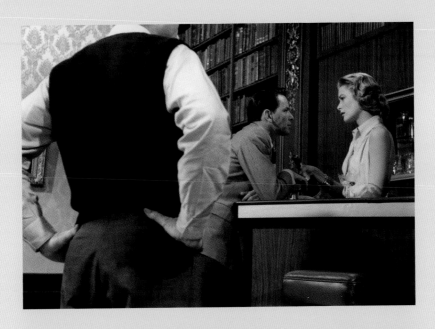

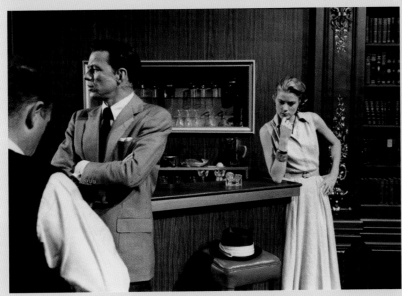

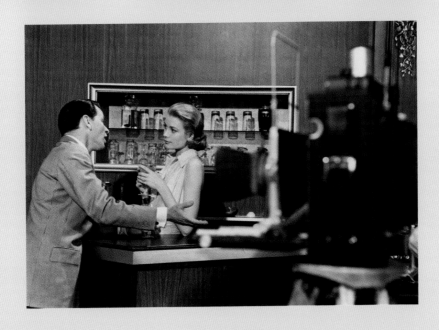

**OPPOSITE** Sinatra performs "Mind If I Make Love to You?"  **ABOVE** Grace rehearses with Frank Sinatra and director Charles Walters.  **OVERLEAF** Grace with Frank Sinatra.

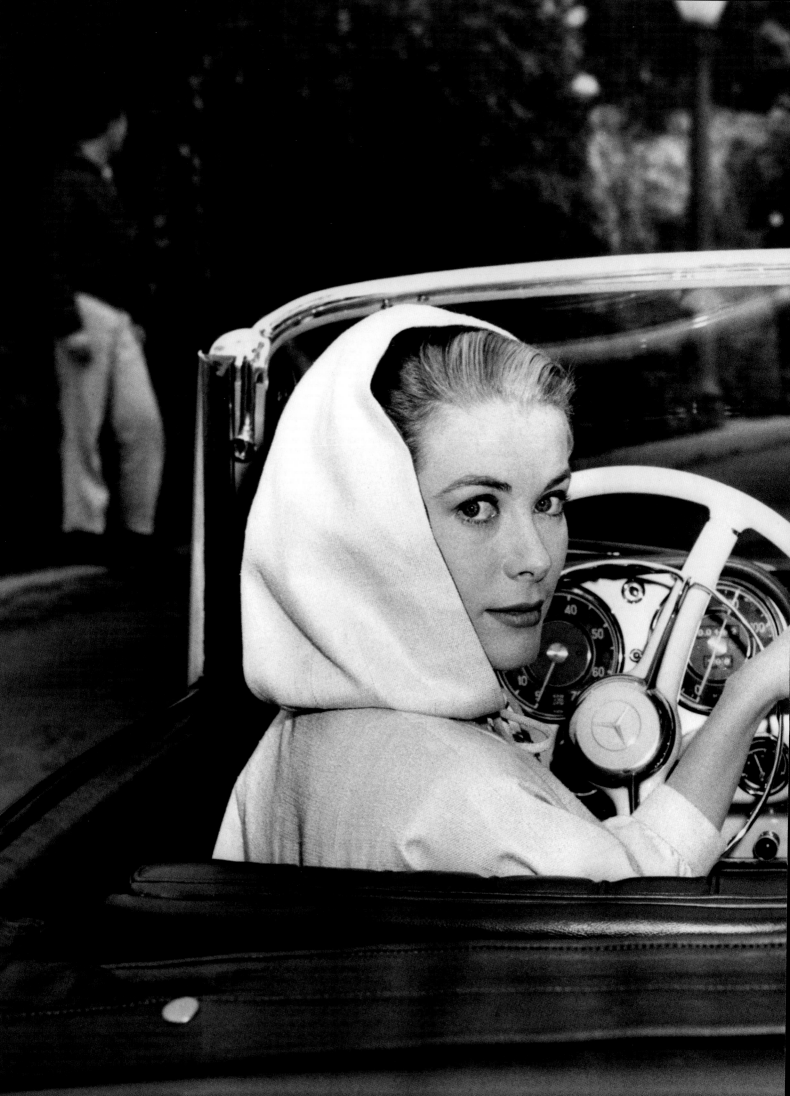

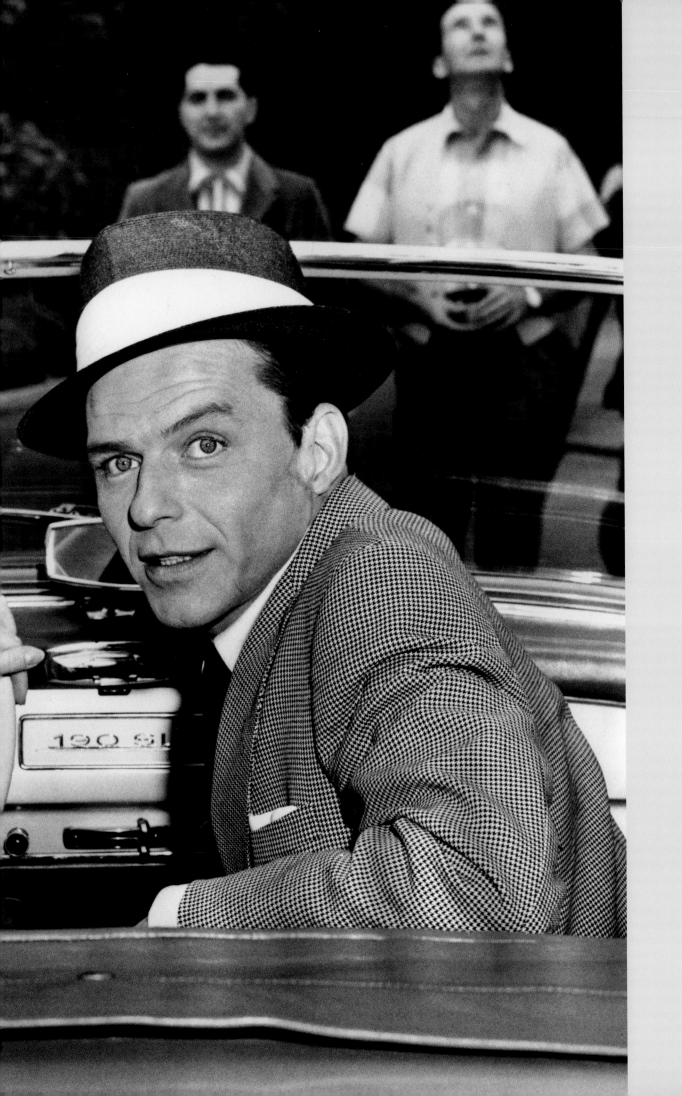

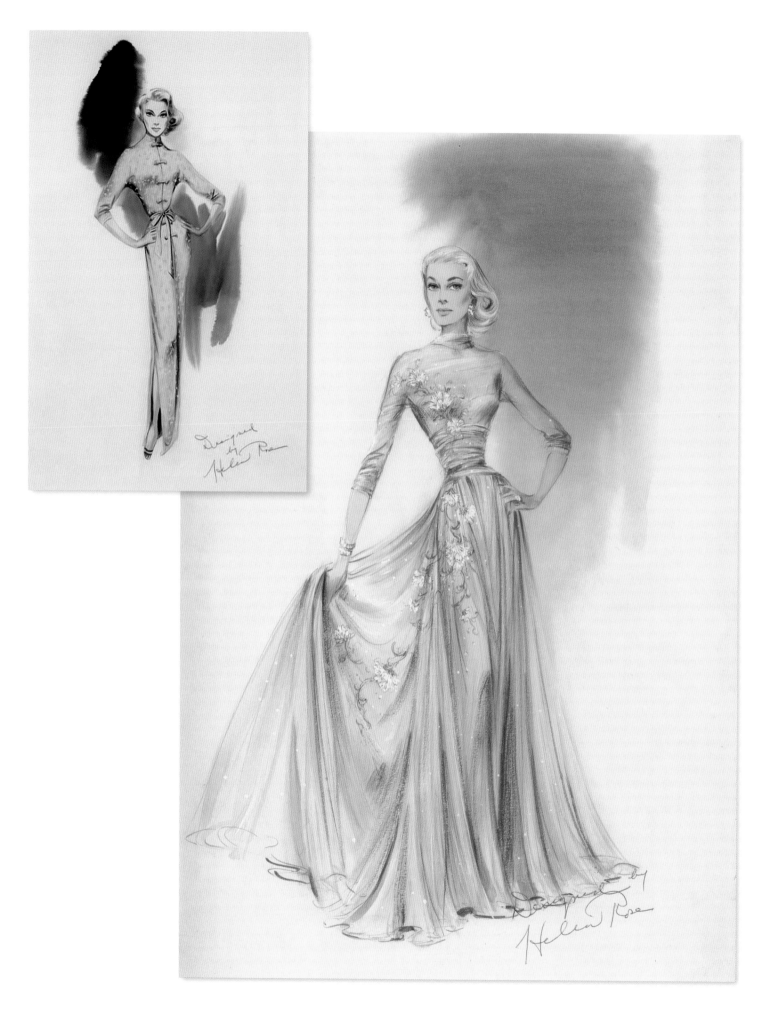

**ABOVE** Helen Rose wardrobe sketches by Donna Peterson.  **OPPOSITE** Grace wears the wedding dress for Tracy's second marriage.

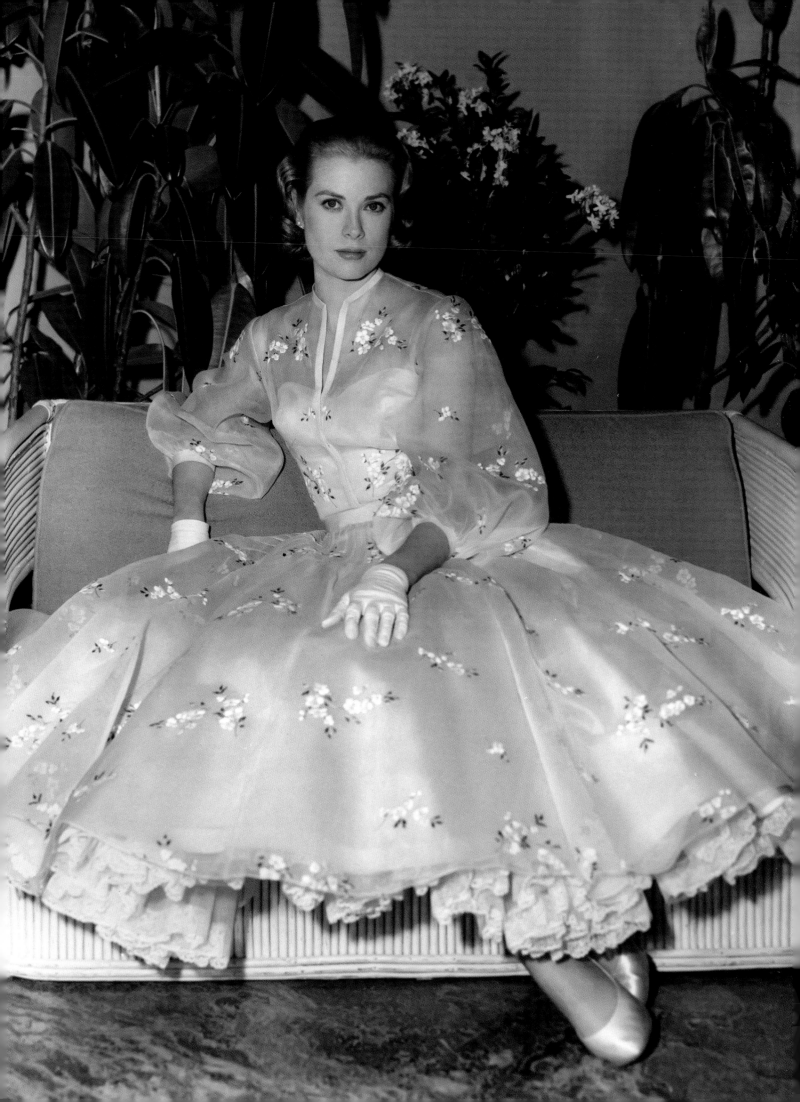

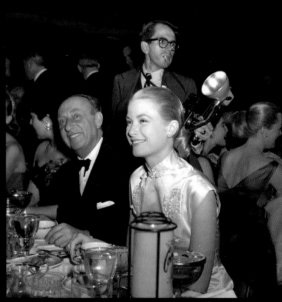

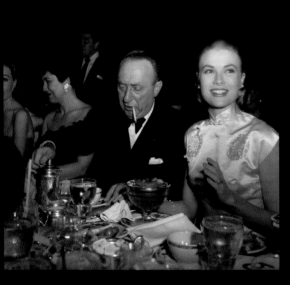

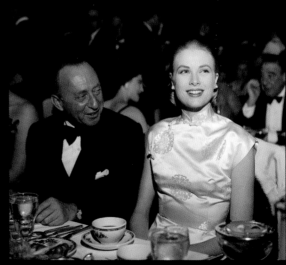

**TOP LEFT** At the Golden Globes in February 1956, Grace accepts the Henrietta Award for World Film Favorite. Pictured w
her are Jean Simmons (left) and Gregory Peck (center). **TOP RIGHT AND ABOVE** Grace, seated next to producer Joe Pasternak
beams during the Golden Globes dinner. **OPPOSITE** A pensive Grace greets the press in Chicago in January 1956.

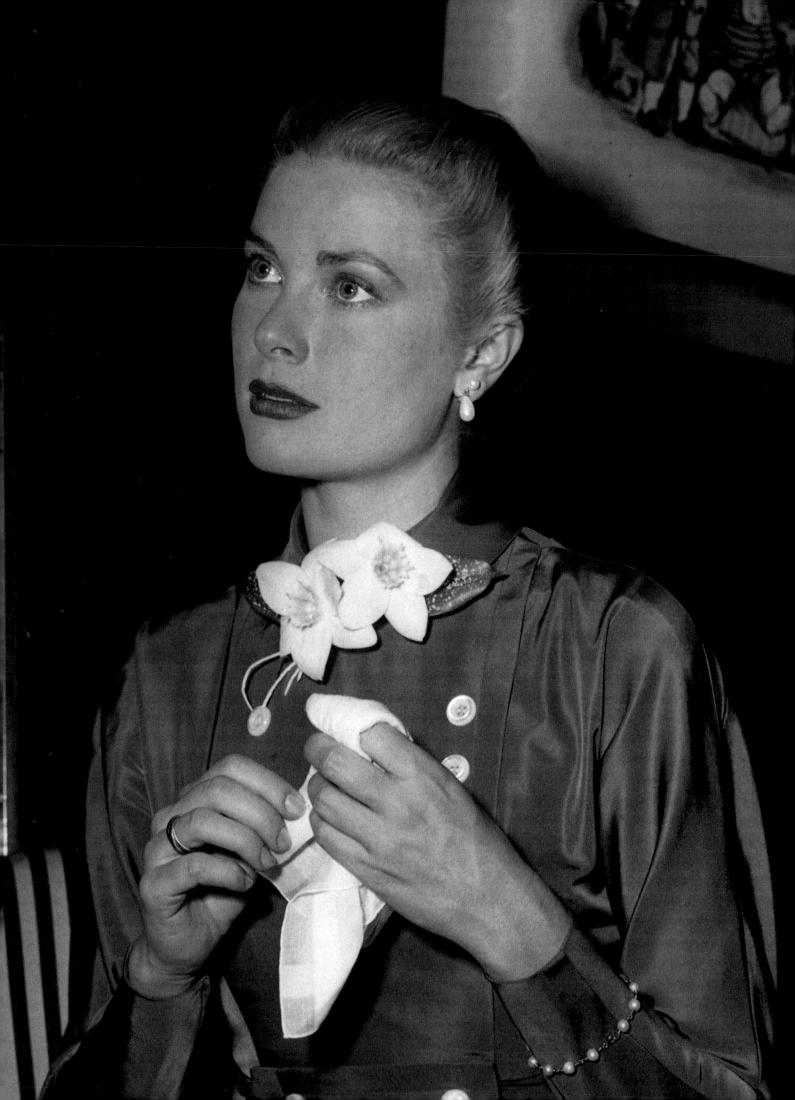

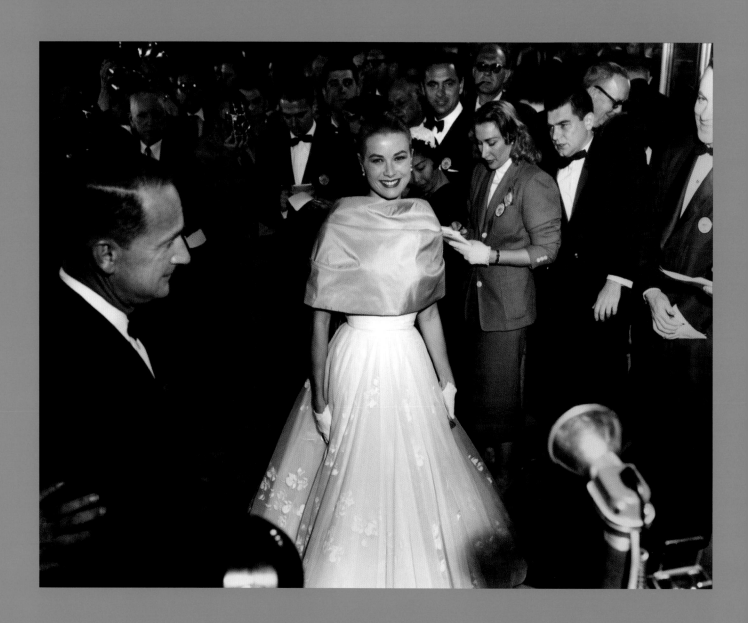

**TOP** Grace attends the 1956 Academy Awards. **ABOVE LEFT** The *High Society* soundtrack album. **ABOVE RIGHT** A ticket stub for the premiere. **OPPOSITE** Grace Kelly on the set.

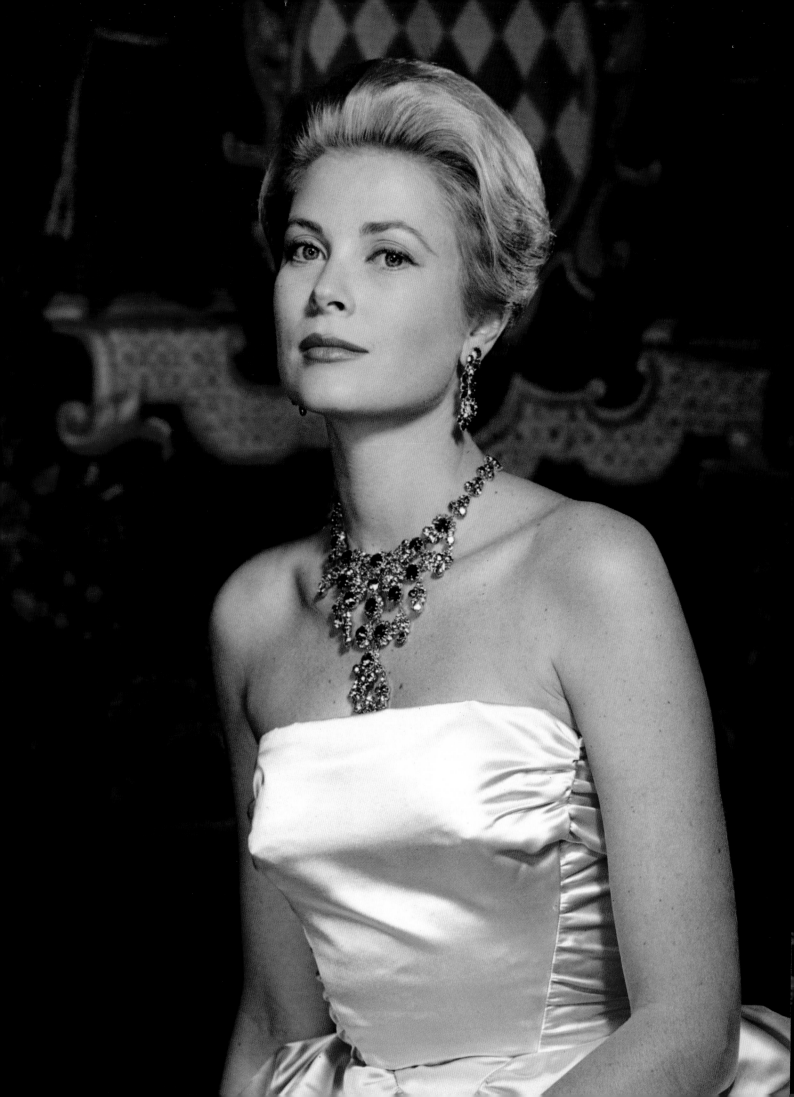

# THE MONACO YEARS

## 1956–1982

As the press fawned over the glamour of royal life on the Riviera, Grace probably never dreamed that life in Monaco would be rougher than any day on a movie set, and that she would need to create even more illusion than she had as an actress.

Grace Kelly had been her own woman. However, Princess Grace would be a product of every strict rule of protocol, formed by centuries. As on a film set, Grace was still being directed, but royalty is not allowed its own artistic expression—it must use the language of diplomacy. As an actor, Grace could use her own emotions and imagination to construct a character. But as a princess, she would be told how to behave. A royal court allows for no creative contributions, no unique personality to shine through; they wanted nothing more than for Grace to keep her behavior in line and not slip up.

In the same way that Grace Kelly was the actress Hollywood didn't know it needed, Hollywood was the town Grace Kelly didn't know she needed.

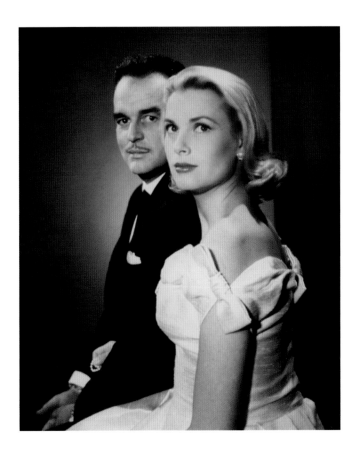

Monaco had once been the poorest state in Europe. In the mid-nineteenth century, Prince Charles III opened a casino there. He named the hilltop after himself and Mount Charles became Monte Carlo. Gambling was illegal in France and Italy, so aristocrats came to the gaming tables of Monte Carlo. Profits were so great that Prince Charles abolished taxes in Monaco, and for their own good, forbade Monaco citizens to enter the casino. The law is still in effect.

On April 4, 1956, Grace and her family, her pet poodle, Oliver, and eighty pieces of luggage arrived at Pier 84 in New York to sail aboard the USS *Constitution* to Monaco. There were also about fifty friends on board,

as well as a number of journalists. Three of Grace's bridesmaids traveled on the ship too. The selection of bridesmaids had become a national obsession. Rita Gam Guinzburg had been used to the spotlight, and to a certain extent, so had Judith Balaban Quine. But Grace chose her other four bridesmaids from her salad days—Carolyn Scott Reybold, Bettina Thompson Gray, Marie Frisby-Pamp, and Sally Parrish Richardson—turning them into instant celebrities.

As the press fought to obtain exclusive stories aboard the *Constitution*, Grace was in a much different mental place. "The day we left our ship was surrounded in fog. And that's the way I felt—as if I were sailing off

**OPPOSITE** Princess Grace, photographed by Philippe Halsman in 1959. **ABOVE** Grace and Rainier during their engagement.
**OVERLEAF** Grace waves good-bye as she sails for Monaco.

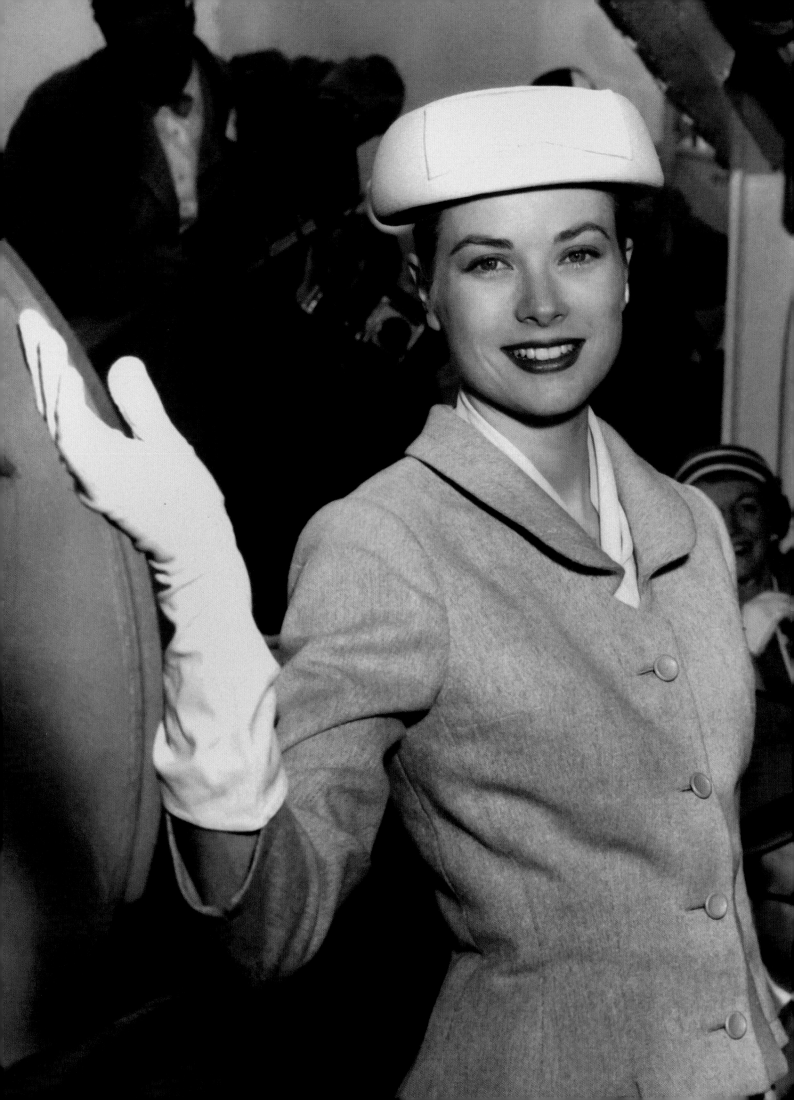

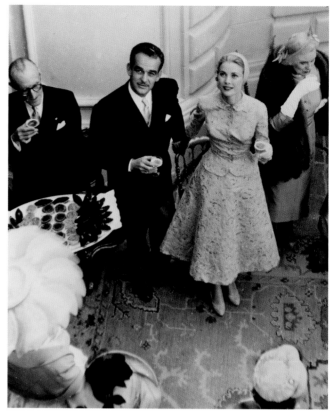

into the unknown," Grace recalled. "I had been through several unhappy romances. And although I had become a star, I was feeling lost and confused. I didn't want to drift into my thirties without knowing where I was going in my personal life." Though the atmosphere aboard the ship was festive, Grace's mood became reflective. "I couldn't help looking out into the fog and wondering: what is going to happen to me? What will this new life be like? . . . What sort of world was waiting for me on the other side of that fog?"

Across the Atlantic, citizens of Monaco were just as unsure of their future. "The only Americans they had seen until then had been G.I.s and tourists," said Baron Christian de Massy, the nephew of Prince Rainier. "And what was an actress? The actresses were the little starlets from the Cannes Film Festival, letting their bikini top fall down. And the Monegasque women and old men were saying, 'My God, we're having one of those as our next ruler, are we?'"

The USS *Constitution* arrived in Monaco on the morning of April 12, 1956. Rainier met Grace on his yacht, the *Deo Juvante*, and a crowd of over 20,000 turned out along the port. There was plenty of drama for the

newspapers. Rainier's mother, Princess Charlotte, reportedly snubbed Grace, and—in a scene straight out of *To Catch a Thief*—there were two jewel robberies, one involving Grace's bridesmaid Marie Frisby Pamp.

On April 18, 1956, Rainier and Grace were married in a forty-minute civil ceremony. The entire wedding was documented for the film *Wedding in Monaco*, and Grace and Rainier immediately repeated the civil ceremony for the film cameras. Grace received 142 official titles. An elegant garden party reception was held for all of Monaco's 3,000 adult citizens, with a brilliant fireworks display in the evening.

The religious ceremony took place the following day at the Cathedral of St. Nicholas. Six hundred guests attended, including Ava Gardner and Aristotle Onassis. The event was televised to thirty million people and became the first multinational media event of its kind. When asked on their twentieth anniversary what they were thinking at their wedding, Rainier joked, "My God, it's too late!" Grace added, "Trapped!" Then she thought for a moment and said seriously, "No . . . walking up the aisle, I thought, Here I am. This is a one-way street now. There's no way out of this." In another interview, Grace

**TOP LEFT** Grace with her poodle Oliver, just before leaving for Monaco. **TOP RIGHT** Grace and Rainier at the reception following the civil wedding ceremony.

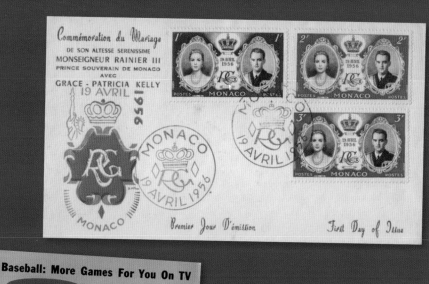

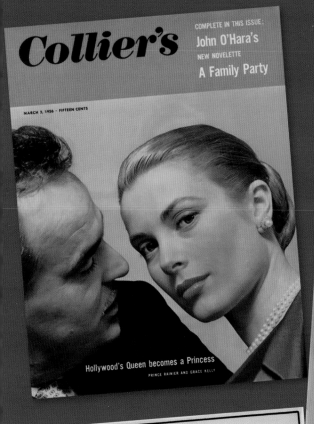

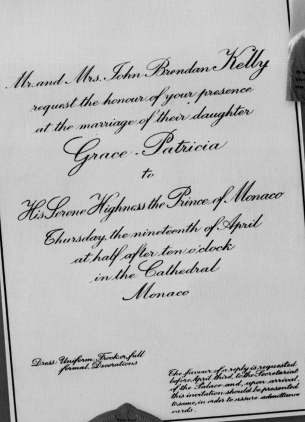

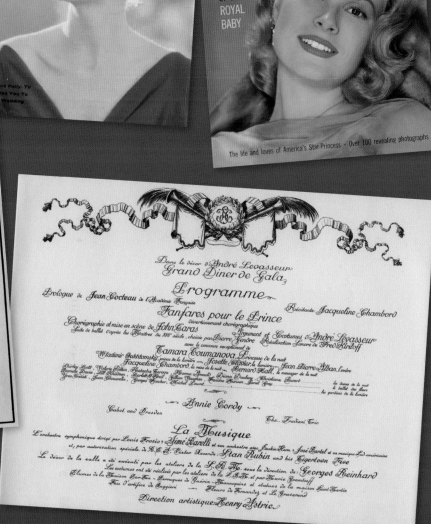

**ABOVE** Interest in all things Monegasque included (clockwise from right): a first day cover with stamps of the royal couple; a *TV Guide* from the week of the wedding and a special magazine devoted to Grace's life; an invitation to one of the galas in Monaco held during the week of the wedding; a Princess Grace cigar band; the invitation to the wedding; and the royal couple on the cover of *Collier's* magazine.

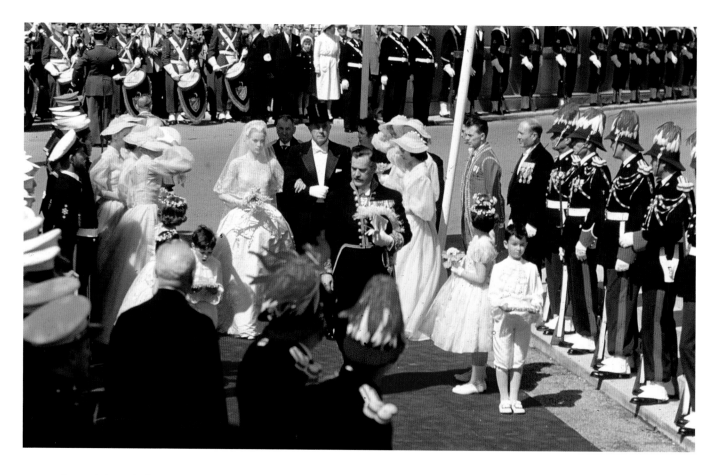

remembered the whole engagement and wedding as "so hectic and so quick and frantic. There was no time to sit and think about anything."

After the event and reception, Grace and Rainier boarded the *Deo Juvante* to begin their seven-week honeymoon cruise around the Mediterranean. The wedding party looked down into the harbor from the battlements of the palace, and watched them. "The last time I saw Grace was, in my own imagination," Rita Gam said later, "when she was on the yacht chug-chug-chugging away into the Mediterranean after the wedding was over, and I realized there was no more Grace Kelly. Grace Kelly was a memory. Grace Kelly was history. There was only Princess Grace of Monaco."

When she stepped off the yacht at the end of the honeymoon, not only was she Princess Grace of Monaco, she was also carrying the country's heir. On August 2, Rainier announced the happy news to the world. The pregnancy was a difficult one, causing Grace to be sick constantly—not only in the morning but often all day. Amid this discomfort, she was taught royal protocol,

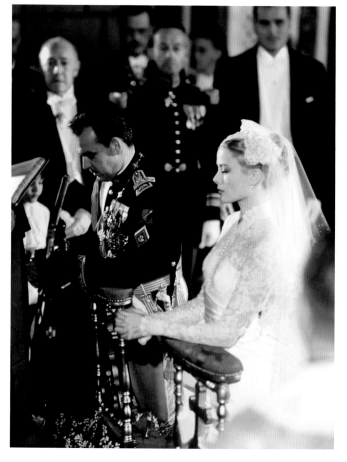

**TOP** Grace arrives at the church for the religious ceremony, escorted by her father. **ABOVE** The wedding ceremony was the first royal wedding televised on a large scale, and was watched by millions.

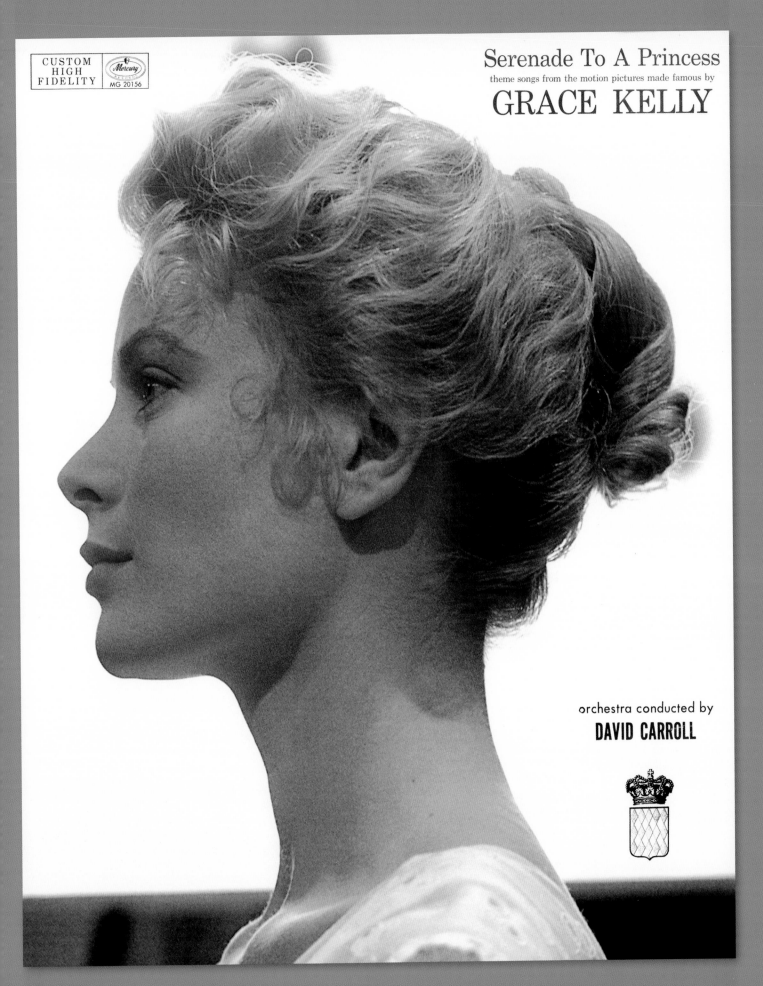

Serenade To A Princess
theme songs from the motion pictures made famous by
GRACE KELLY

CUSTOM HIGH FIDELITY
*Mercury*
MG 20156

orchestra conducted by
DAVID CARROLL

**ABOVE** An album was released featuring the scores of Grace's films to capitalize on the wedding.

267

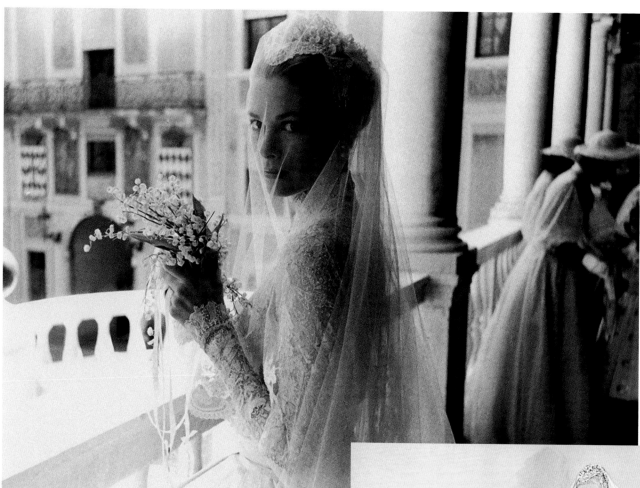

learned a new language, and oversaw the staff of the 225-room palace. Rainier's mother and sister did not readily accept Grace, and she was known to experience bouts of homesickness. "There were a lot of things to adjust to," Grace said of those early days.

Rainier was anxious to support Grace in her new role as princess, but Grace also had to adjust to her husband's temperament, which could change rapidly. Rainier was often described by the press as shy, but his wife soon learned that Rainier also had a temper. Grace's penchant for avoidance may have been the best way to handle Rainier until he cooled down. "He's a Gemini—two people in one," Grace said. "Light and darkness. When it's dark, I avoid it. Or we make light of it, you know, turn a quarrel into a laugh."

Princess Caroline Louise Marguerite was born on January 23, 1957. Twenty-three cannon blasts signaled to the residents of Monaco that the princess had given

**TOP** The wedding gown was designed by MGM's Helen Rose. **ABOVE** The sketch for the dress by Helen Rose's sketch artist Donna Peterson.

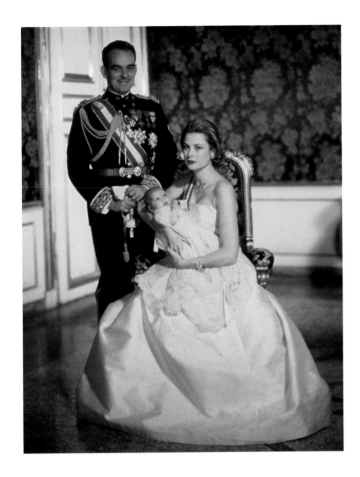

birth to a baby girl. A national holiday was declared and gambling ceased for the day. Five months later, Grace was pregnant again. On March 14, 1958, Prince Albert Alexandre Louis Pierre was born. This time, 101 cannon blasts alerted the citizens of Monaco that a boy had been born.

"Once Caroline was born, and then Albert, I began to feel my roots in Monaco," Grace said. "Now that I had my new family around me, I could move outside the palace into the community." Grace began using her new position to undertake charity and social work. In 1957, the United Nations asked Grace to make a thirty-minute Christmas Day radio appeal for aid for 53,000 refugees still in camps in Western Europe. She recorded the program on December 24 with United Nations radio announcer George Movshon.

Grace's charity work helped her to maintain ties to Hollywood. As head of the Monaco Red Cross, Grace was able to entice her old Tinseltown friends—such as Cary Grant and Frank Sinatra—to attend Monaco's annual Red Cross Ball. This helped to make the event the highlight of the social season. "Once Grace's life as a performing

artist seemed to come to a close as she became Princess of Monaco, she didn't discard her feeling for the arts—any part of them," said Judith Balaban Quine. "She wanted very much to have Monaco be a cultural center."

Winning over Monegasque society was not easy, but no one could deny that Grace Kelly was good for Monaco. After her arrival the number of visitors to the country doubled. Property values increased. Monaco took its place on the world stage, with Grace as its primary attraction.

Privacy was one sacrifice she made for her new very public life. At the palace, there was a constant flow of staff. Outside, a crush of photographers wherever she and Rainier went. "I don't know how she was able to protect that small core that is so necessary—that keeps you sane—but she did," Rita Gam said. "Grace had the extraordinary ability of not rising above it, but separating herself from it. It was almost a mystical kind of ability she had to be the quiet eye in the middle of a horrendous hurricane."

In 1960, John B. Kelly was diagnosed with stomach cancer. Grace flew to Philadelphia to be by his side; he died on June 20. In his will, he specified that his

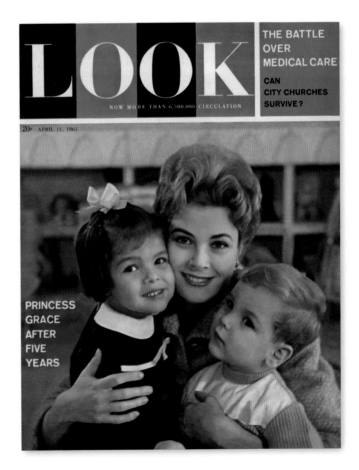

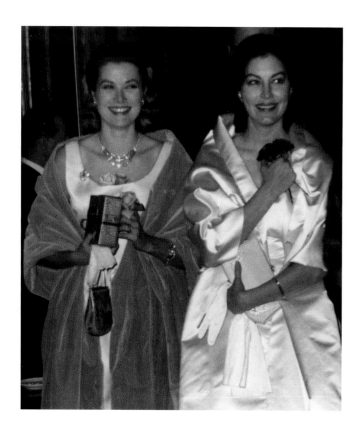

about appearing in Alfred Hitchcock's film *Marnie* (1964), which was then in pre-production. Grace had been a special favorite of Hitchcock's, and he struggled to find a suitable replacement for her unique brand of subtle sex appeal. Grace missed working with Hitchcock too. "In the back of Grace's mind was always the possibility of going back to being a film star. I think she kept it there for those rainy nights," said Rita Gam.

The rainy nights had come. Grace had suffered two miscarriages after Albert was born, and her hopes for another child were dashed—at least for the moment. She was suffering bouts of depression and sometimes sleeping at odd hours of the day. "She was sad not to have an active creative life," said Judith Balaban Quine. "I think Grace missed being a working person."

Rainier had mellowed, and no longer opposed the idea of Grace making another film. He even arranged for Grace to shoot *Marnie* during her summer vacation, so it would not interfere with her official duties. The title character, Margaret "Marnie" Edgar, is a frigid thief who is blackmailed into marriage by her employer (eventually played by Sean Connery). Though *Marnie* was a sex mystery, both Rainier and Grace trusted Hitchcock to execute the premise in good taste.

But when the official announcement was made, the press began speculating that Grace and Rainier's marriage was in trouble. Even worse, the French press insisted that Grace was returning to films to raise money to fight France over its tax altercation. MGM also had

daughters' inheritances should not be shared by their husbands but should "help pay the dress-shop bills which, if they continue as they have started out, under the able tutelage of their mother, will be quite considerable." If Grace or other members of the family were hoping that the document would confirm their father's love for them, Jack Kelly was not forthcoming—although he did include a word of appreciation for his family: "Up to this writing, my wife and children . . . have given me much happiness and a pardonable pride, and I want them to know I appreciate that."

In 1962, a crisis occurred after Prince Rainier engaged Martin Dale, the former U.S. vice-consul in Nice, to entice foreign businesses to Monaco, depriving France of some of its tax revenue. France's president Charles de Gaulle was furious and rescinded France's new business agreements with Monaco, taking the extra step of blocking the borders between Monaco and France. De Gaulle even halted trade between Monaco and France, which threatened businesses in Monaco. In 1963, Rainier disbanded his new business plan. Only citizens that had registered as Monegasques prior to 1957 could enjoy tax-free status now.

It was under this cloud that Grace was approached

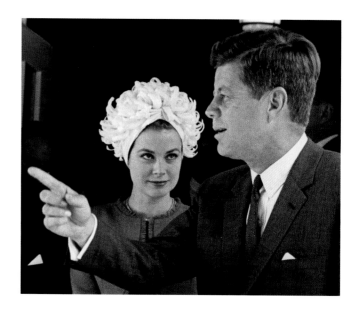

**TOP** Grace and Ava Gardner attend the Bal de la Rose in Monaco in 1960. **ABOVE** Grace at the White House with President John F. Kennedy, 1961.

questions about the legal implications of Grace's working for another studio, when she had never fulfilled the rest of her contract with them.

Grace felt she had no choice but to withdraw from the project. She wrote a note to Hitchcock: "It was heartbreaking for me to have to leave the picture. I was so excited about doing it, and particularly about working with you again." Rupert Allan, for one, was relieved that Grace would not be making that particular vehicle—a film that would be criticized for treating its female protagonist cruelly, even sadistically. "Thank goodness," Allan said. "Why would she want to do it? Why would Hitchcock want to do it?"

As an actress, Grace's biographer Gwen Robyns wrote, "she knew that she hadn't reached her potential." Yet Grace was forced to prematurely close the door on that chapter of her creative life. After withdrawing from *Marnie*, Grace had to accept that her film career would probably never be revived. "She realized that what she had always wanted in her life was going to be lost," Rita Gam observed. "She would never be able to act again, which is what she had wanted more than anything else."

Hollywood's loss became the world's gain. Grace threw herself into her charity work. In 1963, she founded AMADE to protect children from violence, exploitation, and abuse. In 1964, she founded the Princess Grace of Monaco Foundation to promote local artisans and provide scholarships for those gifted in the arts. Over the years in Monaco, Grace was either fully or partially responsible for modernizing the hospital; founding a day care center; enlarging the home for the elderly; founding the ballet school and ballet festival; and helping the Garden Club grow into an international flower-arranging festival.

"She was a giving person," said her brother, John B. Kelly Jr. "She heard of a family with eight children. The father had been killed in a car accident. The mother had been admitted to a mental institution. The kids were divided among local households. Grace took one child, a nine-year-old boy, into the palace. She insisted that the child be treated like a member of the family. Grace never advertised these things."

After years of speculation by the tabloids, Grace finally

TOP Grace and Maria Callas in Monaco, 1962. ABOVE Grace was a favorite on European magazine covers, such as this 1962 cover of *Freundin*.

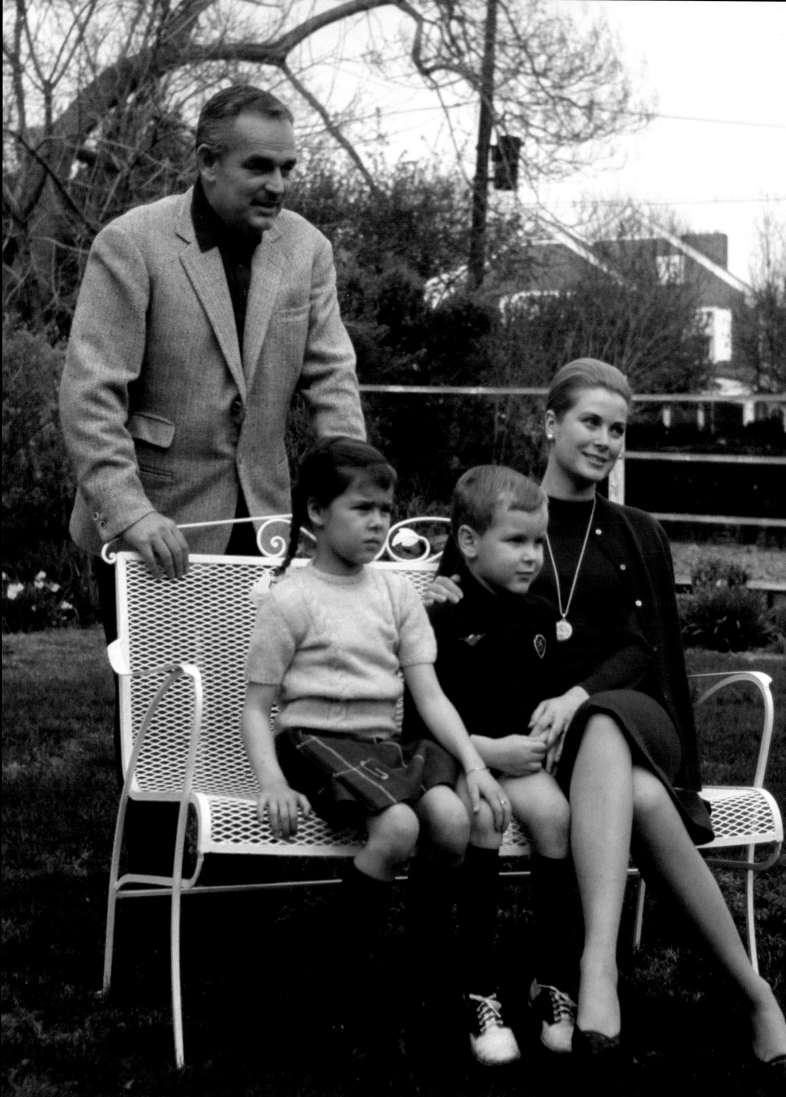

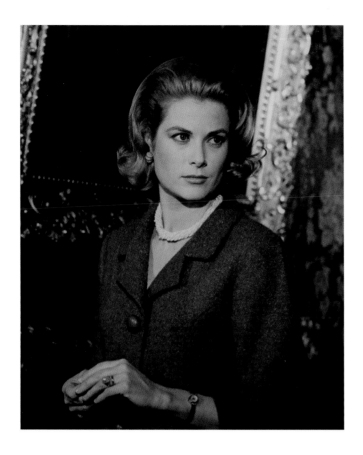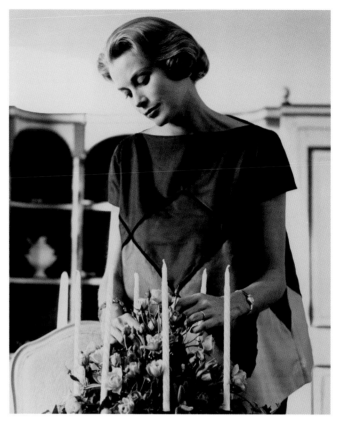

did become pregnant again and delivered Stéphanie Marie Elisabeth on February 1, 1965. Grace loved being a new mother and buried her disappointments in caring for Stéphanie. "Grace always adored children," said Rita Gam, "and she almost over-adored her own children. She was the typical loving, sometimes too disciplining, but always giving mother."

Though a Hollywood feature would never develop, Grace would appear occasionally in documentaries promoting Monaco, such as the 1959 German-produced film *Love in Monaco*. In 1963, she hosted the CBS TV special *A Look at Monaco*, the principality's answer to Jacqueline Kennedy's televised tour of the White House. In 1966, Grace provided the introduction to a dramatic feature film produced by the United Nations. *The Poppy Is Also a Flower* starred Stephen Boyd, Yul Brynner, Angie Dickinson, and Rita Hayworth in a story about United Nations narcotics agents. Nearly every year, Grace agreed to a television appearance to help promote her country or to honor an old Hollywood friend.

Though she granted them with some regularity,

television interviews were difficult for Grace. She had felt the criticism so acutely in her early days in Monaco that she fretted over each word she spoke publicly. When Barbara Walters interviewed Grace in 1966, Walters asked the question the world was always asking: was Princess Grace happy, had she really achieved the fairy tale? "I've had many happy moments in my life," Grace answered. "I don't think happiness is a perpetual state that anyone can be in. No, life isn't that way. But I suppose I have a certain peace of mind." Walters recalled, "When the interview was over, she almost broke down in tears, it was so difficult."

Grace was expecting again in 1967. But while in Canada attending the World's Fair, Grace became ill and was rushed to the hospital. It was discovered that the boy Grace was carrying had died inside of her a month earlier. Doctors performed a missed abortion, and Grace had to accept that she could not bear another child.

She kept busy with her royal life, and found time to host the TV special *Tour of Monaco*, a one-hour musical tour of Monaco, and to appear in a pretaped segment for

**OPPOSITE** (left to right) Rainier, Caroline, Albert, and Grace on a visit to Philadelphia in 1963.
**ABOVE LEFT** Grace hosted a televised tour of the palace in 1963. **ABOVE RIGHT** Grace in 1965.

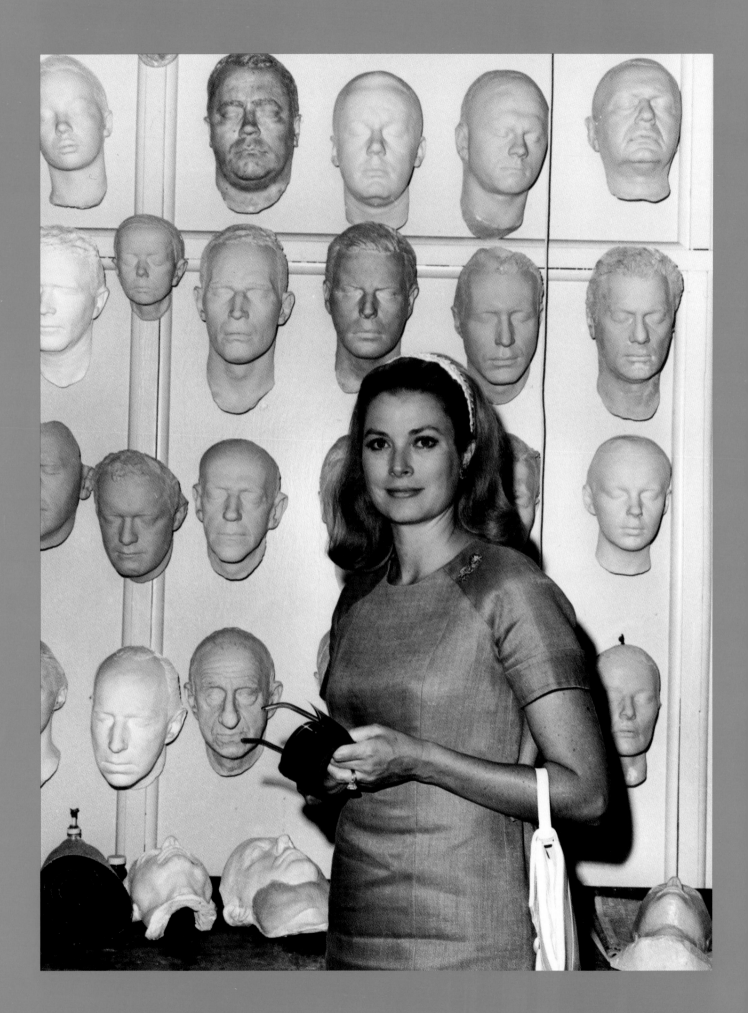

**ABOVE** Grace revisits some of the tools of her former trade on a visit to Universal Studios in Los Angeles in 1967.

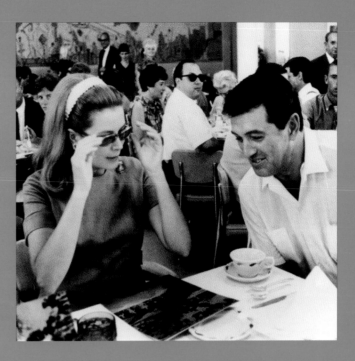

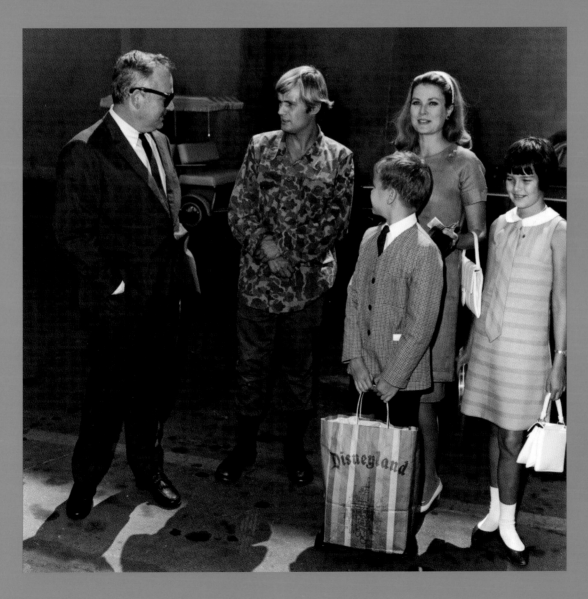

**TOP LEFT** At Universal, Albert, Grace, and Caroline examine frames of CinemaScope film.  **TOP RIGHT** Grace lunches with Rock Hudson.
**ABOVE** (left to right) Rainier, actor David McCallum, Albert, Grace, and Caroline.

the 40th Annual Academy Awards. In the 1970s, Grace and Rainier began spending more time apart. Rainier was preoccupied with affairs of state, and Grace moved to Paris with Caroline while she attended school. "Grace had a very happy marriage in many ways," said Judith Balaban Quine. "She had a very difficult marriage in many ways because she had a very difficult, special situation in life, which gave her enormous privilege in one way, but gave them both very major burdens."

As the children matured, Grace found ways to return to her love of performing. In 1976, she was invited to recite American poetry as part of the United States Bicentennial. That same year, Grace joined the board of Twentieth Century Fox. Jay Kanter who was now an executive at the company, received word that a woman was sought to fill a vacancy on the board. "Then suddenly it came to me," Kanter said. "Grace always loved movies and here was some association she could have with the film business and she didn't have to spend very much time."

When Grace arrived for her first board meeting, the studio had hoisted the flag of Monaco on the flagpole at the entrance. A big party was given to welcome

Grace, "but she took it very seriously," Kanter said. "She would get all the board books, ask questions—endless questions—in the board meetings. She was back in show business." According to chairman Dennis Stanfill, Grace "had such a sound business sense. I really admired it. Did that woman know Hollywood!" If Grace had any idea about using the position to return to films, "she certainly never hinted about it to us," Stanfill said. "The standing offers were always there."

One of those offers was a lead role in *The Turning Point* (1977), a feature film set in the ballet world. Though Grace had been taking ballet lessons since she was a young girl, she turned the role down. But filmmaking was on Grace's mind. In 1976, she met the handsome young Austrian film director Robert Dornhelm and agreed to narrate his documentary *The Children of Theatre Street* (1977). "She looked after everybody, from the make-up person to the electrician," Dorhelm said of Grace. "She just enjoyed being with a film crew again, knowing that everybody there adored her and they respected her."

In 1977, NBC filmed a television documentary about Grace's life. Titled *Once Upon a Time . . . Is Now: The*

**ABOVE LEFT** Princess Grace in 1970. **ABOVE RIGHT** Princess Grace financed the comeback performances of Josephine Baker, pictured here in 1969.

*Story of Princess Grace*, the special was produced by Bill Allyn, Grace's old friend from her acting days. Lee Grant hosted, and interviews with George Seaton, James Stewart, and Edith Head were featured. When Grant sat down to interview the princess, Grace could not open up. "You're just repeating [things]," Grant told her, "and you're not saying anything about how you felt about your co-actors and costars,'" she said. Grace turned to a friend and asked, "Am I boring? I don't want to be boring." Grant remembered that Grace was crying. "She had little tears coming down her face."

Grant asked Grace why she didn't speak more candidly. "The women here in Monaco don't like me, and so I have to watch everything I say and everything I do because they're so critical," Grace told Grant. "Who would have thought?" Grant said later. "The princess—she's gotten everything, she's Cinderella, and there she was, so lonely and so unhappy."

Since 1971, Grace had been walking in the mountains of Monaco collecting flowers, which she pressed in old telephone books. She would then arrange them on artboard to make pressed flowers collages, which she signed using her premarriage initials—GPK. Some friends were puzzled by this hobby. "Here was one of the most vital women in the world, and she making pressed flower collages?" wondered Rupert Allan.

With just one phone call, Grace could have returned to filmmaking or entered into nearly any creative endeavor of her choice. But films, plays, even poetry readings, require collaboration. With her pressed flowers, Grace was free to express her creativity as she saw fit. In the small room in the palace allotted to her hobby, she was free from criticism. In the summer of 1977, Grace went public with her flower collages, exhibiting fifty of them at the Galerie Drouant in Paris. The collages (priced between $400 and $1,600) sold out.

In February 1978, Grace returned to the American stage. To help celebrate International Wildlife Year, Grace toured six U.S. cities with poetry readings. *Birds, Beasts and Flowers* was created by John Carroll and costarred Richard Pasco. "All of those who were close to her knew that she longed for the stage," said Grace's friend Fleur Cowles. "She liked to step foot on it and, of course, she

ABOVE Whether informal or formal, in the 1970s Grace personified the idea of a princess for royalty watchers.

Grace maintains her connections to show business. **ABOVE** In 1971, Grace attends a press conference with old friend Cary Grant. **RIGHT** Again with Cary Grant, at a benefit for the Motion Picture and Television Relief Fund in Los Angeles in 1971. **BELOW** Grace appears on *The Mike Douglas Show*, which was broadcast across the U.S., but was filmed in Philadelphia.

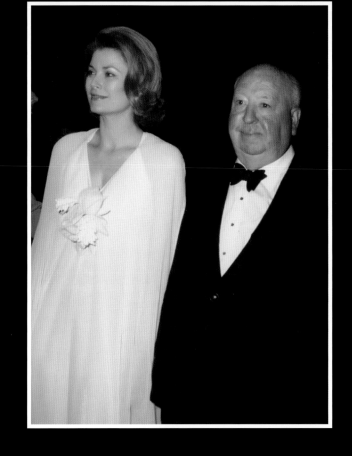

ABOVE LEFT Grace with Alfred
Hitchcock at the Film Society
of Lincoln Center tribute to the
director in 1974. ABOVE RIGHT Grace
talks with actress Lee Grant in 1977,
during the filming of the television
special about Grace's life, *Once
Upon a Time…Is Now: The Story
of Princess Grace.* LEFT During her
time on the board of Twentieth
Century Fox, Grace attended a
screening of the studio's new film
*Star Wars* in 1977.

found the way by reading poetry." It seemed as though Grace had finally found a way to act on the stage, in a manner that was acceptable to the citizens of Monaco. "Grace was an artist and she did it through poetry," said Rita Gam.

The media frenzy that surrounded the Monaco royal family reached fever pitch in June 1978, when Princess Caroline married Philippe Junot, a venture capitalist often described in the press as a "playboy." For years, the tabloids had gotten miles of copy out of portraying Caroline as a hard-partying princess, with Grace at her wit's end trying to control her rebellious daughter. Though they had doubts about the marriage lasting, Grace and Rainier gave their blessing. "She was very open, very modern," Princess Caroline said of her mother, "and she said, 'Go make your mistakes. Try not to make too much of a mess of it. You can always come home, and this is what I'd do in your place."

The press continued to hound Caroline and Junot all through their marriage. When paparazzi caught Junot at a nightclub in New York, dancing with another woman, it spelled the end of the union. Rita Gam recalled Grace's frustration with the intrusive media. "She said, 'They're so horrible. They're absolutely ruining my life. Why don't they leave us alone? Why don't they leave my children alone?'"

In November 1979, Grace appeared on *The Mike Douglas Show*, which broadcast for an entire week from Monaco. Prince Rainier, Caroline, and Albert also appeared. "I'm a very immodest mother," Grace told Douglas. "I think all my children are lovely. Of course, there are times I've wanted to strangle them, but I'm glad I resisted the temptation." In 1980, Grace toured the United States again with poetry readings. In December, she appeared on the television show *G.E. Theater Presents Omnibus* with John Westbrook, reading the poems "American Names" by Stephen Vincent Benét and "The Owl and the Pussycat" by Edward Lear.

After a performance by Grace at a London poetry presentation in March 1981, she met with Prince Charles and Lady Diana Spencer, who was making her first official appearance since becoming engaged, and photos of Grace with the couple appeared all over the world. In April, Grace and Rainier celebrated their twenty-fifth wedding anniversary at the home of Frank and Barbara Sinatra in Rancho Mirage, California. Gregory Peck, Ricardo Montalbán, and Cary Grant were among the forty guests. The press reflected on the couple's years of marriage, and so did Oleg Cassini. "These kinds of marriages are organized, arranged," he said. "That she'd marry a man she didn't even know is proof of her obedience, as conceived by a very militant Catholic family."

Ava Gardner's assessment was more balanced. "Who's happy all the time? Only a complete idiot," Gardner said. "Grace is like me, a realist. You take what life dishes out and grab what goodies you can for yourself along the way. She's grabbed quite a few—a husband, three kids, all the money in the world. She lives in a palace." She also had a packed social calendar and was accepting more and more creative projects now that the children were grown.

In February 1982, Grace taped *Night of 100 Stars*, a televised celebration of the Actors Fund's 100th anniversary, at Radio City Music Hall. Over 200 screen luminaries participated, including Jane Fonda, Lauren

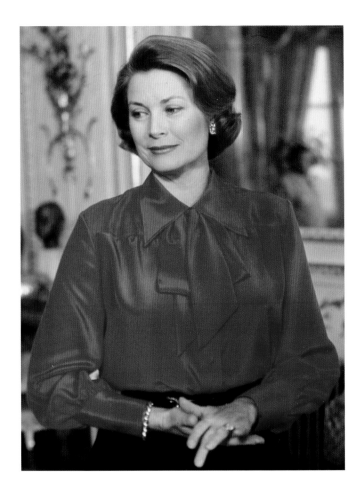

**ABOVE** Grace in 1977, during the filming of *Once Upon a Time… is Now: The Story of Princess Grace*.

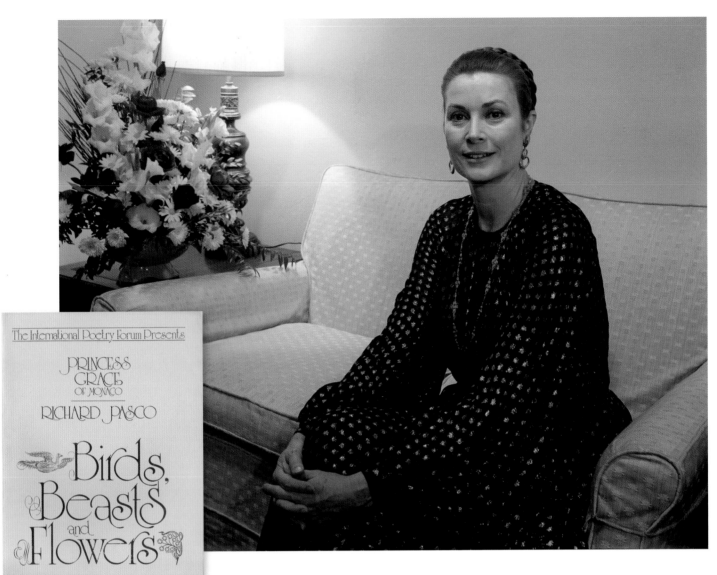

Bacall, Elizabeth Taylor, Bette Davis, Robert De Niro, Brooke Shields, Dustin Hoffman, and Goldie Hawn.

In March, the Annenberg Center at the University of Pennsylvania held "A Tribute to Grace Kelly, Actress" in Philadelphia. Bob Hope, Stewart Granger, Jimmy Stewart, and Rita Gam attended the gala event. Grace had a cold but held a press conference. Asked to name her favorite leading man, she said, "You're really putting me on the spot," and declined to go any further.

In the summer of 1982, Grace realized a dream—the opening of a small live theater, built along the harbor in Monaco. It was Grace's intention to create a repertory company in Monaco, enlisting some of the actors with whom she had worked on her poetry readings. She may have even cast or directed some of the productions herself.

Perhaps the biggest professional mystery of Grace's

career was a thirty-seven-minute film she helped to create and starred in, called *Rearranged* (1982). Grace had been looking for another project on which to work with Robert Dornhelm, and finally she financed one herself. The plot centered on Monaco's annual flower festival and involves a scientist who the princess mistakenly believes is a champion flower arranger. The movie had a small premiere in Monaco. A television network said they would show the film if it were longer, and Grace and Dornhelm began discussions about how to expand the project. But it was not to be, and the film has never been shown again. "She has a couple of scenes where you really see the fine person she was, and the great actress she was," says costar Edward Meeks. "I think it's very difficult to accept or to imagine that this film will never be seen by the public."

Certain scenes in the film may have been too

**ABOVE** Grace just before taking to the stage to perform *Birds, Beasts and Flowers* in Pittsburgh in 1978. **INSET** A program for the performance.

prophetic. "There's a scene actually in the car, in the same car in which she had the accident," Dornhelm said. "And she's telling this astrophysicist that life would be a very boring place if we wouldn't experience pain. Pain is better than no emotion at all. And then she just sits and looks, and it's a very interesting study, knowing in the same car, not far, on the same street, she had this accident."

On Monday, September 13, 1982, Grace and Stéphanie left Roc Agel, the family's country home, to drive to Monaco. Grace had an appointment with her couturier, and had loaded some dresses needing alterations in the backseat of the family's 1972 Rover 3500. For this reason, Grace left her usual chauffeur behind and decided to drive Stéphanie herself. In the evening, Grace was planning to take Stéphanie to Paris, where the young woman would be attending the Institute of Fashion Design. Later in the week, Grace was scheduled to do an interview for *Good Morning America*.

Grace had never liked to drive, and the hairpin turns between La Turbie and Monaco must be negotiated carefully. At about 9:54 a.m., a truck driver saw Grace's car swerve to the left and hit the mountain side of the road. The truck driver sounded his horn and the car seemed to right itself. But at the next hairpin turn, the car sped up. It went flying over a hill down through tree tops, striking the trunk of a tree. The car bounced upside down and rolled several times before coming to a stop on its roof and nose.

Grace and Stéphanie were taken to the Princess

Grace Hospital in Monaco. Initial reports from the palace were that brake failure was responsible for the accident and that Grace had only suffered a broken leg. In fact, Grace had probably suffered a stroke while driving, and had sustained a broken thigh bone, a fractured knee, and a possible brain injury. Because the Princess Grace Hospital did not possess a CAT scan machine, nearly twelve hours elapsed before Grace's brain could be properly examined. It was determined that Grace had suffered two brain injuries—one caused by the accident and one by a stroke.

As soon as the media picked up the story of Grace's accident, newspapers across the world printed details of the crash—but gave the impression that a full recovery was imminent. On the night of September 13, hope for a recovery dwindled as the princess deteriorated rapidly. On September 14, 1982, Rainier and his children were told that nothing more could be done for Grace. They made the decision to remove her from life support, and Grace Kelly died at 10:15 that evening.

"What happened that day, it was the most tragic day of my life," Princess Stéphanie said. "I know that I did everything I could for it not to happen—for the car not to go off the road. I tried everything, but it was too late." Rumors swirled the week after Grace died that Stéphanie had been driving, or that she and Grace had been arguing when the car went off the road. As Stéphanie recovered from injuries in the hospital—including a hairline fracture in her neck—Rainier stopped the French police from questioning her, which only fueled the media

**TOP** Grace attends the American Film Institute salute to Jimmy Stewart in Los Angeles in February 1980.
**ABOVE** Grace performs poetry with John Westbrook on the ABC television show *Omnibus* in December 1980.

 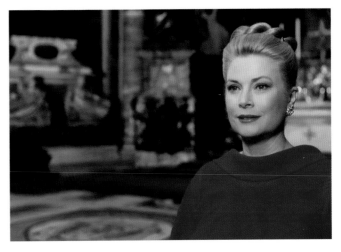

speculation. For all of Princess Grace's charity work and her desire to be remembered as "a decent human being and a caring one," sadly the press turned her death into a circus of conspiracy theories.

The public, however, mourned openly; flowers sent from around the world covered the palace grounds. Nearly 100 million people watched Grace's funeral on TV; royalty and dignitaries from across the globe were in attendance. Rainier seemed lost, sobbing and relying on Caroline for support. "There was a sense of sadness that I've never felt before," Rita Gam said. "It's an image that I'll always carry with me. The light that was Grace was gone and nobody could quite accept it." On September 21, Grace was buried at St. Nicholas Cathedral in Monaco. "I think she won the hearts and the love of the Monegasque people because when she died, I've never seen such true sorrow," Lizanne LeVine said.

"I think they would have had a wonderful old age together," Gwen Robyns said of Rainier and Grace. "They were enjoying each other on a completely different level from what they'd had before. They were getting together. It was going to work out." When Judith Balaban Quine interviewed Rainier for her book *The Bridesmaids*, Rainier told her, "I wanted more time to be alone [with Grace], to be private, to share our real thoughts and feelings about ourselves and one another and life. The things that we all get caught up and get too busy to do." Grace would have concurred. When asked what she wanted for her twentieth wedding anniversary, Grace said, "Maybe I'll ask for a year off with him—and no one else!"

Grace's role as Monaco's First Lady fell to Caroline after Grace's death. Caroline worked hard to realize Grace's dreams for the principality, including establishing a classical ballet company in Monaco in 1985. When Princess Caroline was asked what she would remember most about her mother, she answered: "The laughs. We all had a good time together . . . she was such a happy, funny person. I don't think people got that."

The Hollywood community from which Grace had retired twenty-five years earlier was stricken. Suddenly, the full realization hit: the entertainment world would never see the likes of a Grace Kelly again. Film critic Charles Champlin wrote a touching tribute in the *Los Angeles Times*, observing that the allure, the elegance, and the strength of a woman like Grace was "a bafflement and perhaps even a trouble in a town where women preferably come out of molds, and don't break them." A letter to the *Times* succinctly summarized Grace's appeal: "She personified everyone's dreams and fantasies."

A star-studded memorial service was held in Los Angeles. In his eulogy, Jimmy Stewart spoke for many in Hollywood—and around the world—when he said, "You know, I just loved Grace Kelly. Not because she was a princess. Not because she was an actress. Not because she was my friend. But because she was just about the nicest lady I ever met. Grace brought into my life, as she brought into yours, a soft, warm light every time I saw her. And every time I saw her was a holiday of its own. No question, I'll miss her. We'll all miss her. God bless you, princess."

**ABOVE LEFT** (left to right) Cary Grant, Barbara Sinatra, Frank Sinatra, Grace, and Gregory Peck at the Variety International Humanitarian Award ceremony honoring Frank Sinatra in Los Angeles in April 1980. **ABOVE RIGHT** One of Grace's last professional appearances was for the television special *The Nativity*, filmed at the Vatican and released in 1982.

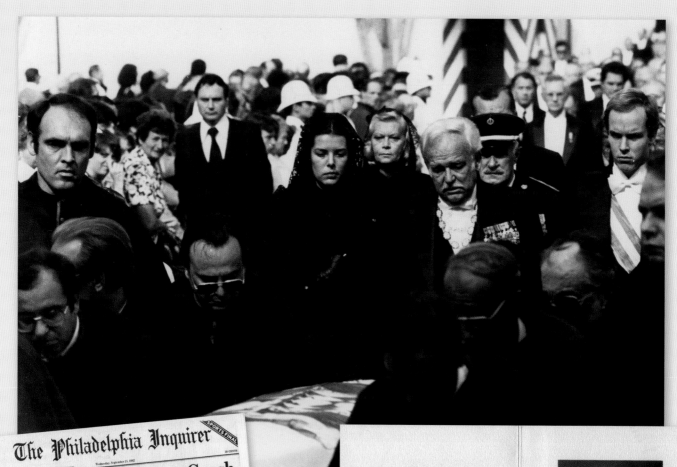

*But if the while I think on thee, dear friend,*
*All Losses are restored, and sorrows end.*
  *William Shakespeare*

*'Quelqu'un d'entre vous souffre-t-il? Qu'il prie''*
  *JC 4 - 13*

*"So much I live for others that I am almost a stranger myself".*
  *Pope Innocent III*

*Sur le seuil de sa maison*
*Notre Père t'attend*
*Et les bras de Dieu*
*S'ouvriront pour toi*

*"I would like to be remembered as a decent human being and a caring one".*
  *Princesse Grace, July 22, 1982*

*"Je suis la résurrection et la vie; celui qui croit en moi, ne mourra jamais".*
  *Jésus à Marthe*

*The sadness of death gives way to the bright promise of immortality. Lord, for your faithful people, life is changed, not ended".*
  *Preface I*

**Grace-Patricia KELLY**
Princesse de Monaco

Née à Philadelphie le 12.XI.1929
rappelée à Dieu le 14.IX.1982

*"Seigneur, je ne te demande pas pourquoi tu me l'as enlevée, mais je te remercie de nous l'avoir donnée".*
  *Saint-Augustin*

**TOP** Princess Caroline, Prince Rainier, and Prince Albert follow Grace's coffin through the streets of Monaco. **CENTER LEFT** Grace's death made headlines around the world, but perhaps none so poignant as her hometown newspaper's. **CENTER RIGHT** The Kelly family's Catholic Mass prayer card for Grace. **LEFT** Dina Merrill (second from left) helps Prince Albert (center) and Princess Stéphanie (second from right) award a Princess Grace Foundation grant to the American Academy of Dramatic Arts in 1984. The foundation is one of the ways Grace's family continues her legacy. **OPPOSITE** Princess Grace photographed in 1972.

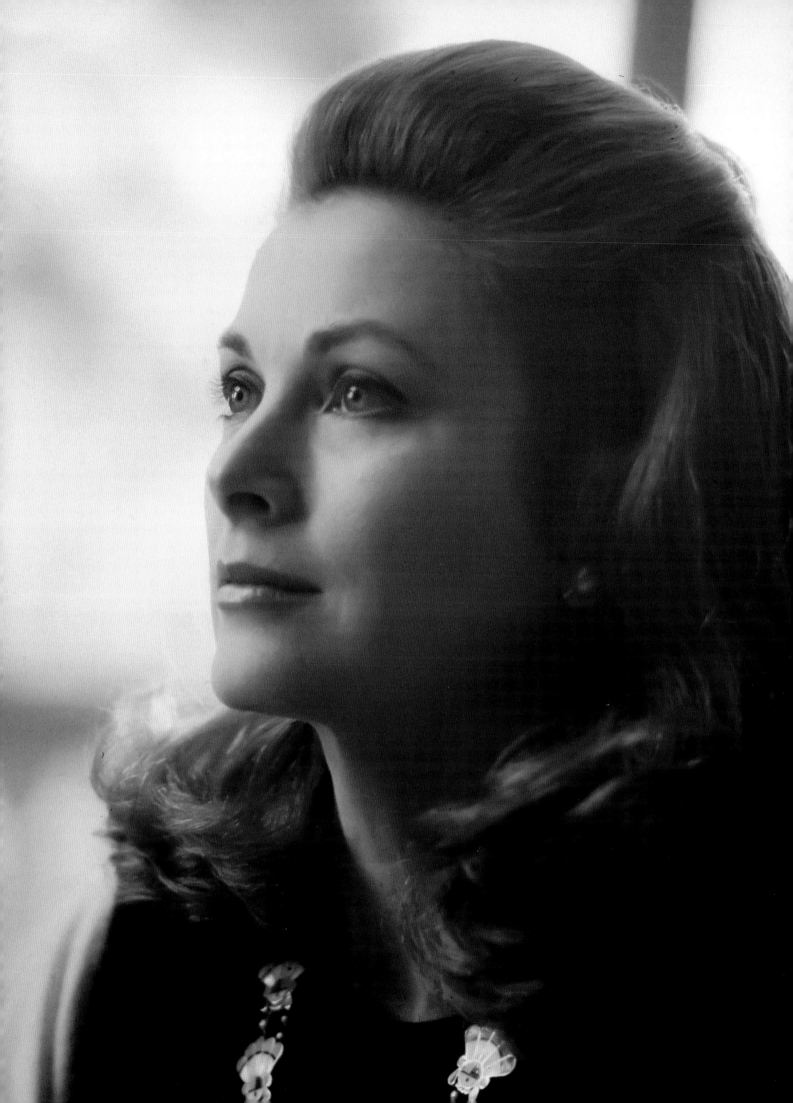

# REFERENCES

BOOKS

Aumont, Jean-Pierre. *Sun and Shadow*. New York: W. W. Norton, 1977.

Balaban Quine, Judith. *The Bridesmaids*. New York: Weidenfeld & Nicolson, 1989.

Belton, John. *Alfred Hitchcock's "Rear Window."* Cambridge: Cambridge University Press, 1999.

Cassini, Oleg. *In my Own Fashion: An Autobiography*. New York: Simon & Schuster, 1987.

Falwell, John. *Hitchcock's "Rear Window:" The Well-Made Film*. Carbondale, Ill.: Southern Illinois University Press, 2004.

Gaither, Gant. *Princess of Monaco: The Story of Grace Kelly*. New York: Henry Holt, 1957.

Gam, Rita. *Actress to Actress*. New York: Nick Lyons Books, 1986.

Gardner, Ava. *My Story*. New York: Bantam Books, 1990.

Granger, Stewart. *Sparks Fly Upward*. London: Granada, 1981.

Kazan, Elia. *A Life*. New York: Alfred A. Knopf, 1988.

Lacey, Robert. *Grace*. New York: G. P. Putnam's Sons, 1994.

Phillips, Brent. *Charles Walters: The Director Who Made Hollywood Dance*. Lexington, Ky.: University Press of Kentucky, 2014.

Robyns, Gwen. *Princess Grace*. New York: David McKay, 1976.

Rose, Helen. *Just Make Them Beautiful*. Santa Monica, Ca.: Dennis-Landman, 1976.

Schary, Dore. *Heyday*. Boston: Little, Brown, 1979.

Sharff, Stefan. *The Art of Looking in Hitchcock's "Rear Window."* New York: Limelight Editions, 2004.

Spada, James. *Grace: The Secret Lives of a Princess*. New York: Doubleday, 1987.

Spoto, Donald. *The Dark Side of Genius: The Life of Alfred Hitchcock*. Boston: Little, Brown, 1983.

Zinnemann, Fred. *A Life in the Movies*. New York: Charles Scribner's Sons, 1992.

SIGNED ARTICLES

Berg, Louis. "A Kelly Can't Miss." *Los Angeles Times*, March 2, 1952.

Birmingham, Stephen. "Princess Grace: The Facts Behind the Fairy Tale." *TV Guide*, February 5, 1983, 4.

———. "Princess Grace: 25 Years Later: The Truth Behind the Fairy Tale." *McCalls*, March 1981, 16.

Carlson, Tom. "Let's Be Frank About Grace Kelly." *Filmland*, July 1955, 11.

Champlin, Charles. "Grace Kelly: A Princess to the End." *Los Angeles Times*, September 16, 1982.

Christy, Marian. "I Remember Grace: John Kelly Looks Back." *New Idea*, October 20, 1984, 33.

Cronin, Steve. "Has Kelly Found Her Man?" *Modern Screen*, December 1954, 30.

———. "The Whole Town's Talking about Grace Kelly." *Modern Screen*, October 1954, 46.

Crowther, Bosley. "'Dial M for Murder' Is Shown at Paramount." *New York Times*, May 29, 1954.

De Villalonga, Jose Luis. "My Hollywood Days—Princess Grace Tells." *New Idea*, August 30, 1975, 28.

Fiori, Pamela. "Ultimate Grace." *Town and Country*, November 2007, 186.

Farleigh, Frances. "Gant's Book Adds Local Luster." *Hopkinsville Kentucky New Era*, September 3, 1957, 10.

Galante, Pierre. "The Day Grace Kelly Met Prince Rainier." *Good Housekeeping*, May 1983, 154.

Gam, Rita. "That Special Grace." *McCall's*, January 1983, 28.

Hopper, Hedda. "Grace Kelly Has Hollywood on Ear." *Los Angeles Times*, August 8, 1954.

Jacobs, Laura. "Grace Kelly's Forever Look." *Vanity Fair*, May 2010, 182.

Keay, Douglas. "Life with Grace: An Exclusive Interview with Prince Rainier."

*Ladies' Home Journal*, May 1974, 90.

———. "Princess Grace: Did the Fairy Tale Come True?" *New Zealand Women's Weekly*, December 13, 1971.

Kolodny, Annette. "Women and Higher Education in the Twenty-First Century: Some Feminist and Global Perspectives." *National Women's Studies Association Journal* 12 (2000): 130–147.

Levin, Robert J. "Why Grace Kelly Became a Princess." *Redbook*, February 1957, 26.

Mallowe, Mike. "A World without Grace." *Philadelphia*, June 1983, 106.

Marx, Linda R. "Grace Kelly of Philadelphia." *People*, September 5, 1983, 86.

Pepper, Curtis Bill. "The Fairy Tale Marriage 20 Years Later." *McCall's*, March 1976, 98.

Peterson, Marva. "Can Grace Teach Hollywood Some Manners?" *Modern Screen*, July 1955, 33.

Rae, Beverly, and John Wood. "Is the Past Catching Up with Princess Grace?" *New Idea*, June 5, 1978.

Scheuer, Philip K. "Cary Grant, Grace Kelly, Riviera Charm in 'Thief.'" *Los Angeles Times*, August 4, 1955.

———. "Grace Kelly, Alec Guinness Perform Regally in the Well-Timed 'Swan.'" *Los Angeles Times*, April 8, 1956.

———. "'Green Fire' Action Tale." *Los Angeles Times*, January 13, 1955.

———. "Hitchcock Preserves Mood of Suspense in 'Dial M.'" *Los Angeles Times*, June 18, 1954.

Schulberg, Budd. "The Other Princess Grace." *Ladies' Home Journal*, May 1977, 82.

Swartley, Ariel. "Updating a Classic, and Revealing, Wardrobe." *New York Times*, November 15, 1998.

Tusher, Bill. "Grace Kelly: Hollywood's New Garbo?" *Screenland*, March 1955, 13.

Wender, Susan. "Kelly Knows Best." *Modern Screen*, January 1956, 36.

UNSIGNED ARTICLES

"Aw Grace, Say Something." *Toronto Sun*, April 1, 1982, 101.

"The Breaching of the Barbizon." *Time*, February 23, 1981, 122.

"Former Teacher Recalls Princess Grace." *North Hills News Record*, September 17, 1982, 1.

"Grace Kelly: Was It All Her Father's Fault?" *Movie Screen Star Romance Yearbook*, 1955, 18.

"Has Love Caught Up with Kelly?" *Movieland*, November 1954, 27.

"How Do You Do, Miss Kelly?" *Photoplay*, December 1954, 47.

"In 1977, Grace Kelly Invited NBC to the Palace of Monaco." *Hollywood Reporter*, August 2015, 40.

"Kelly's Will: A Testament with a Smile from a Great Man." *Philadelphia Daily News*, June 29, 1960.

"A New Career Flowers for Princess Grace." *Australian Women's Weekly*, September 7, 1977, 26.

"Rear Window." *Look*, September 21, 1954.

"Review: 'High Society.'" *Variety*, December 31, 1955.

"Why Hollywood Women Fear Grace Kelly." *Movieland*, January 1955, 29.

INTERVIEWS

Hitchcock, Alfred. Interviewed by Peter Bogdanovich, 1961–1963. Alfred Hitchcock Papers. Margaret Herrick Library, Academy of Motion Picture Arts and Sciences, Beverly Hills, California.

Kanter, Jay. Interview with author, 2014.

Wiesen, Bernard. Interview with author, 2014.

VIDEO RECORDINGS

*20/20*. Lynn Sherr segment. ABC News, 1989.

*20/20*. "Princess Grace Interview with Pierre Salinger." ABC News, 1982.

*ABC World News Tonight with Ted Koppel*. ABC News, September 15, 1982.

*Archive of American Television*. "Interview with Barbara Walters." May 23, 2000.

*Bravo Profiles: Grace Kelly*. Rainbow Media/Cablevision, 1999.

*Barbara Walters Special*. "Interview with Princess Caroline of Monaco." ABC, September 13, 1985.

*Barbara Walters Visits Princess Grace Kelly*. NBC News, August 3, 1966.

*Entertainment Tonight*. "Interview with Bill Allyn." CBS Paramount Domestic Television, 1989.

*Entertainment Tonight*. Segment on "Rearranged." CBS Paramount Domestic Television, 1992.

*Evening Magazine*. Interview with Baron Christian de Massy, KDKA-TV, 1989.

*Frank Sinatra: In Concert at the Royal Festival Hall*. Warner Music Group, 1971.

*Grace Kelly: The American Princess*. Devillier-Donegan Enterprises, Wombat Productions, 1987.

*Grace Kelly: Hollywood Princess*. ABC News Productions, 1998.

*Grace Kelly: Intimate Portrait*. Hearst Entertainment, November 28, 1995.

*Legends in Love*. Charles Grinker Productions, 1990.

*The Making of "High Noon."* Jessiefilm Inc. and Lamberti Productions Corp., 2002.

*NBC News Today*. NBC News, September 14, 1982.

*Pittsburgh 2Day*. "Interview with Judith Balaban Quine." KDKA-TV, 1989.

*Primetime Live*. "Monaco: The Last Fairytale." ABC News, 1997.

*Regis and Kathie Lee*. "Interview with Judith Balaban Quine." ABC, 1989.

### ONLINE ARTICLES

Kaufman, Richard F. "Sea Stories and Memories: Behind *The Bridges at Toko-Ri*." Accessed July 16, 2016. vc-35andvaaw-35.org.

"Lee Grant Recalls Emotional Encounter with Grace Kelly: 'She Was So Lonely and So Unhappy.'" *Huffington Post.*, July 8, 2014. Accessed August 13, 2016. www.huffingtonpost.com/2014/07/08/lee-grant-grace-kelly_n_5568800.html.

### WEBSITES

afi.com/members/catalog
lapl.org
tvtropes.org

imdb.com
mediahistoryproject.org
wikipedia.org

# PHOTO CREDITS

All photos courtesy Independent Visions Archive and the Walter Albrecht Archive, unless otherwise noted, with the exceptions of:

Pages 4 and 260 © Phillipe Halsman courtesy of Magnum Photos

Pages 8–9 © Peter Basch courtesy of Michelle Basch

Pages 18 (top left), 19 (top right, top left and lower left), 23 (top right), 201 (top left and top right), and 265 (wedding invitation) courtesy of Special Collections Research Center, Temple University Libraries, Philadelphia, PA.

Page 25 photo by Ed Vebell

Pages 81–86 and 205–210 courtesy of the Robert Siegel Pressbook Archive

Page 114 photo by Sharland

Pages 115–120 courtesy of Jerry Ohlinger

Page 157 photo by Cecil Beaton courtesy of the Cecil Beaton Studio Archive at Sotheby's

Pages 226–229 © AMPAS

Pages 236–237, and 251 © Dennis Stock courtesy of Magnum Photos

Page 285 photo by Gianni Bozzacchi © FORUM (G. Tedesco)

Courtesy mptv: Pages 58, 62, 74, 76–79 Sanford Roth; Pages 136–137 Bud Fraker; Pages 154–155 © Mark Shaw; Page 238 (middle left) © Bob Willoughby. These and all other images from the Independent Visions Archive, are exclusively represented by mptv. For more information regarding licensing or purchasing images from mptv, please contact mptvimages at www.mptvimages.com.

The photos and images in this book are for educational purposes and while every effort has been made to identify the proper photographer and/or copyright holders, some photos had no accreditation. In these cases, if proper credit and/or copyright is discovered, credits will be added in subsequent printings.

# ACKNOWLEDGMENTS

I would like to thank my father for taking me to see a poetry reading by Princess Grace of Monaco in 1978, starting my forty-year fascination with one of the world's most remarkable women.

Thank you to Jay Kanter and Bernard Wiesen, who specifically conducted interviews with me for this book. A posthumous thank-you to Rupert Allan, Rita Gam, Lizanne LeVine, and others who shared their memories of Grace with me over the years.

Thank you so much to Sloan De Forest, who was tasked with taming my manuscript to make sure we had room in this book for a few photos. Her revisions are greatly appreciated.

In telling the story of Grace Kelly's career, Stephen Schmidt's art direction brought elegance and great visual sense to the photos and ephemera. We were very fortunate to have his expertise and his eye.

A very special thanks to Stan Corwin, who made this project a reality.

Thank you to Robert Waitches, who worked tirelessly to acquire Grace Kelly research material for me. Thanks to Danny Schwartz for his help with several photographs in this book.

Thanks to the Albrecht family, John Barkworth, Greg Boaldin, Michael Childers, Michael Giammarese, Tim Jenkins, Lisa Malec, Mark Mayes, Robert Mycroft, James Rieker, Donald L. Scoggins, Grant Taylor, and Marissa Vassari.

At HarperCollins, Manoah and I are thankful to Lynn Grady for allowing us to create this book. To editor Sean Newcott, thank you for your kind guiding hand throughout this project. Our gratitude to Michael Barrs, Kell Wilson, and Kate Schafer, who marketed and promoted the book. And thank you to Susan Kosko, Nyamekye Waliyaya, Andrea Molitor, and Richard Arquan, whose expertise in production, editorial, and art made this book a worthy tribute to one of the world's great beauties.

—Jay Jorgensen

If I could dedicate this book to more than one person, the second would be Gregory Stone. His fondness for Grace influenced my own and this book was created and designed with him in mind. Thank you, Gregory.

Very special thanks to Judy Brown, Leonard Evans, Christina Ha, Joshua Kadish, Matt Severson, Robert Siegel, and my agent extraordinaire, Stan Corwin.

Thank you to Ron Avery, Mark Biberstine, Laurent Bouzereau, Carol Bowman, Leslie Broadbelt, Shonda Brown, Brett Davidson, David Del Valle, Joe DiCicco, Ken Eckert, Nicole Eckert, Carey Embry, Grant Fenning, John Fenton, Diana Gabaldon, Chris Gibson, Rachael Graeff, David Haglock, Debbie Harvey, Donna Hill, Dianna Honeywell, Andy Howick, Anna Hrnjak, Jessica Iovenko, Ann Jastrab, Krista Kahl, Audrey and Hannah Koch, Daniel Korman, Jack Ledwith, Mary Susan and Ann Louise Maguire, Howard Mandelbaum, Gregor Meyer, Cory Milton, Laura Owen Mbow, Nazanin McCaffey, LaToya Morgan, Catherine Mowry, Cheryl Brown Mowry, Jerry Ohlinger, Dianne Palmer, Sue Peck, Neal Peters, Kevin Posey, Christy Read, James Richman, David, Teresa, Ron and Rita Ross, Danny Schwartz, Victor Segura, Olga Shirnina, Margery N. Sly, David Smith, Norma Smith, James Sutherland, Barb Tashjian, Karl Thiede, Michael A. Tom, Shelley Brocksmith Toth, Sharon Trommler, Matt Tunia, Lou Valentino, Jeffrey Vance, Jon Varese, Natasha Gregson Wagner, John and Norma Ward, Mary Ware, Seven Whitfield, Tom Wilson, Forrest Winchester, and Roy Windham.

—Manoah Bowman

HarperCollins books may be purchased for educational, business, or sales promotional use. For information, please email the Special Markets Department at SPsales@harpercollins.com.

FIRST EDITION

*Designed by Stephen Schmidt / DUUPLEX*

Library of Congress Cataloging-in-Publication Data has been applied for.

ISBN 978-0-062643339

17  18  19  20  21    LSC    10  9  8  7  6  5  4  3  2  1